STEIDL

KLAUS METTIG / DON´T BE LEFT BEHIND

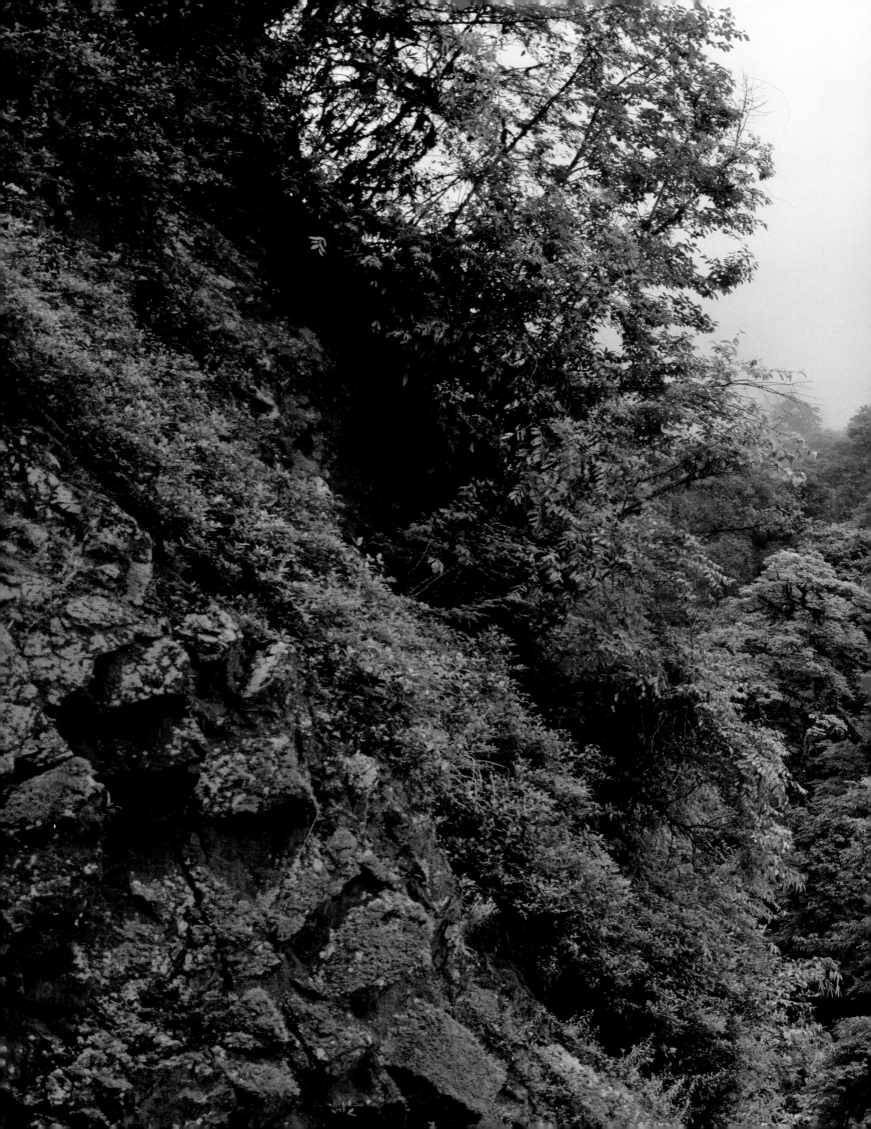

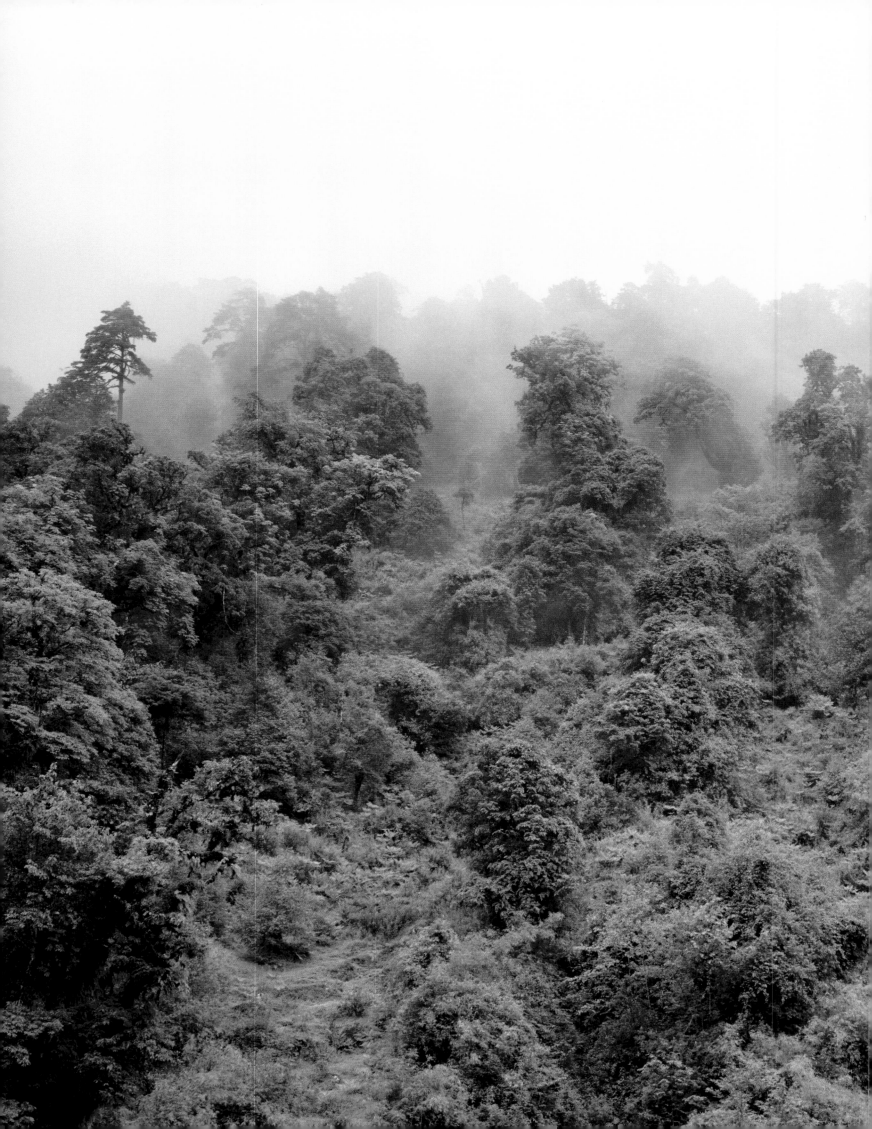

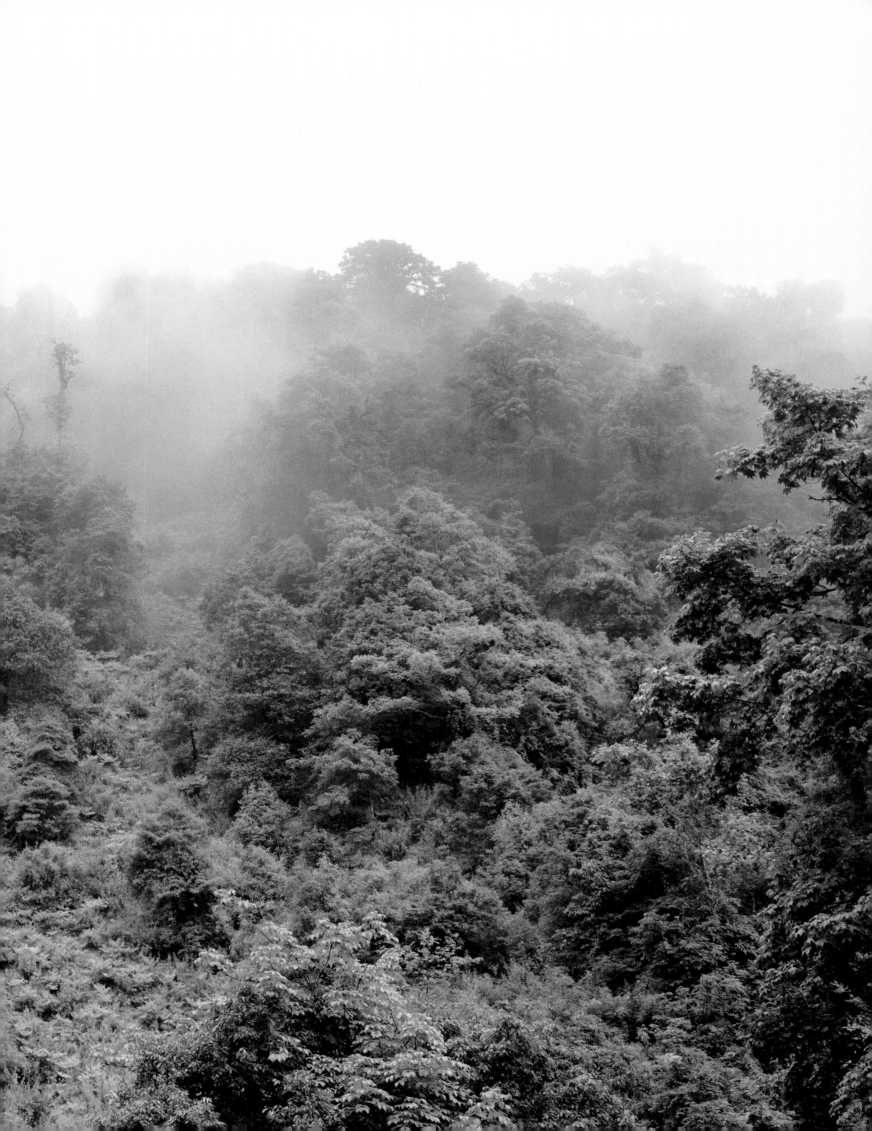

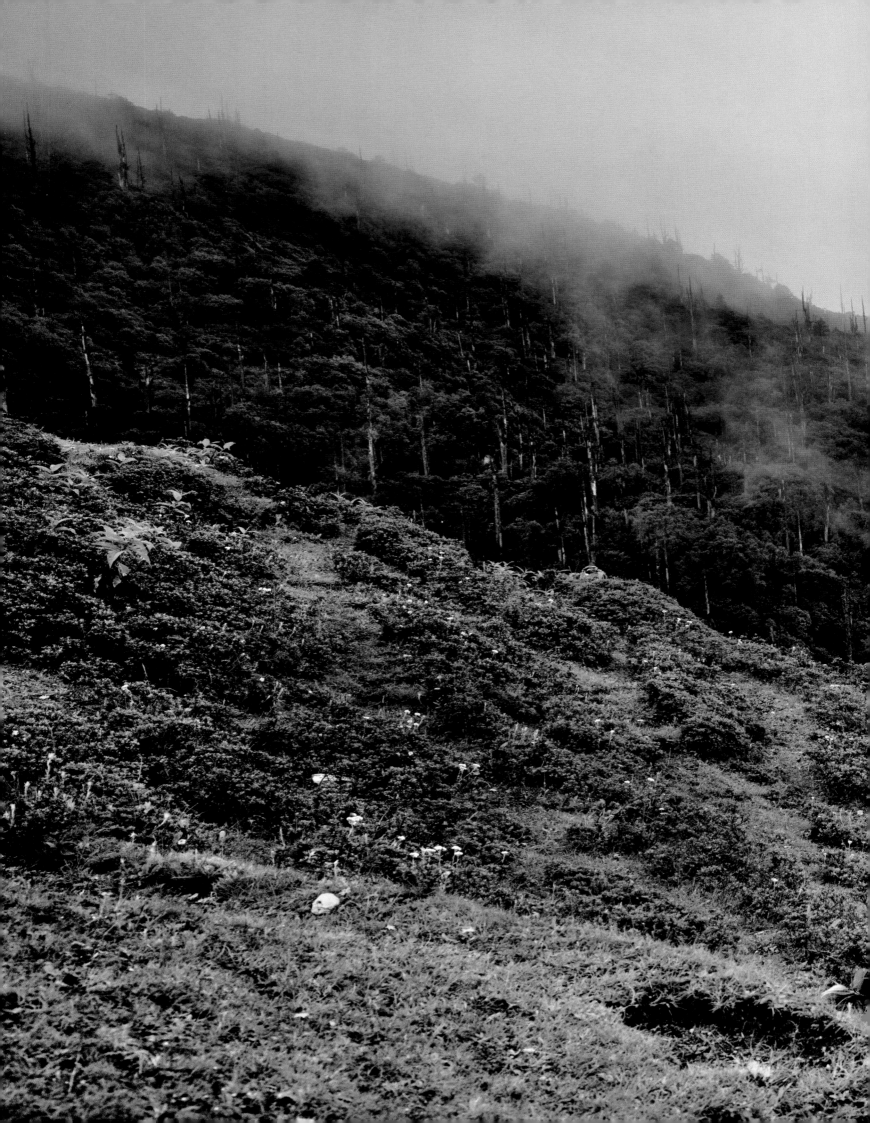

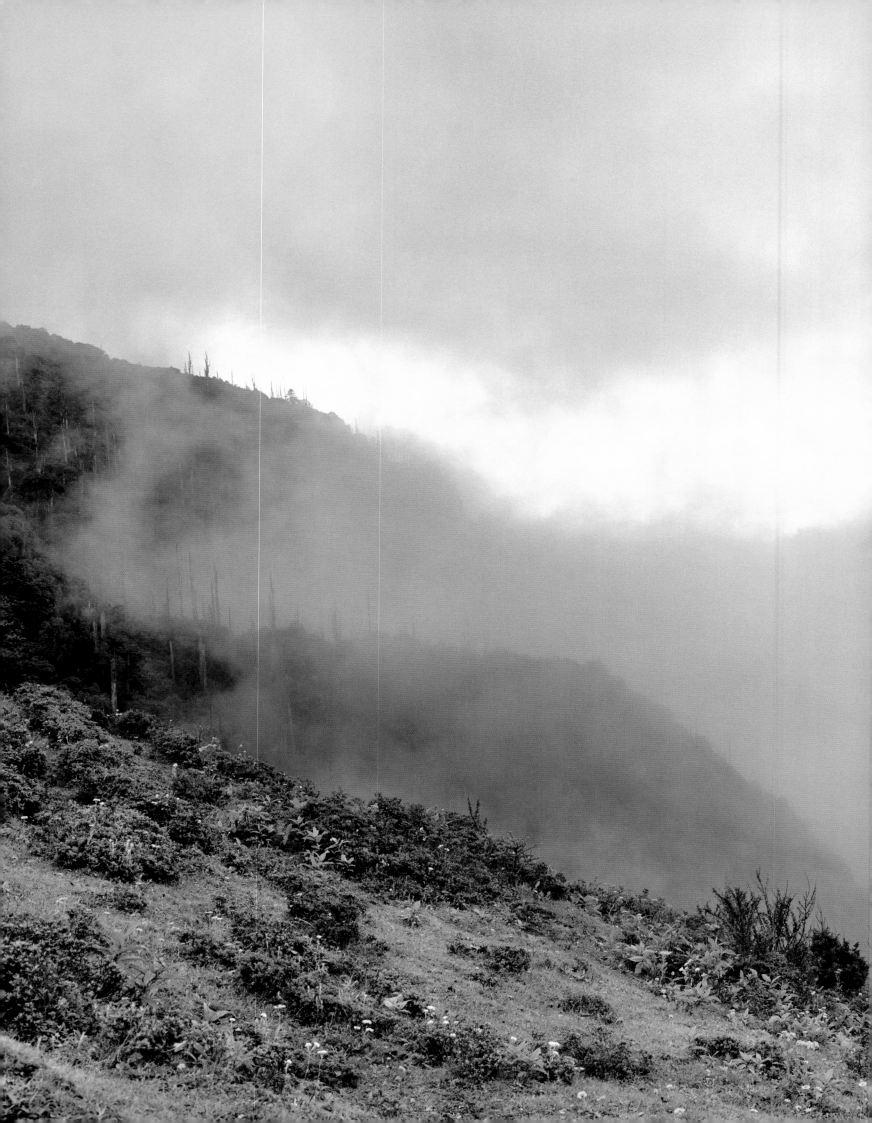

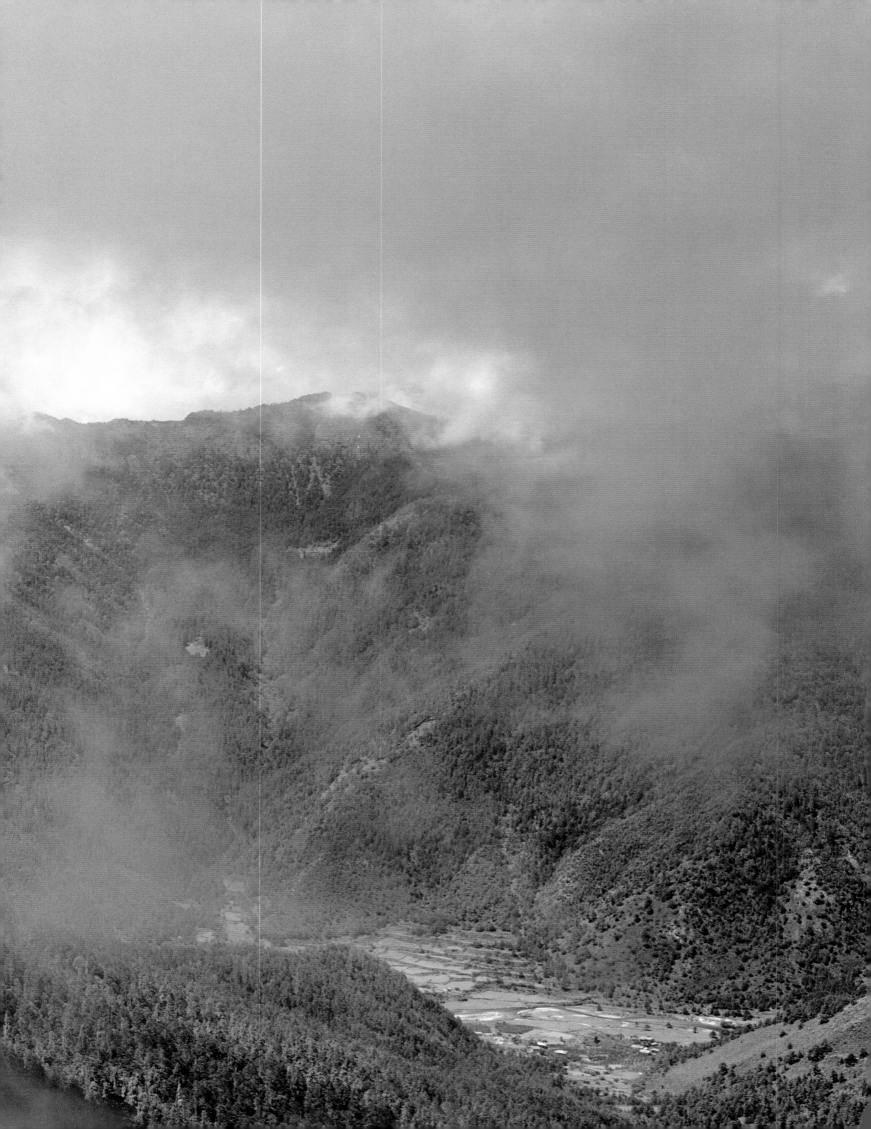

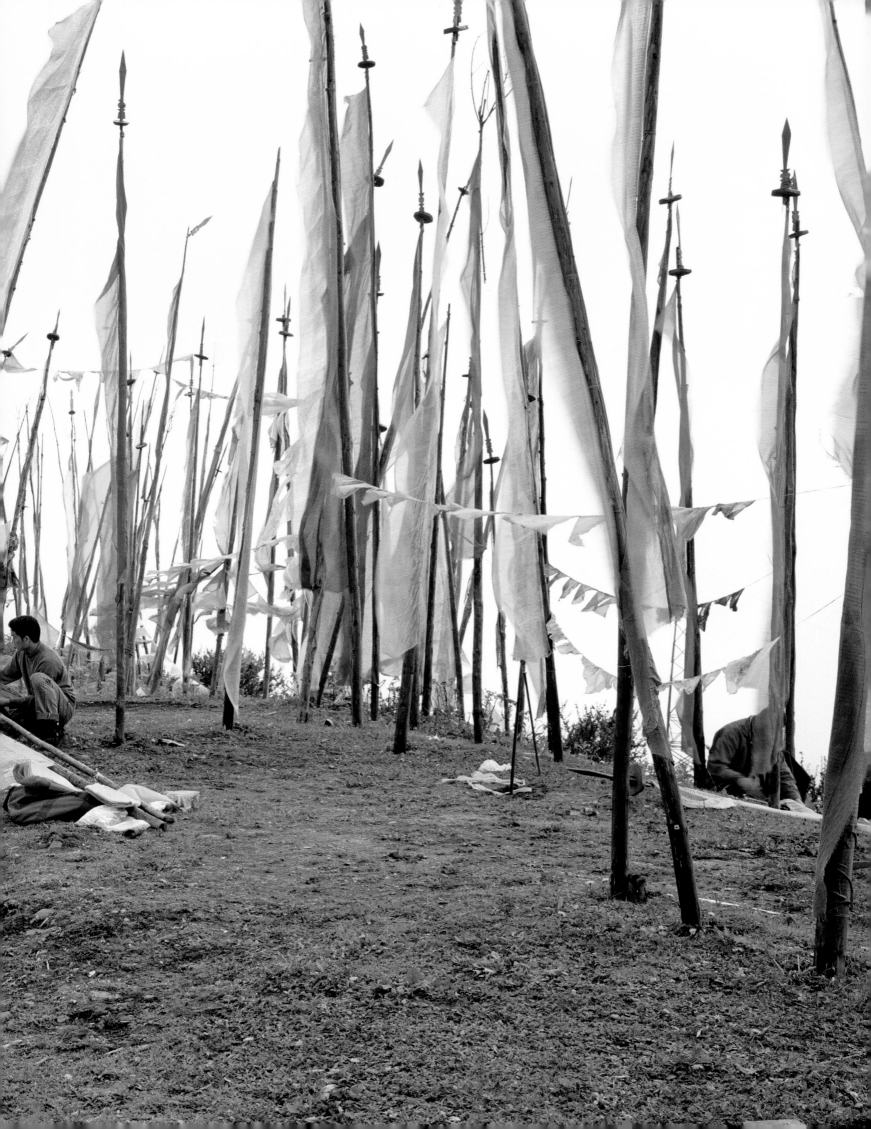

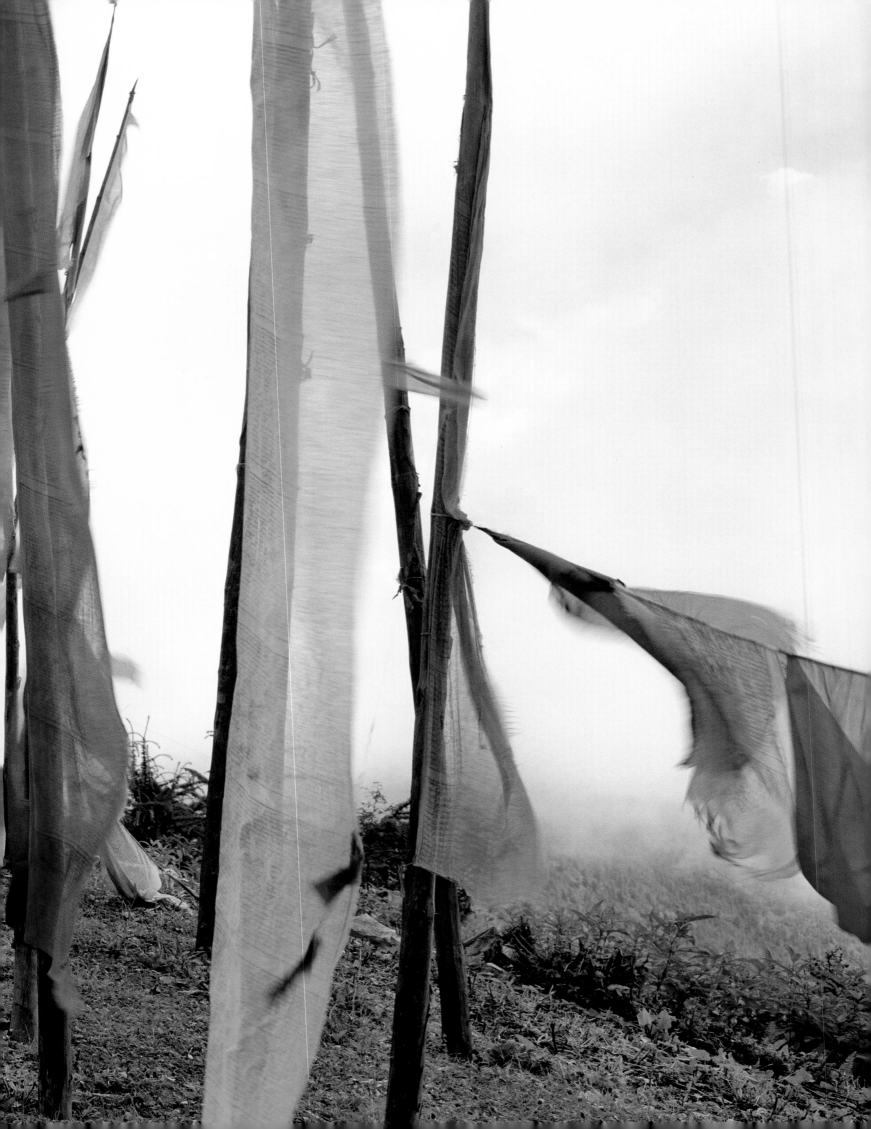

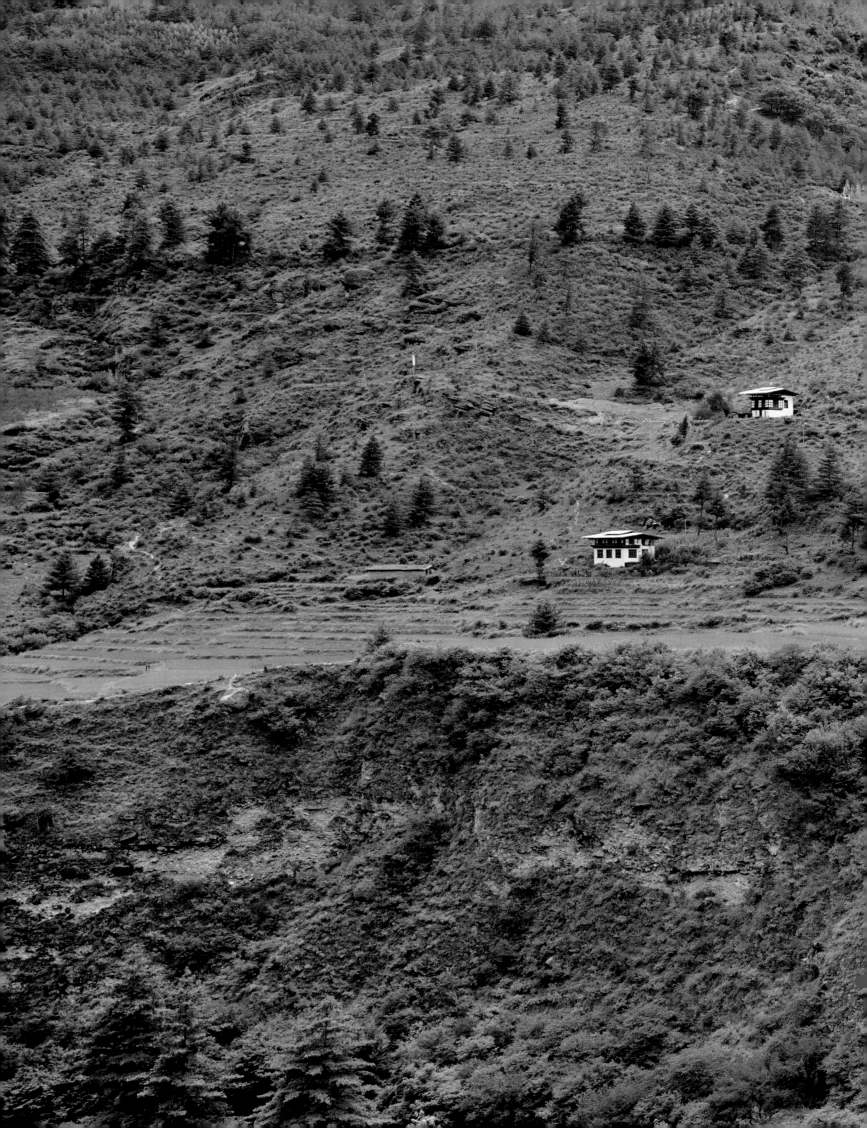

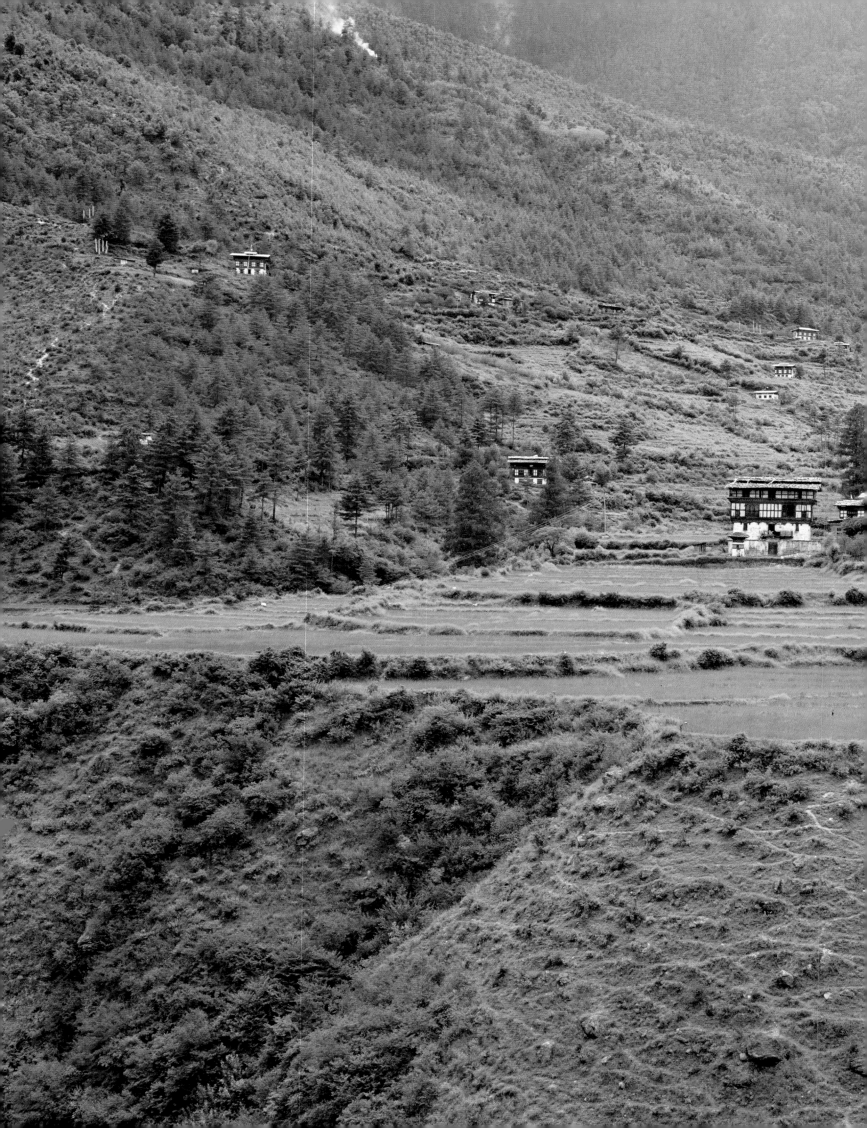

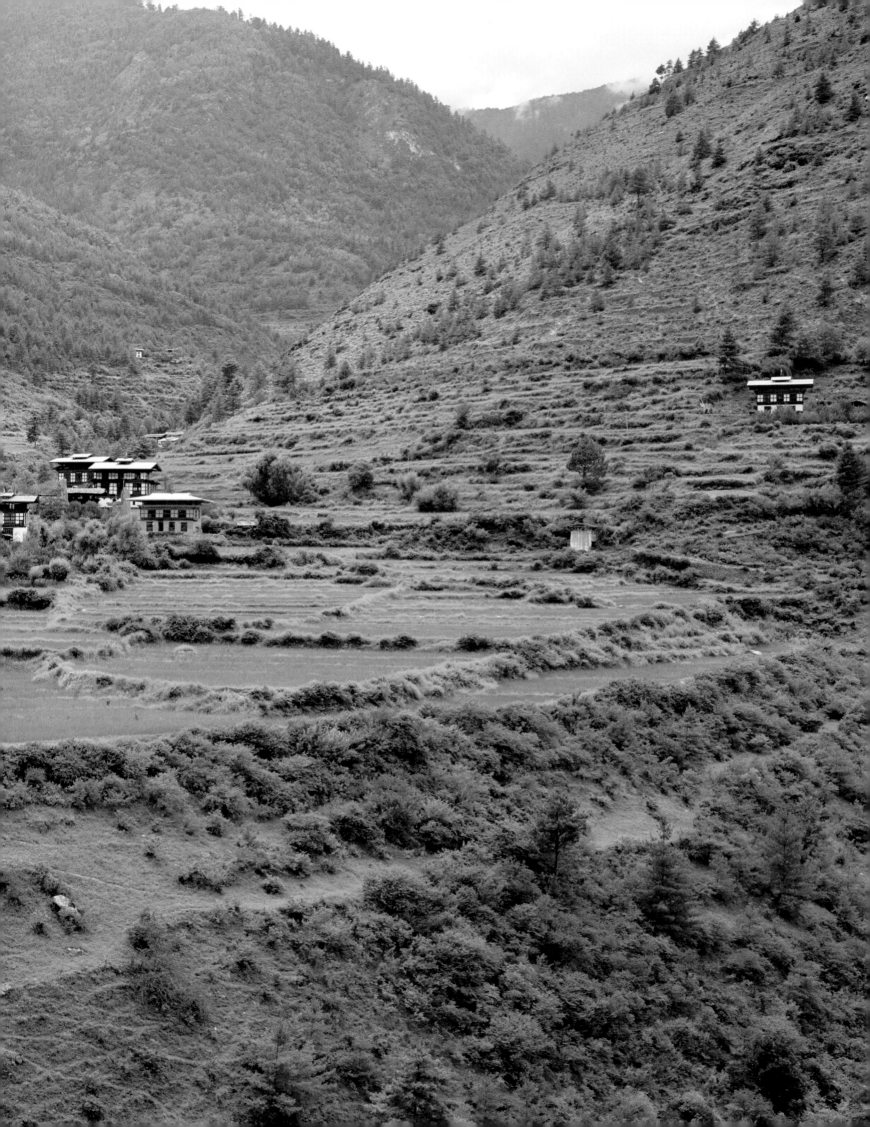

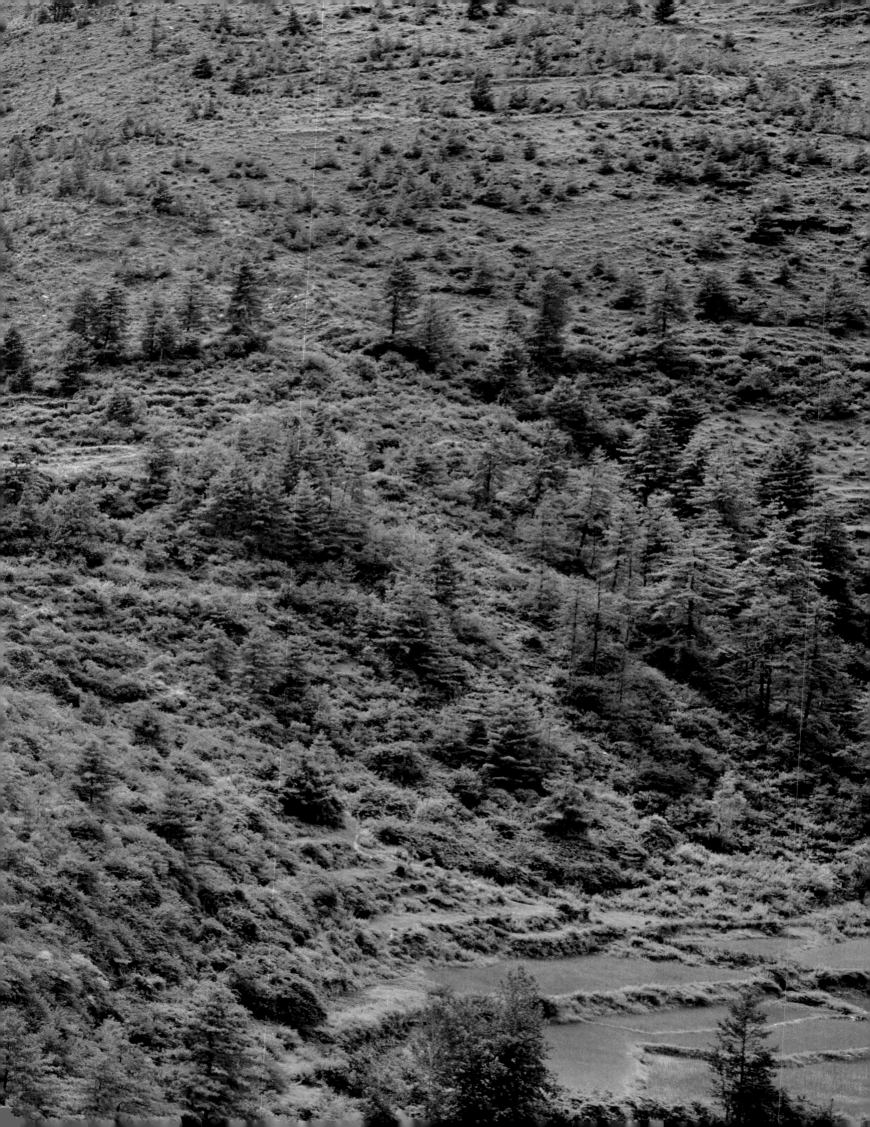

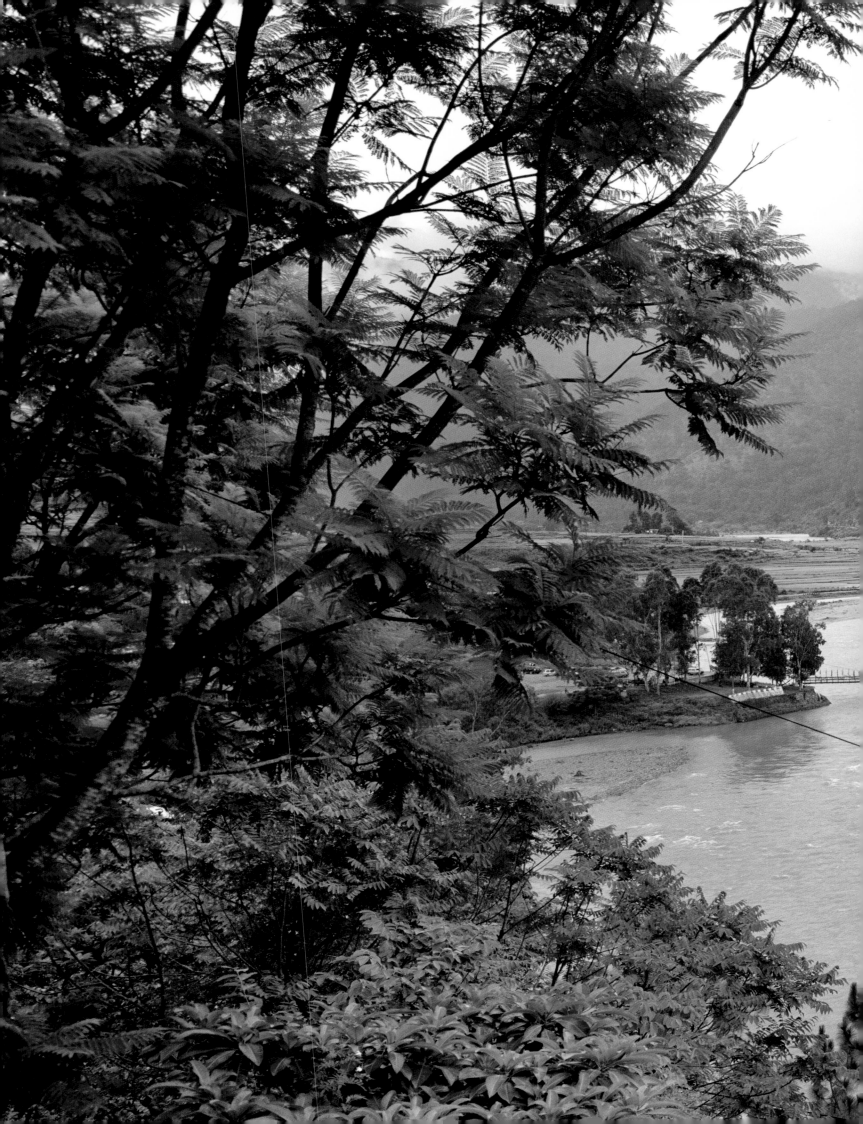

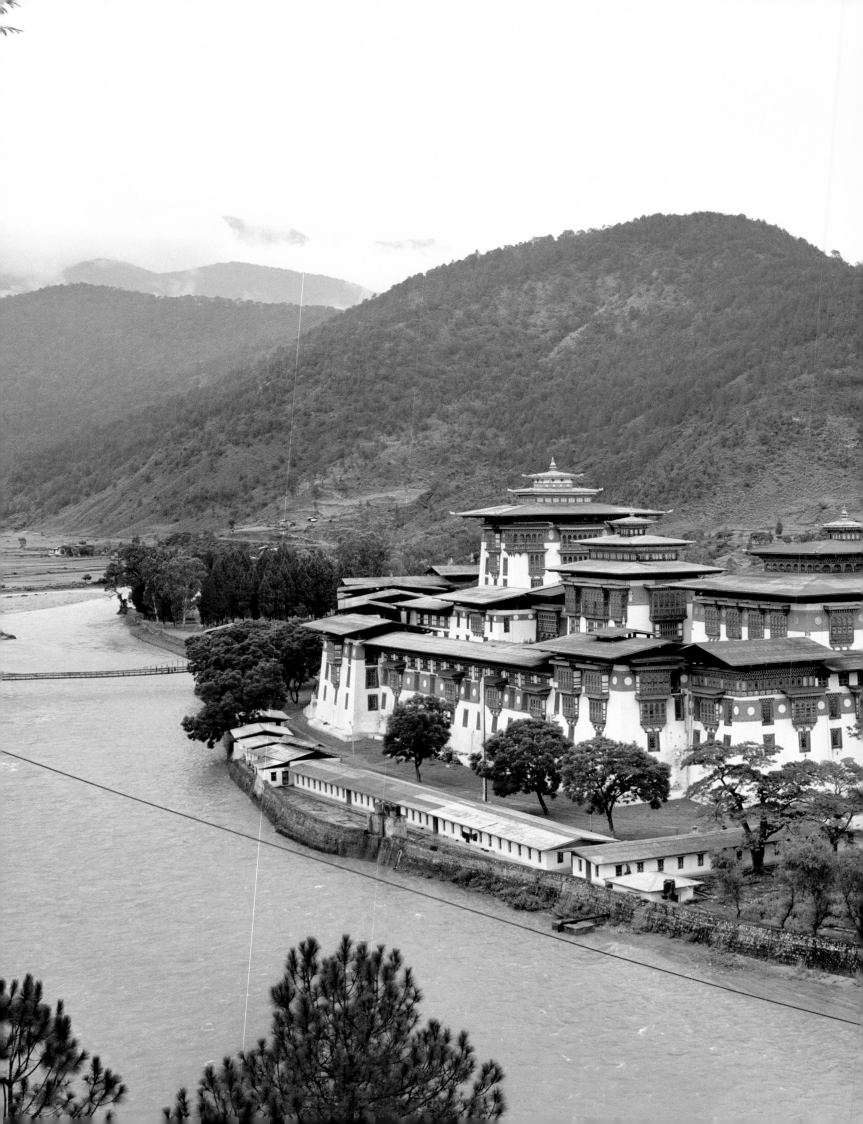

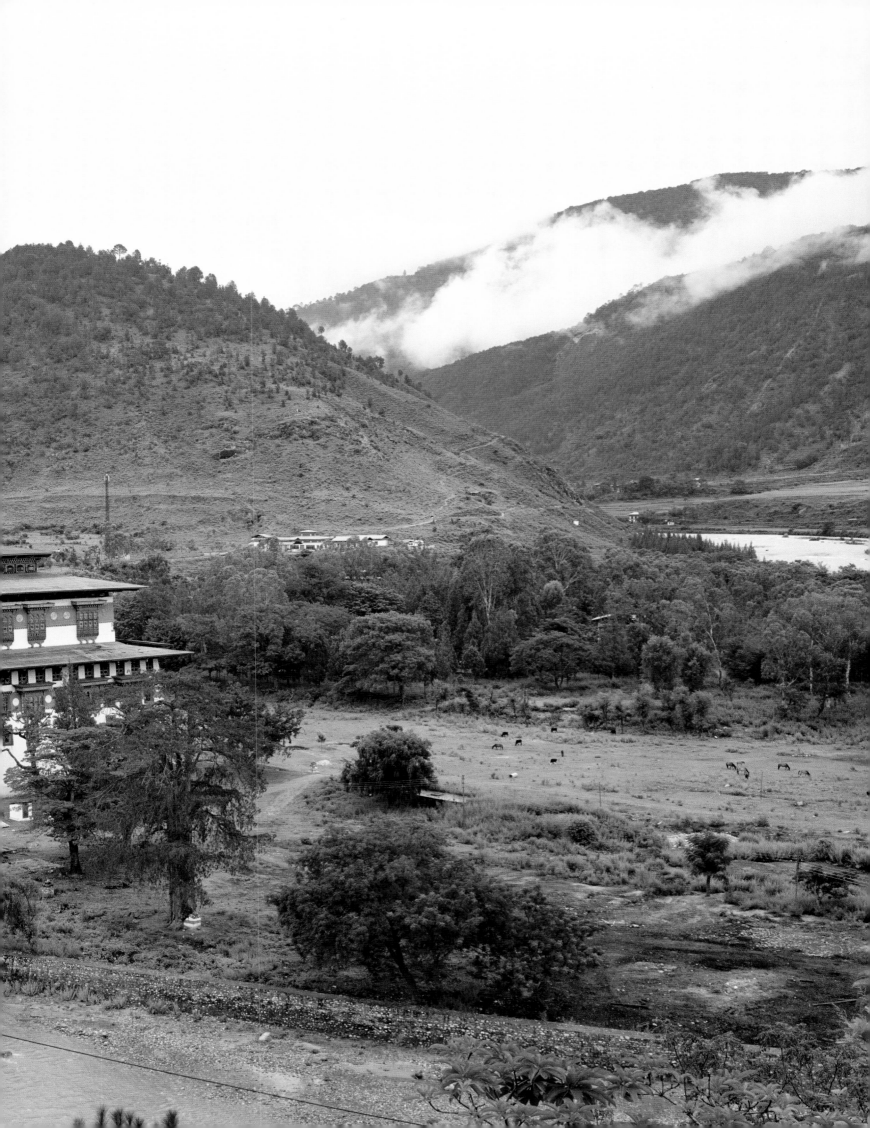

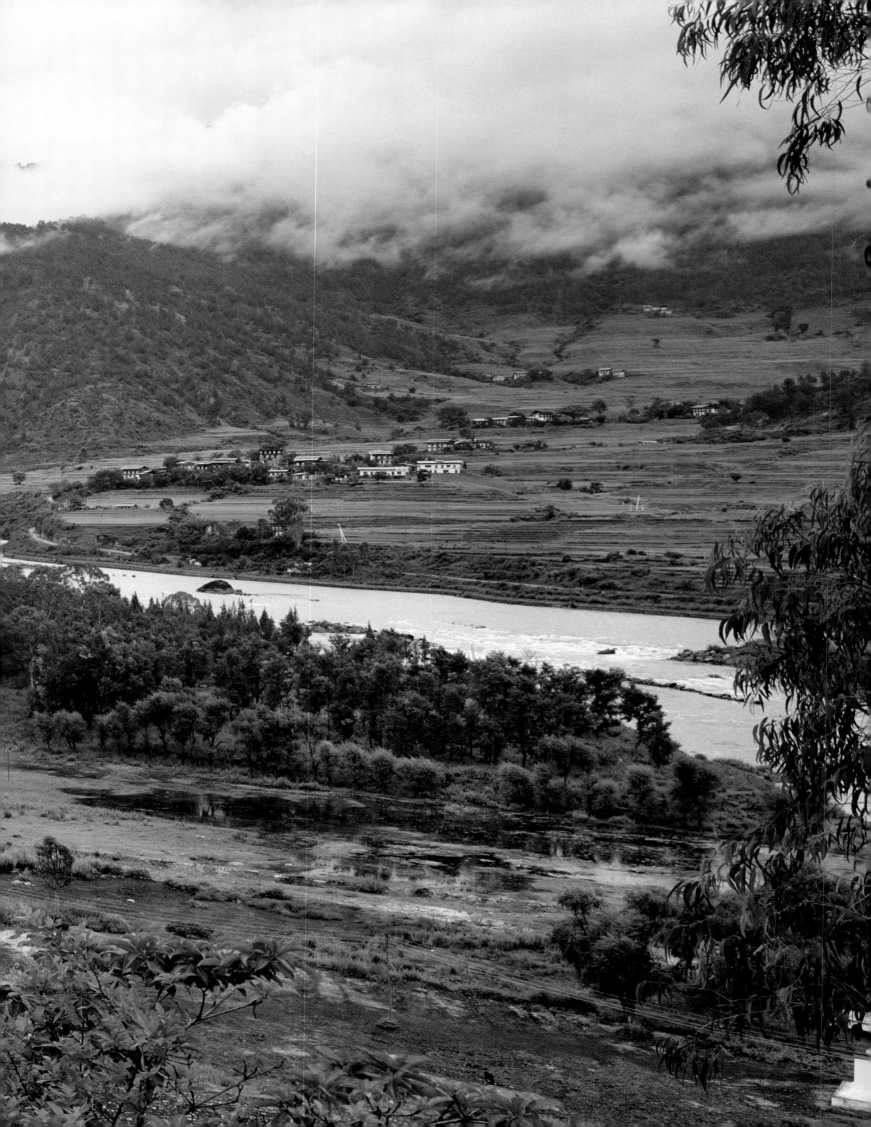

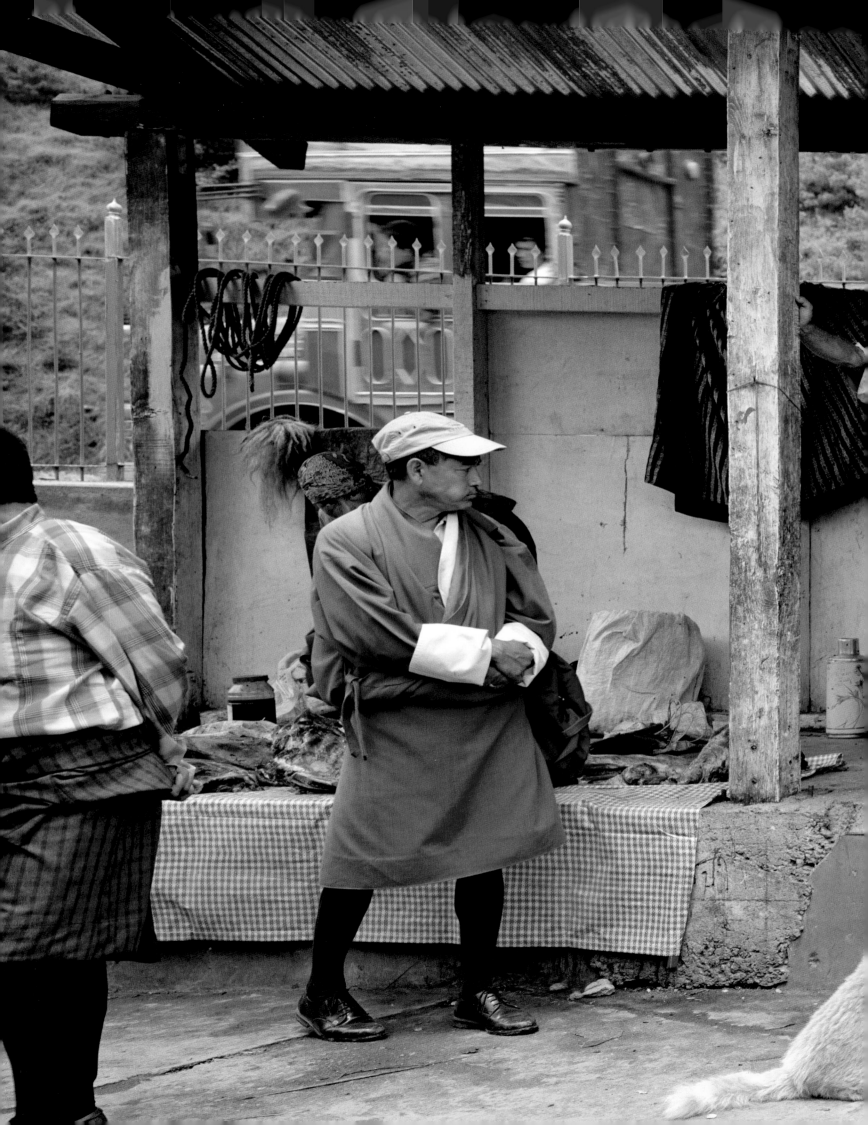

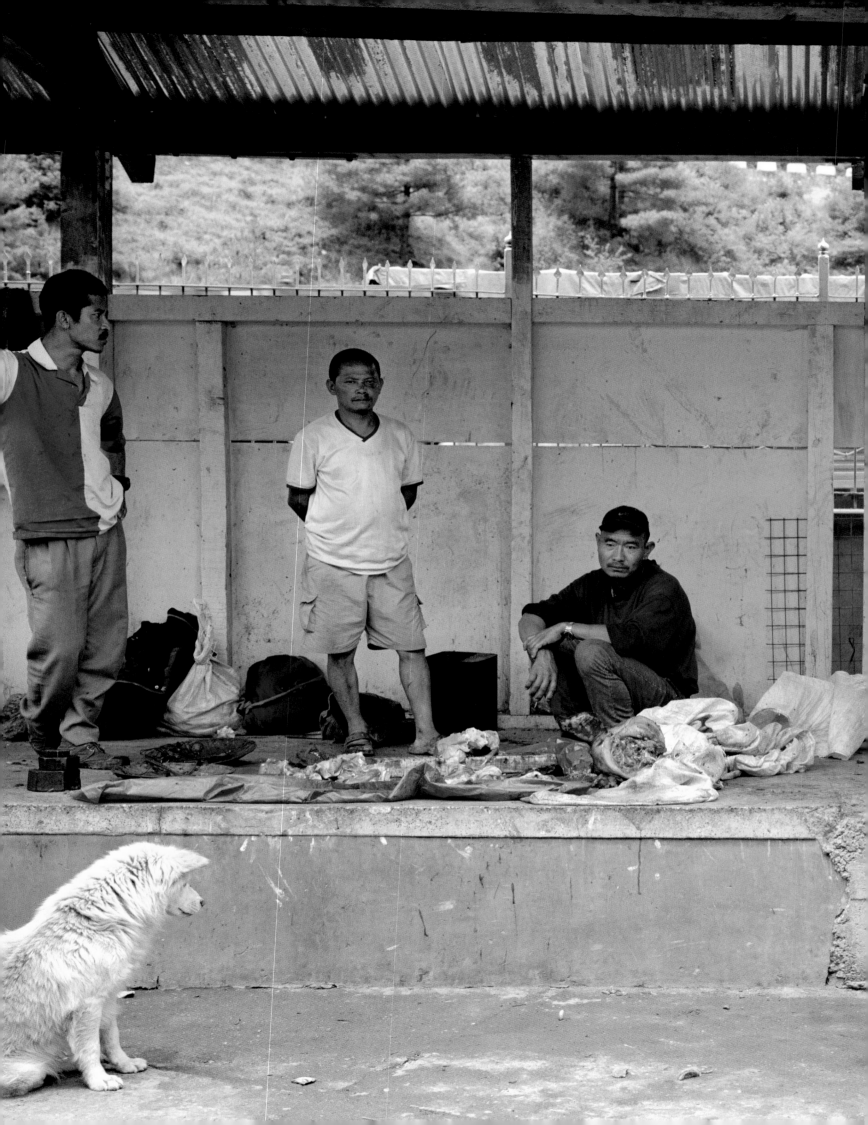

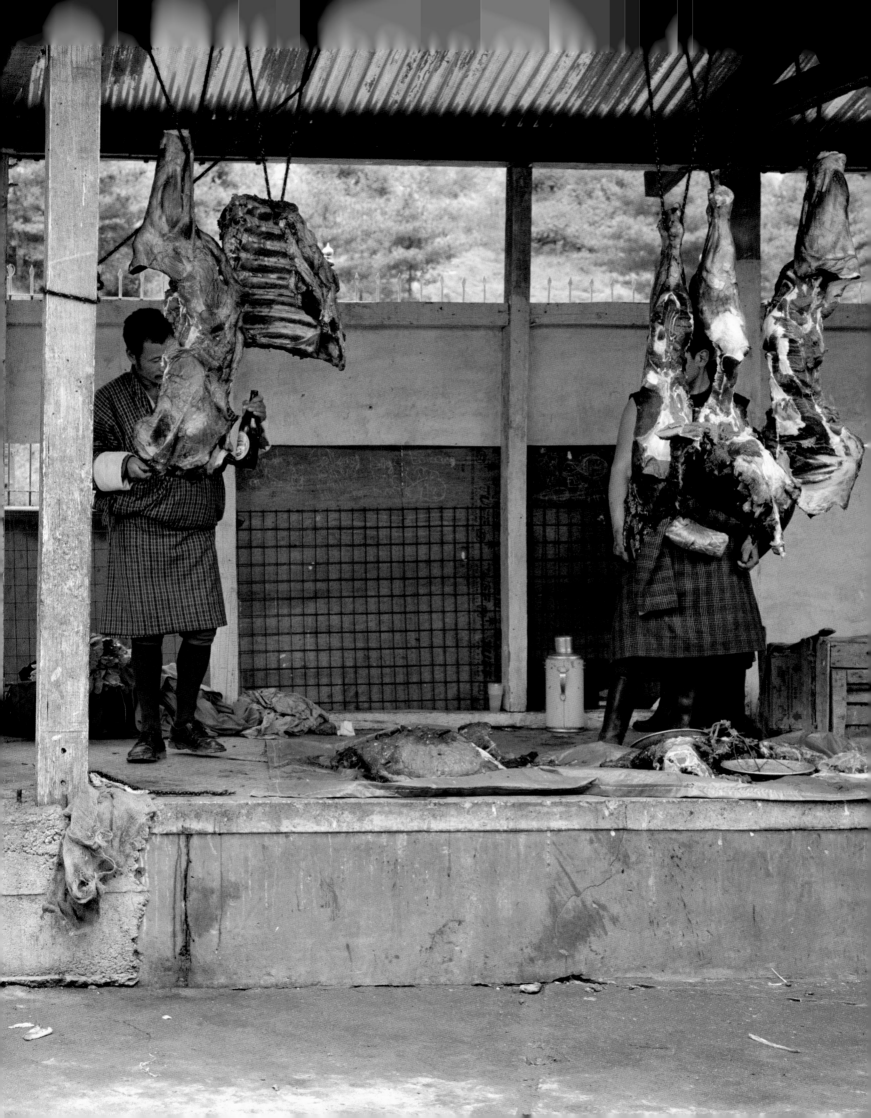

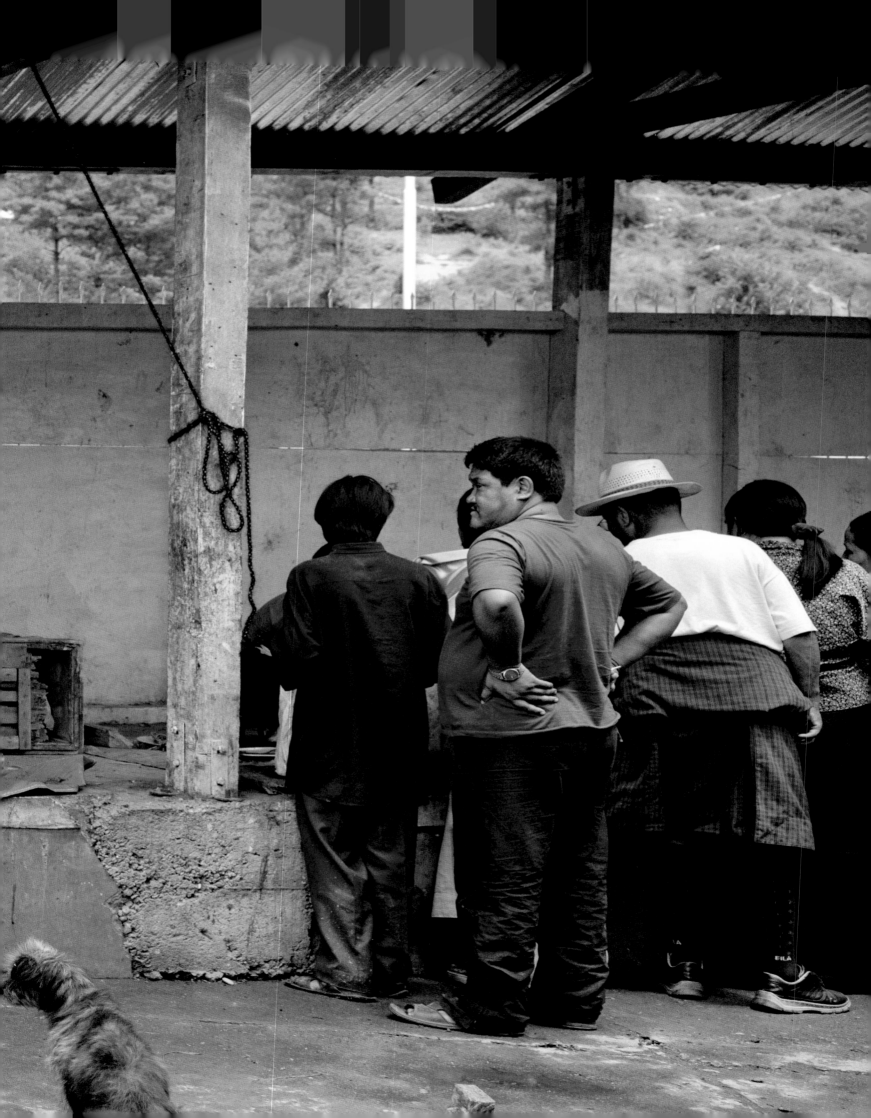

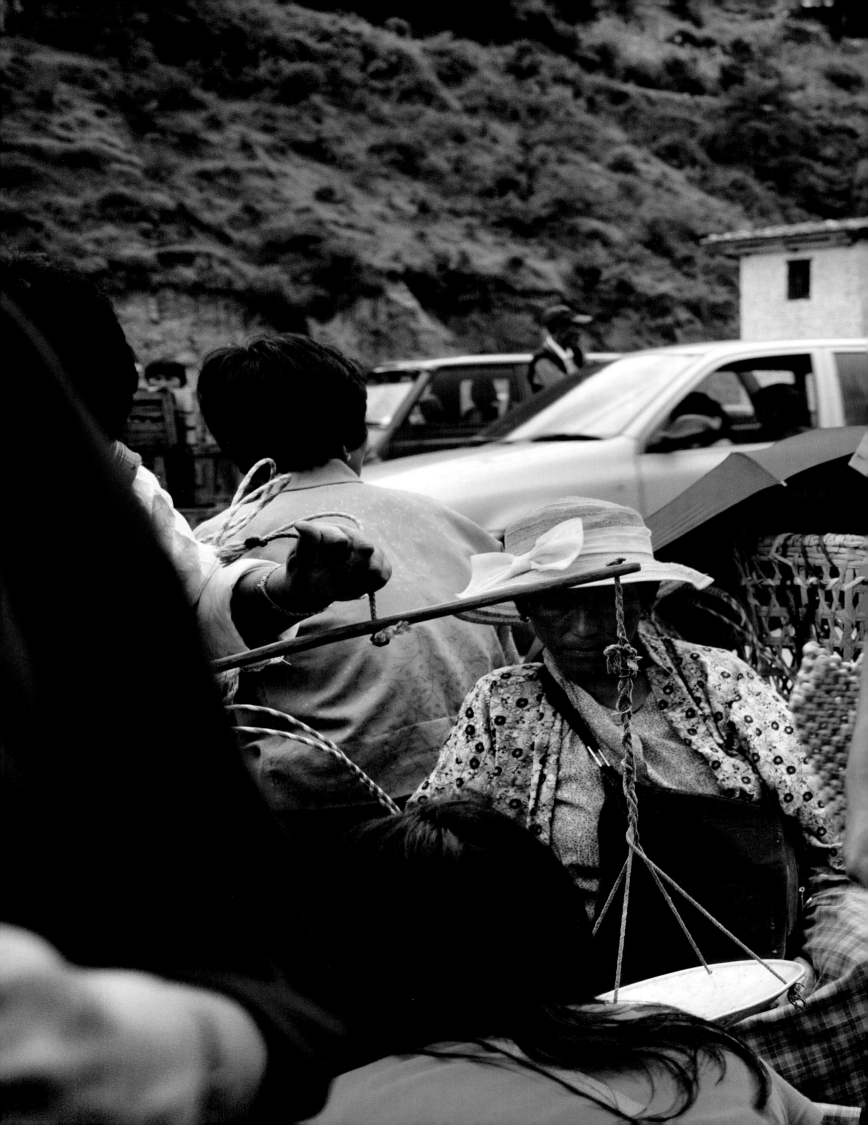

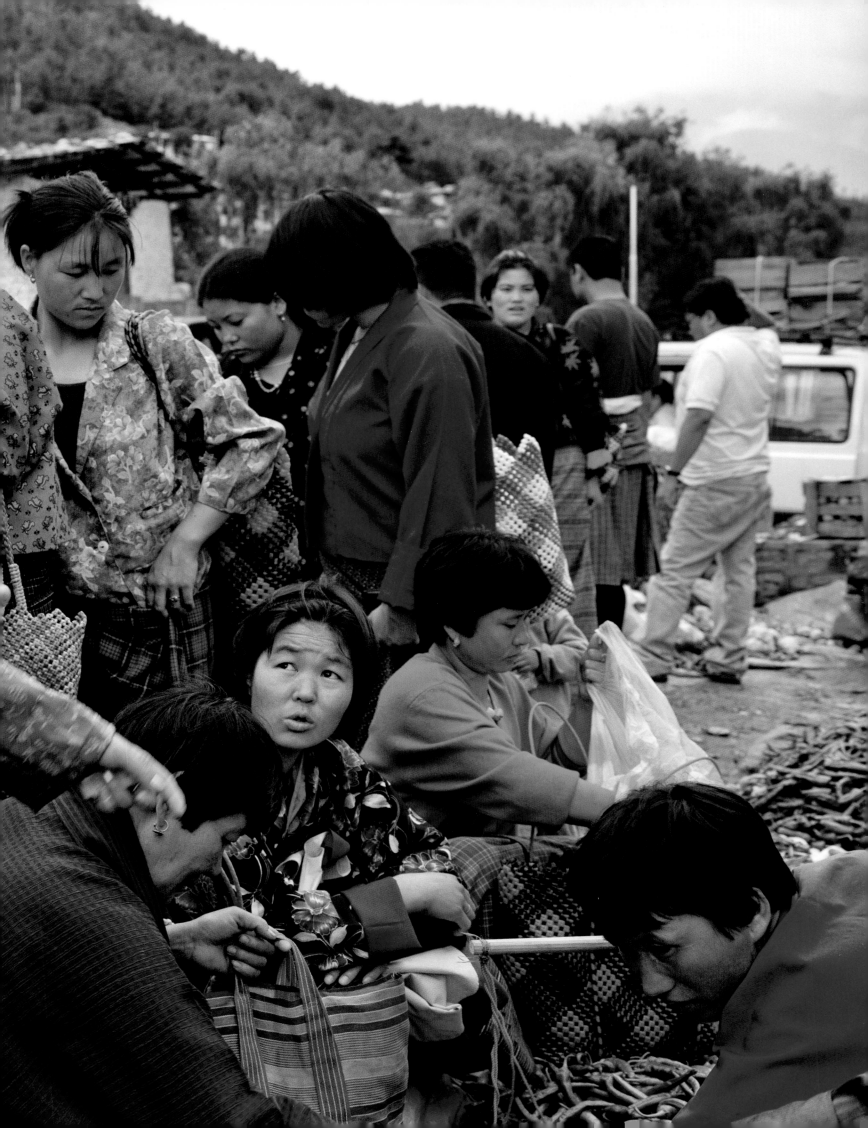

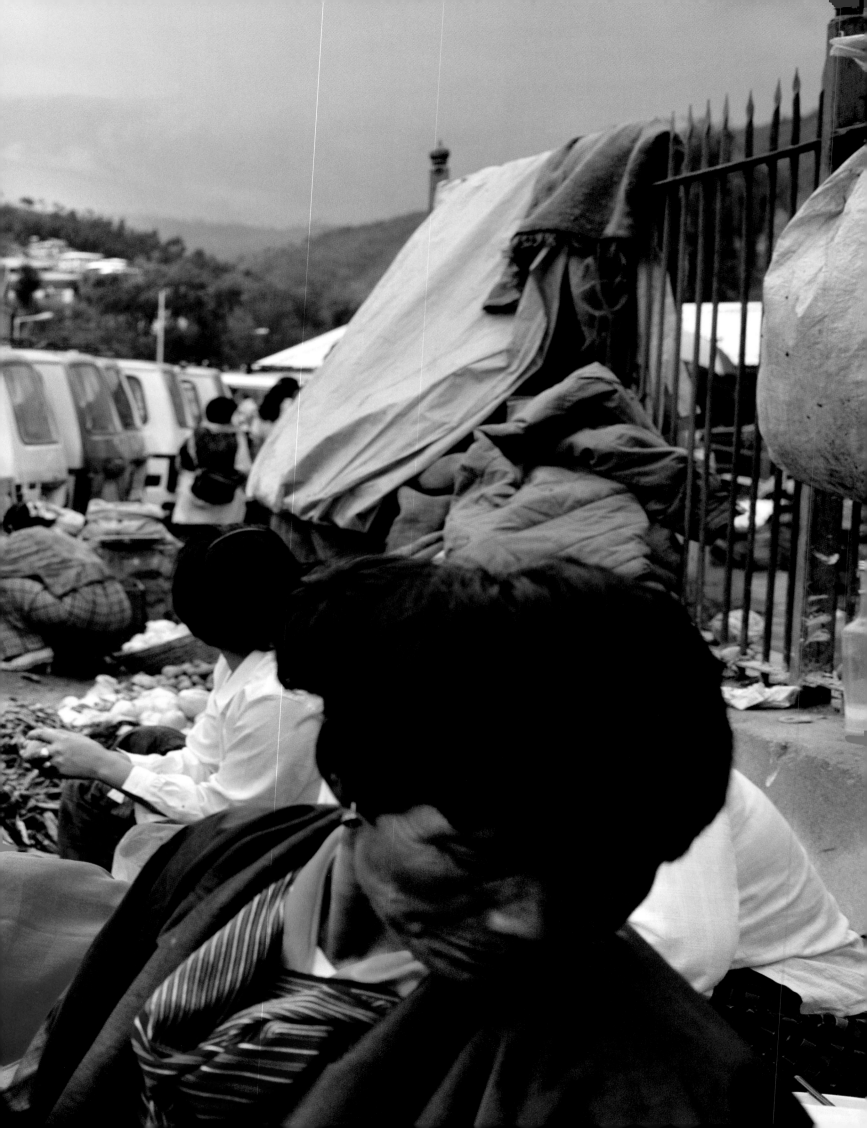

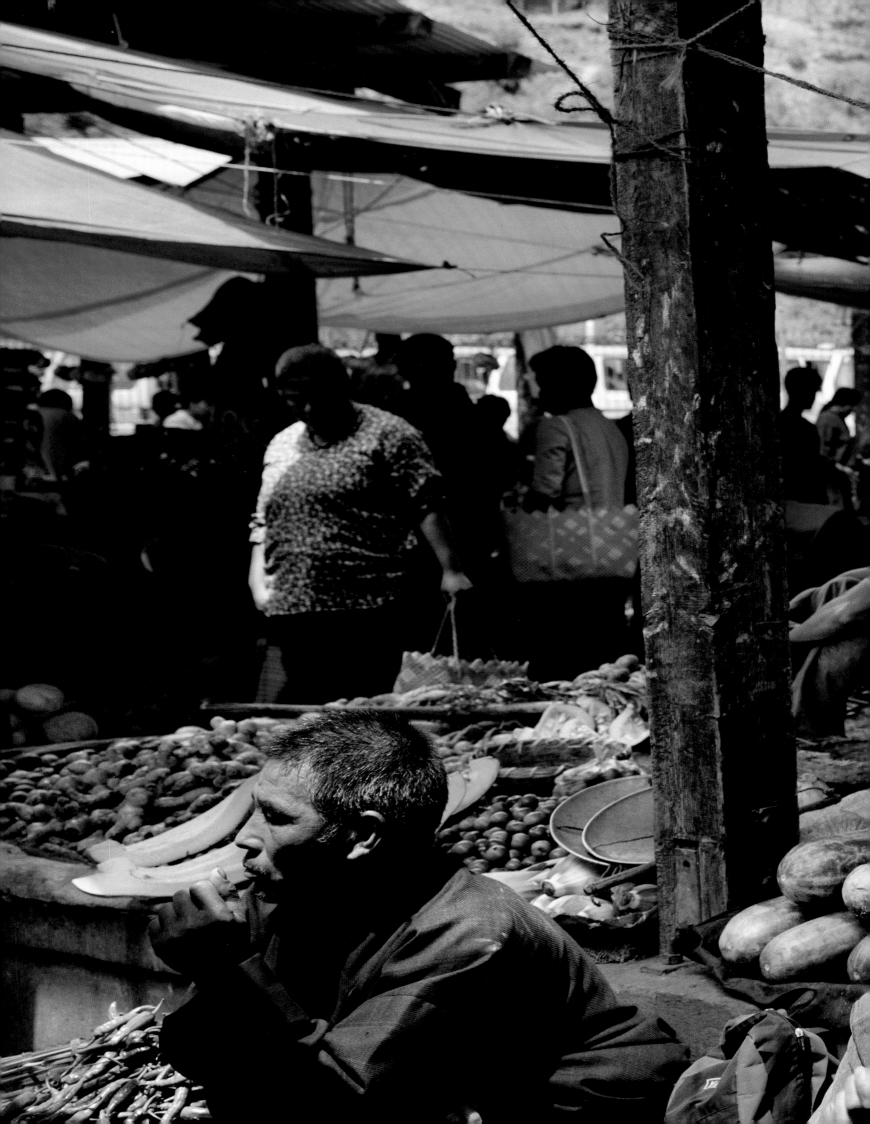

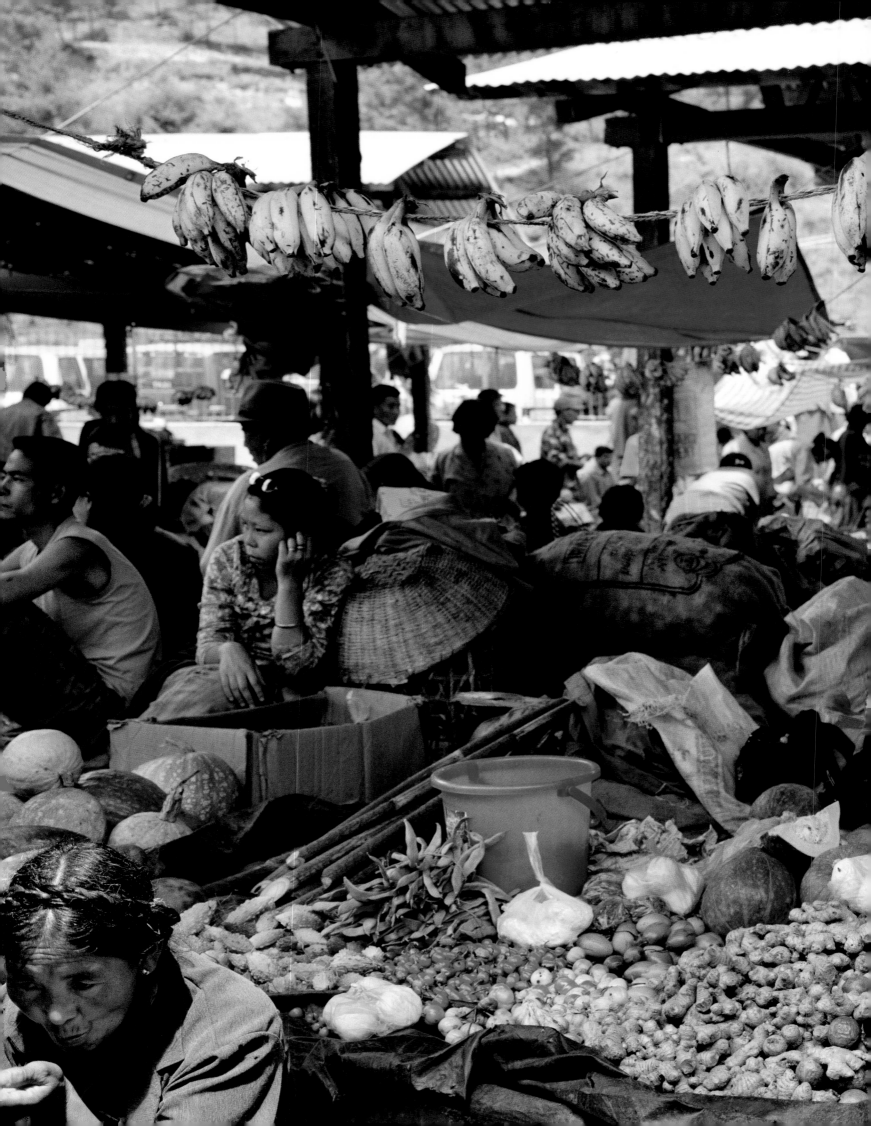

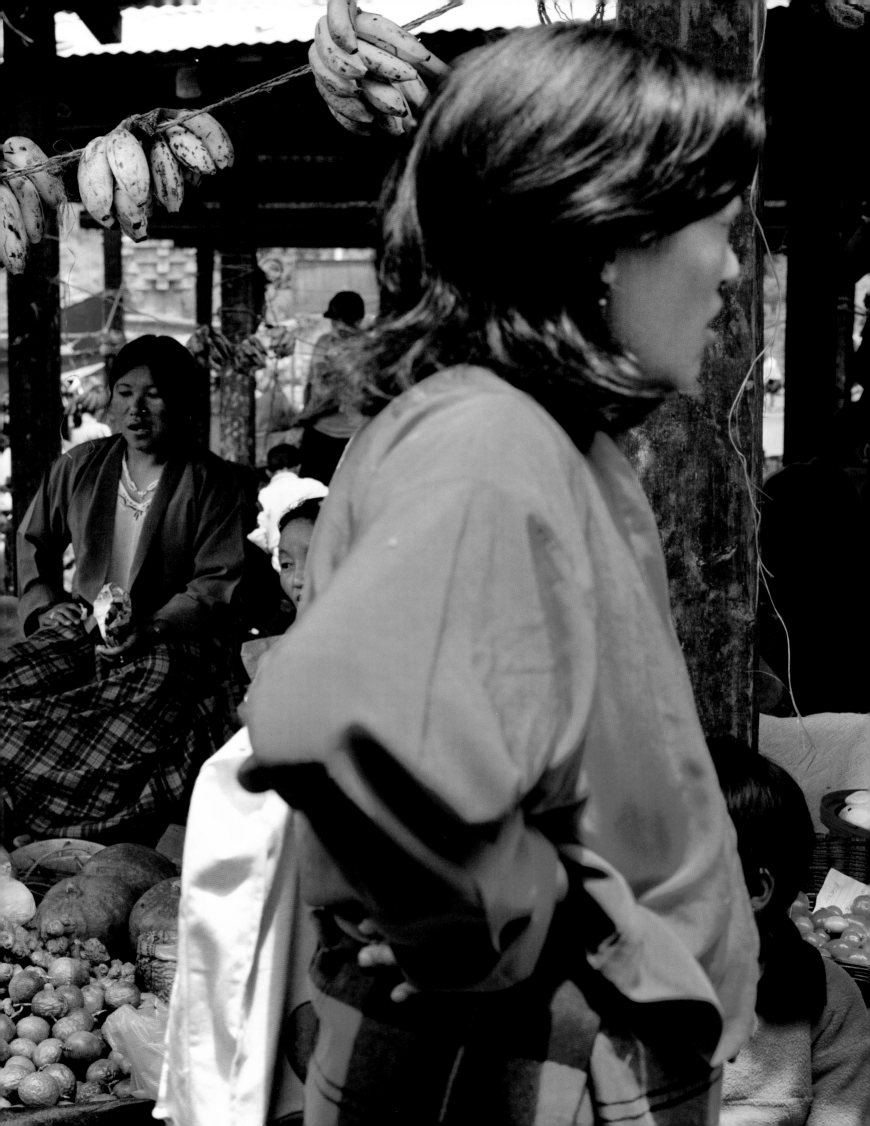

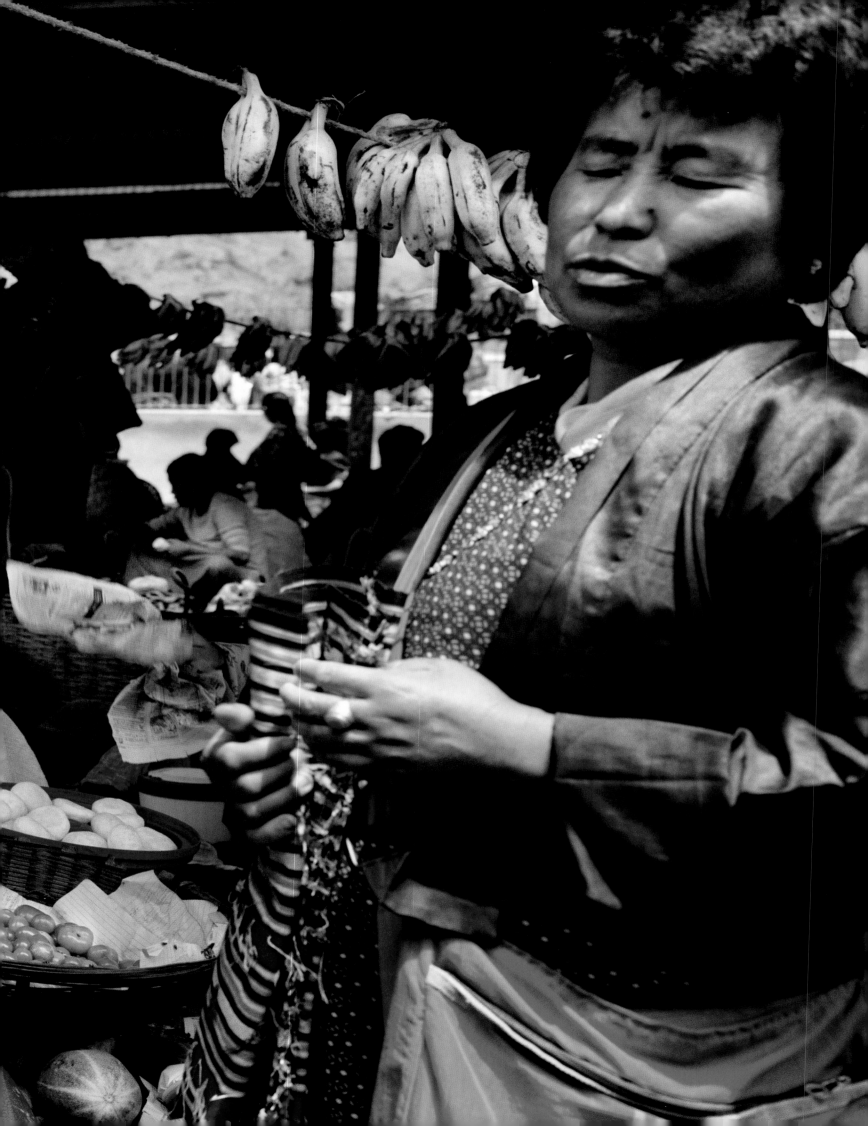

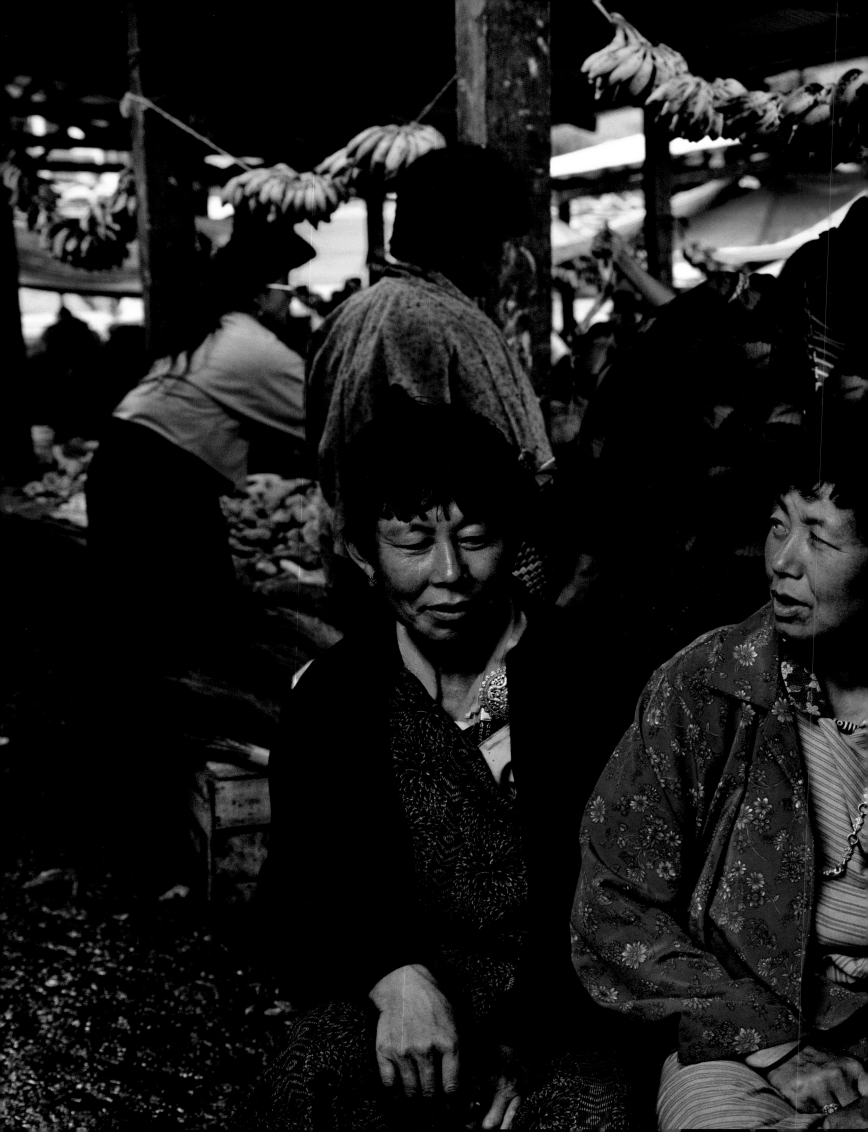

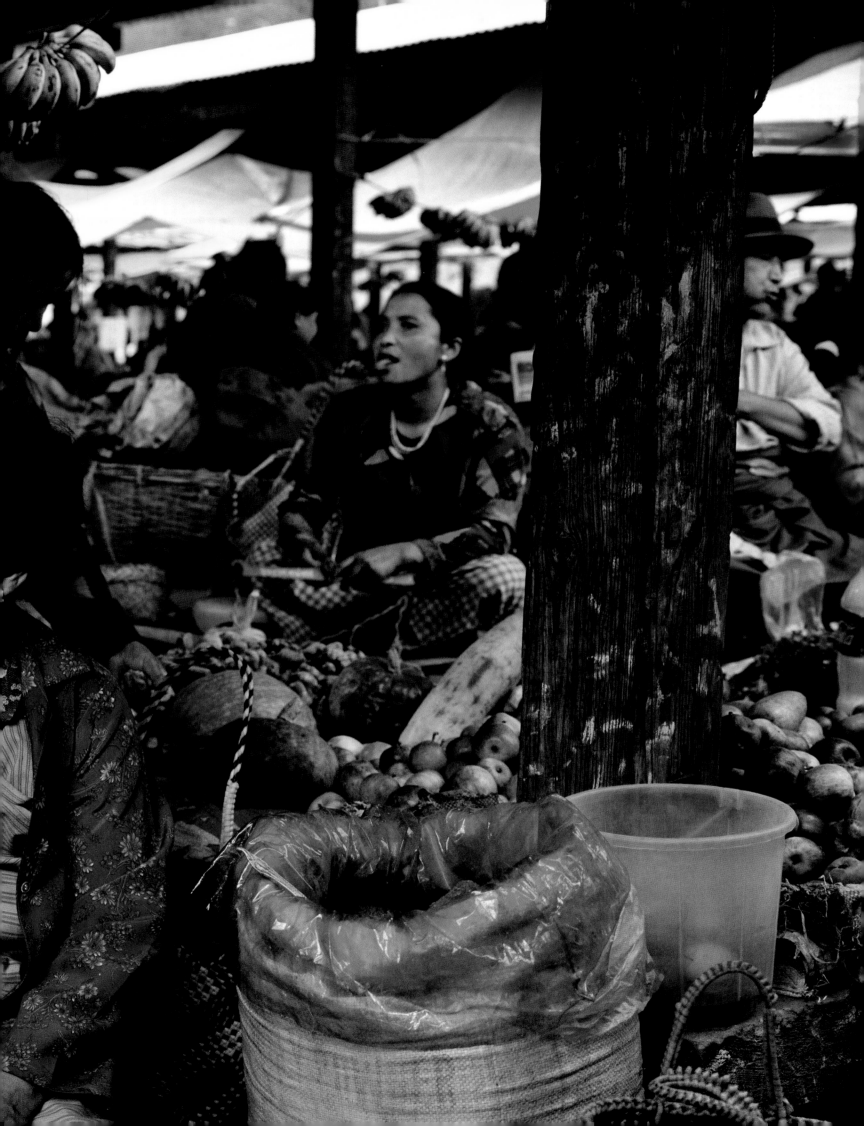

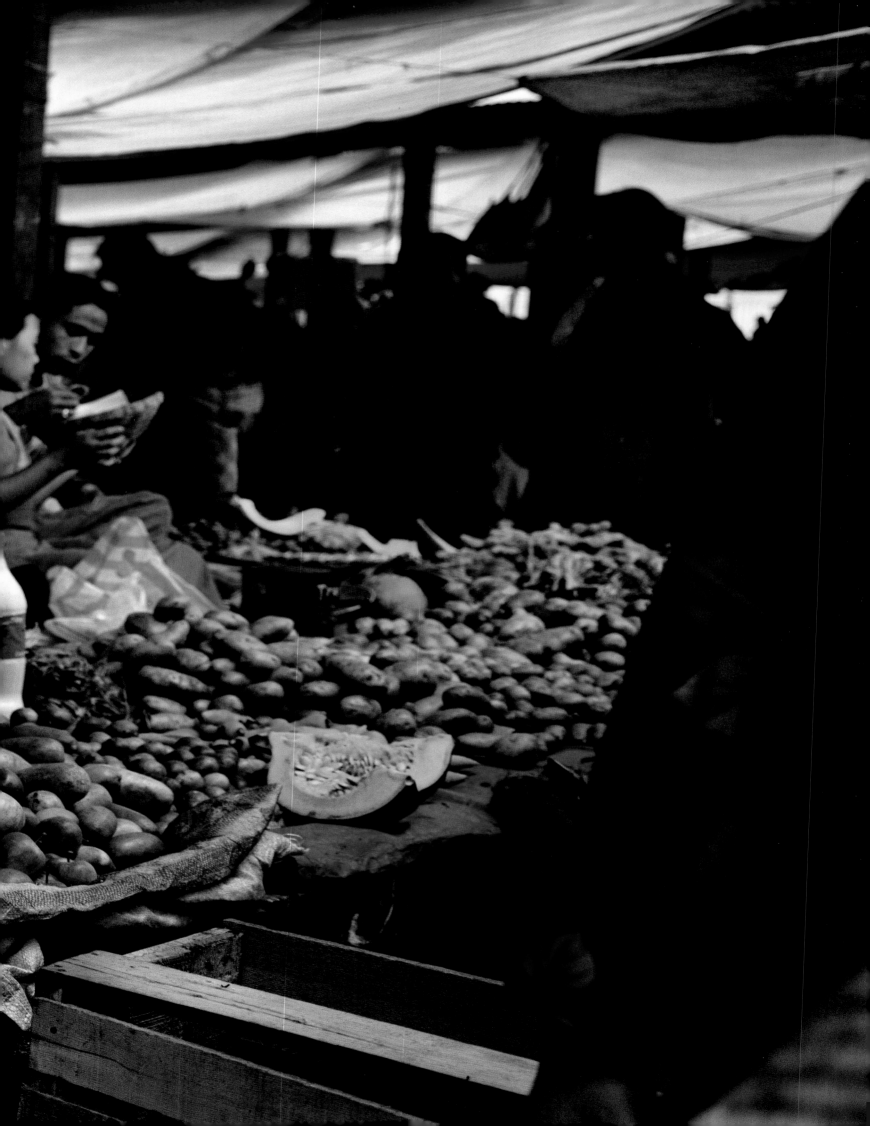

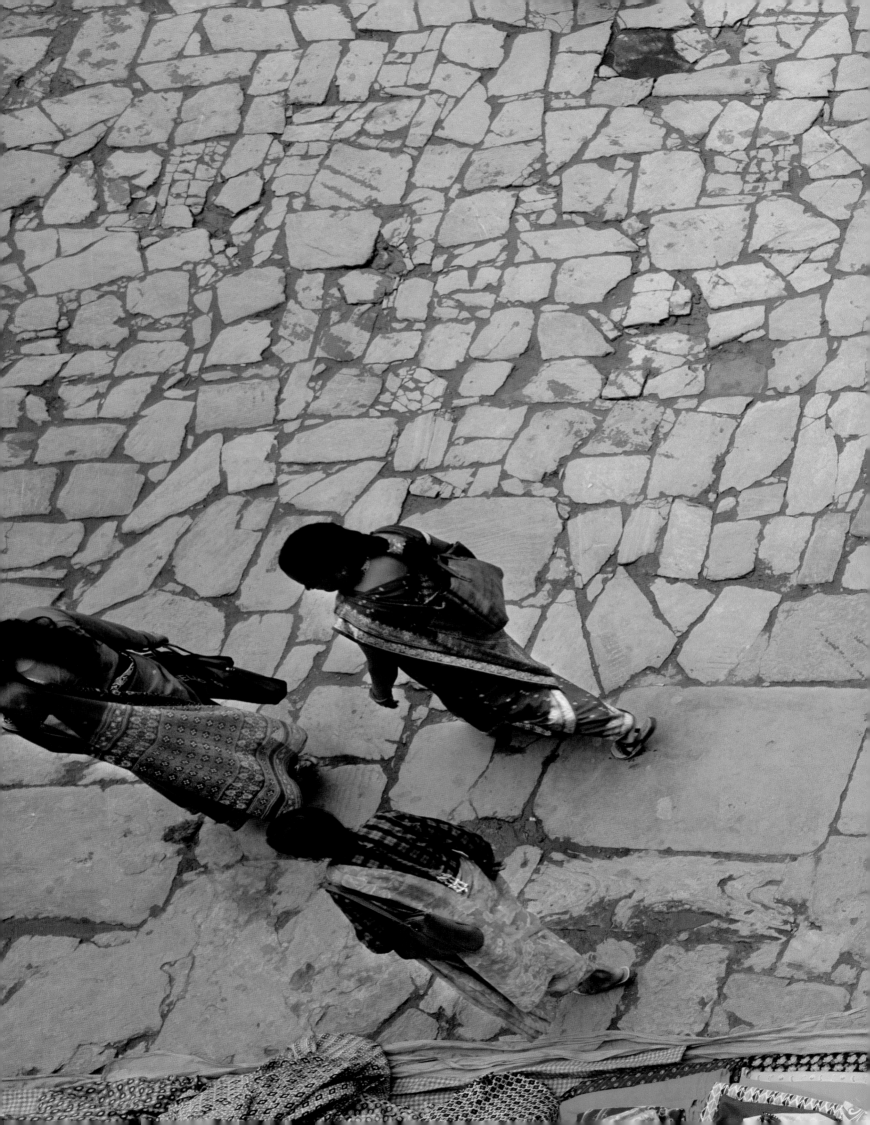

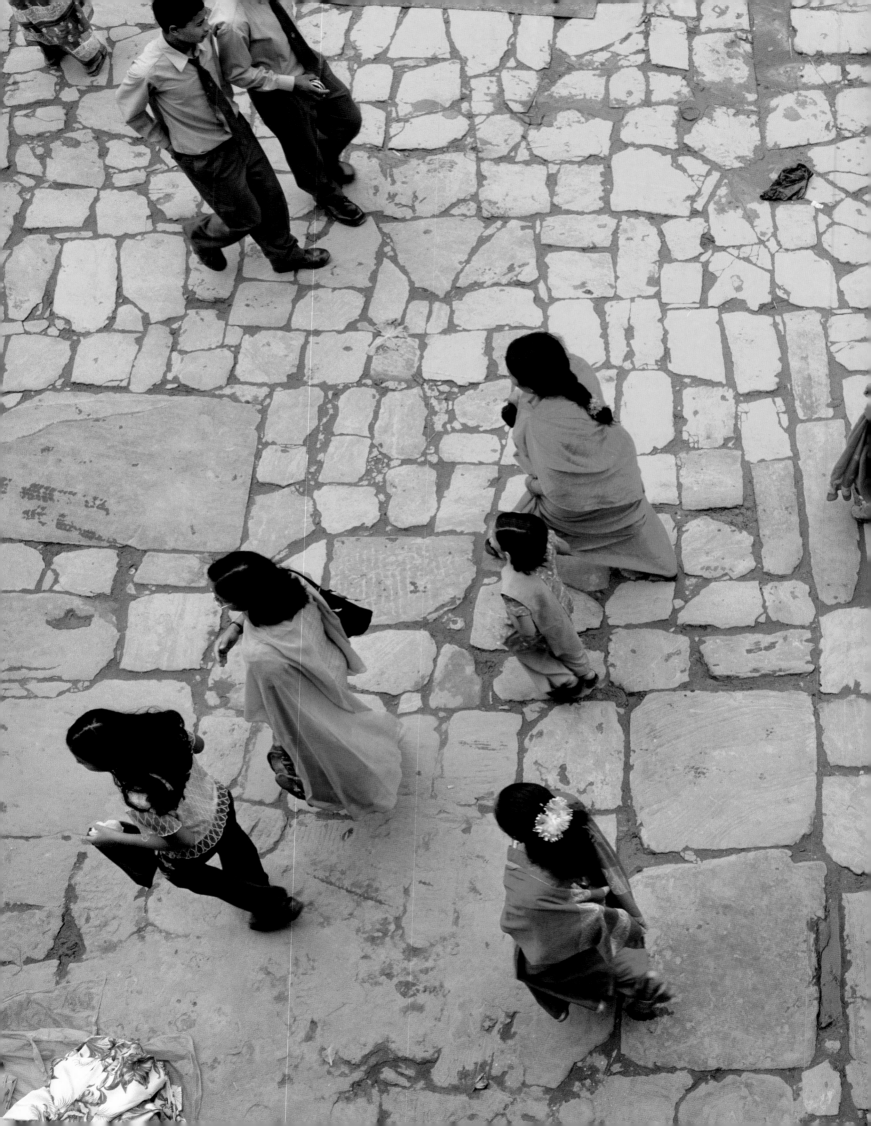

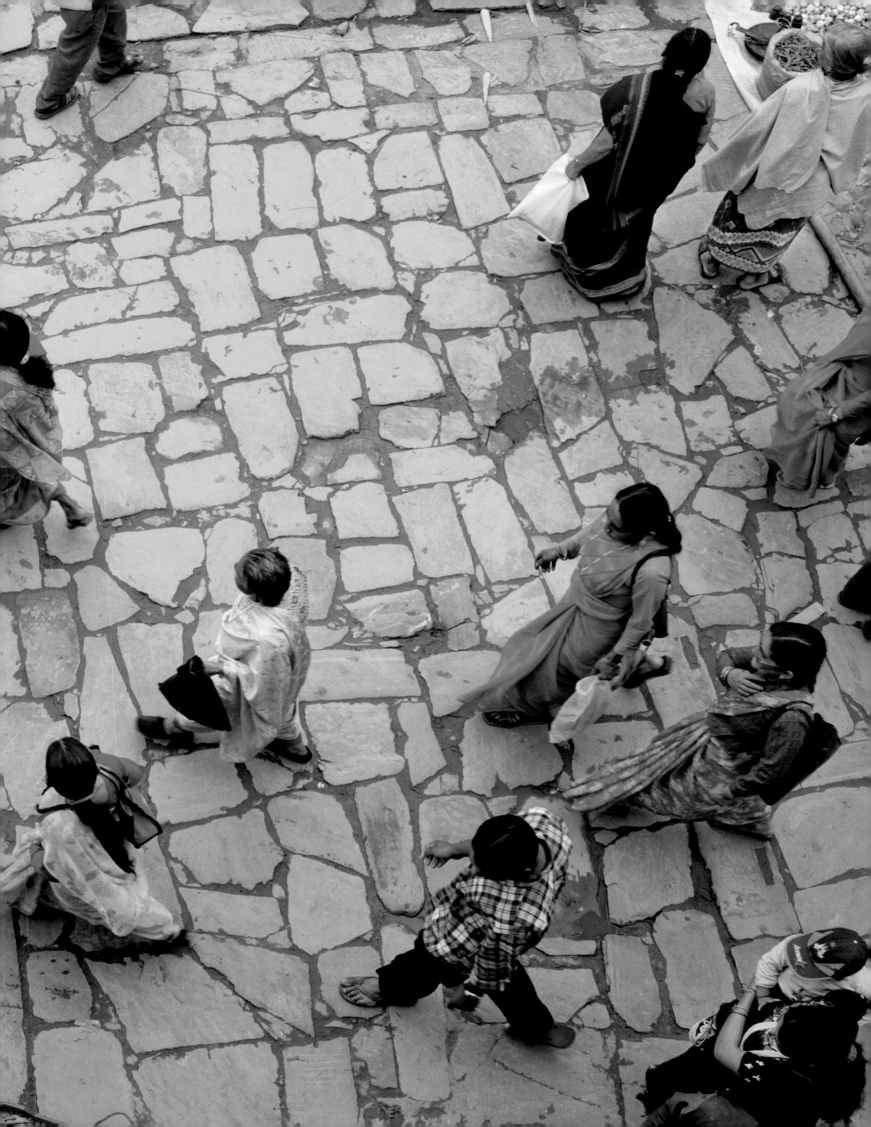

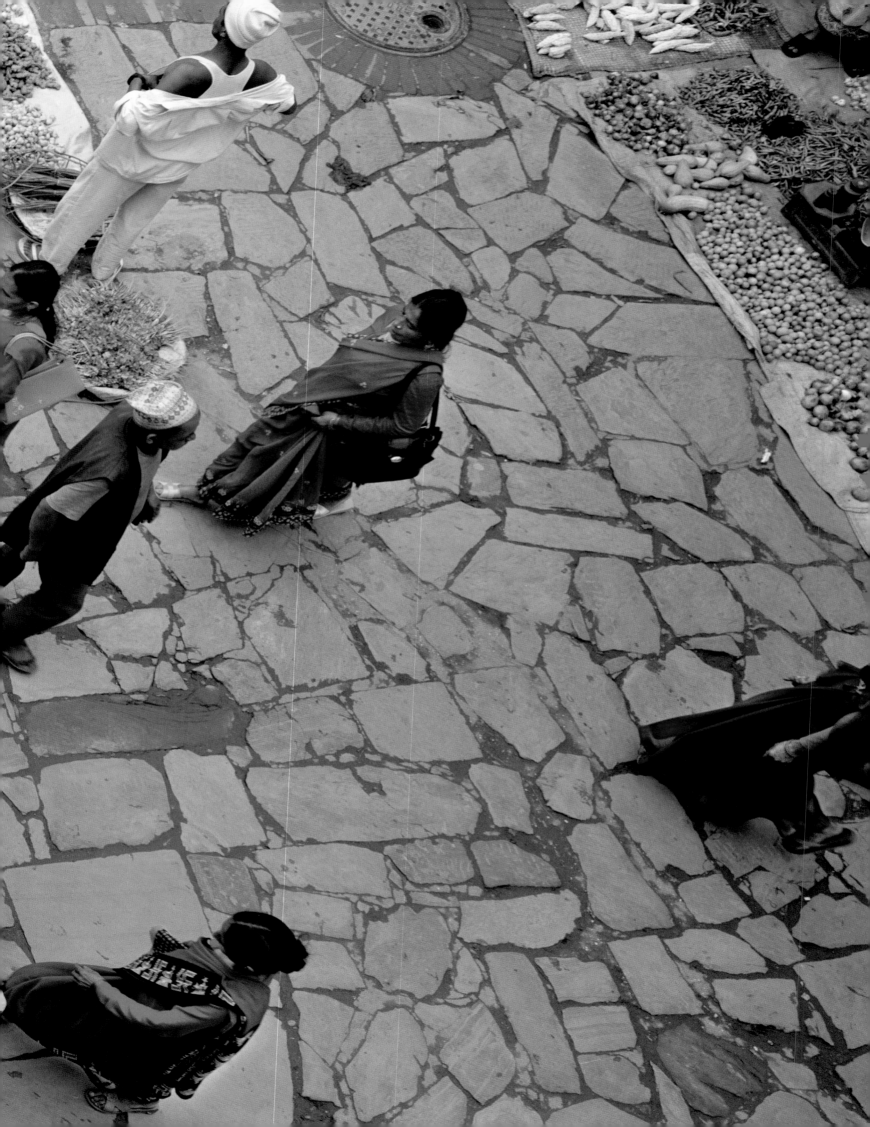

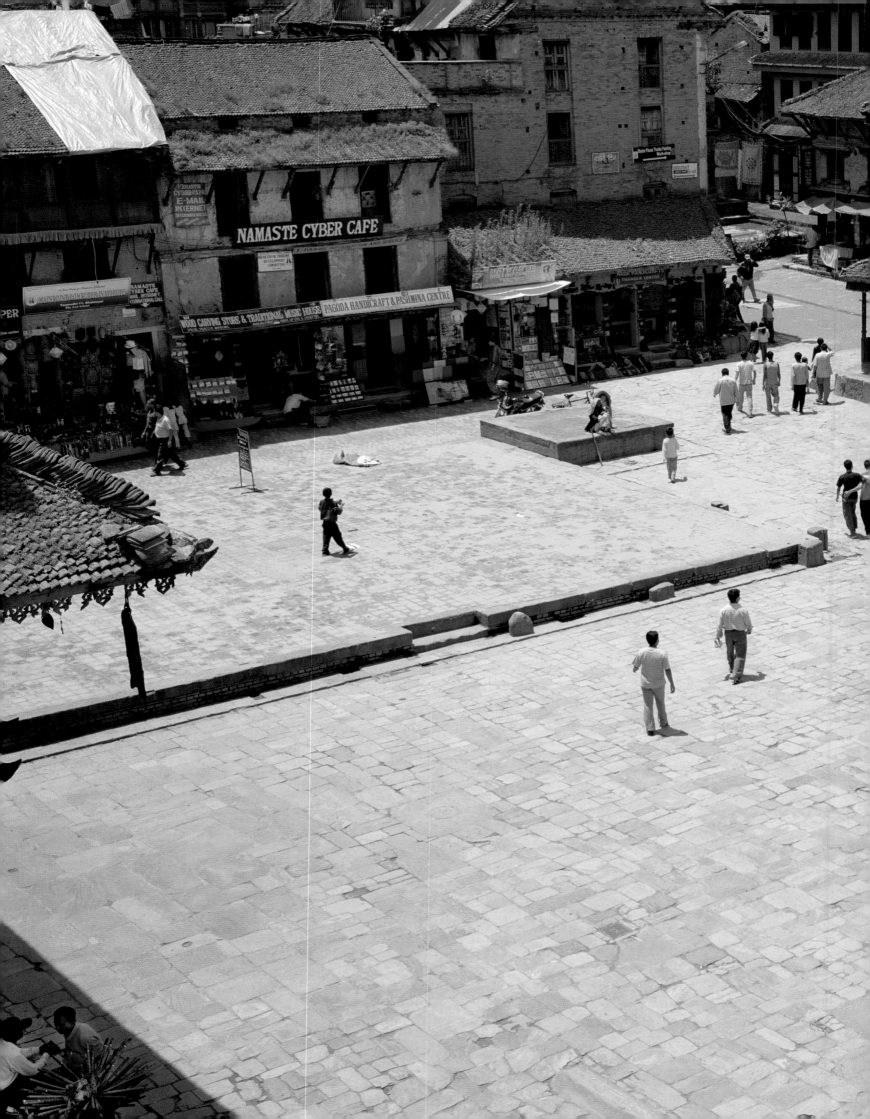

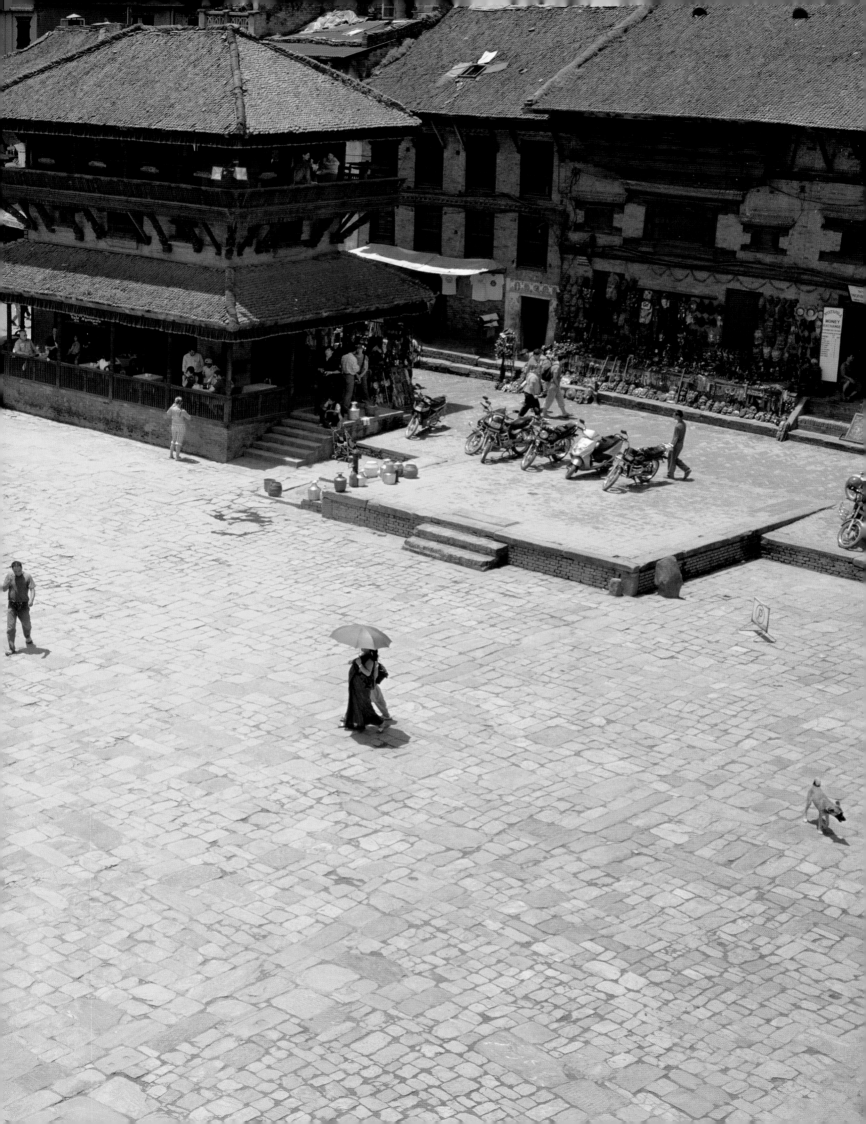

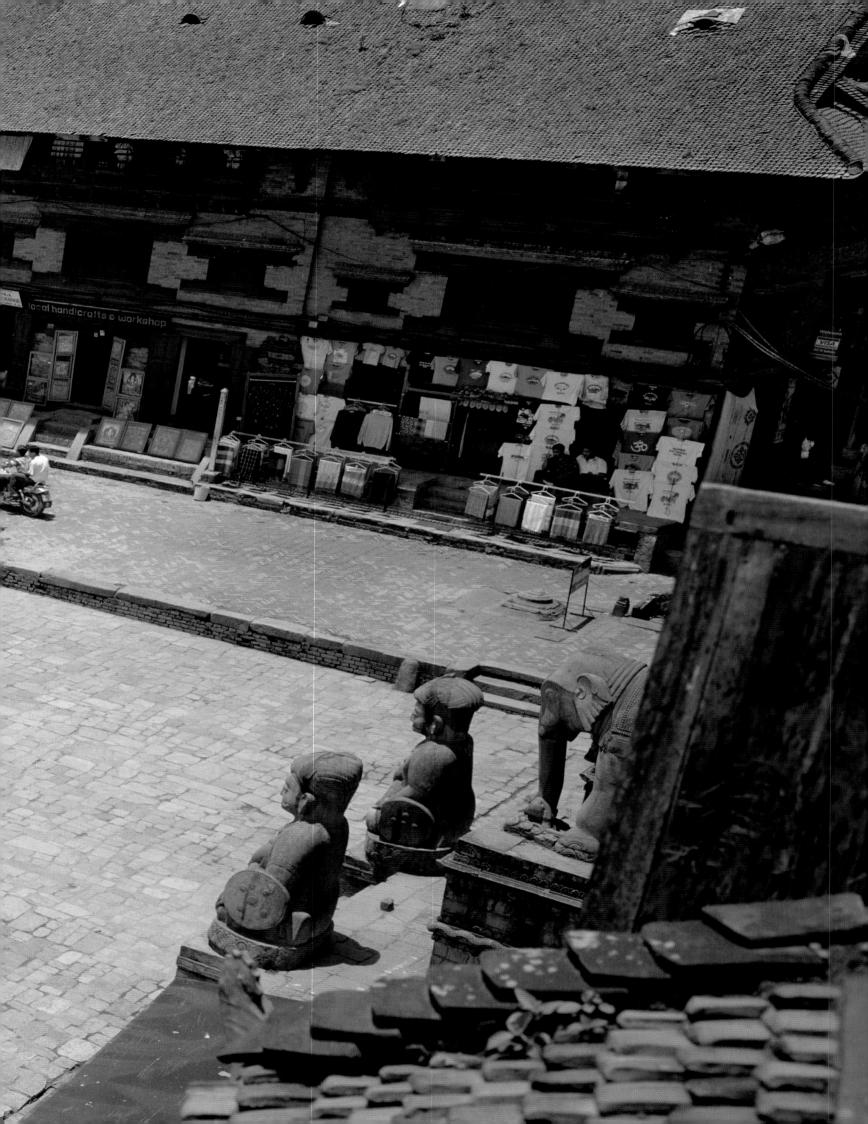

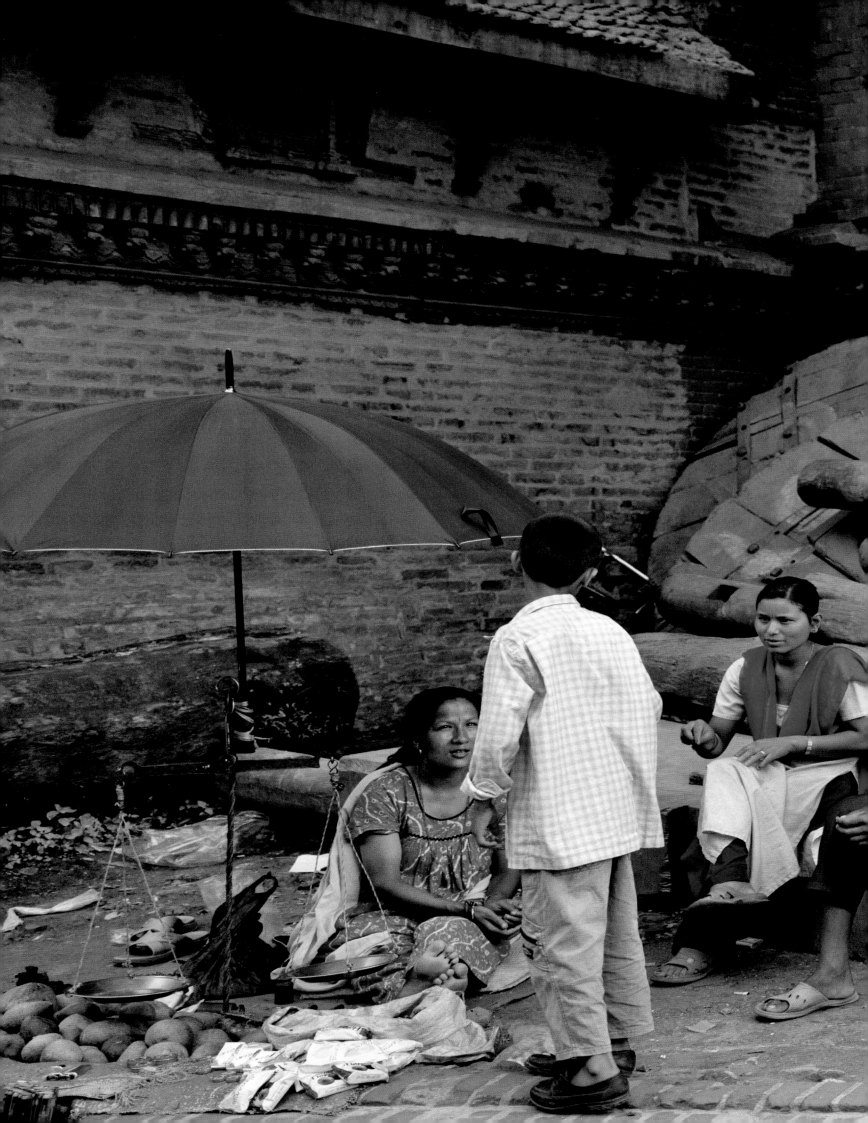

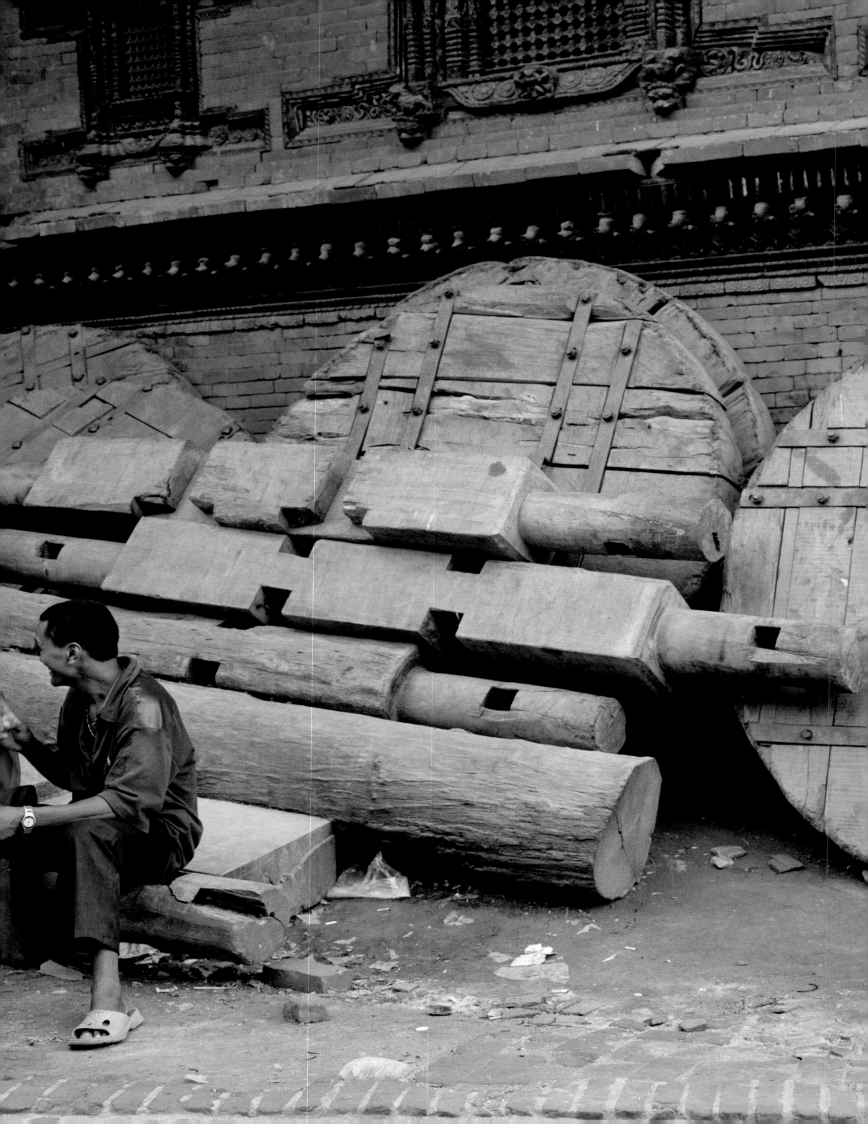

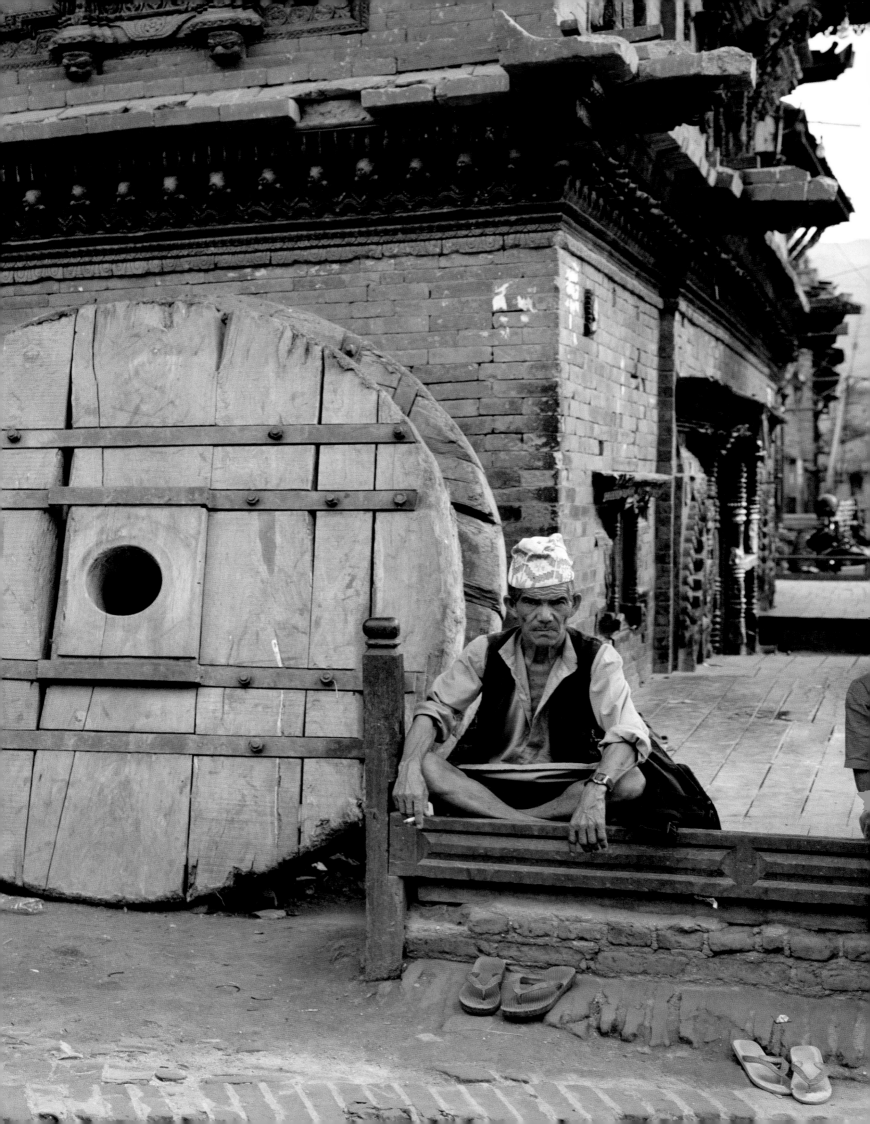

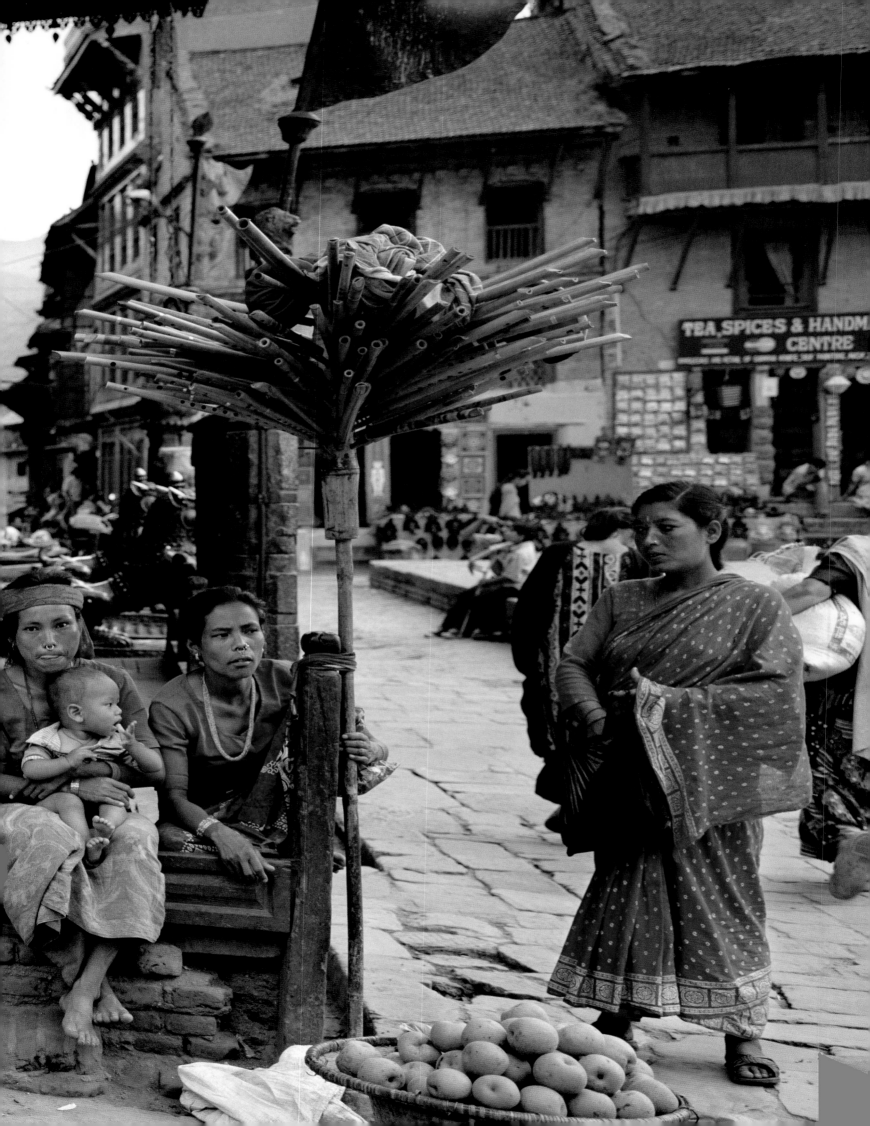

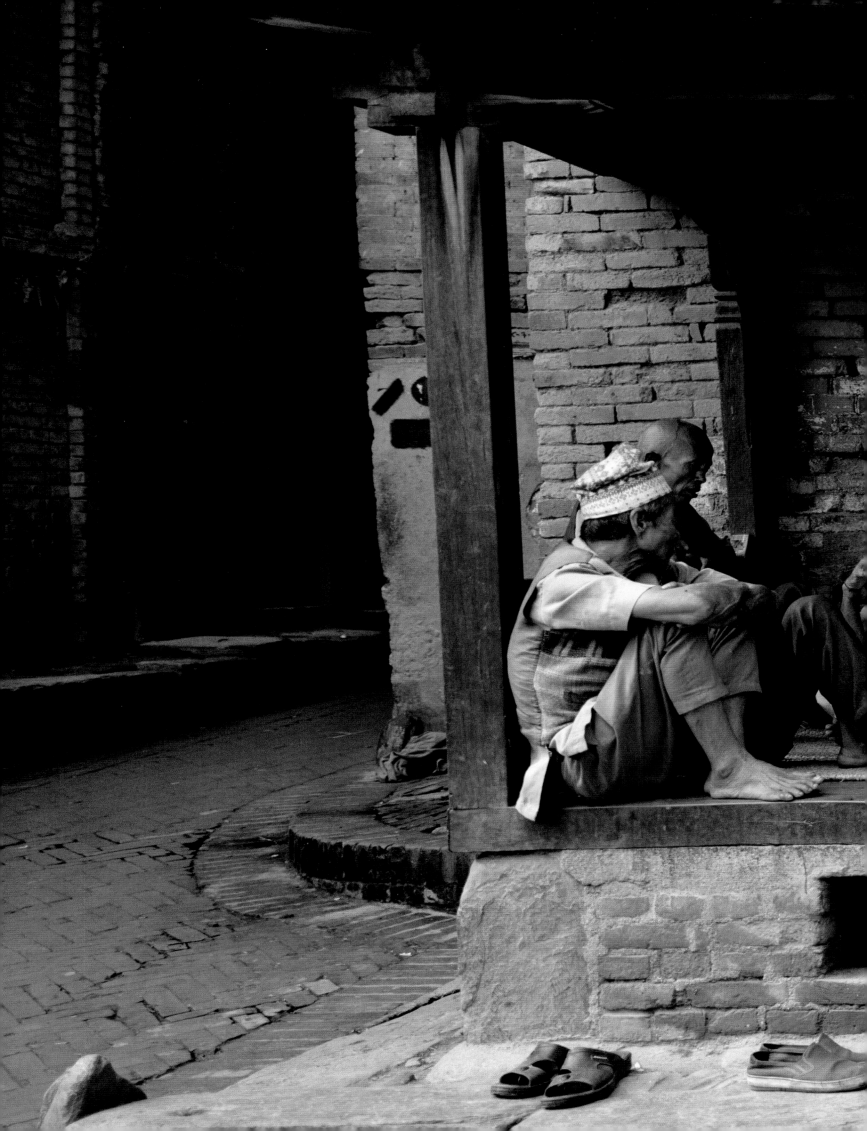

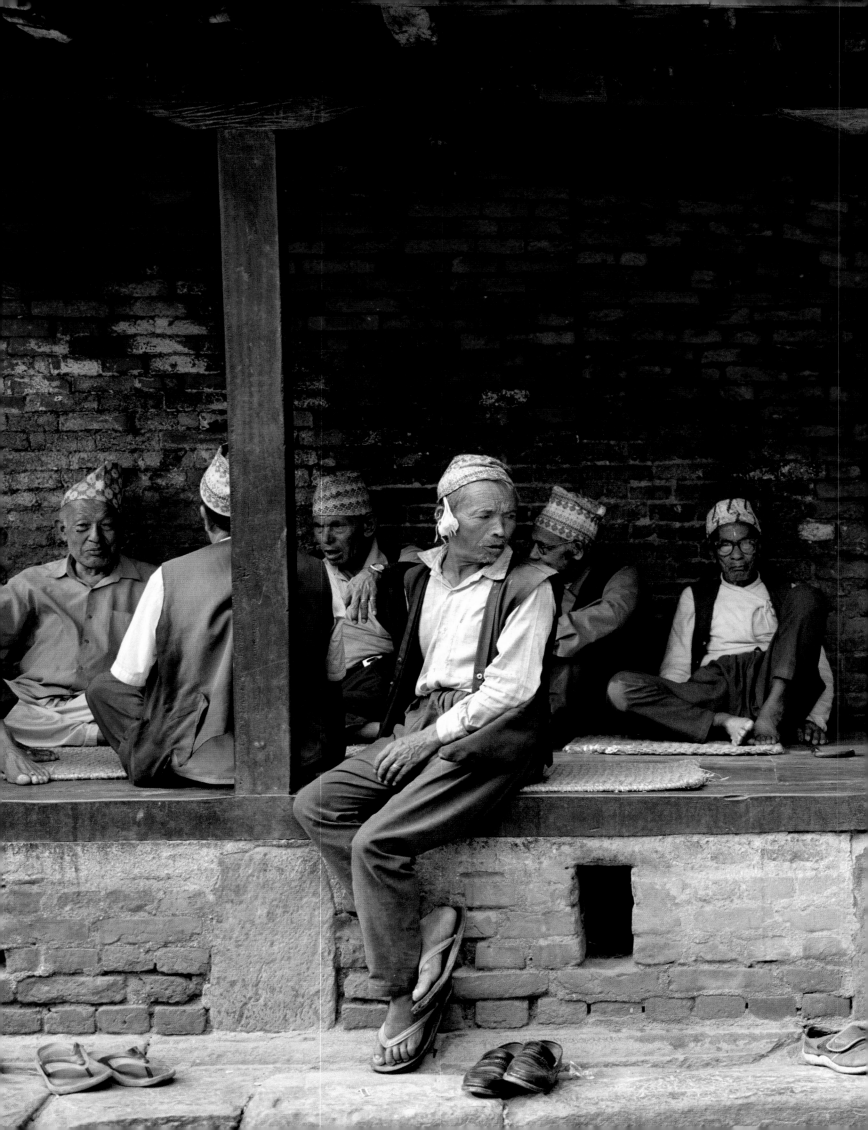

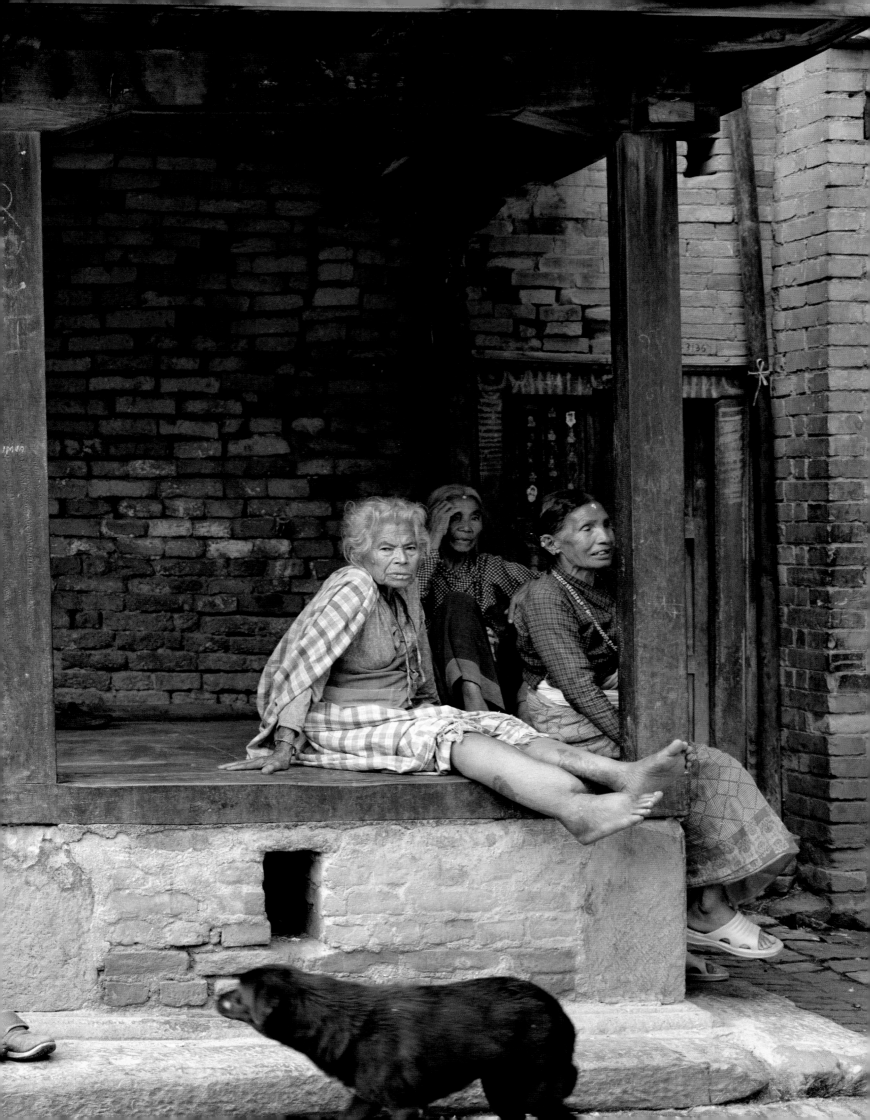

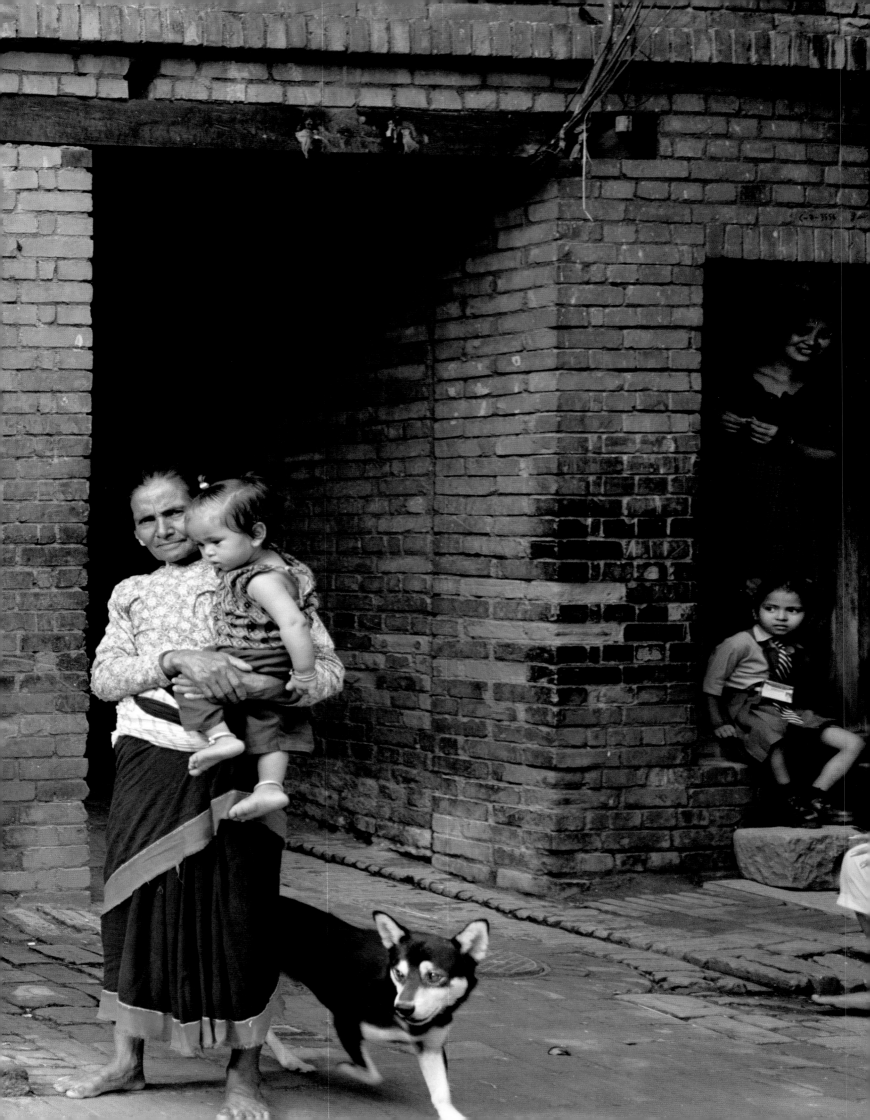

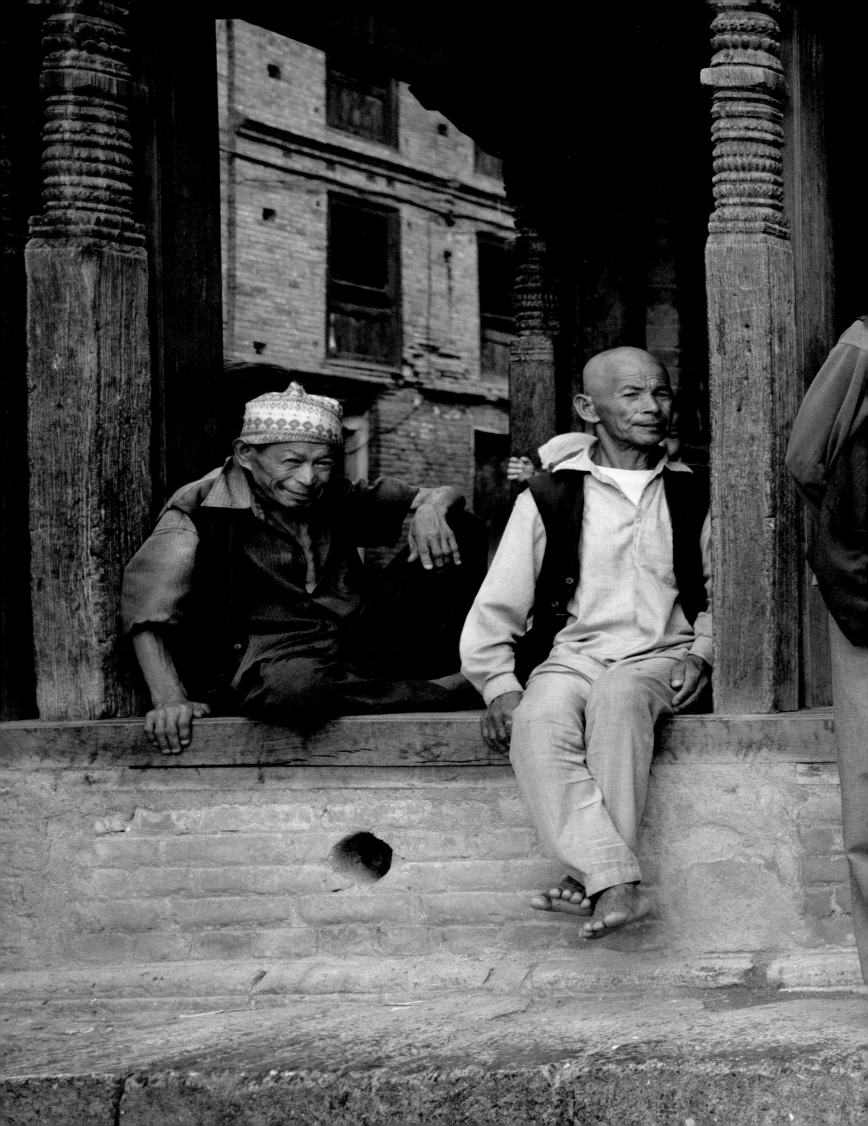

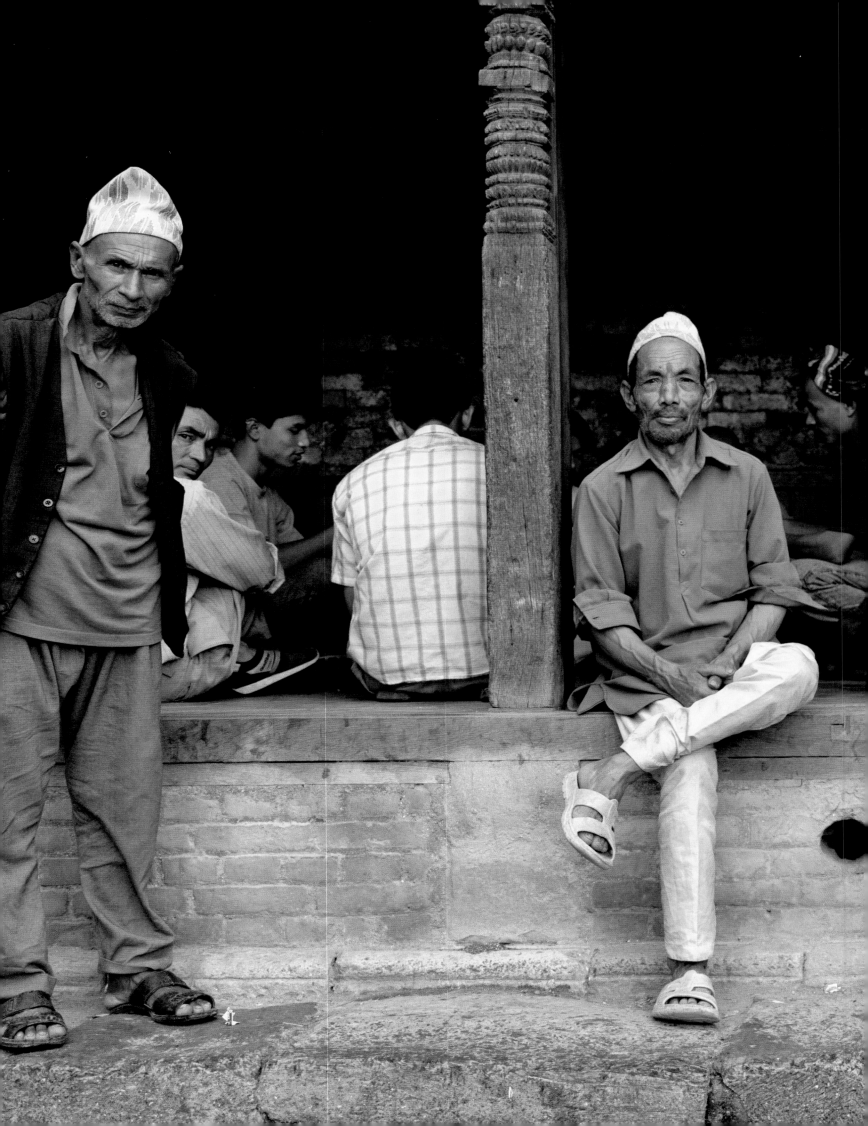

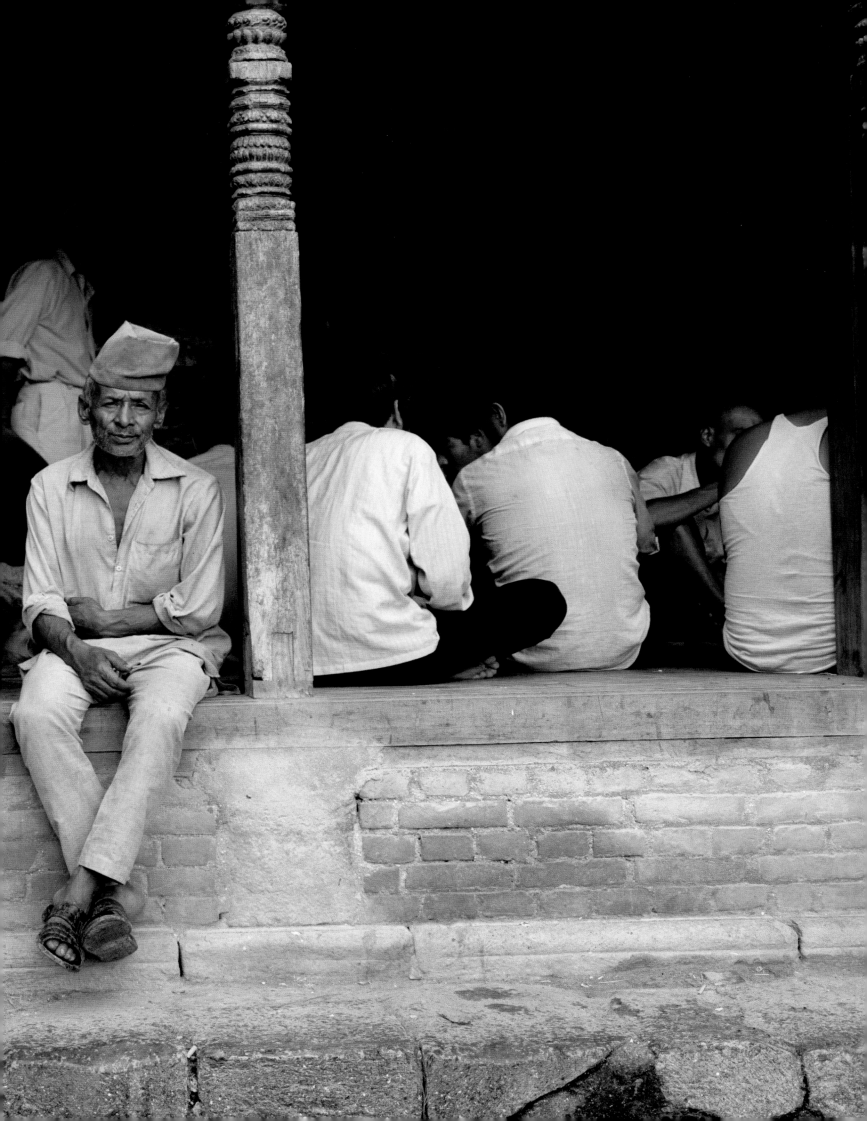

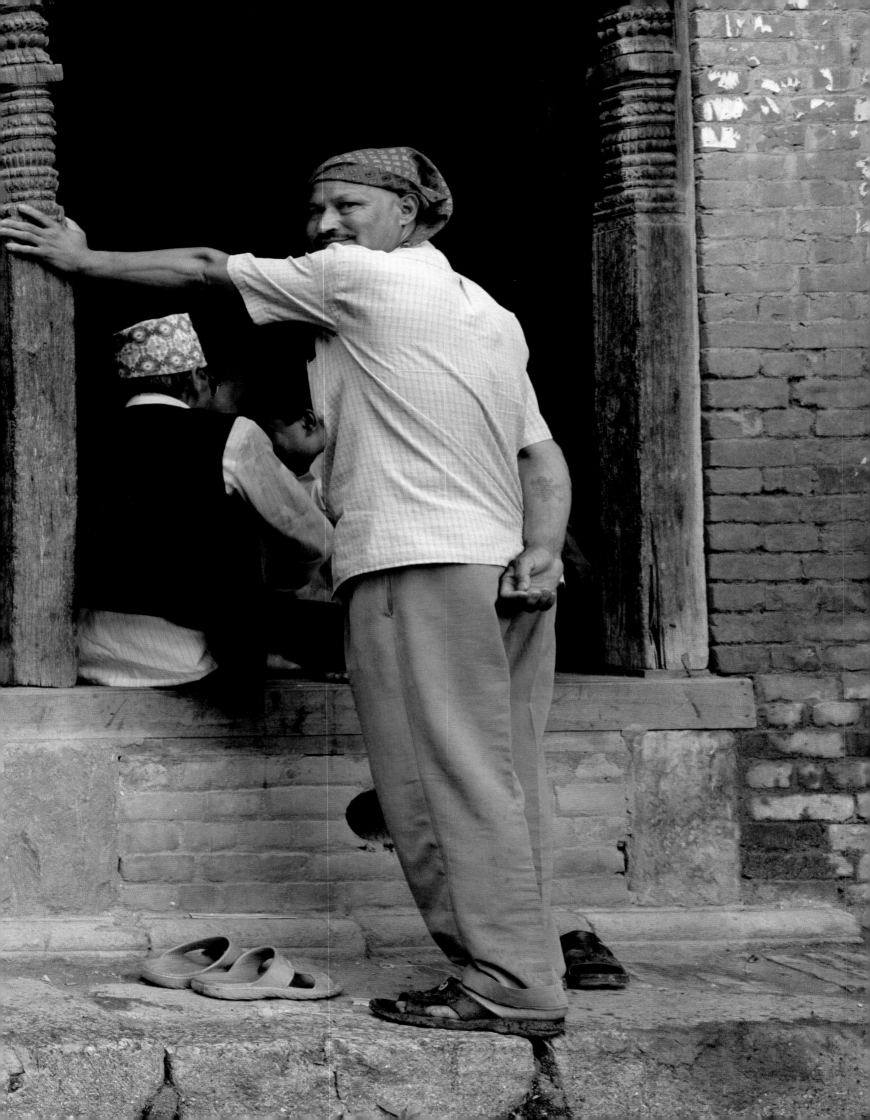

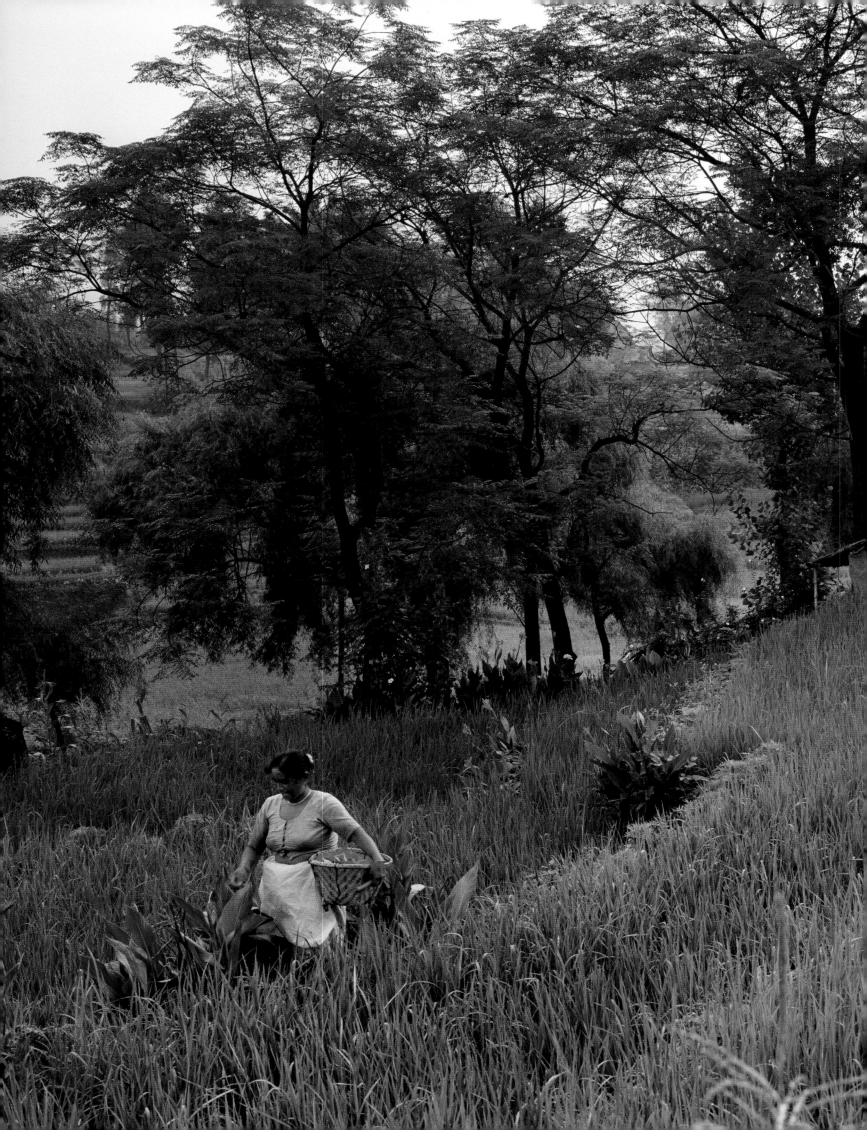

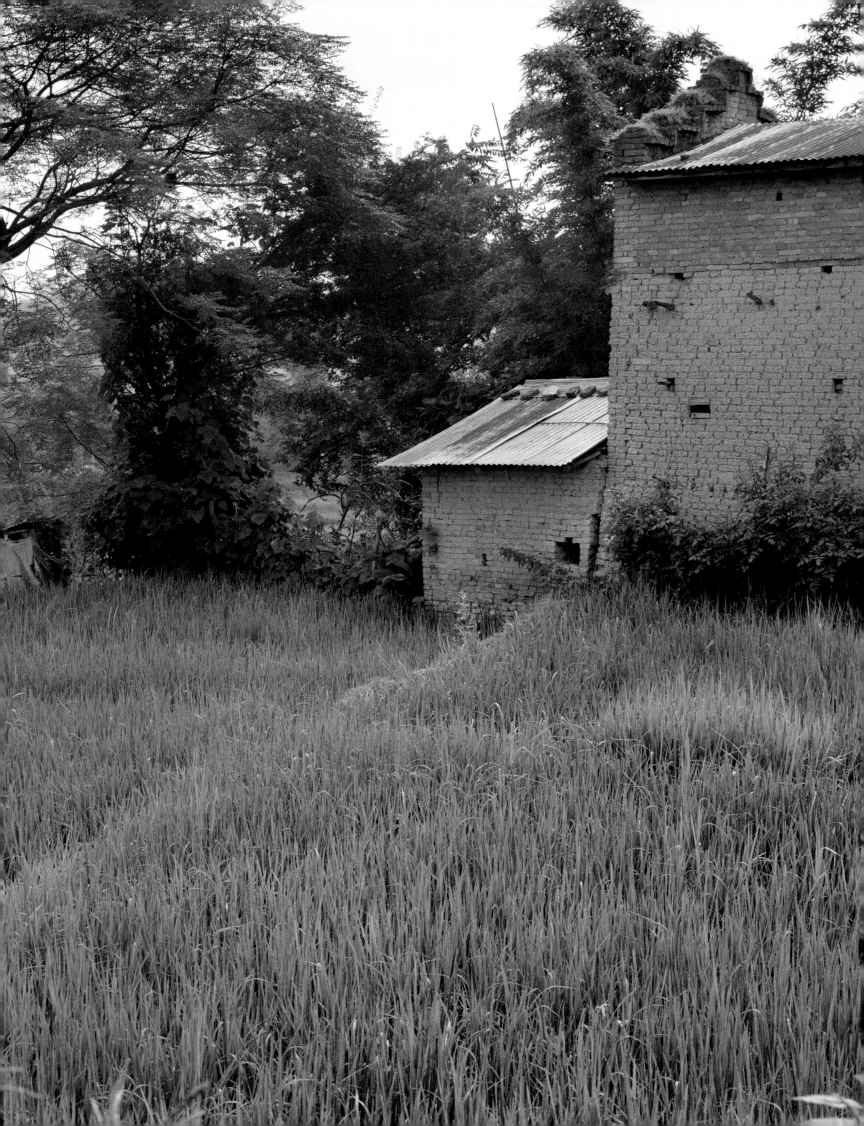

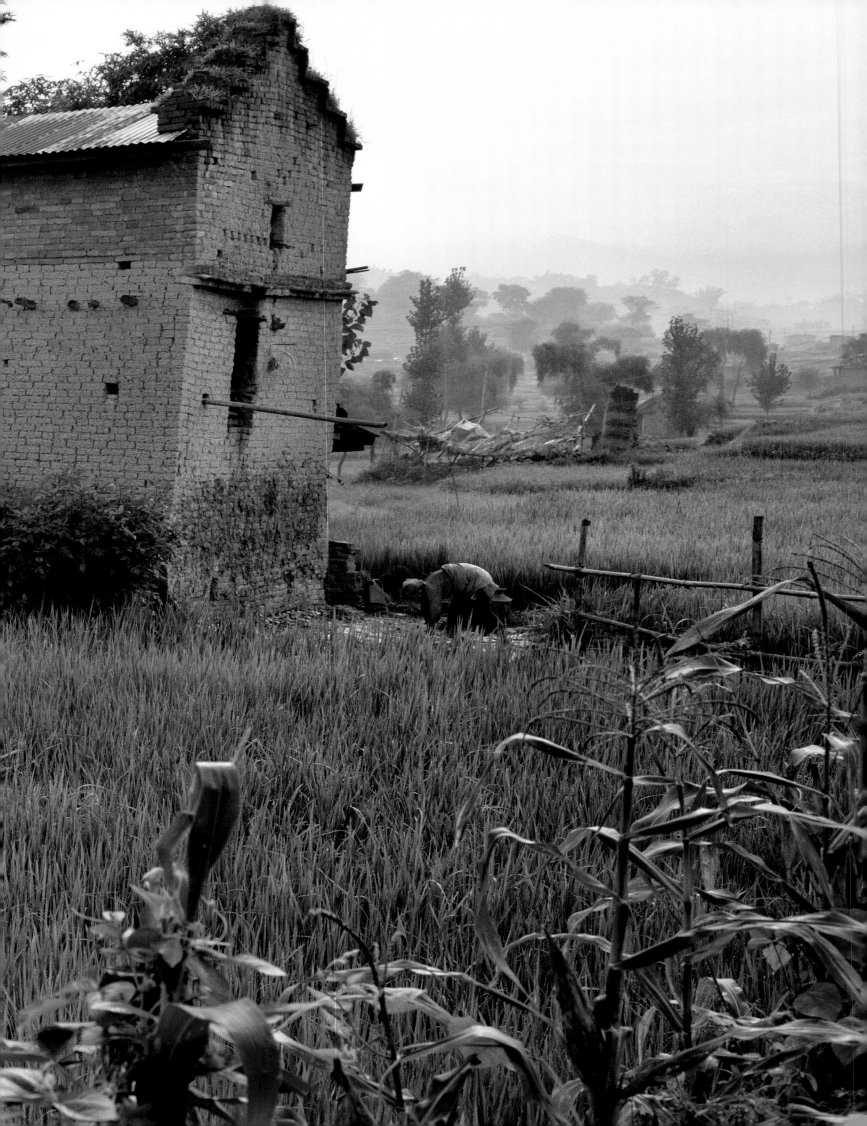

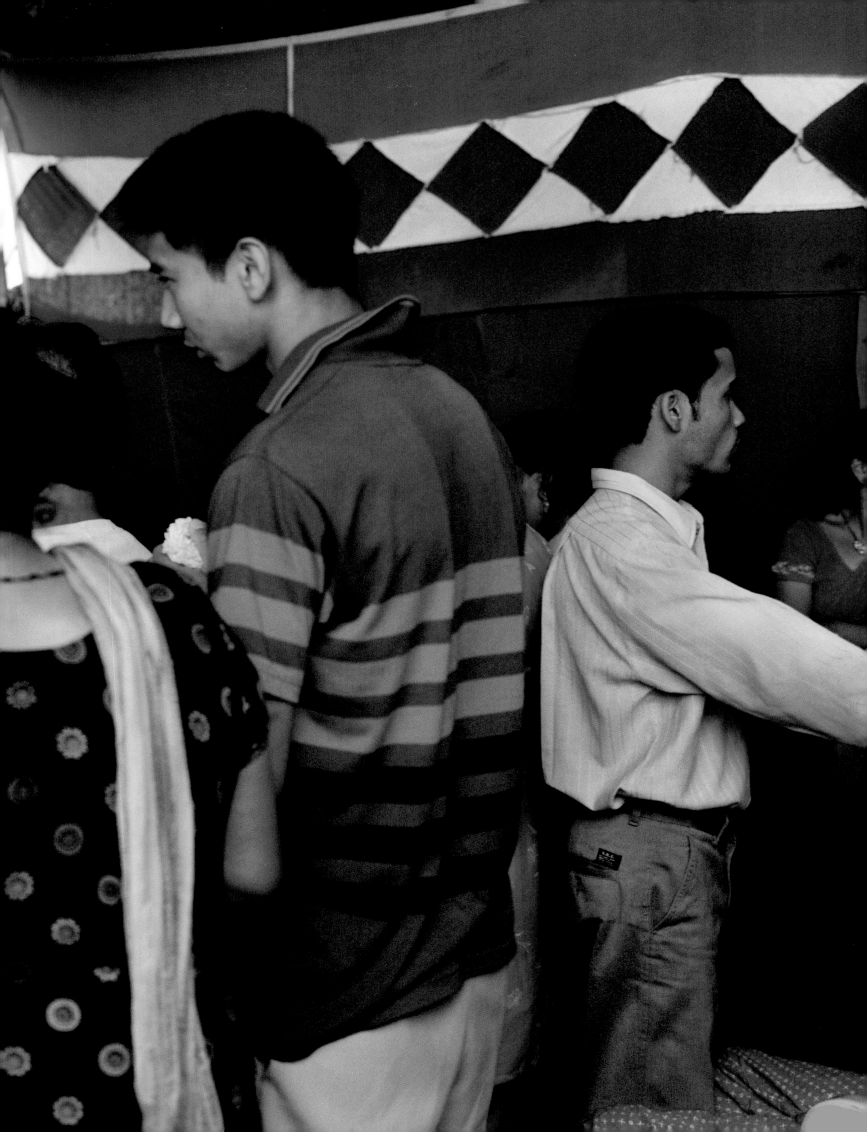

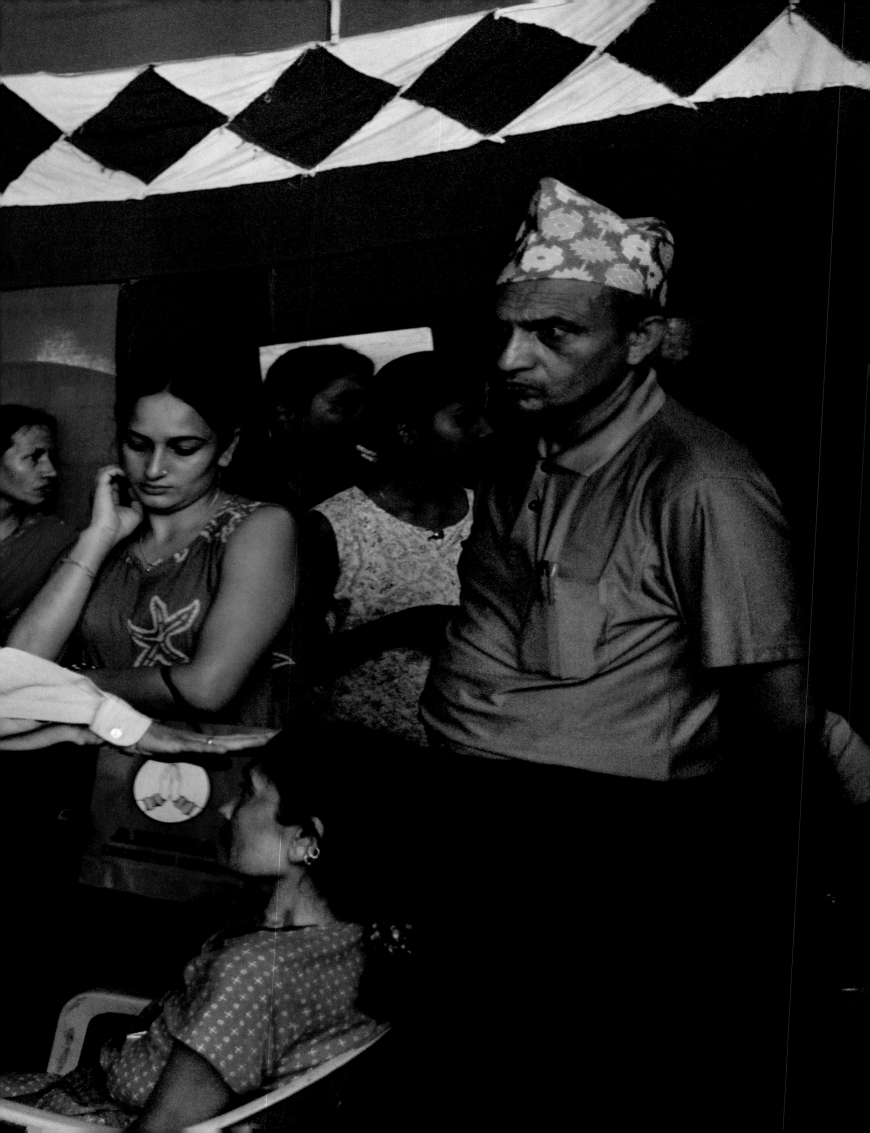

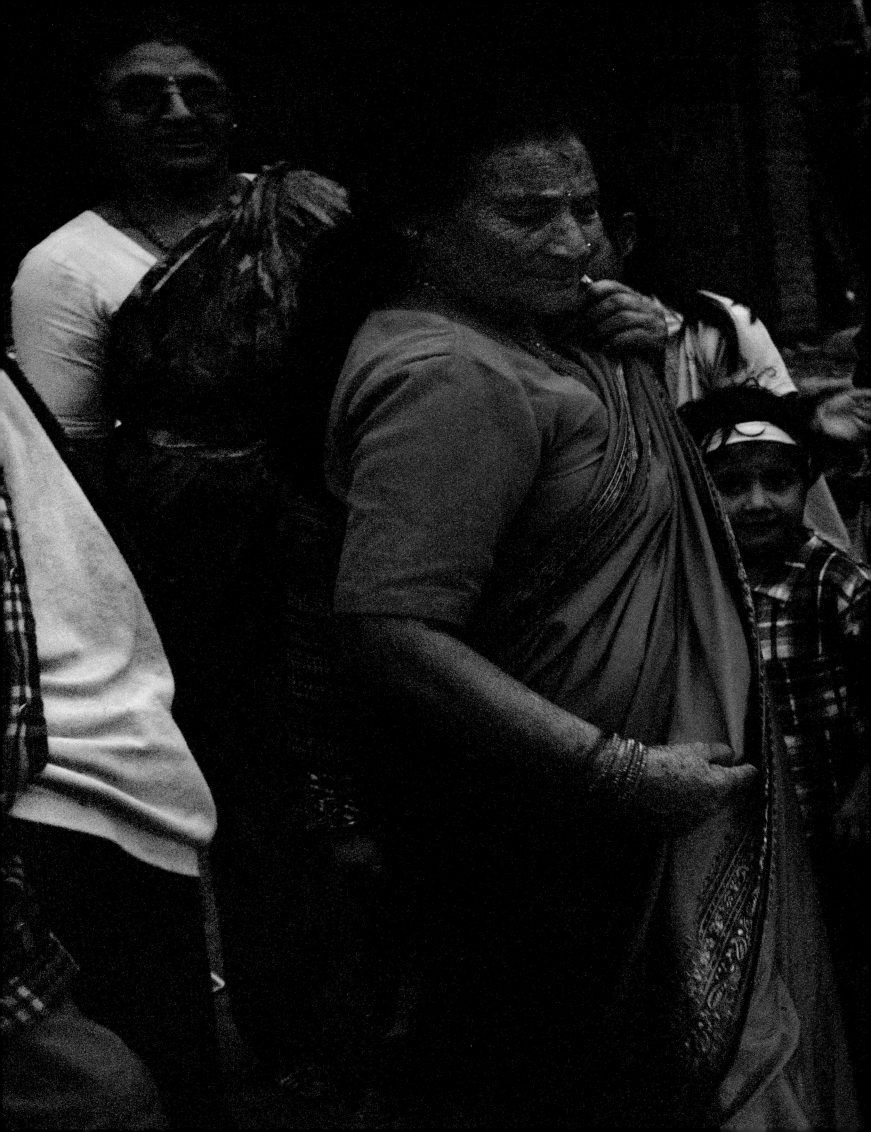

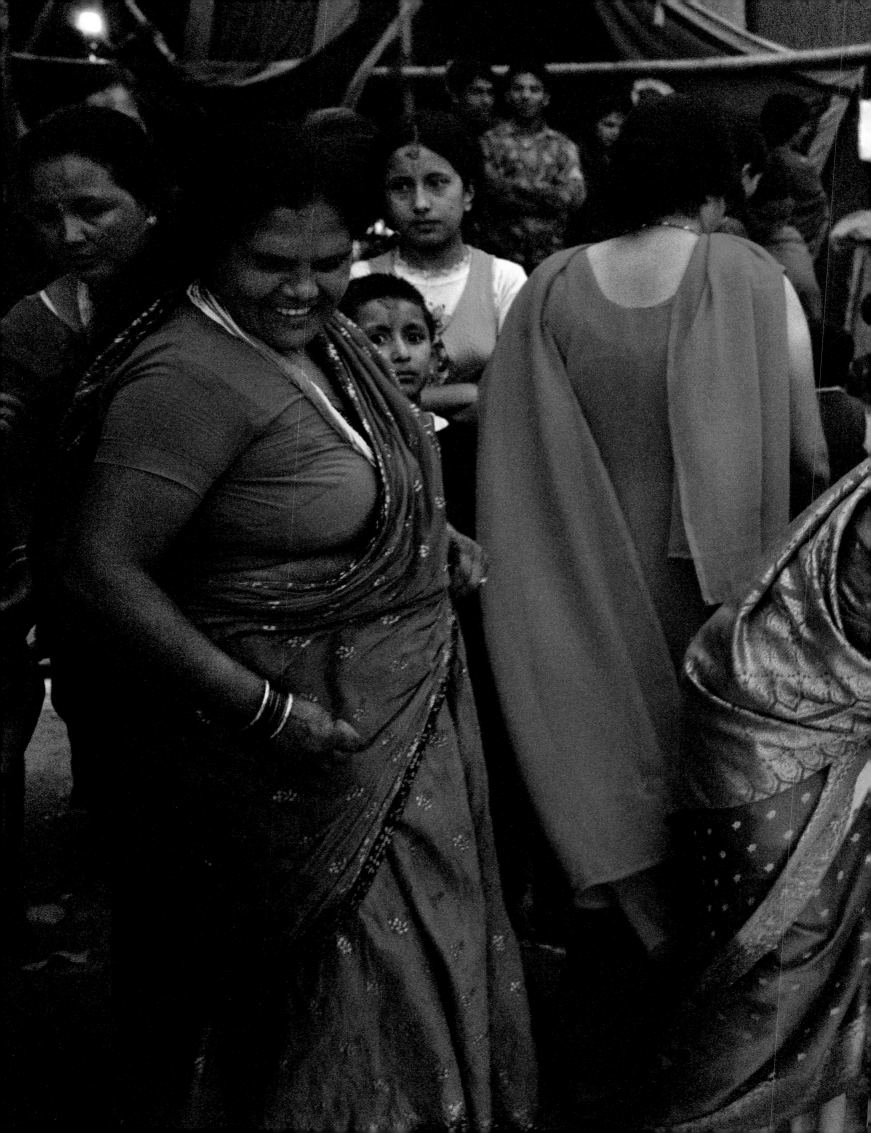

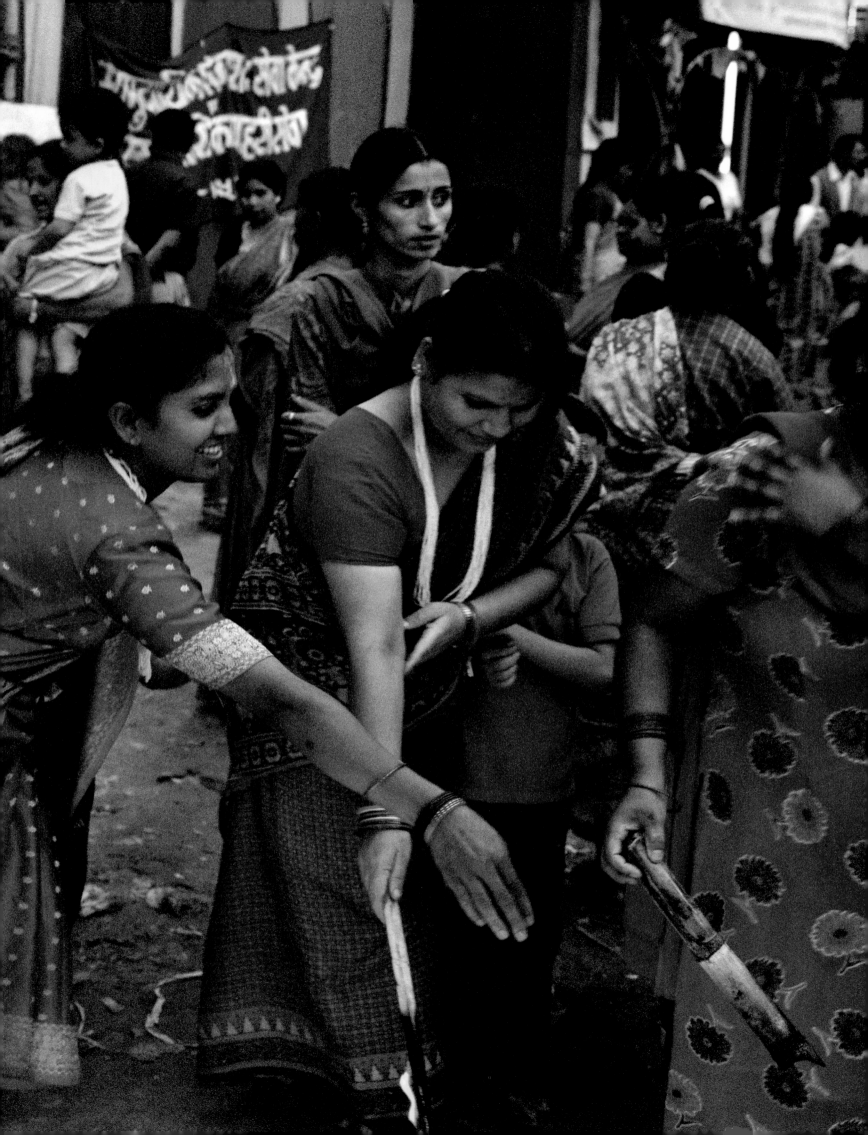

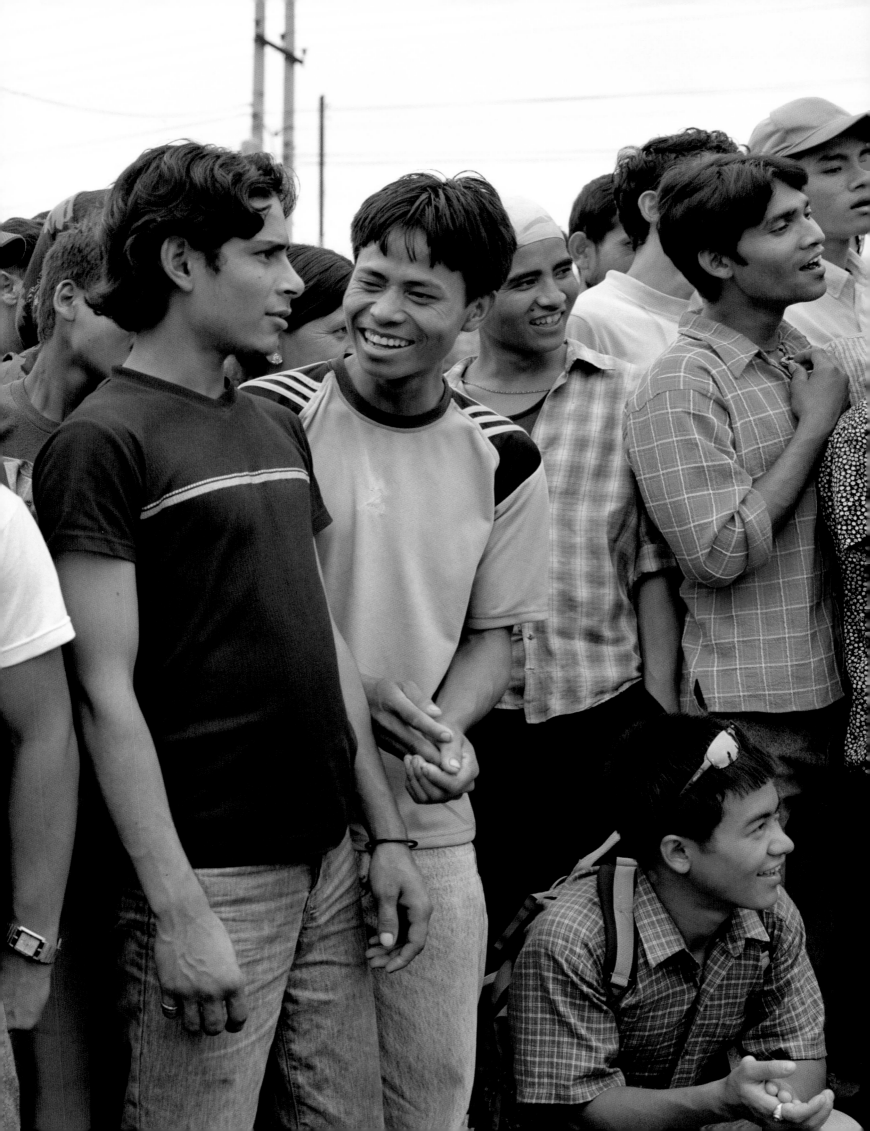

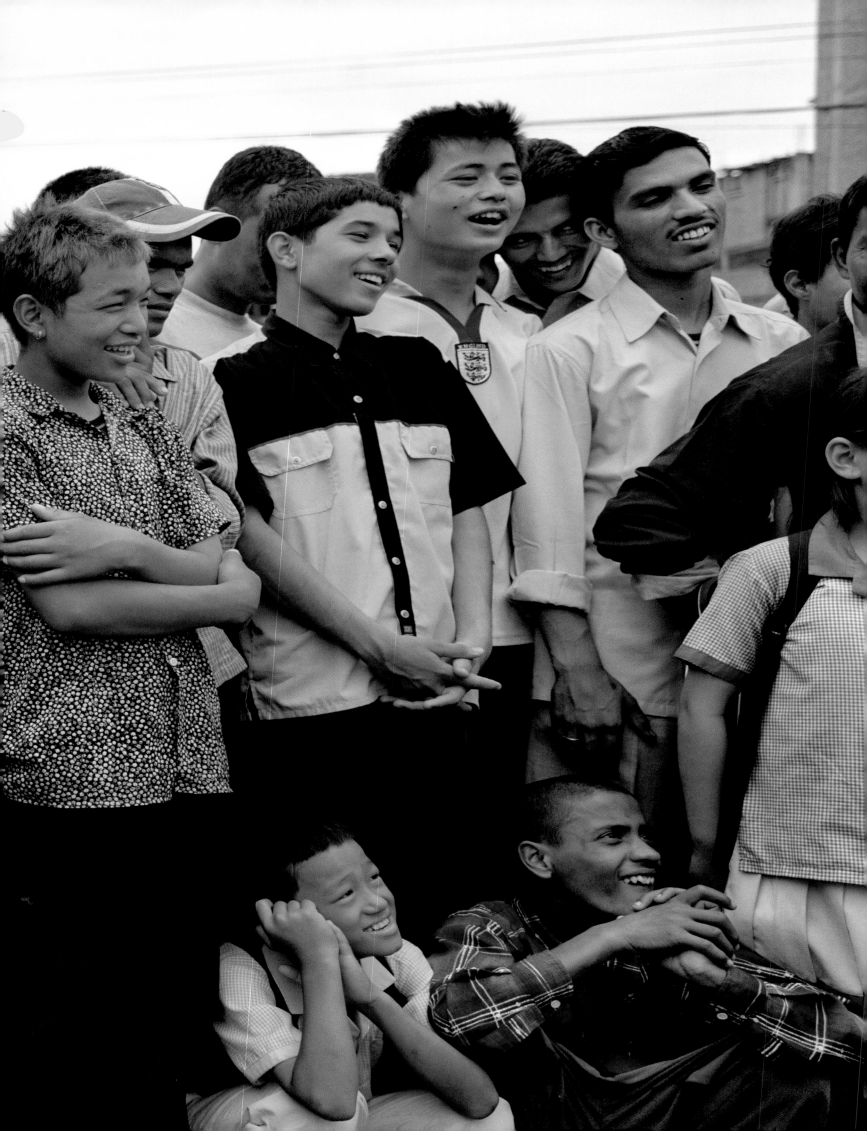

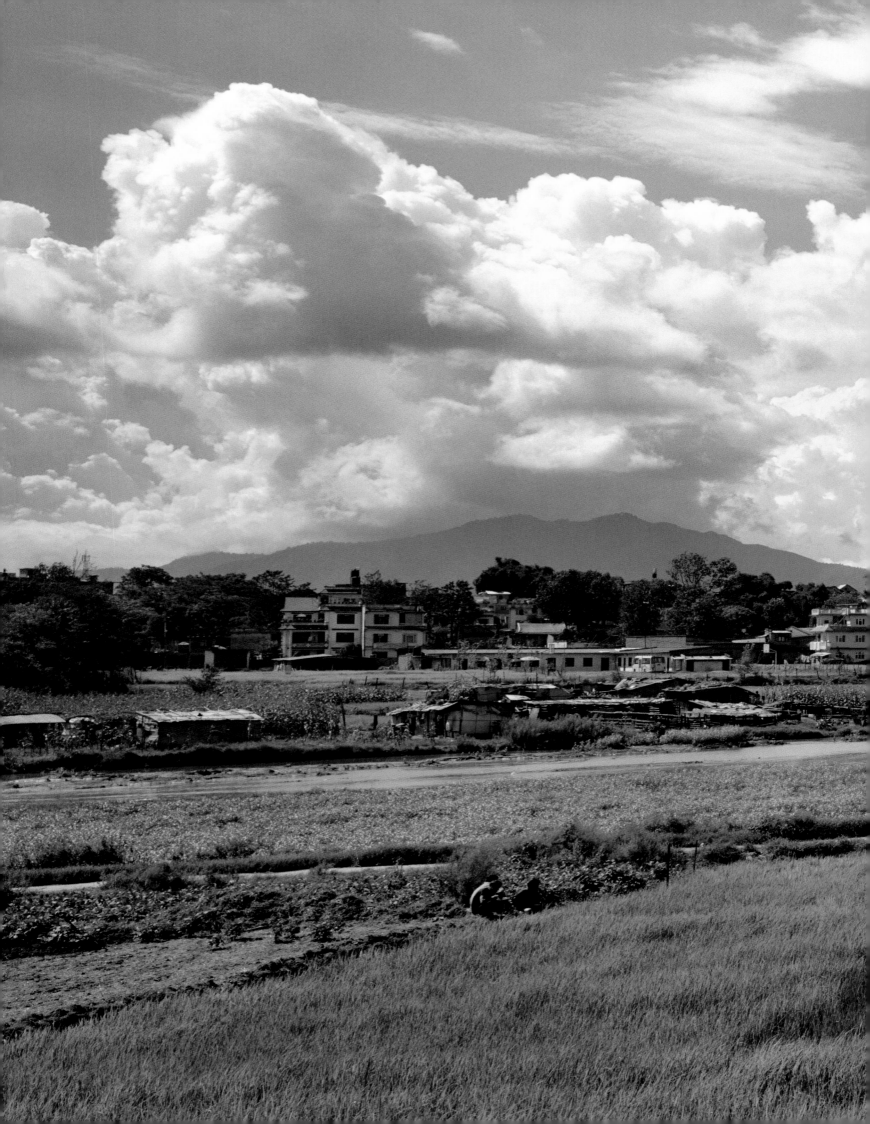

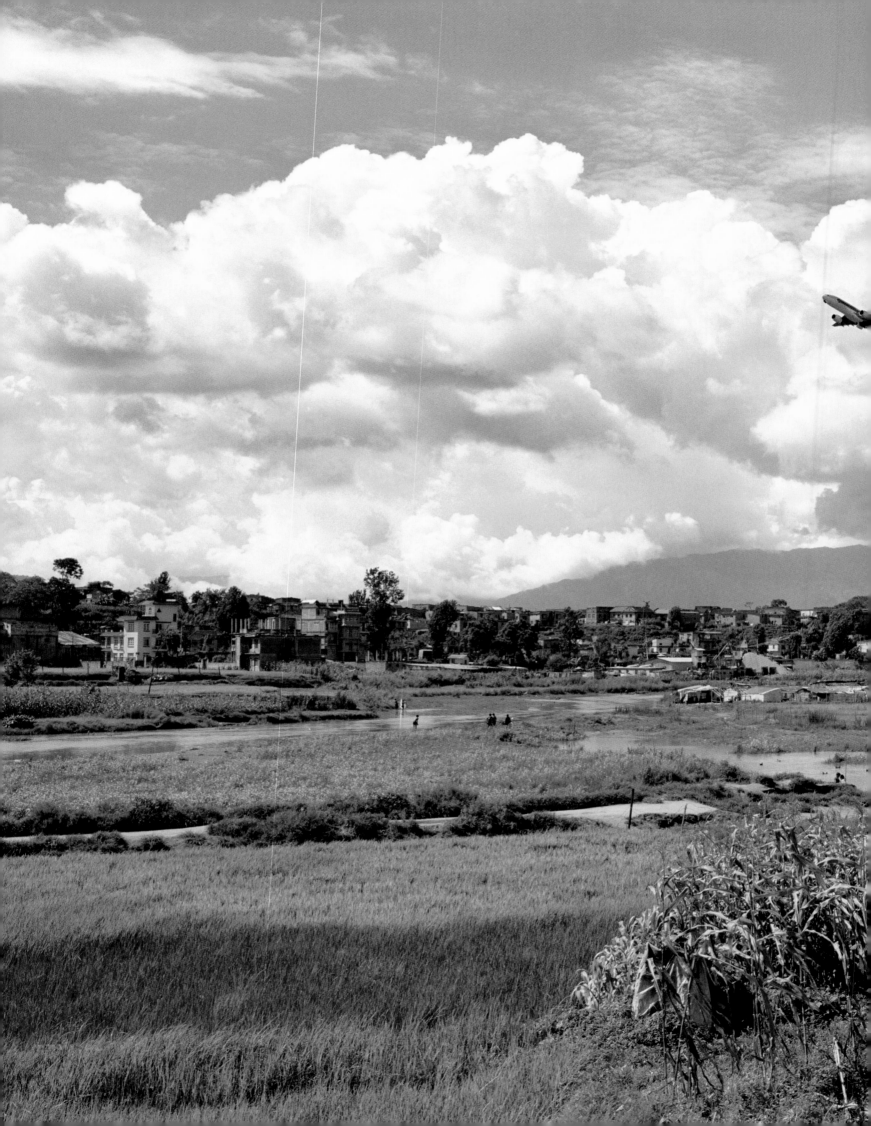

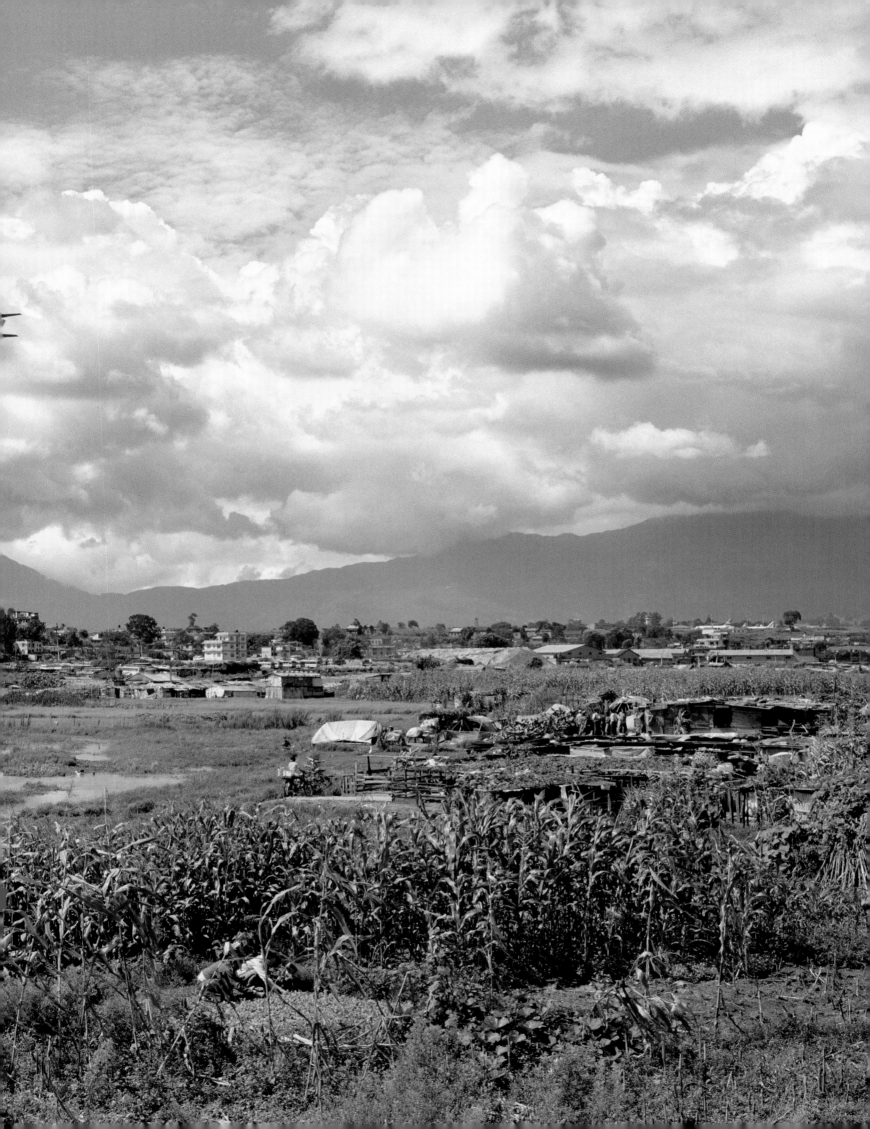

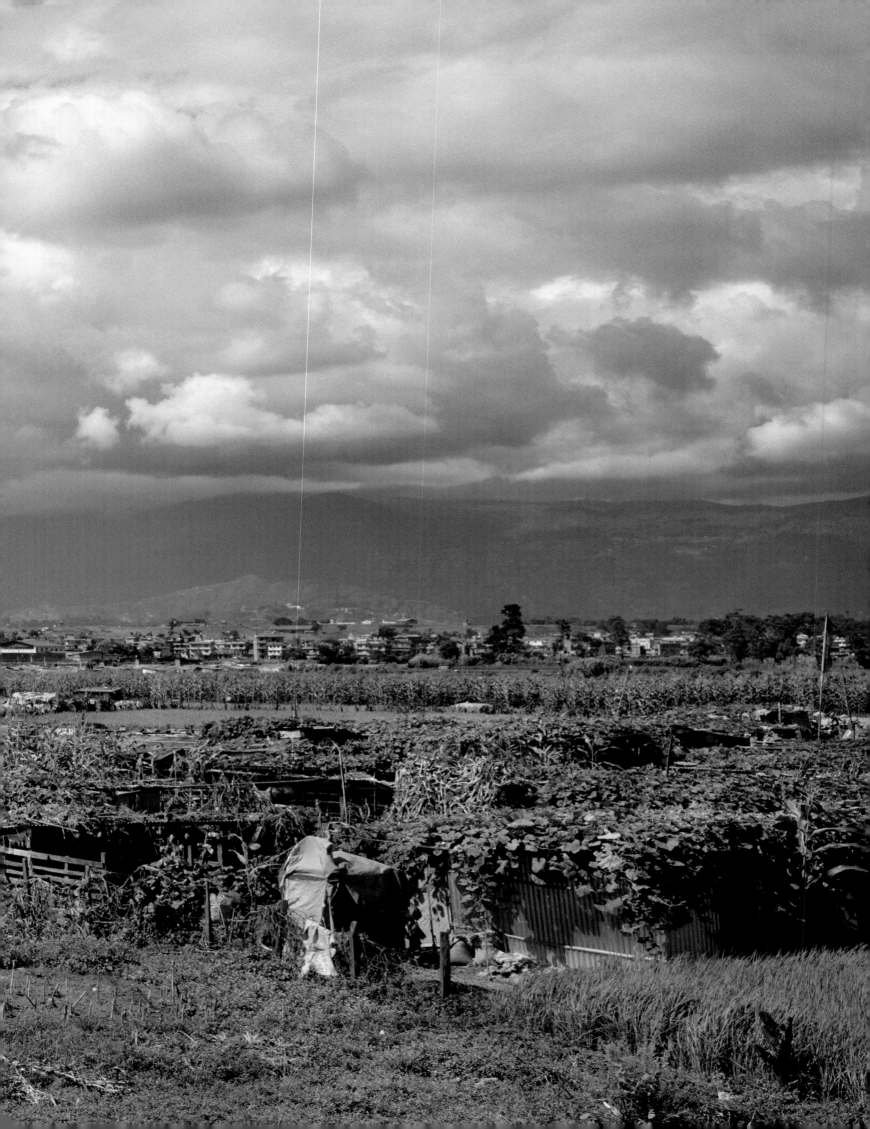

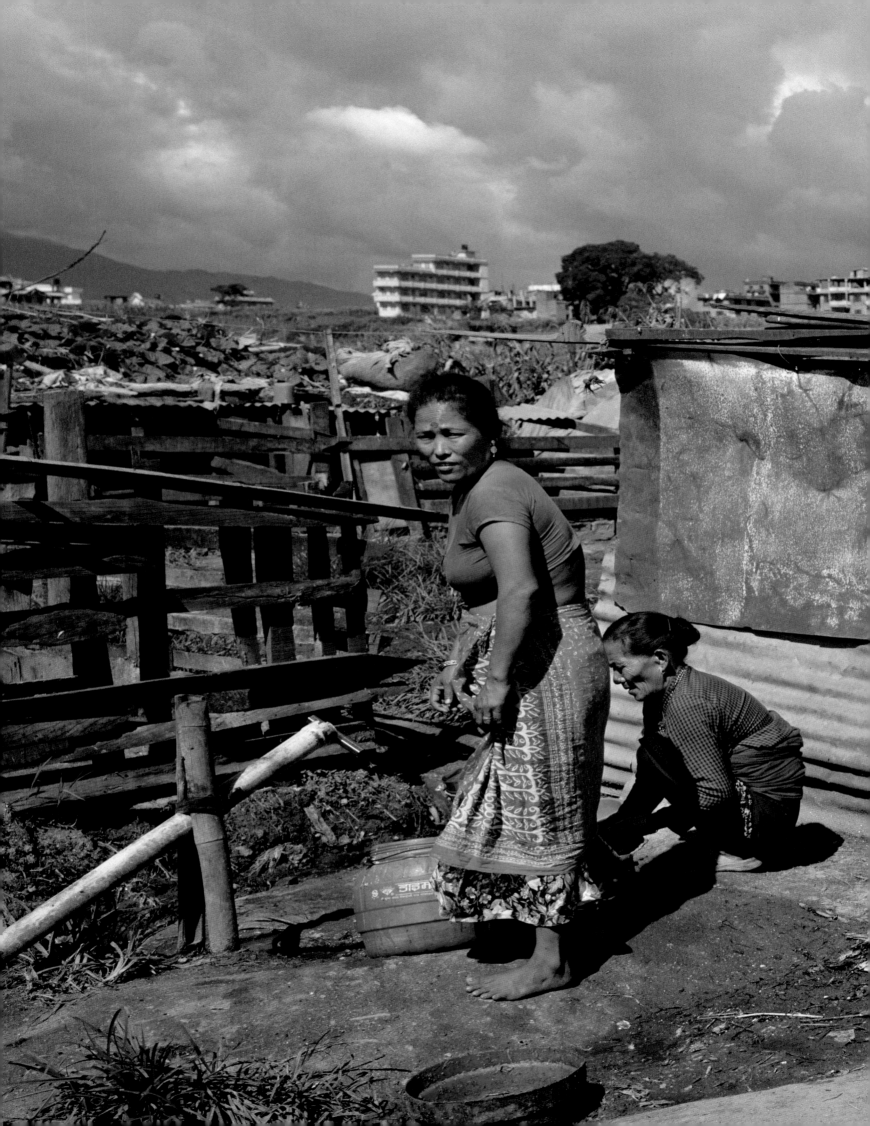

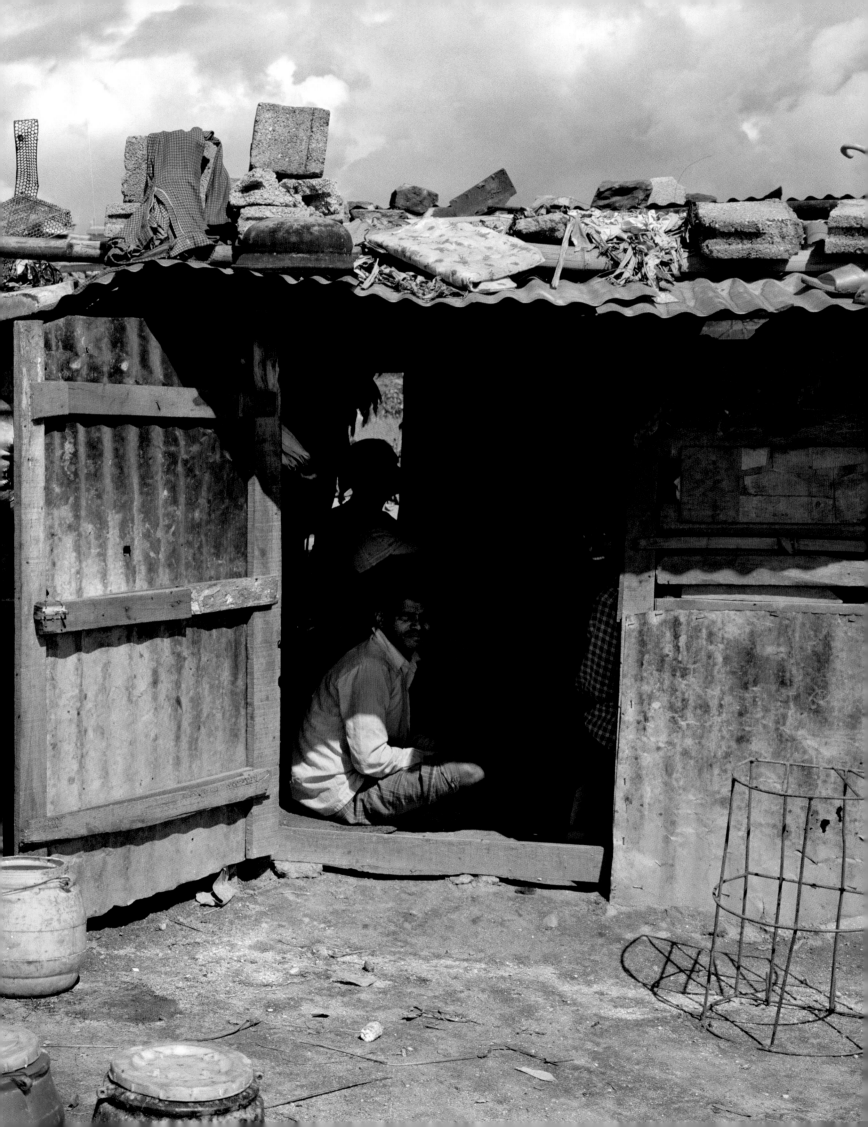

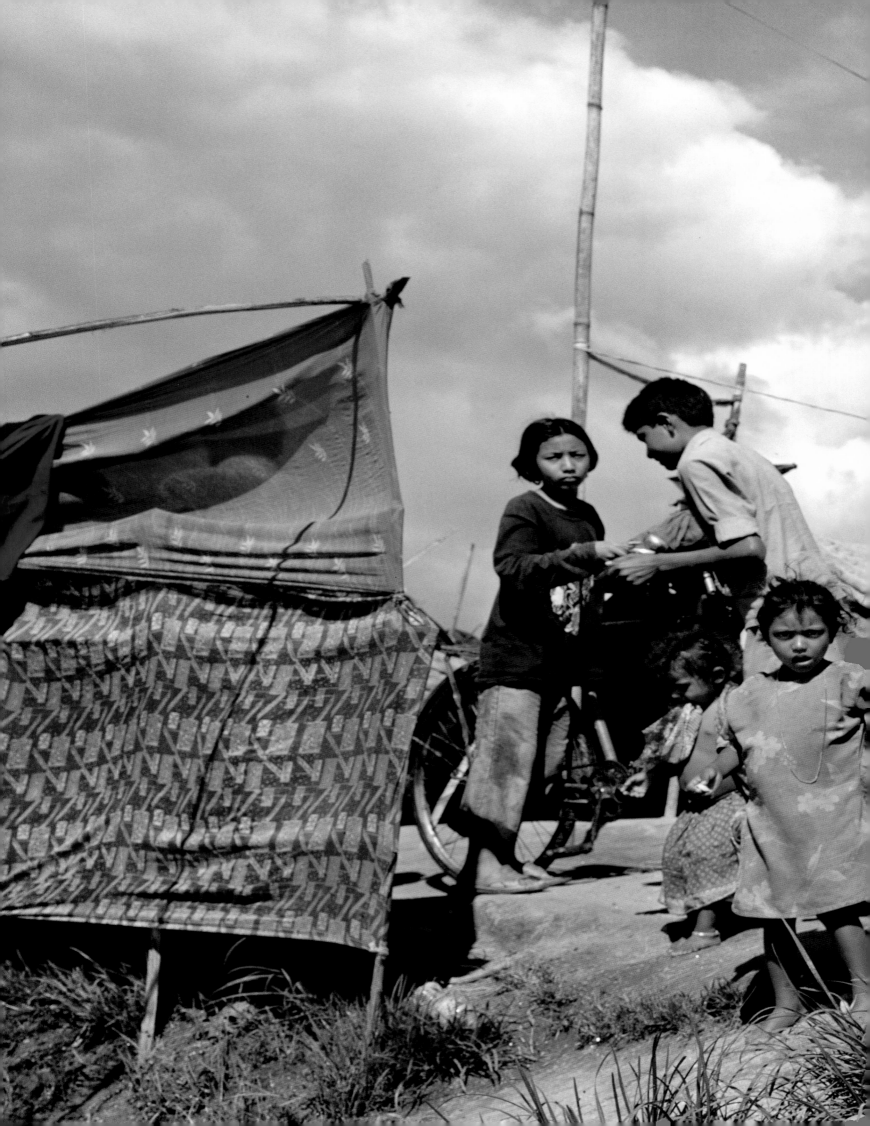

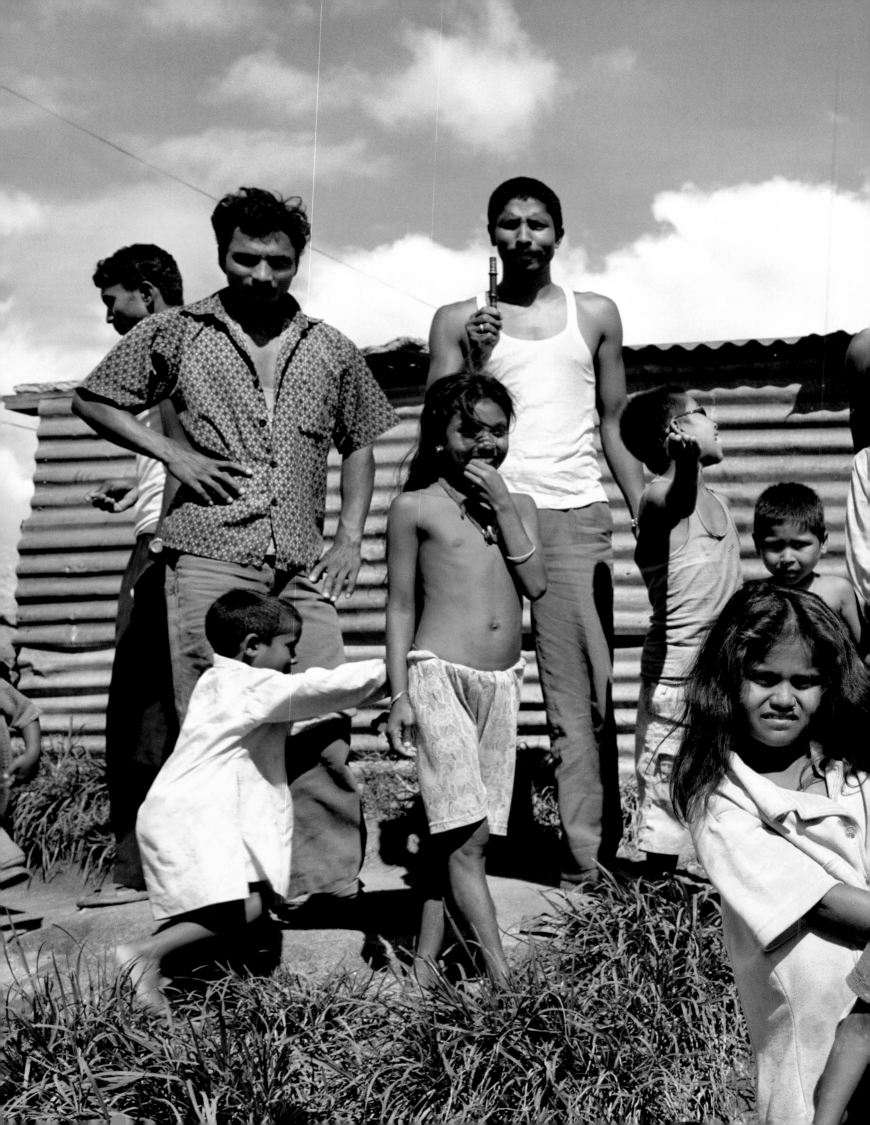

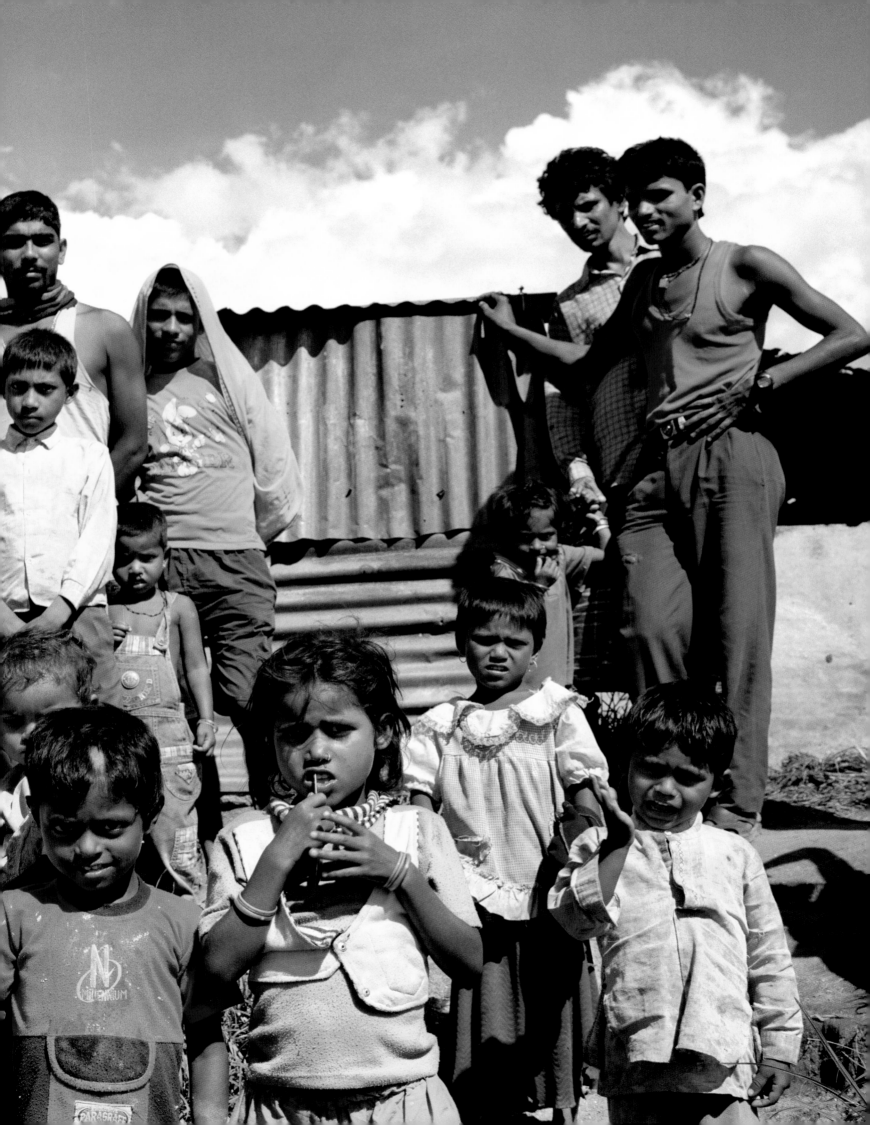

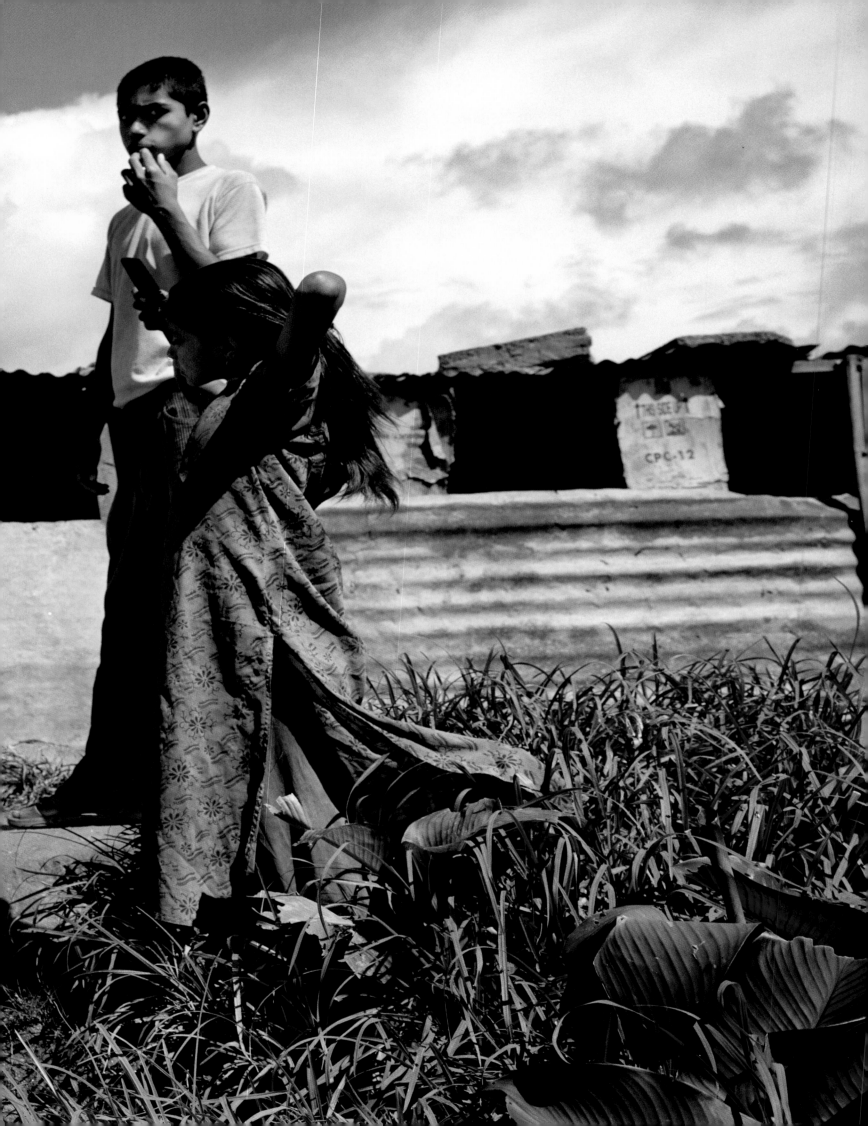

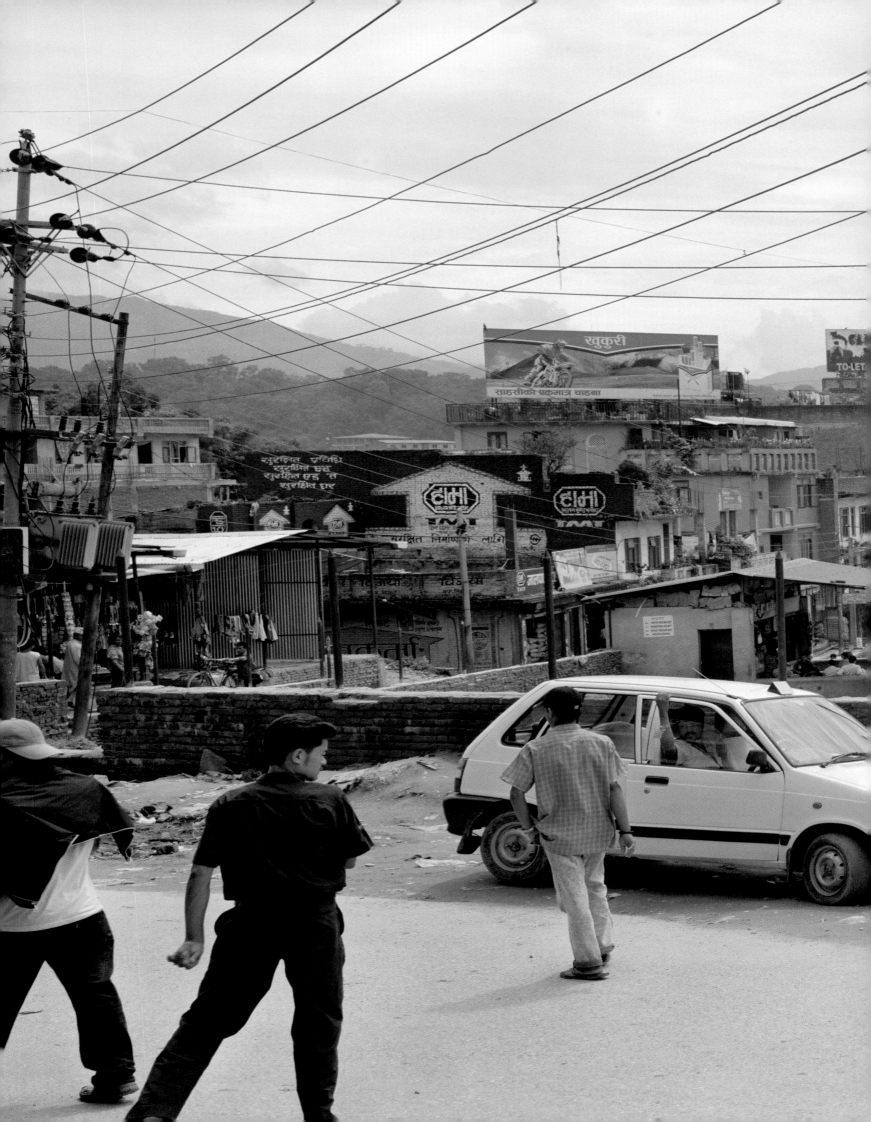

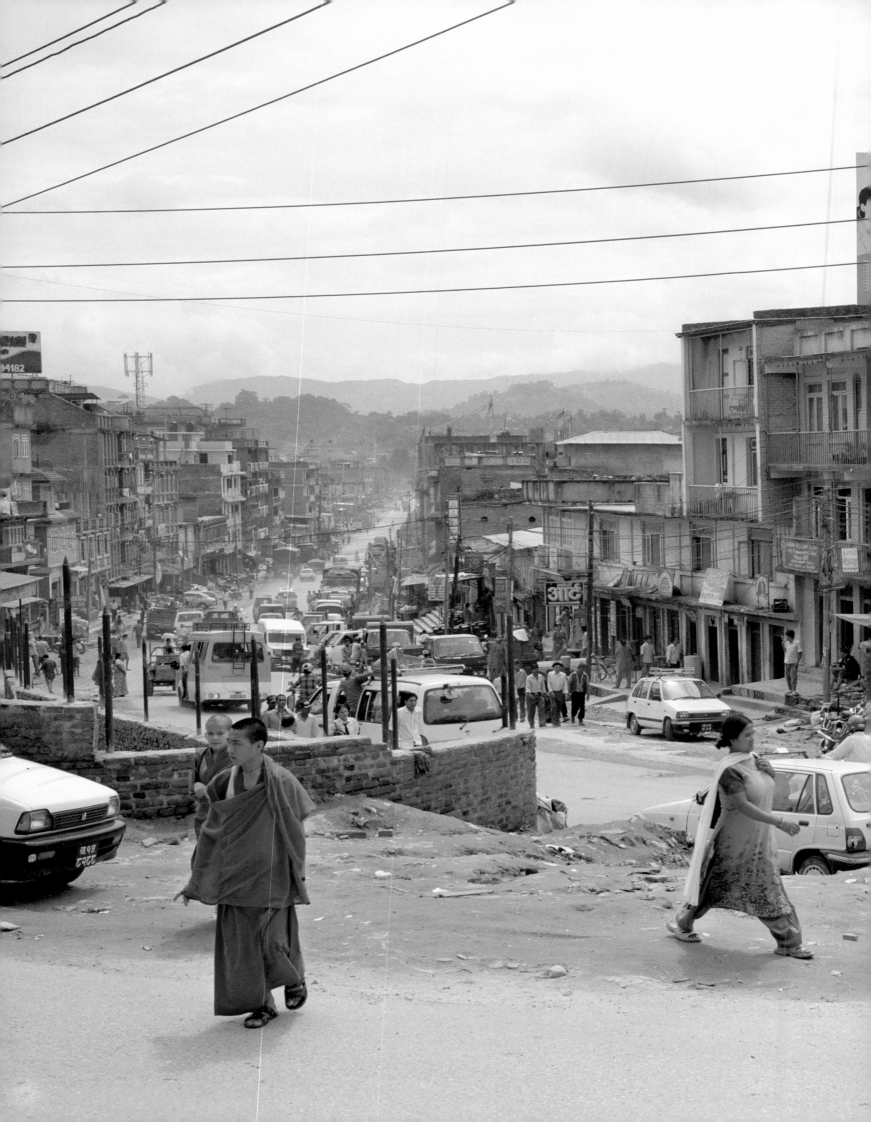

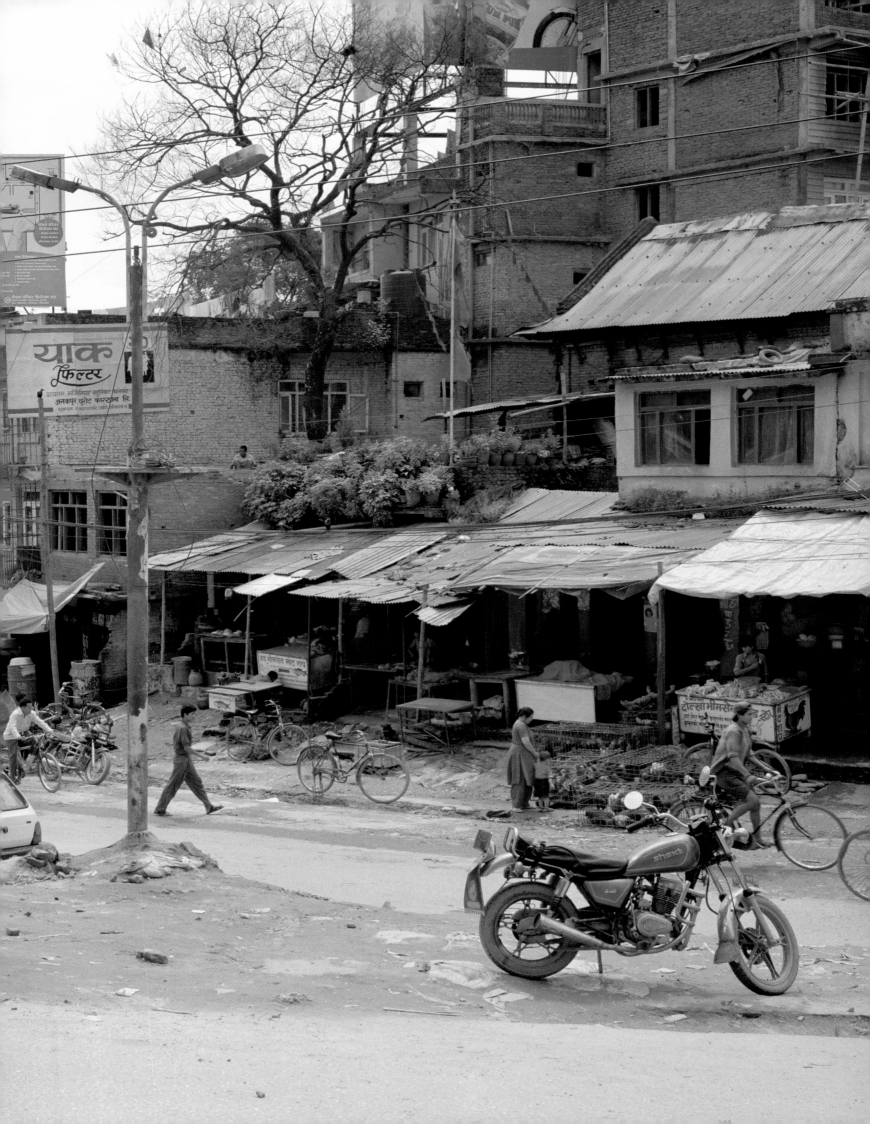

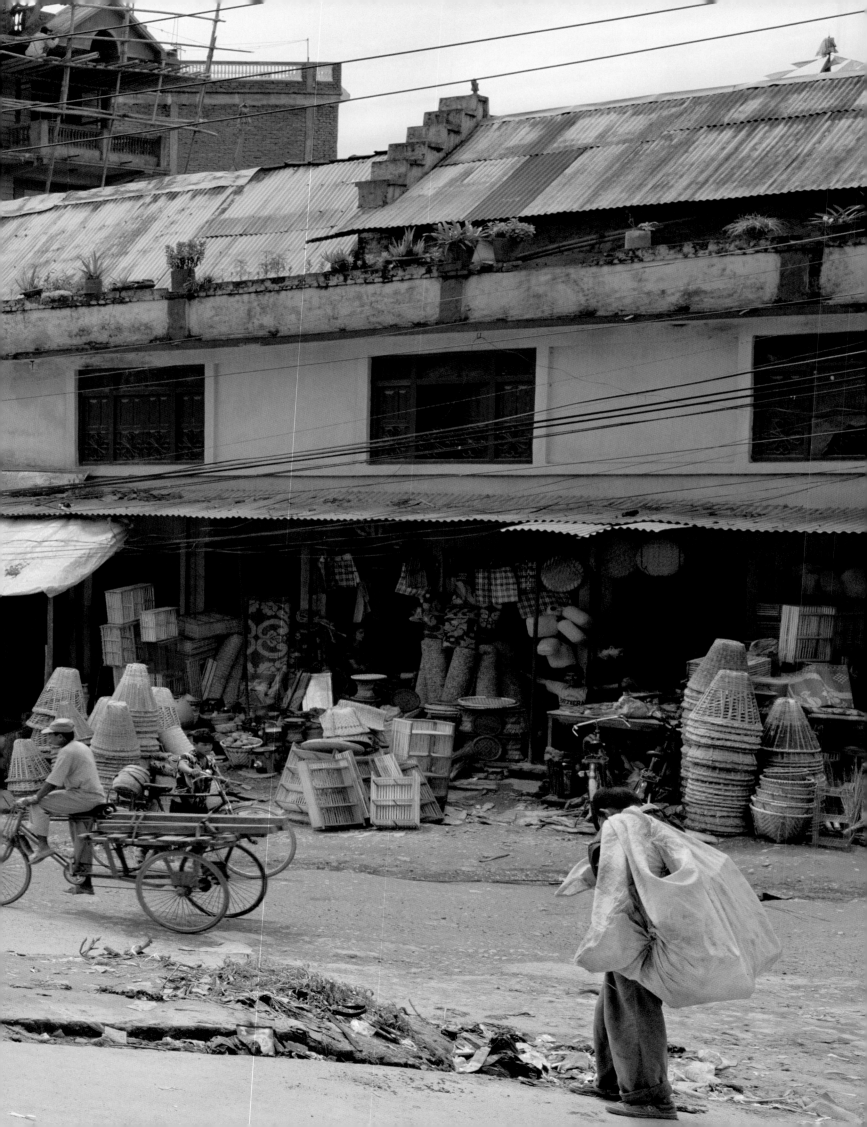

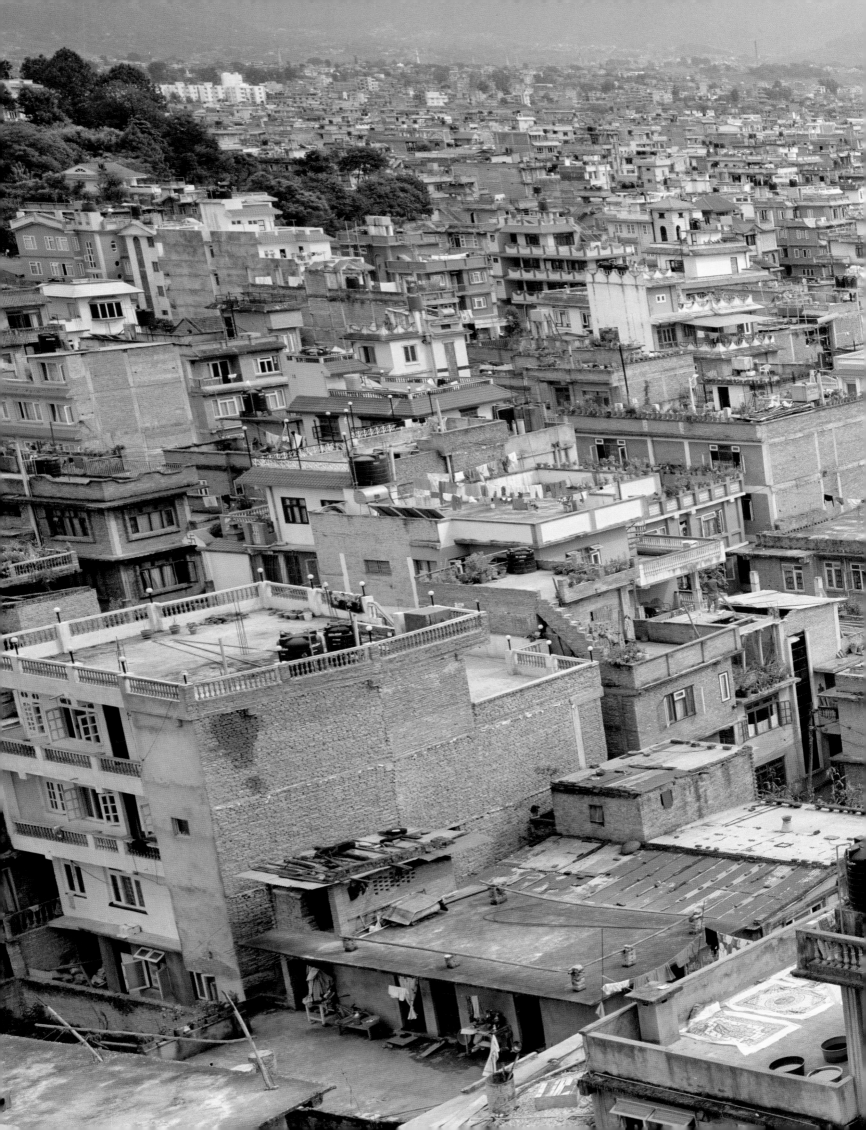

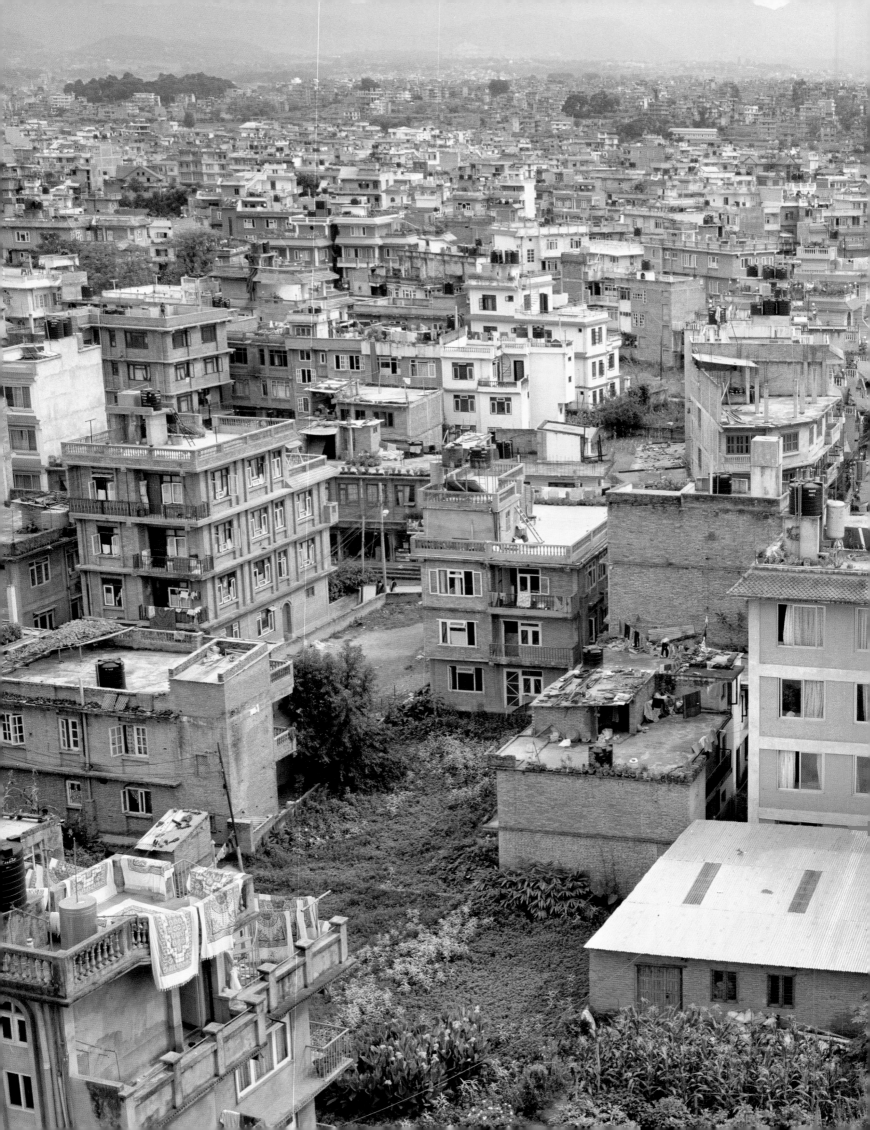

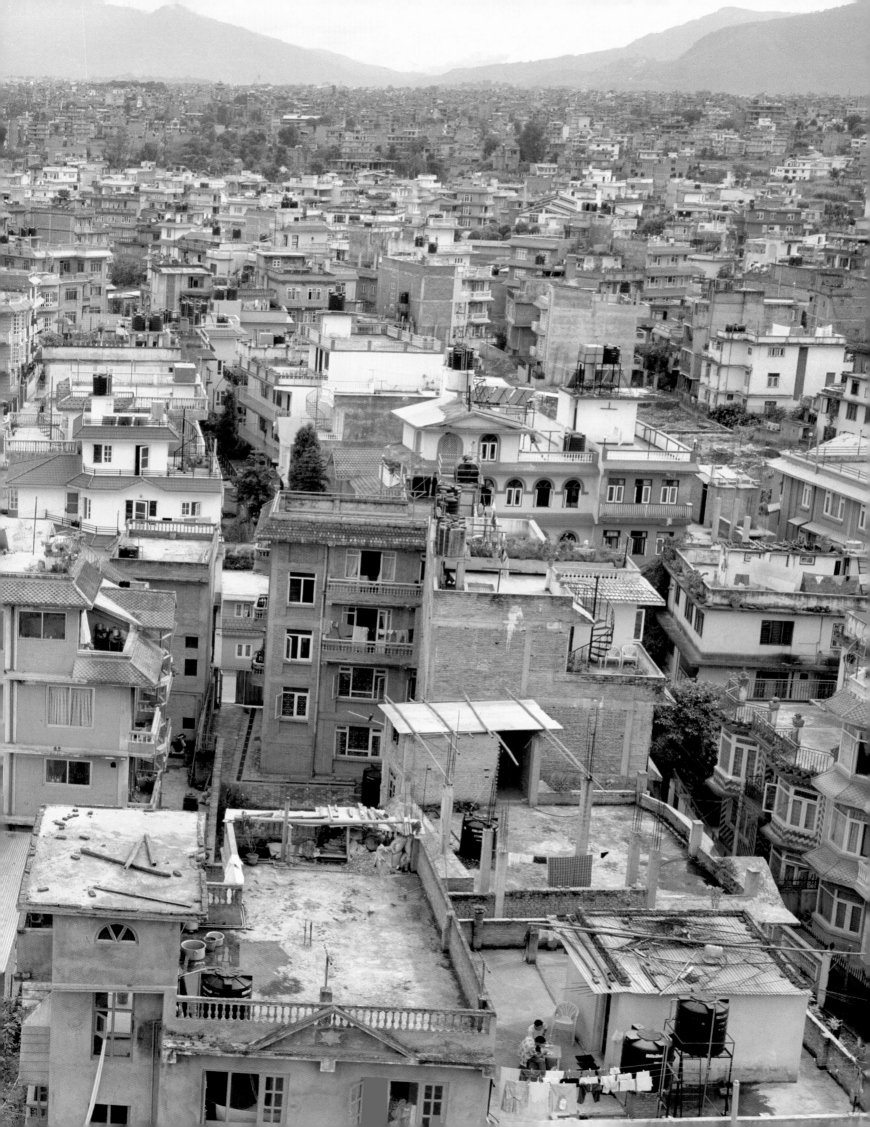

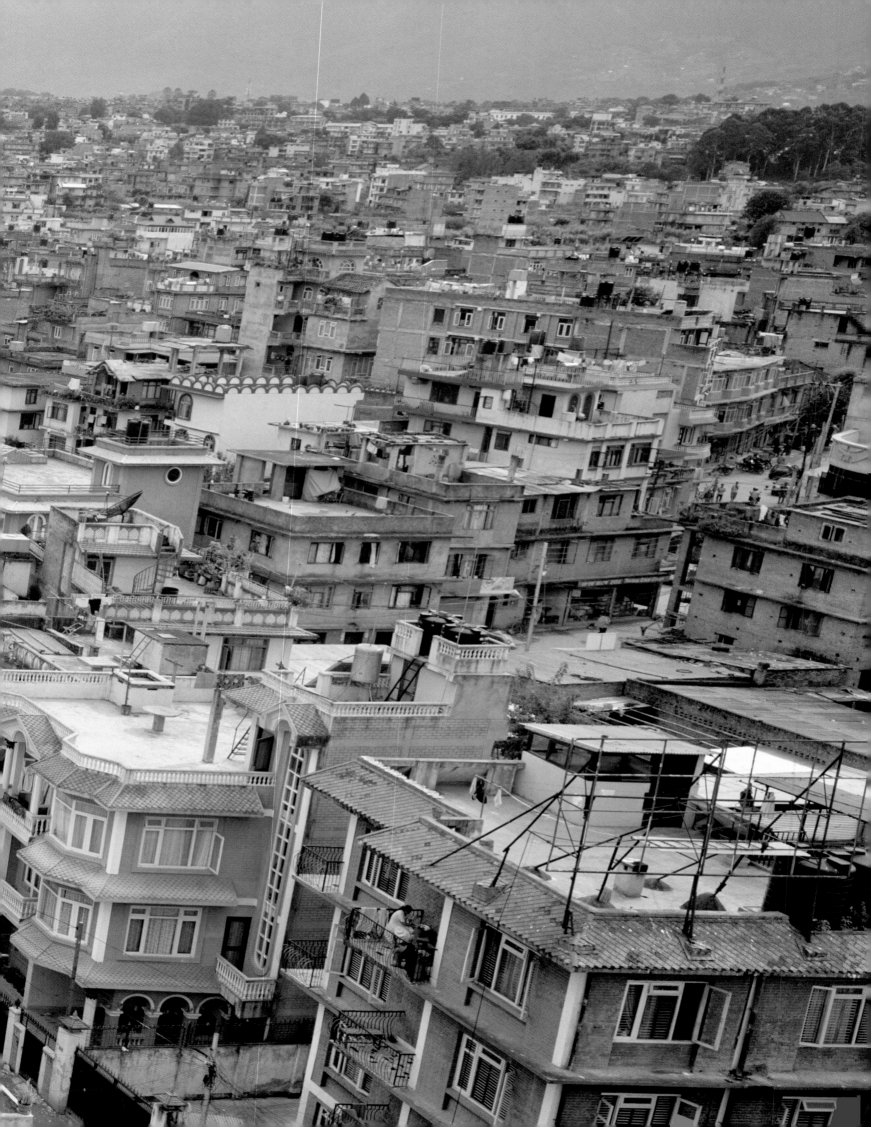

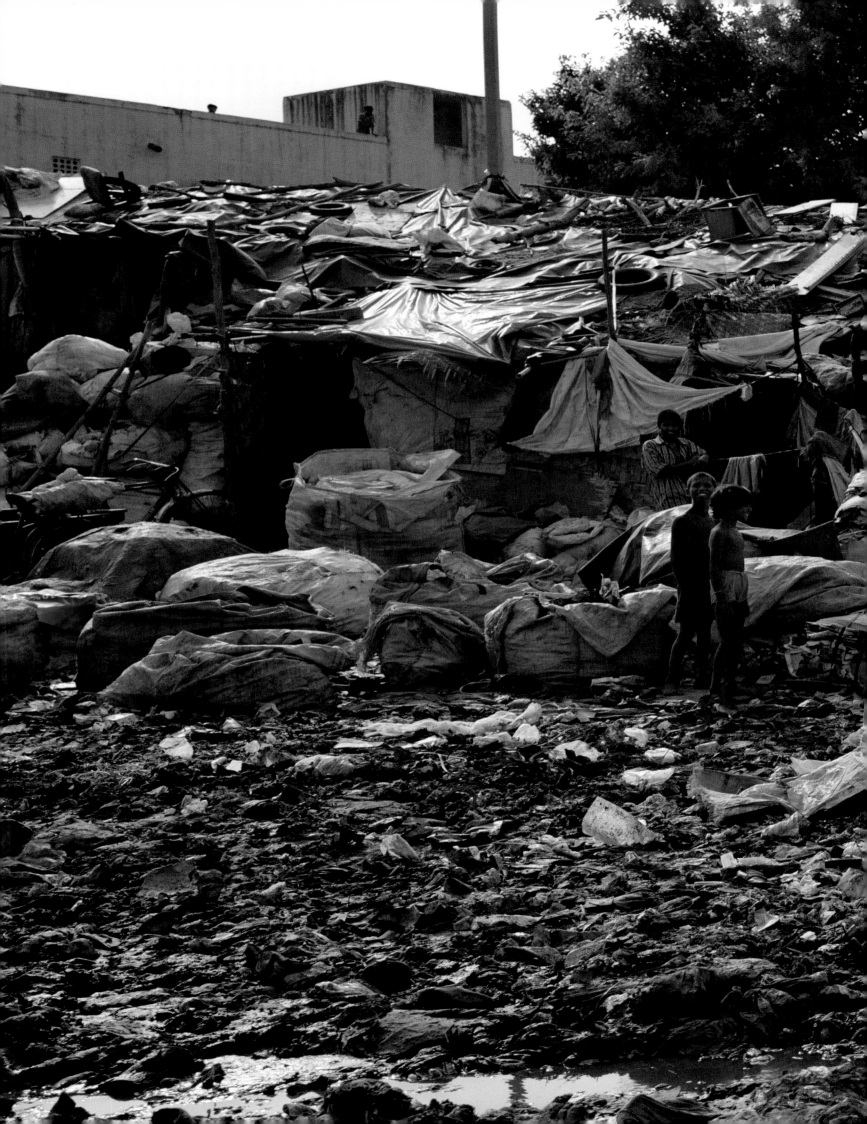

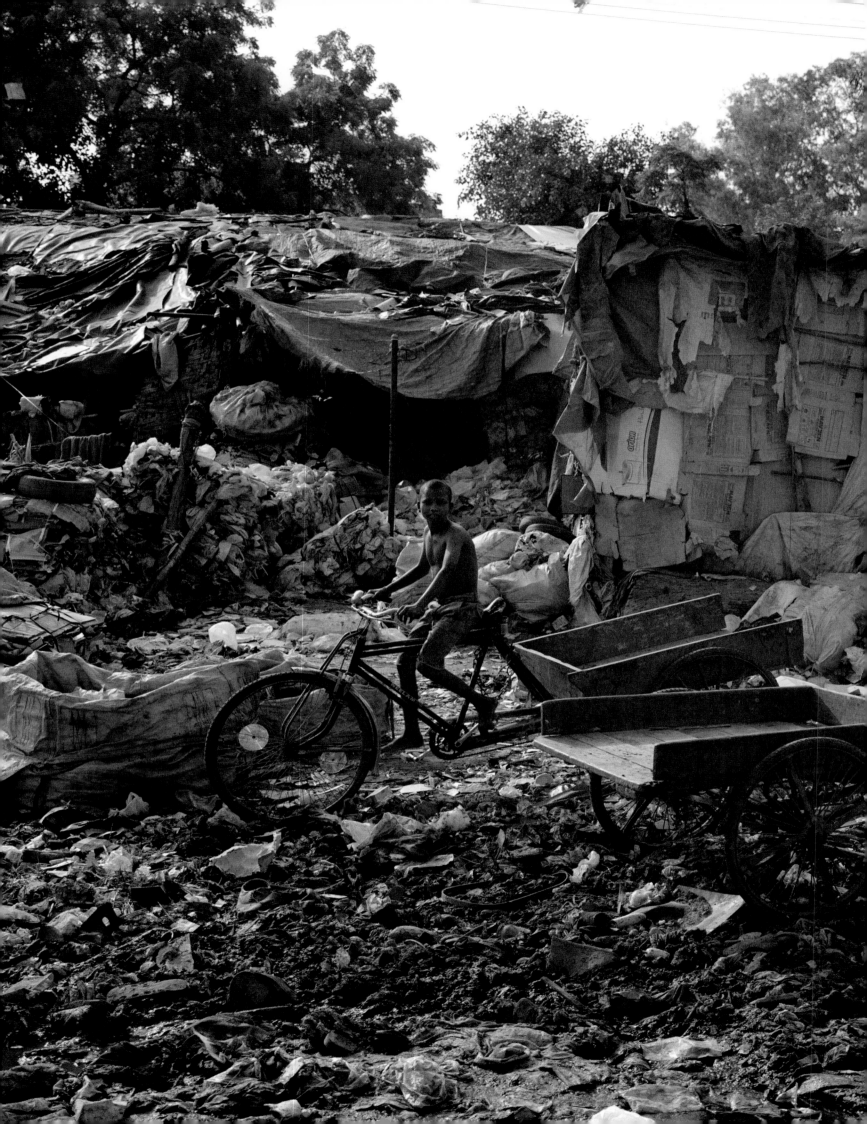

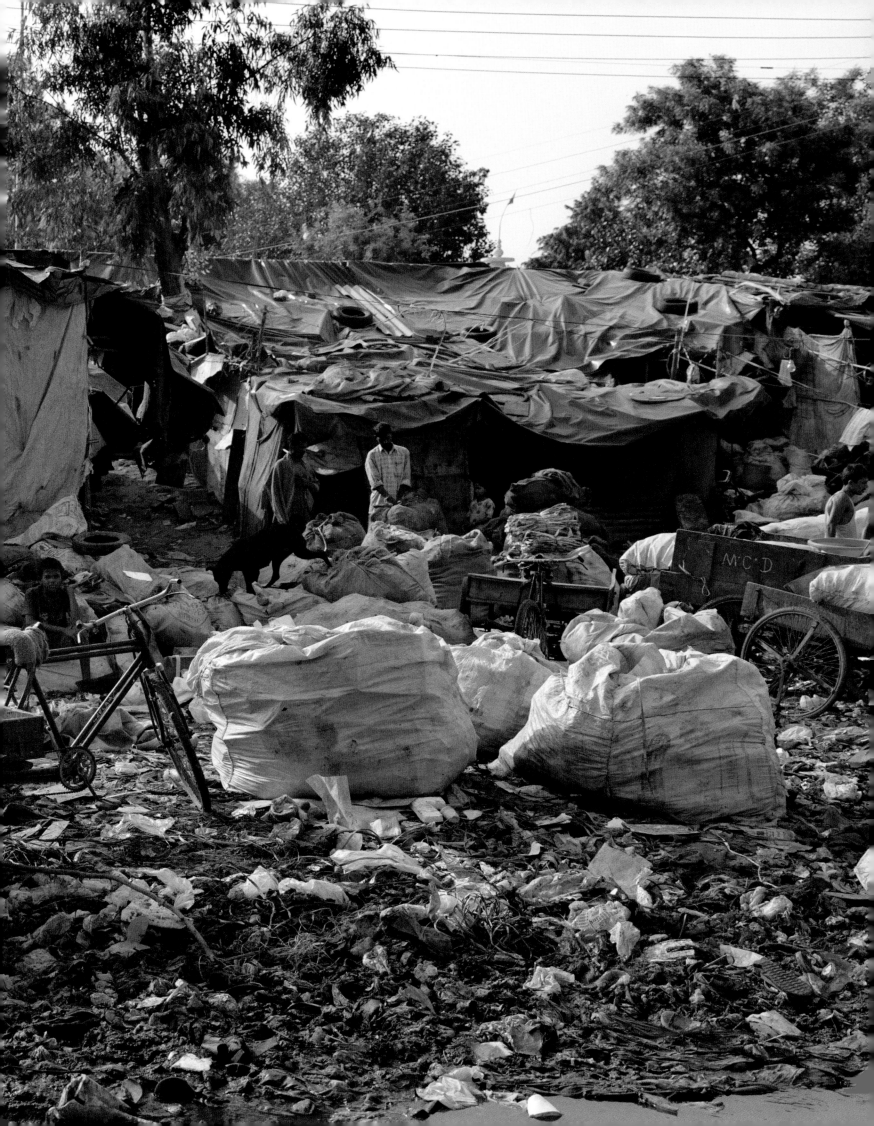

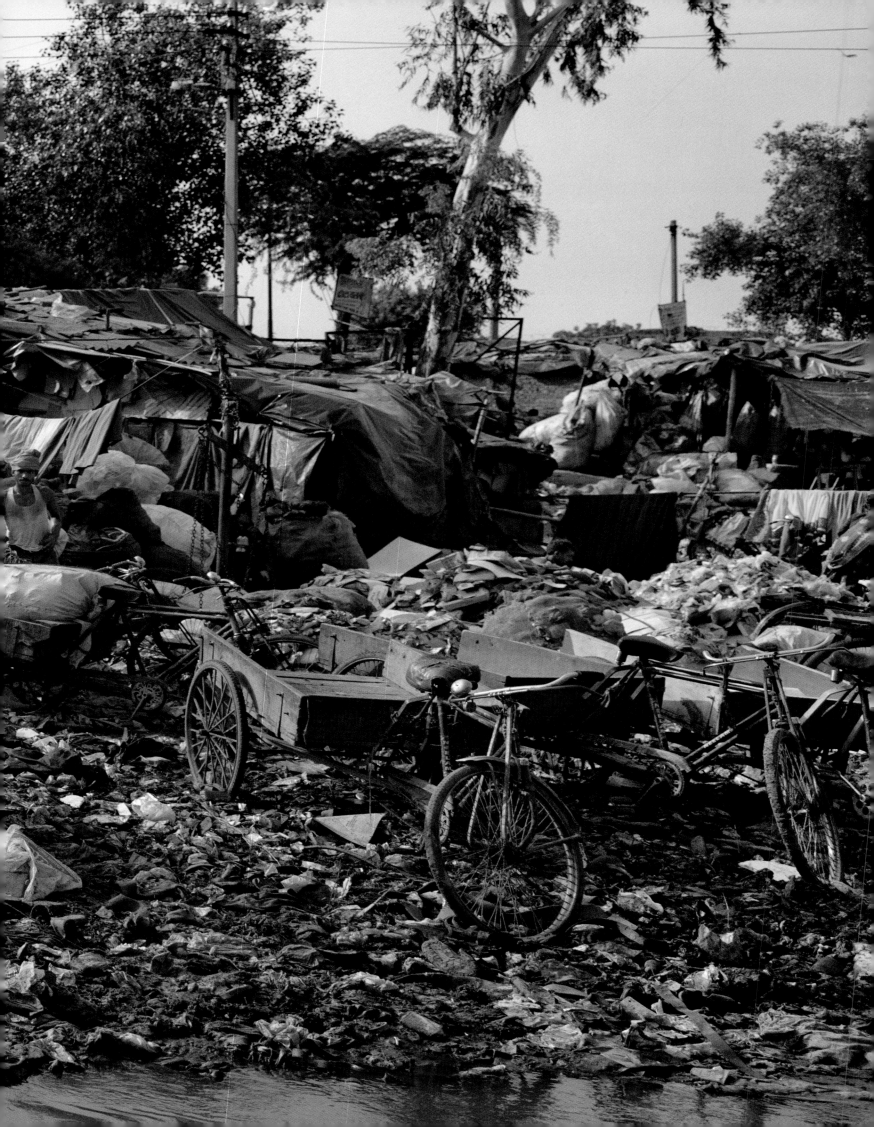

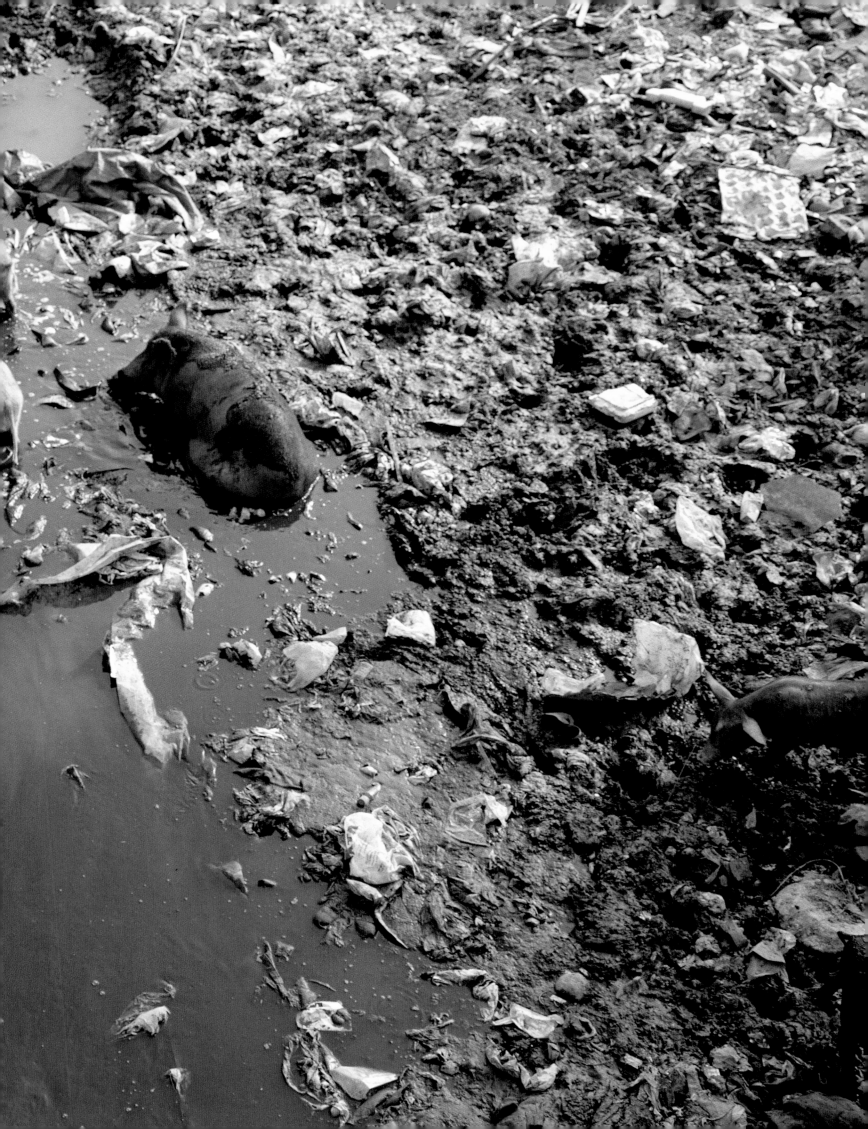

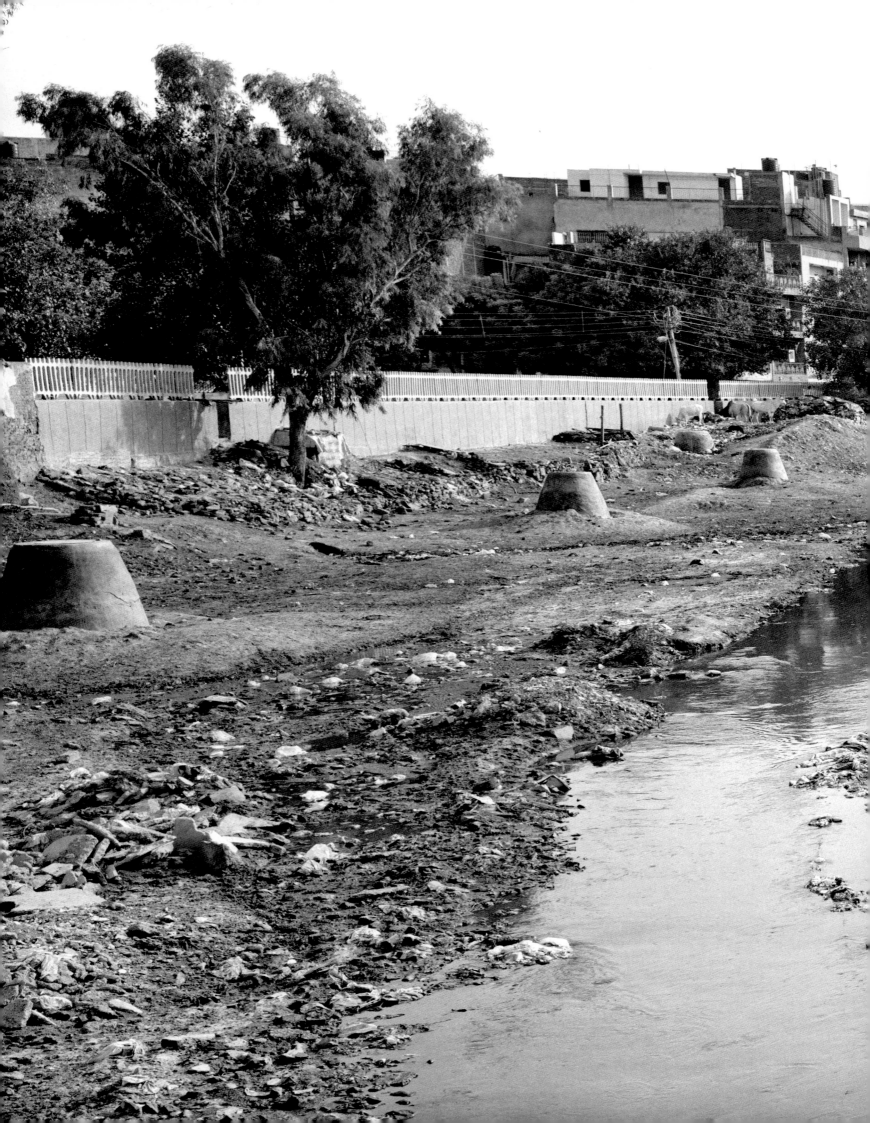

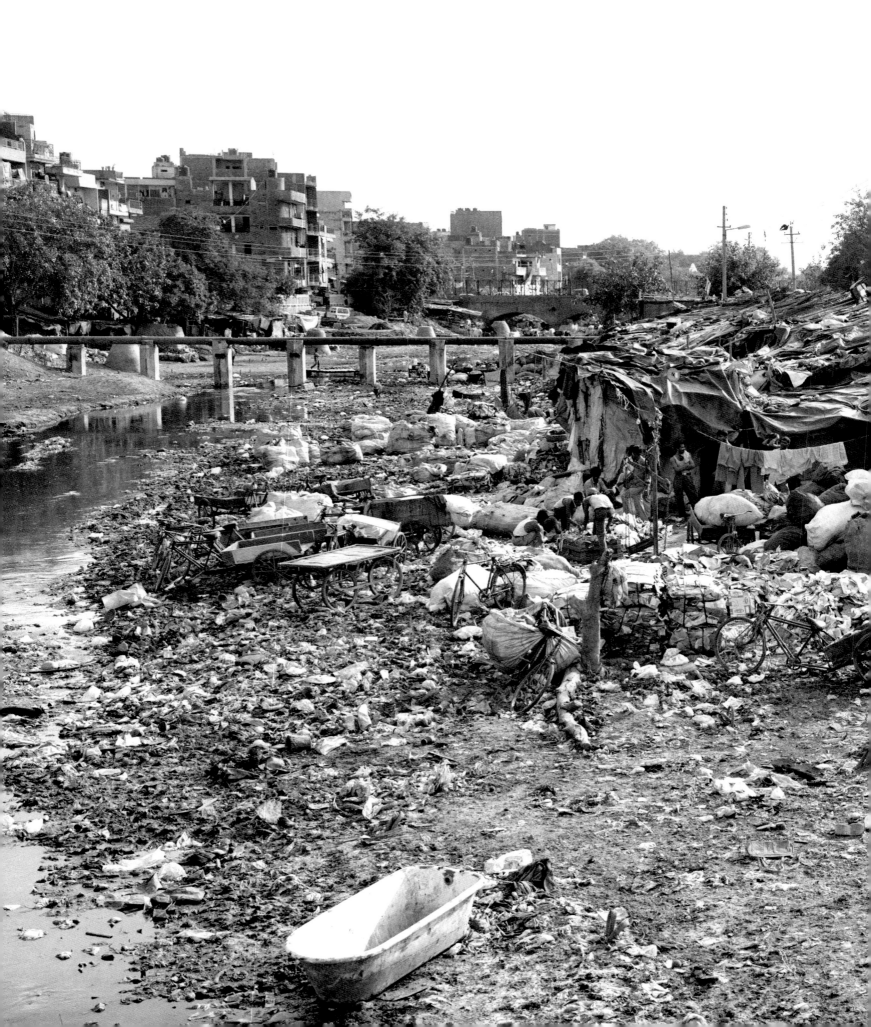

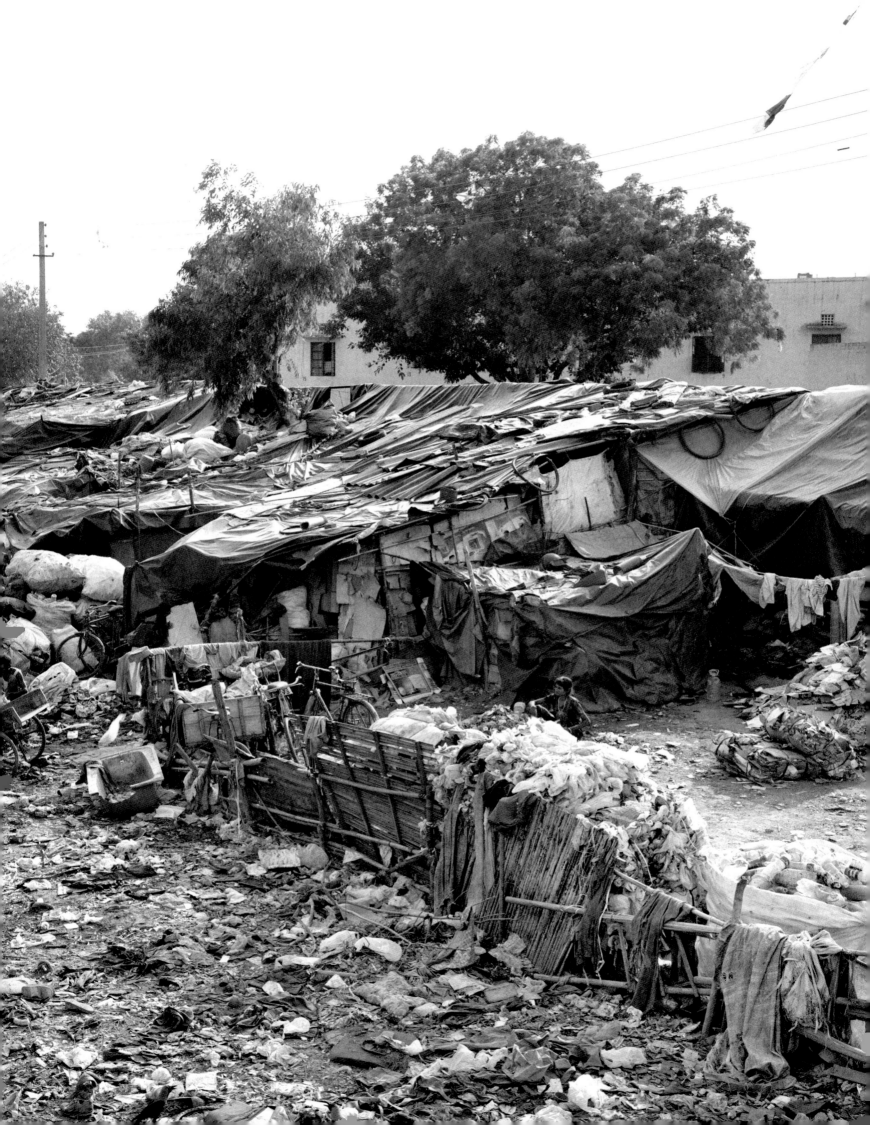

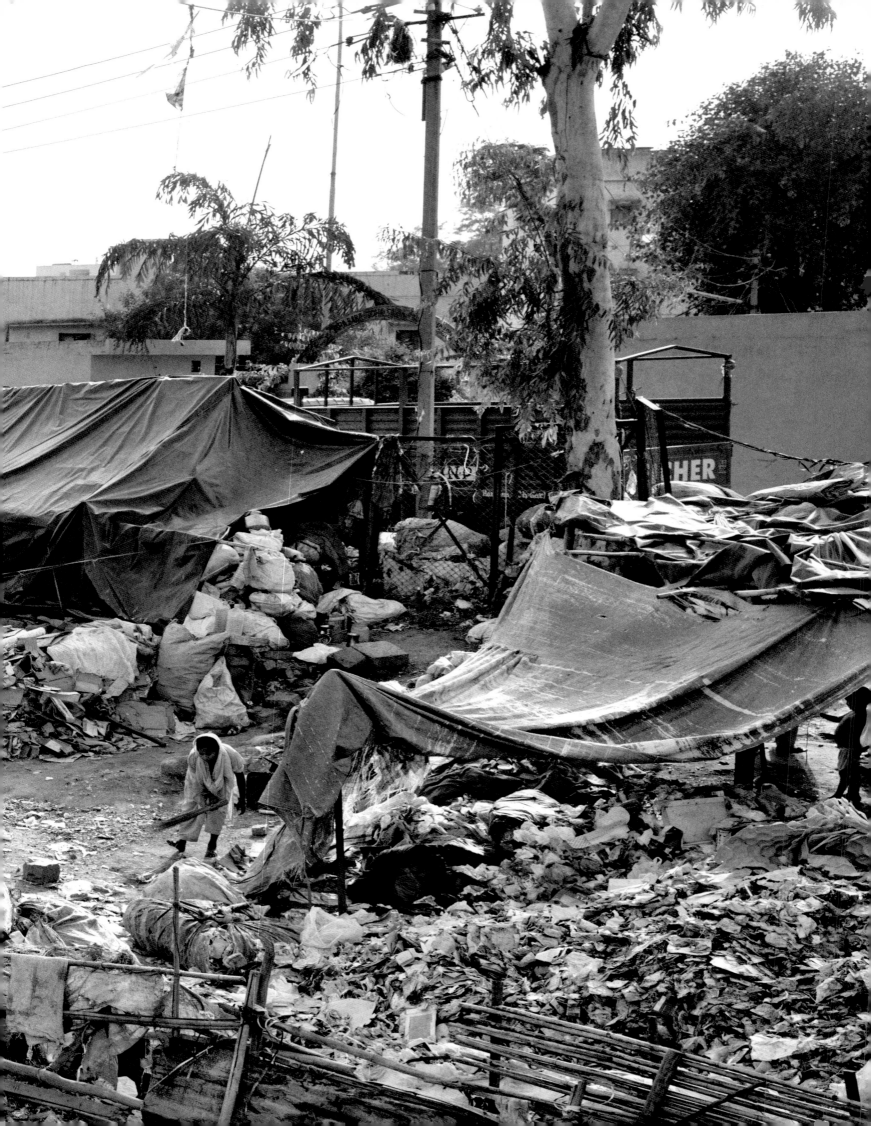

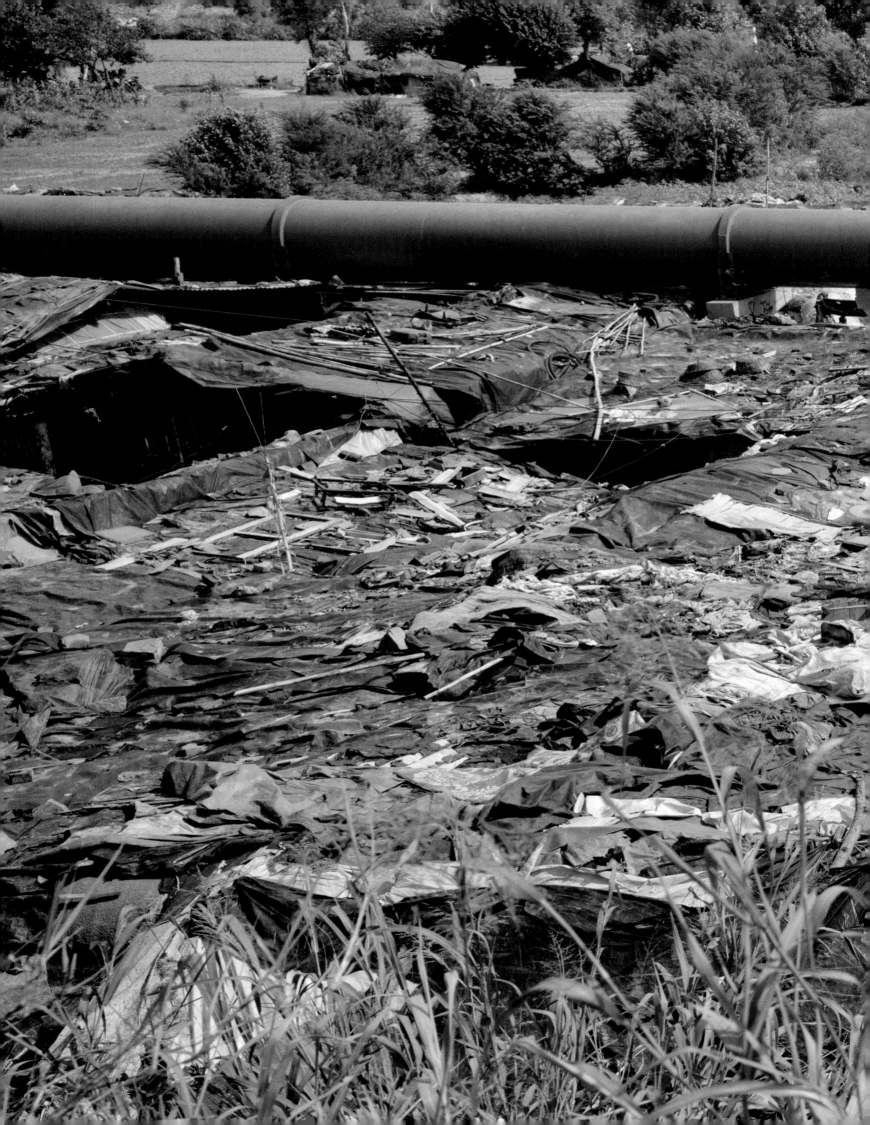

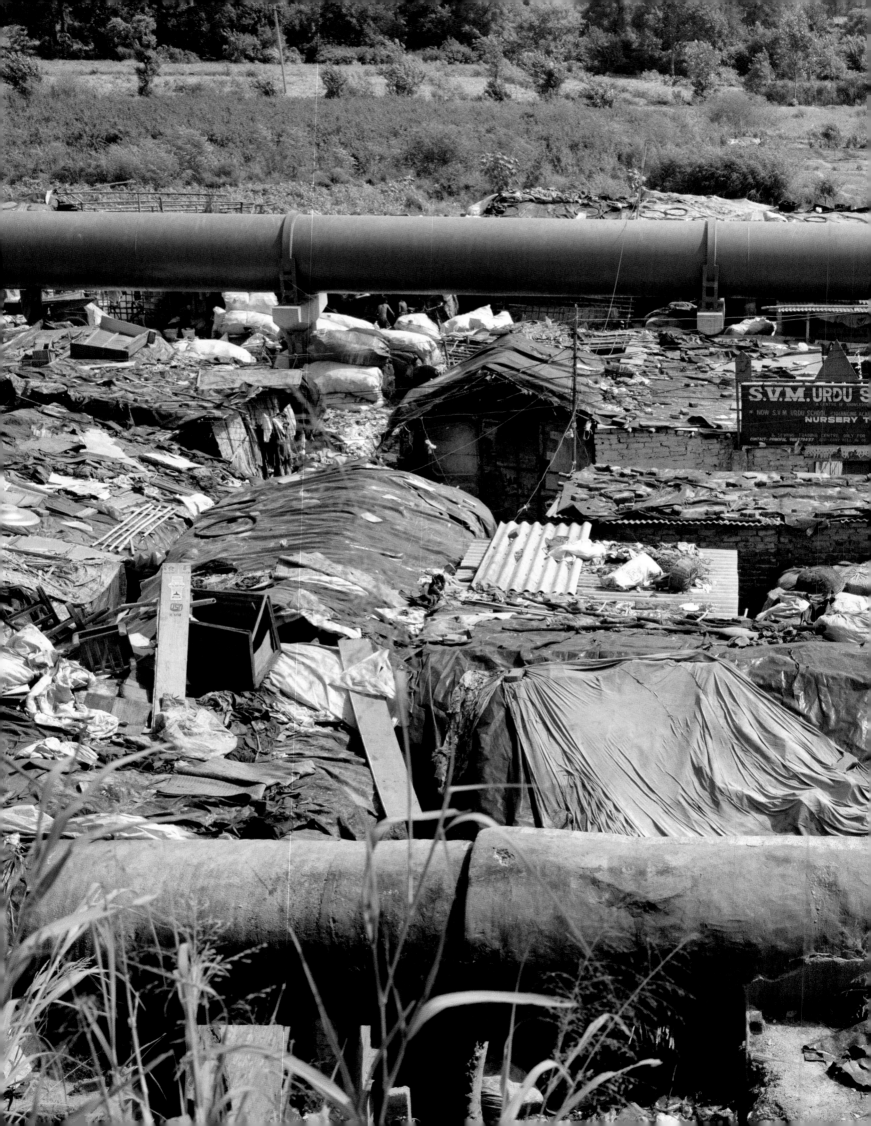

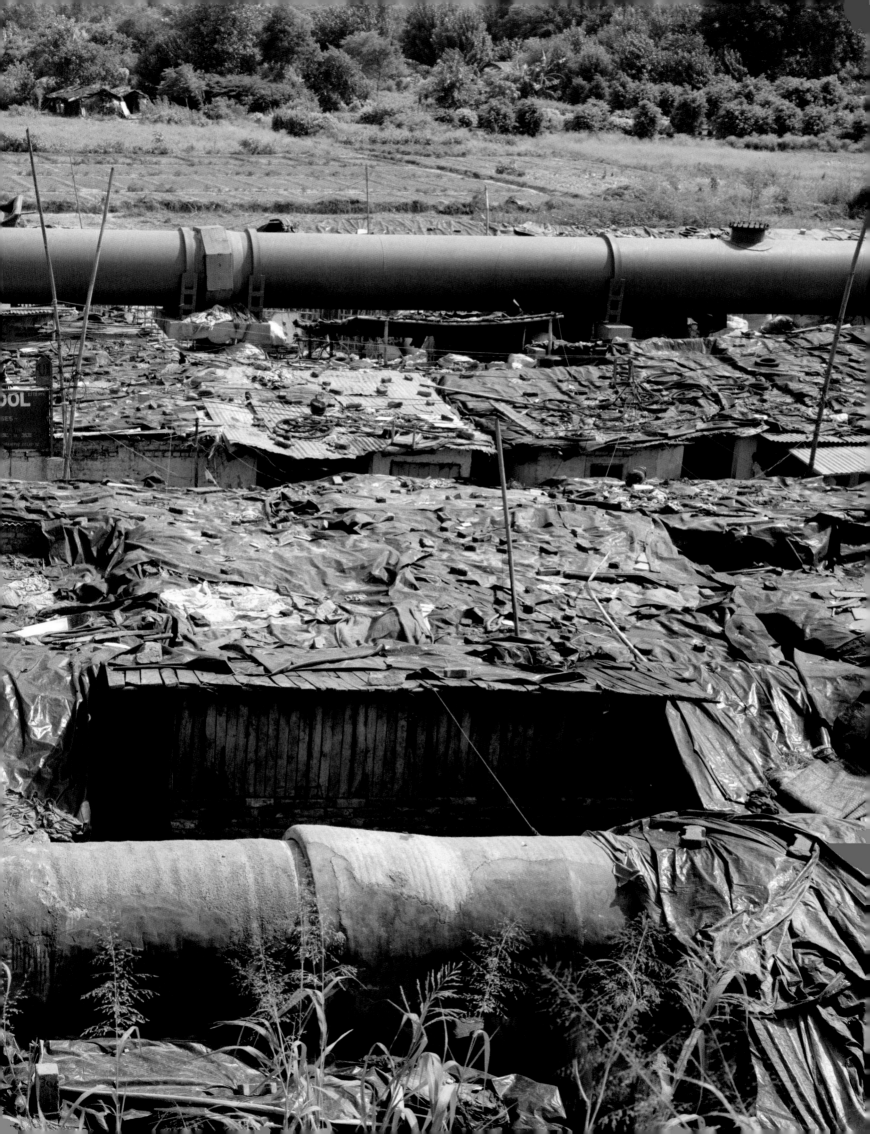

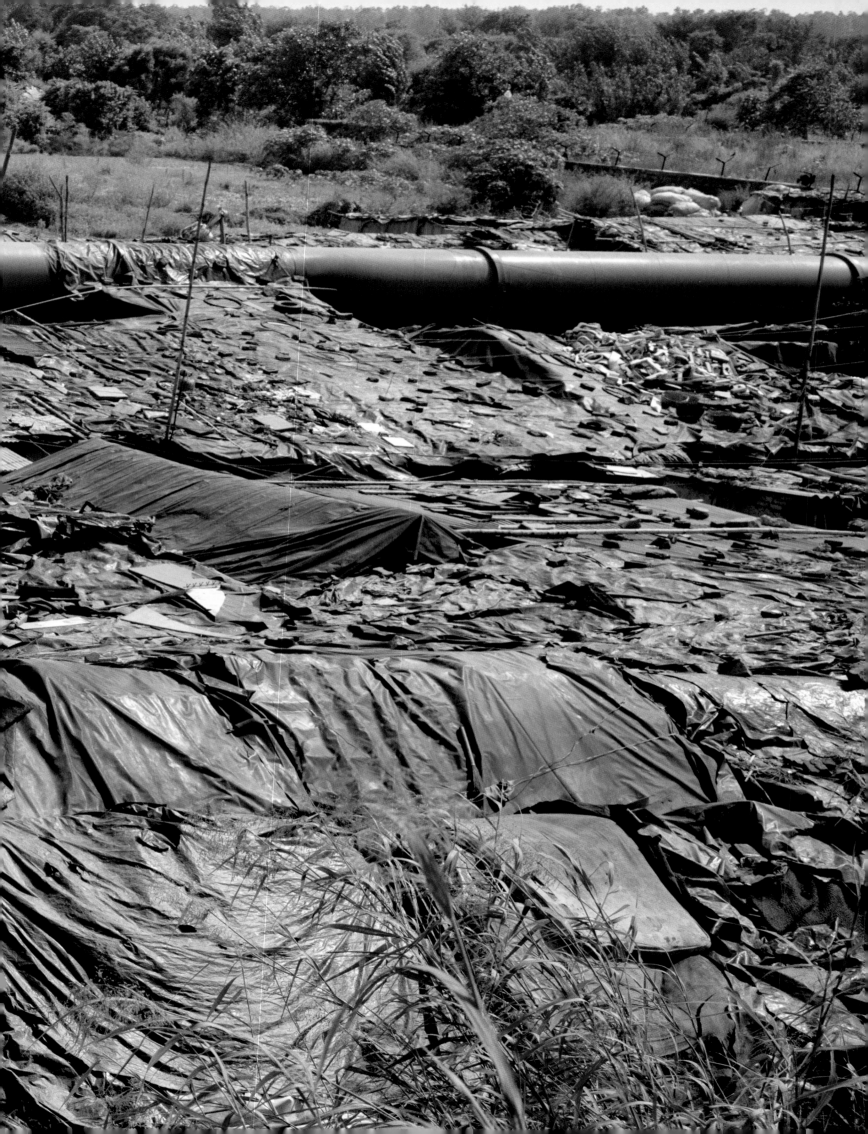

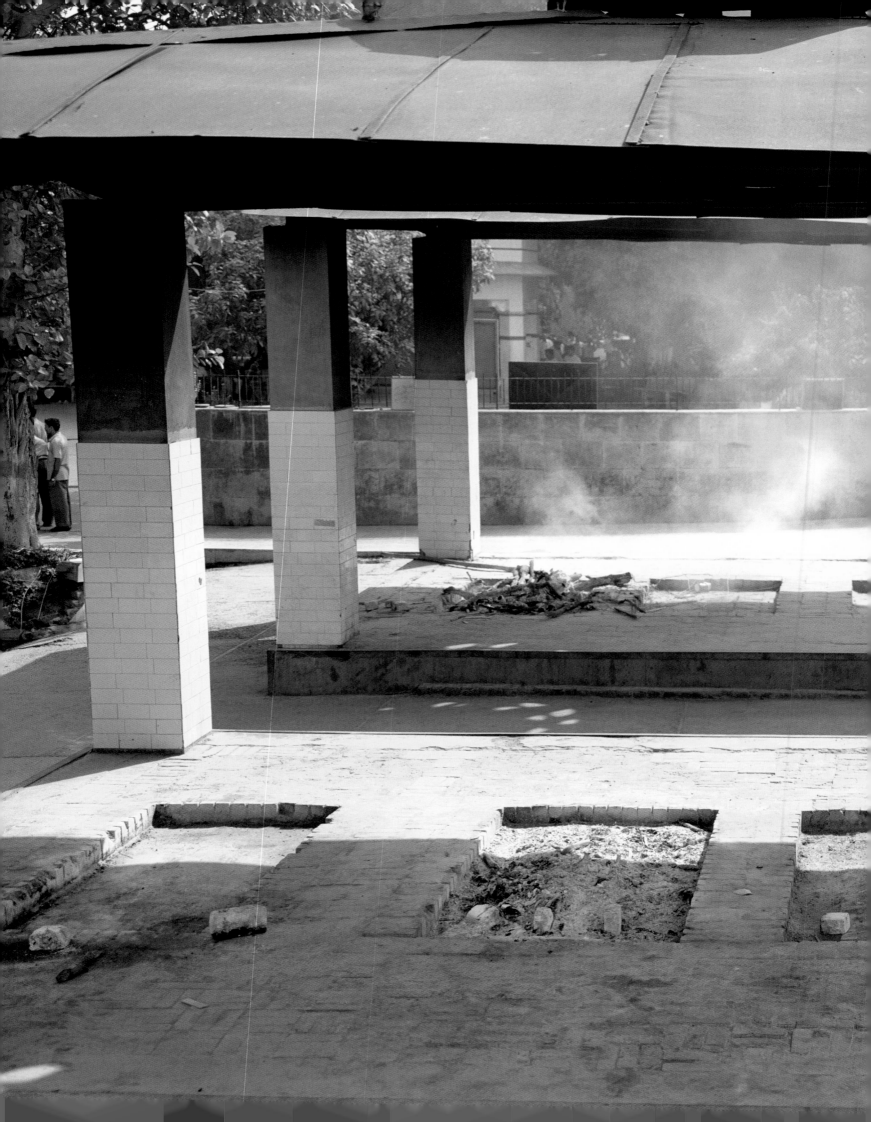

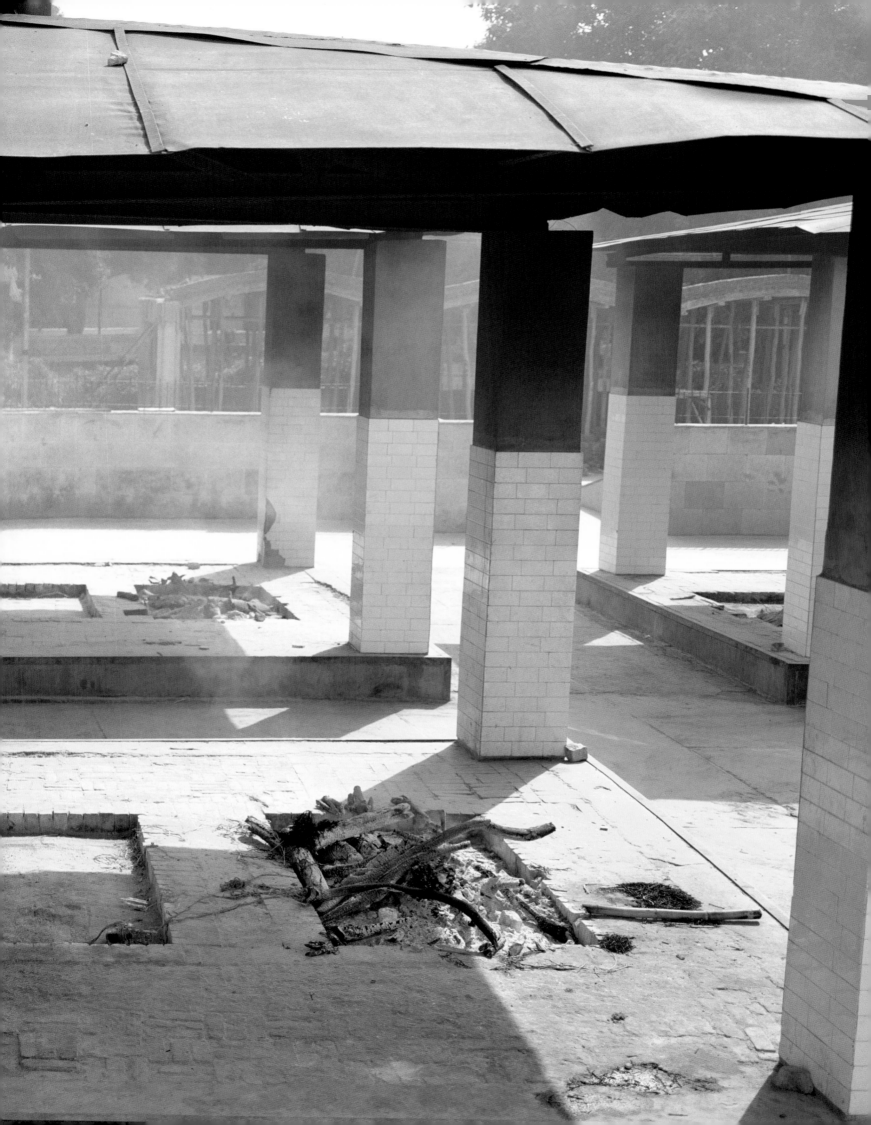

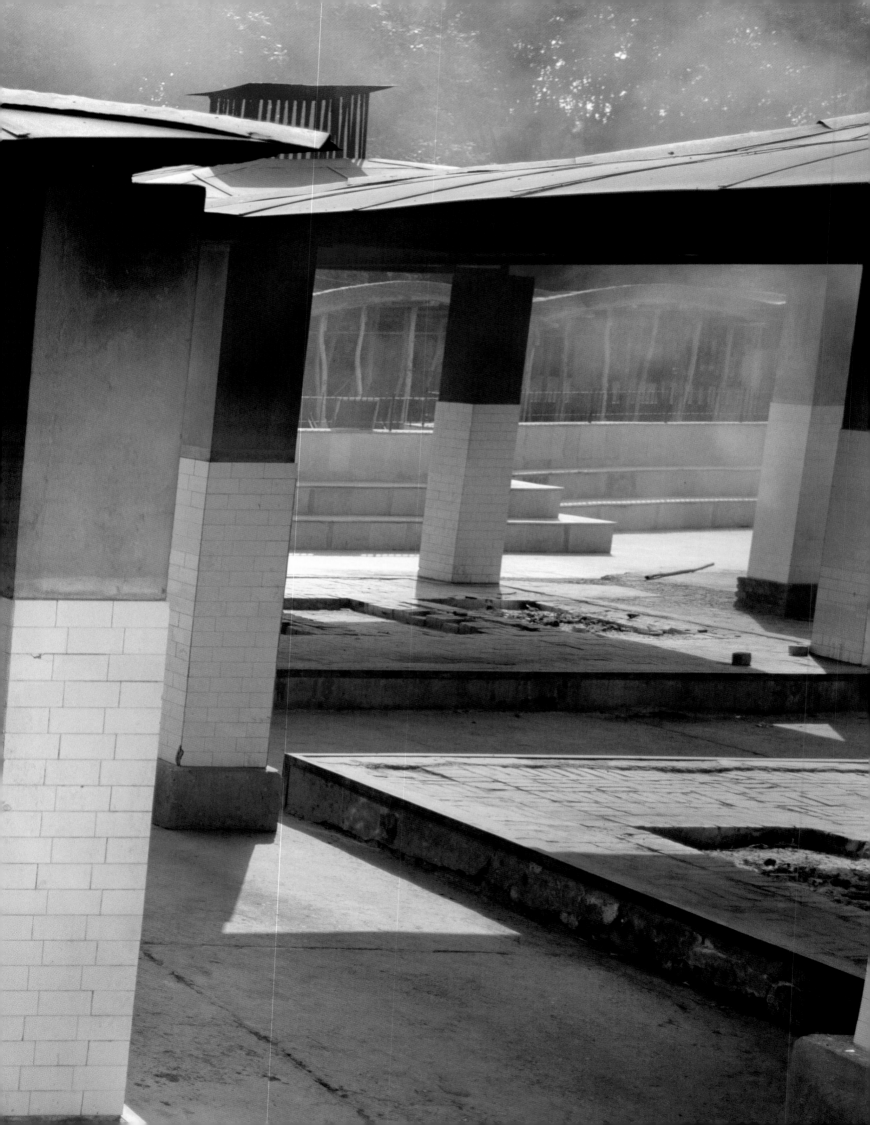

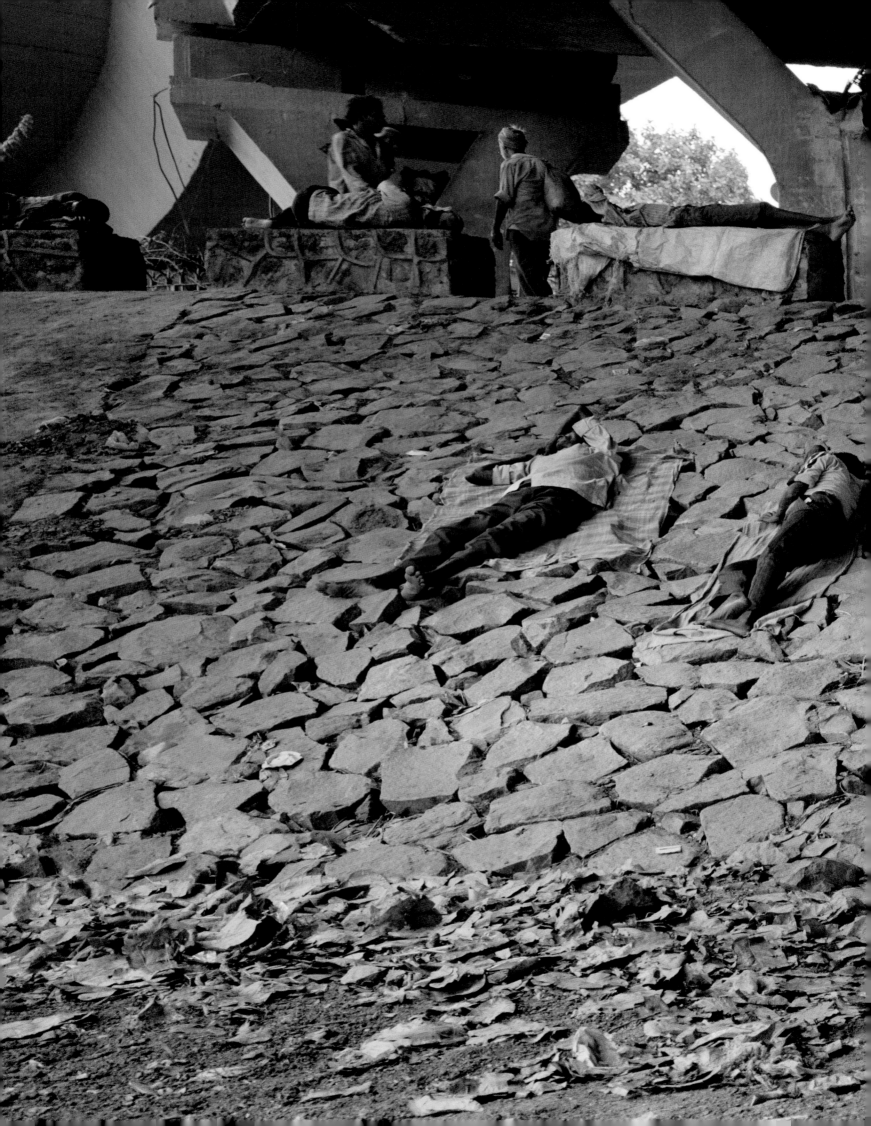

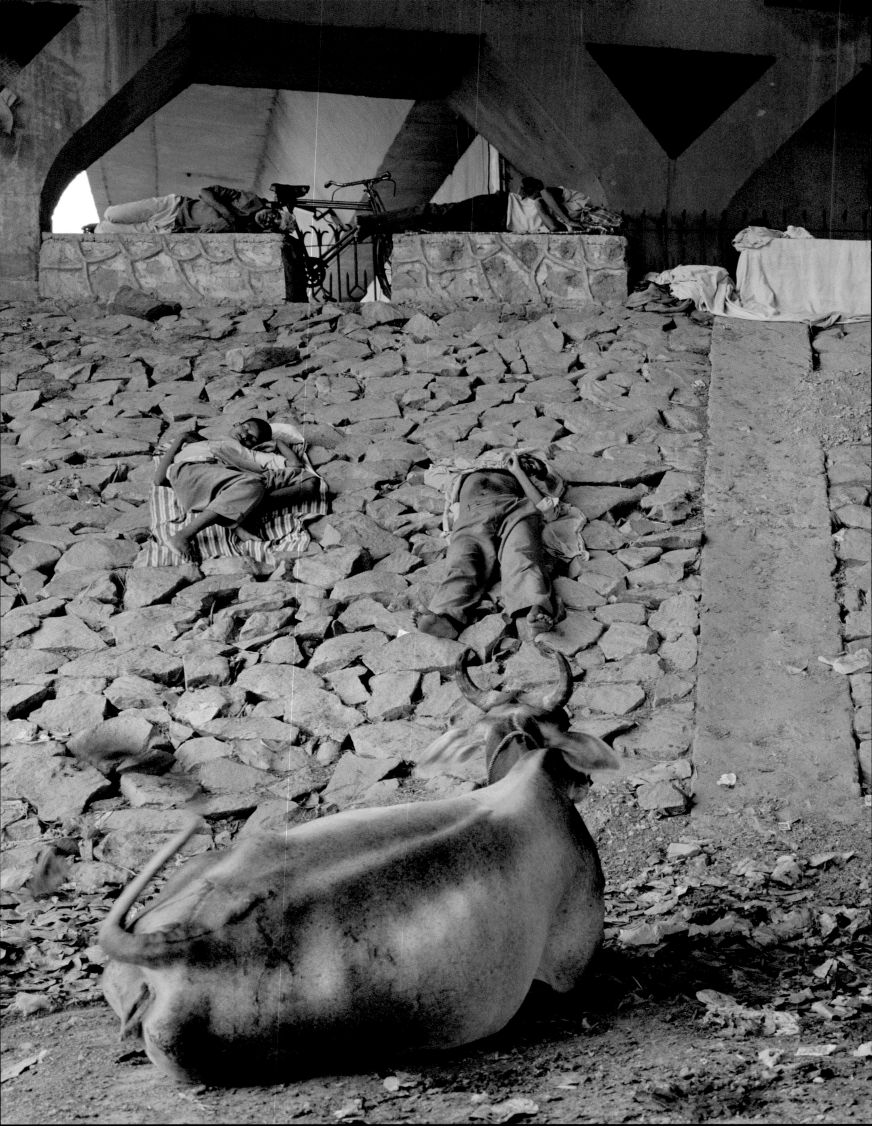

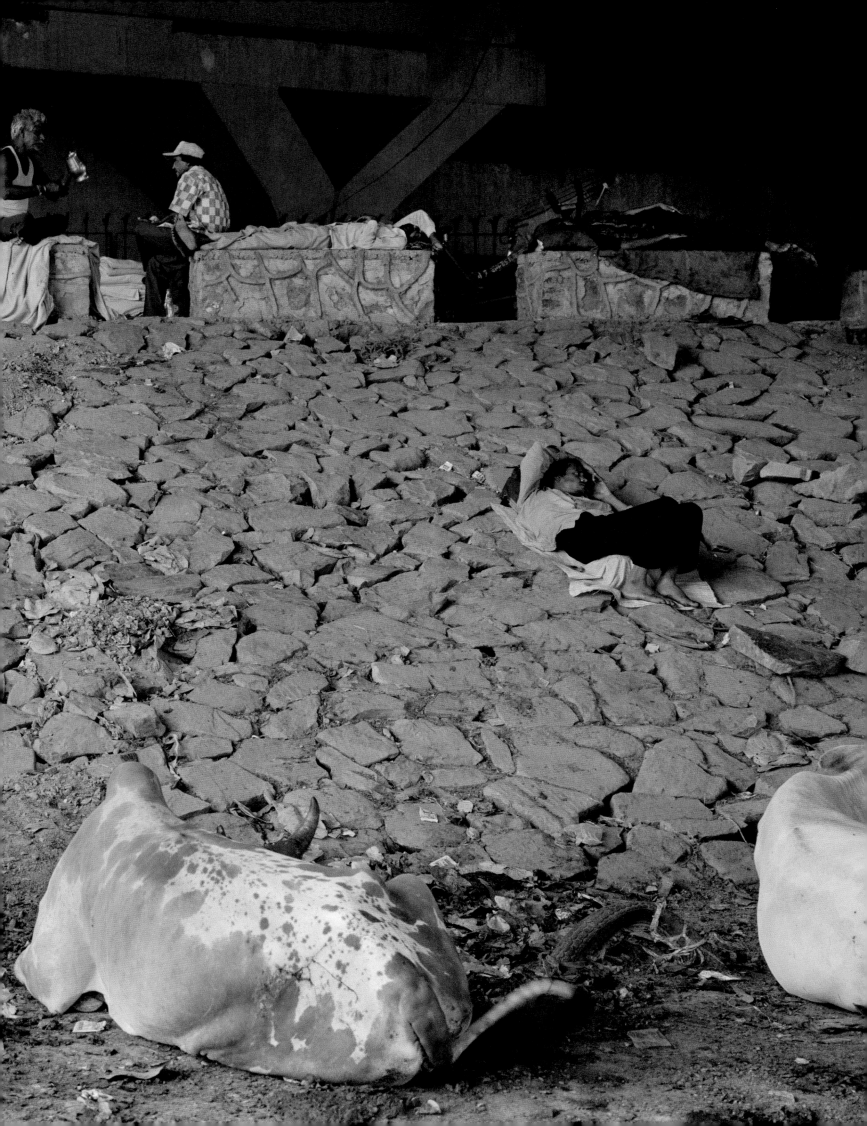

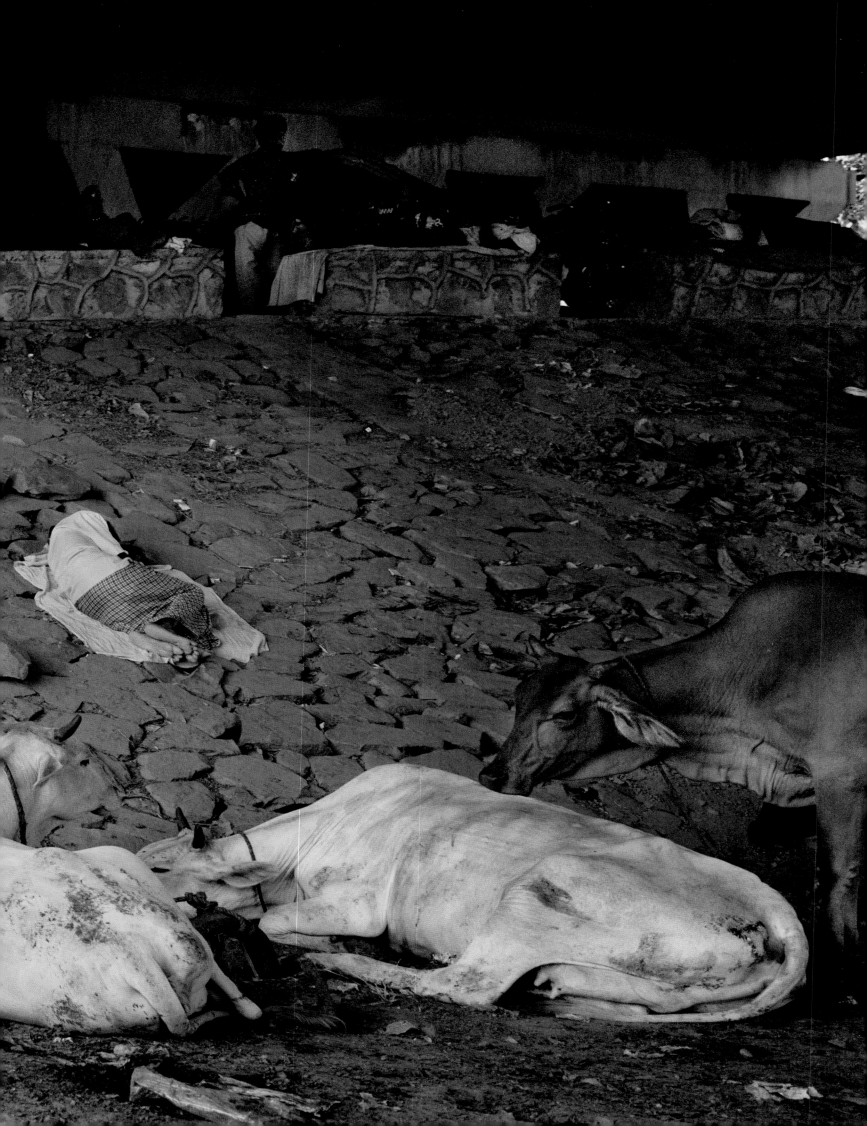

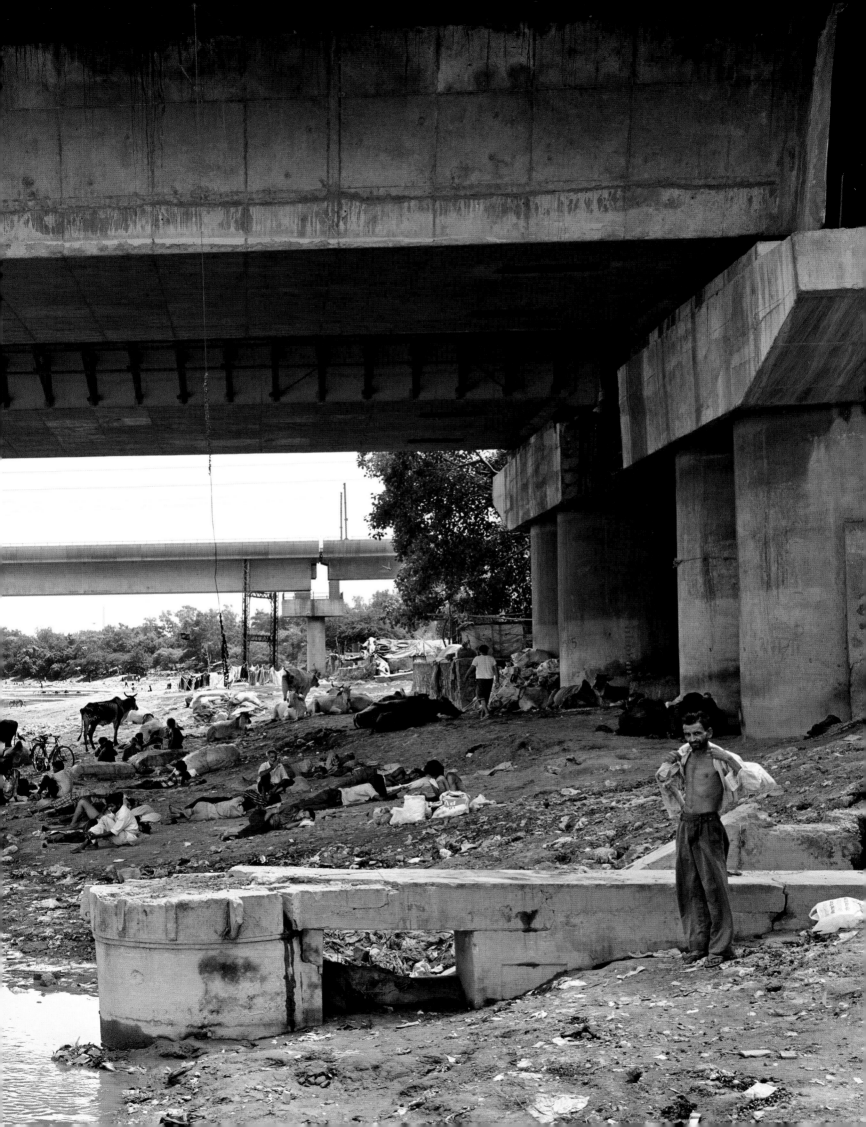

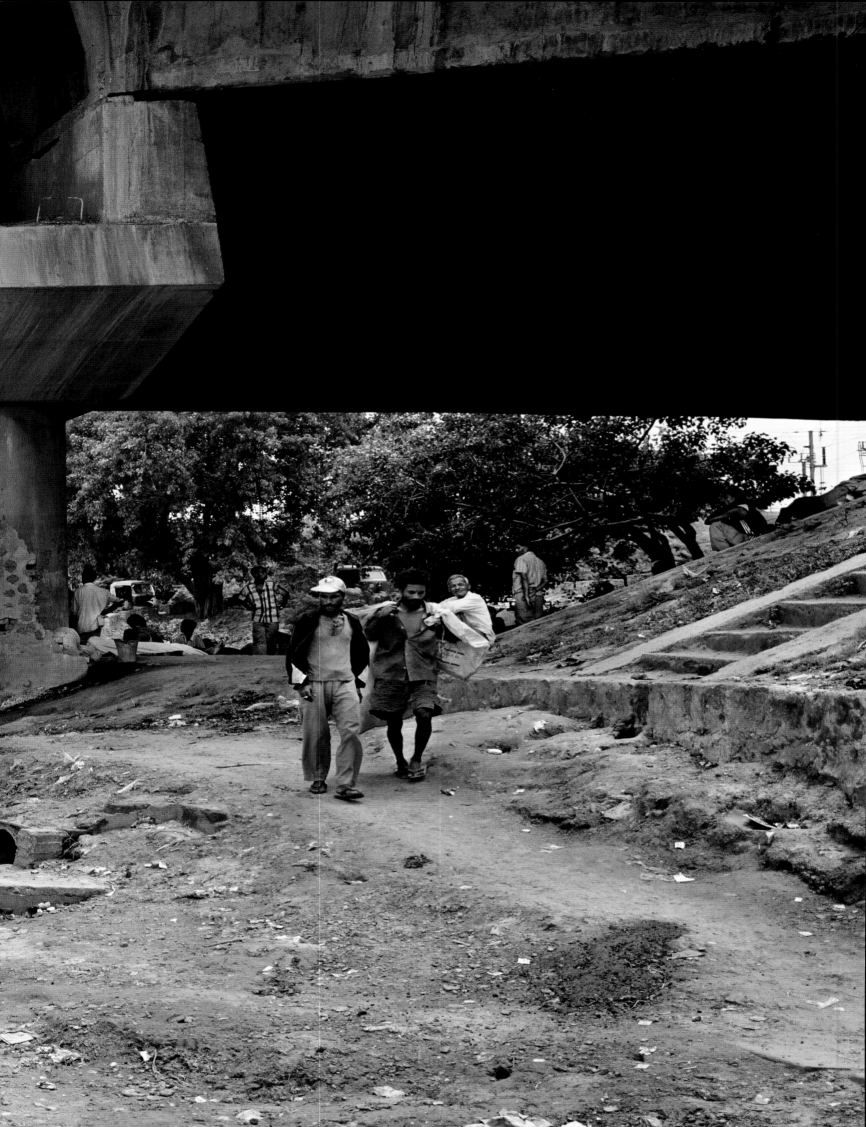

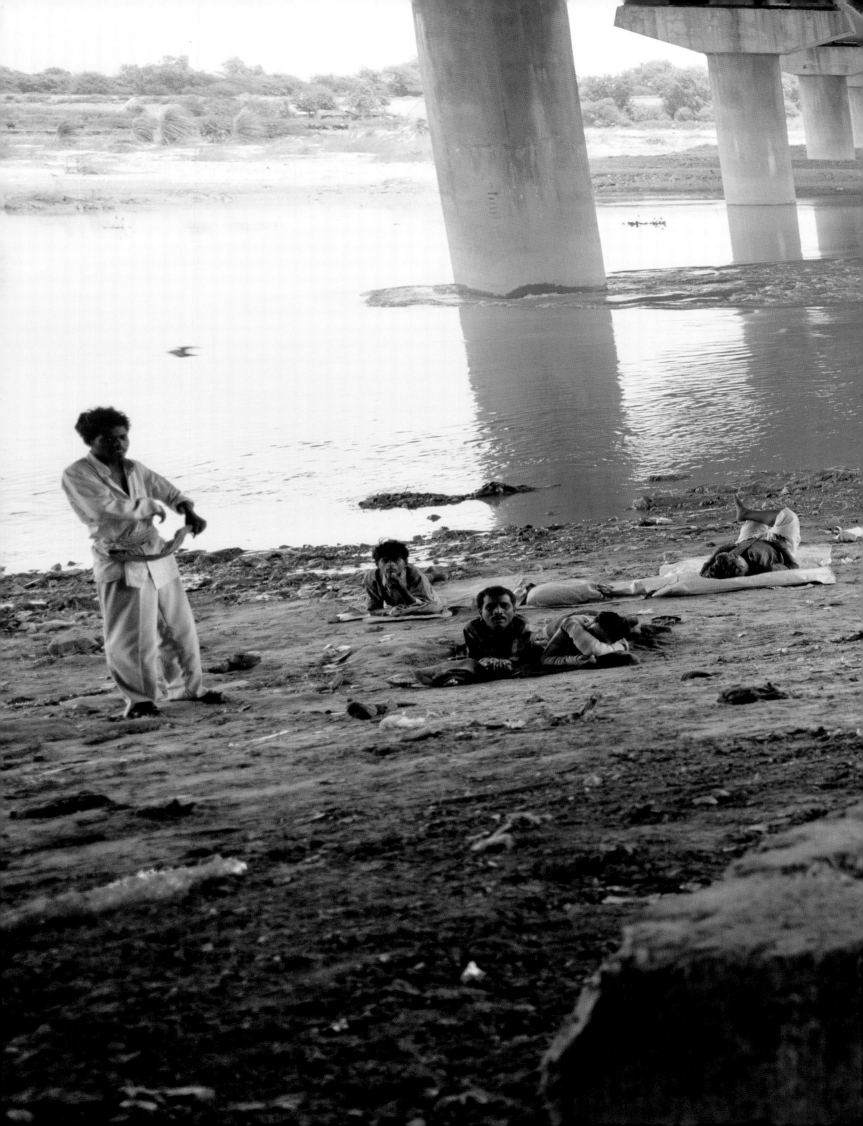

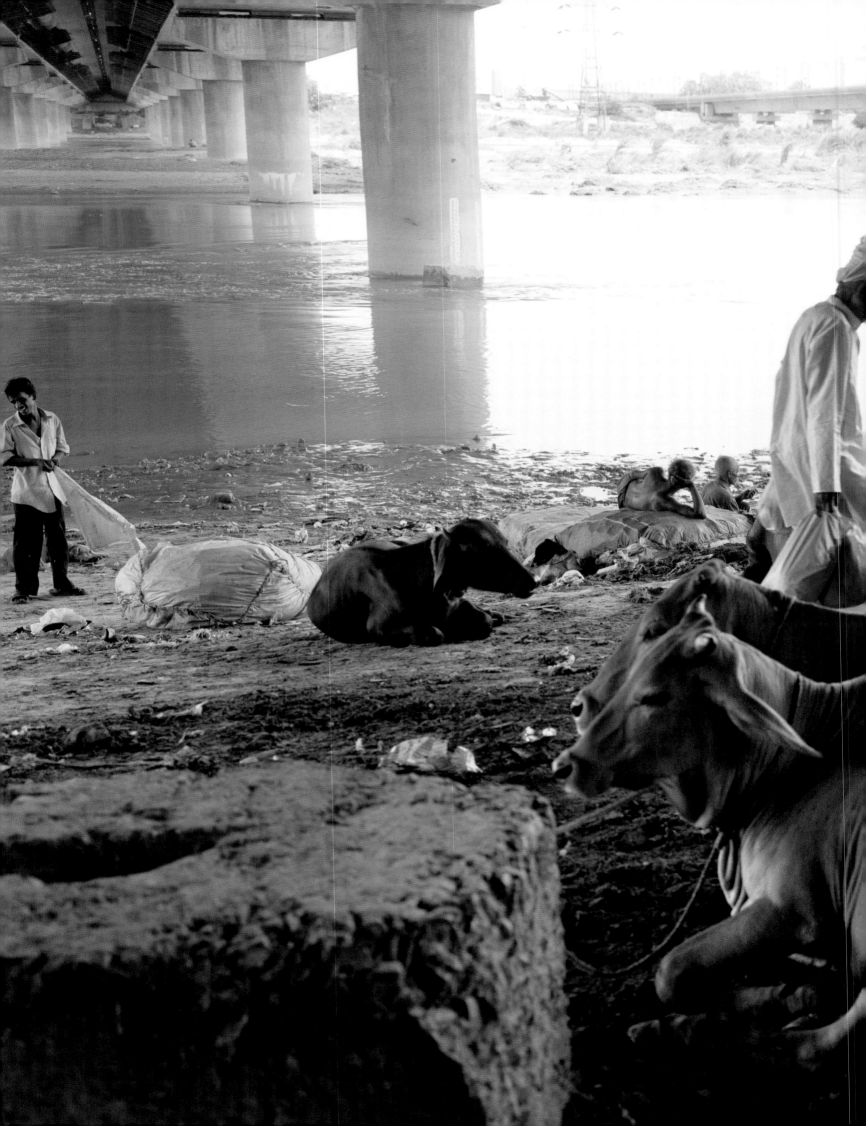

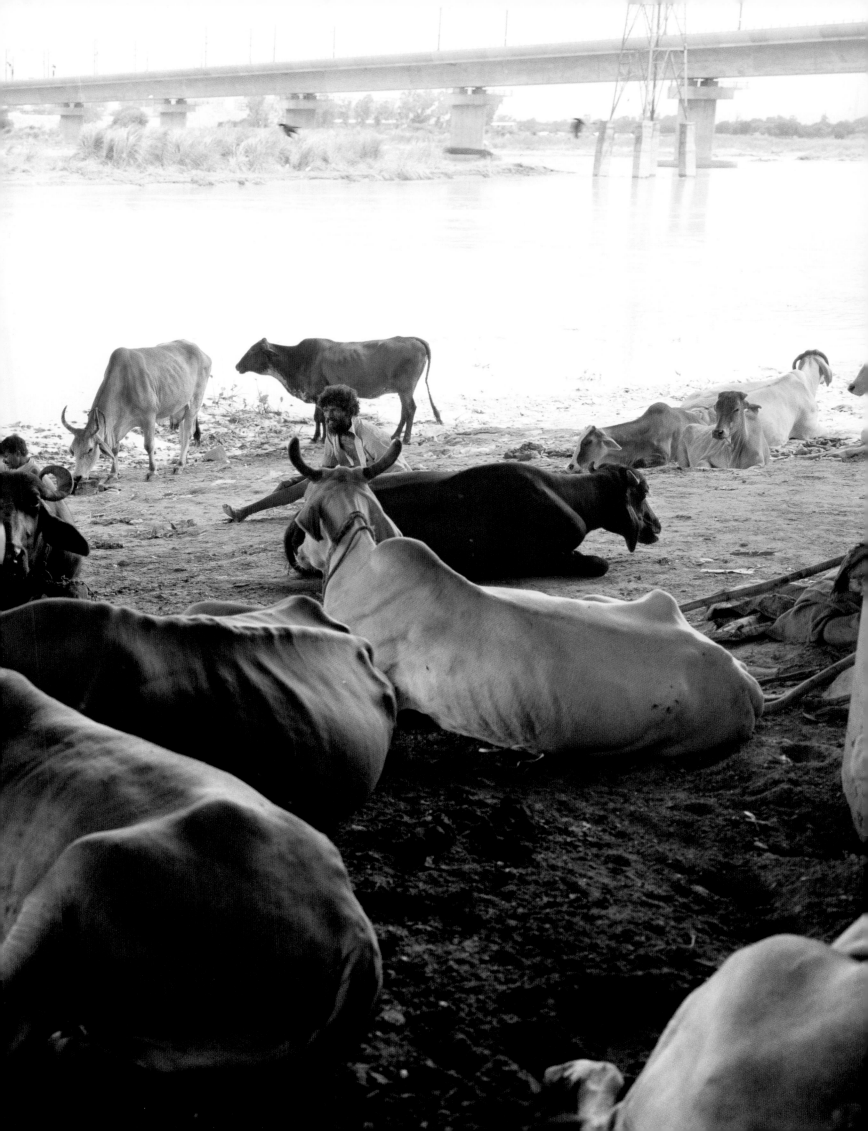

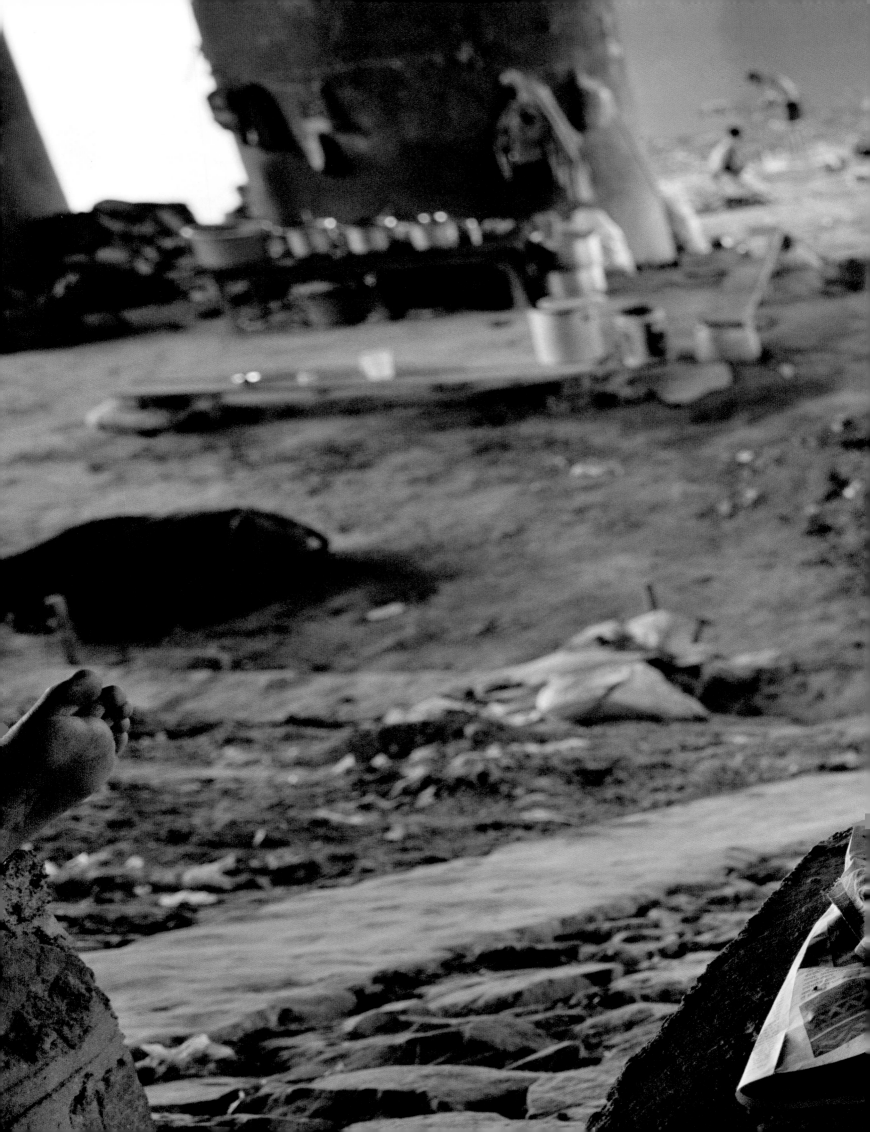

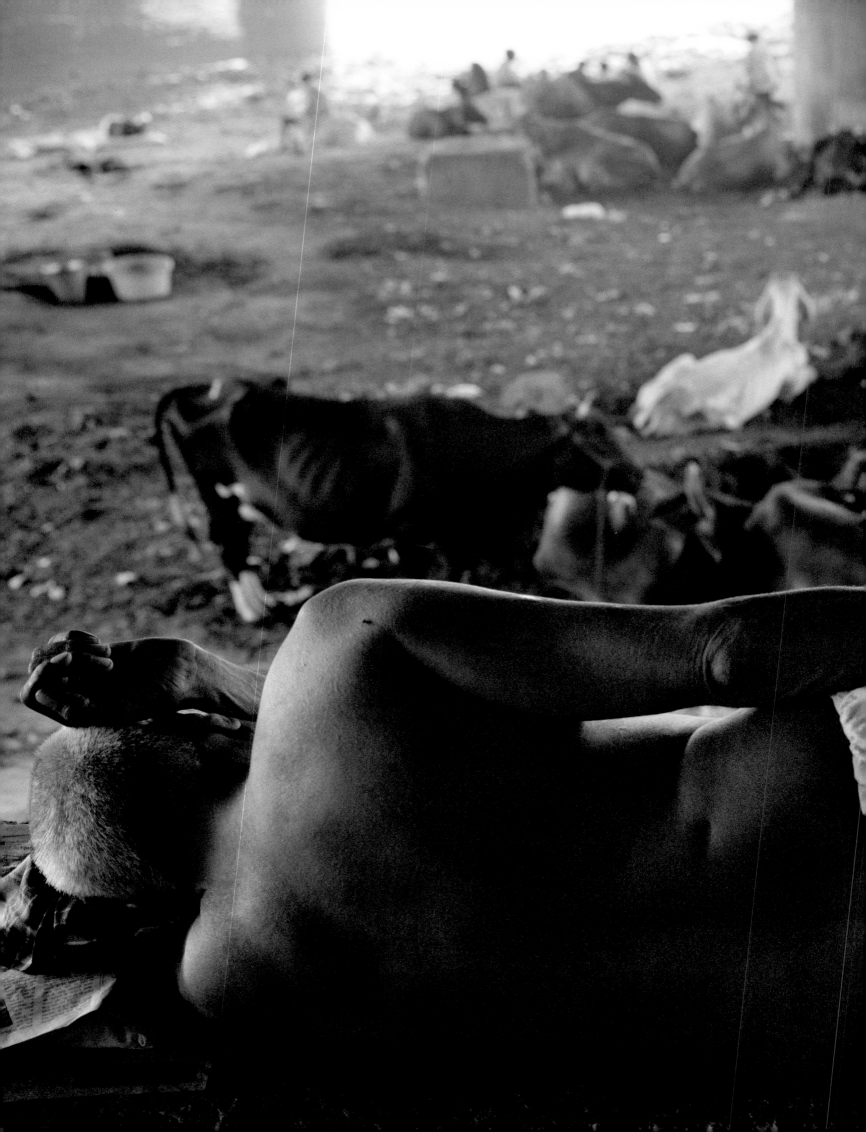

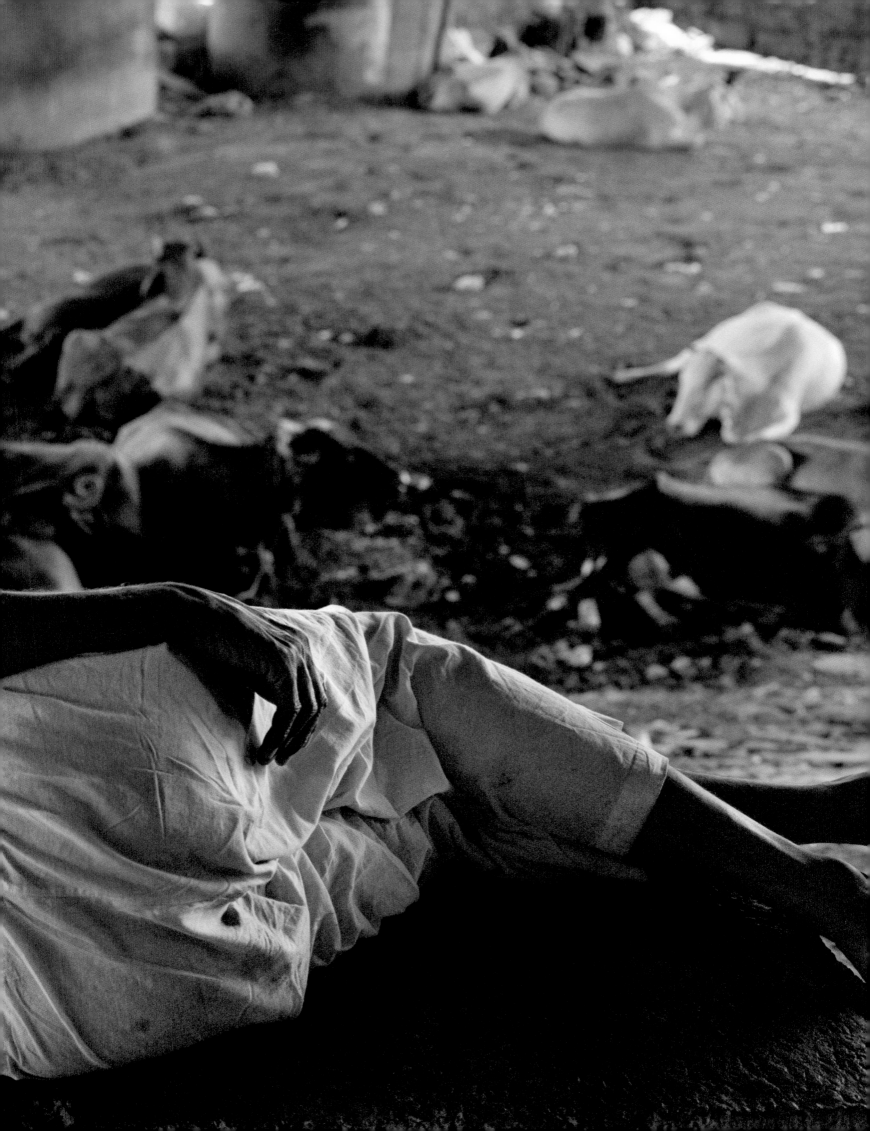

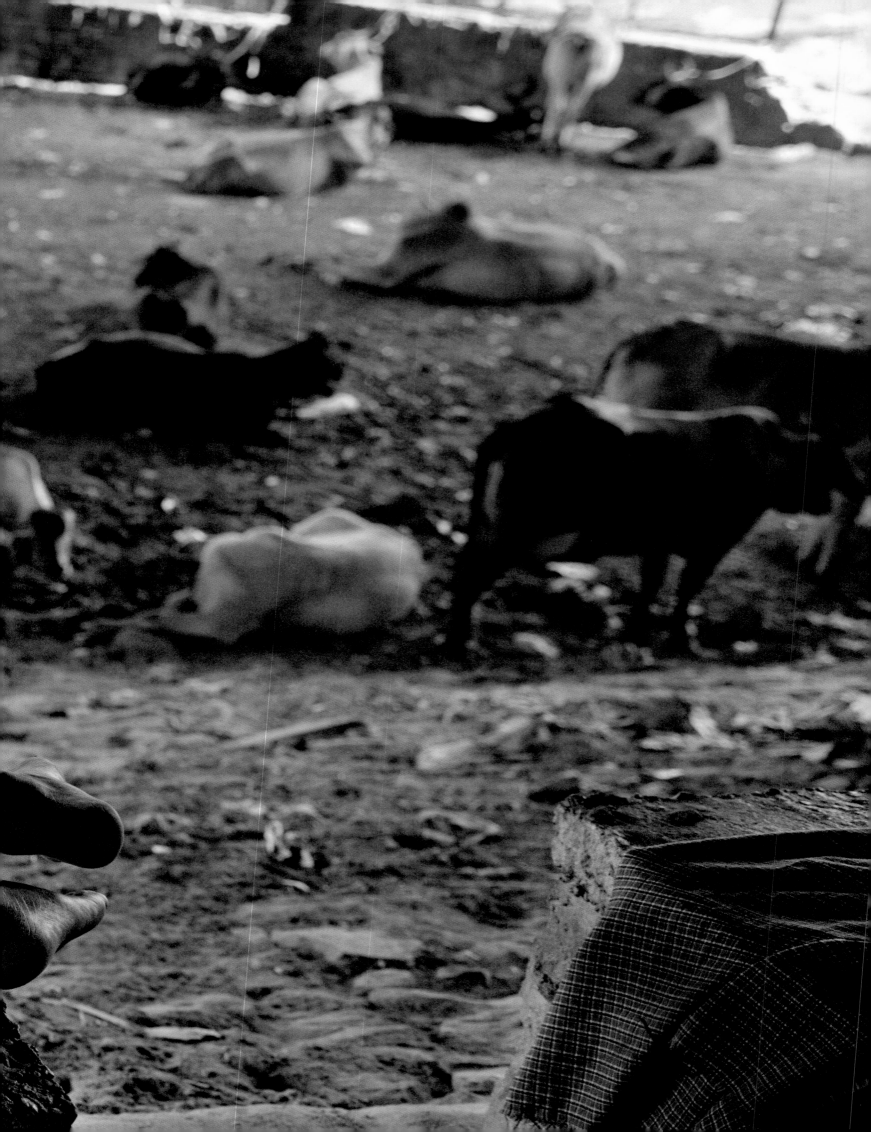

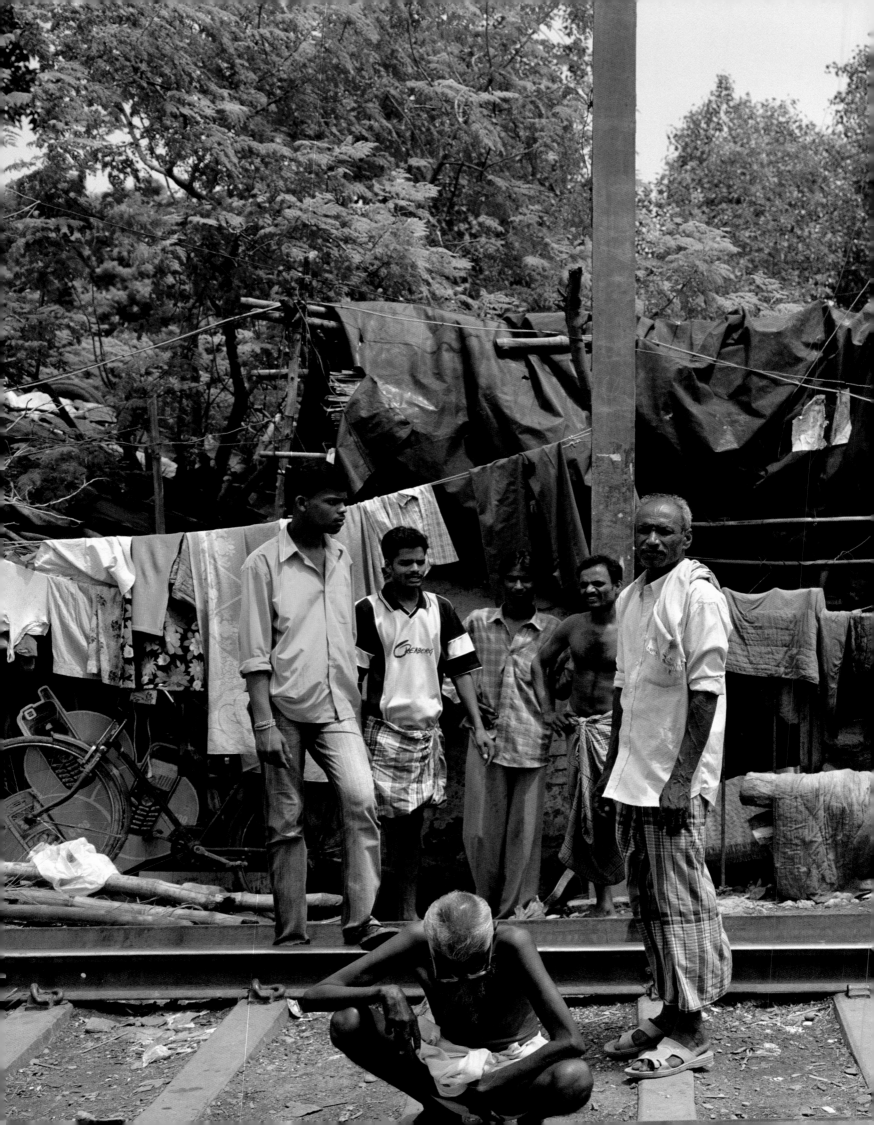

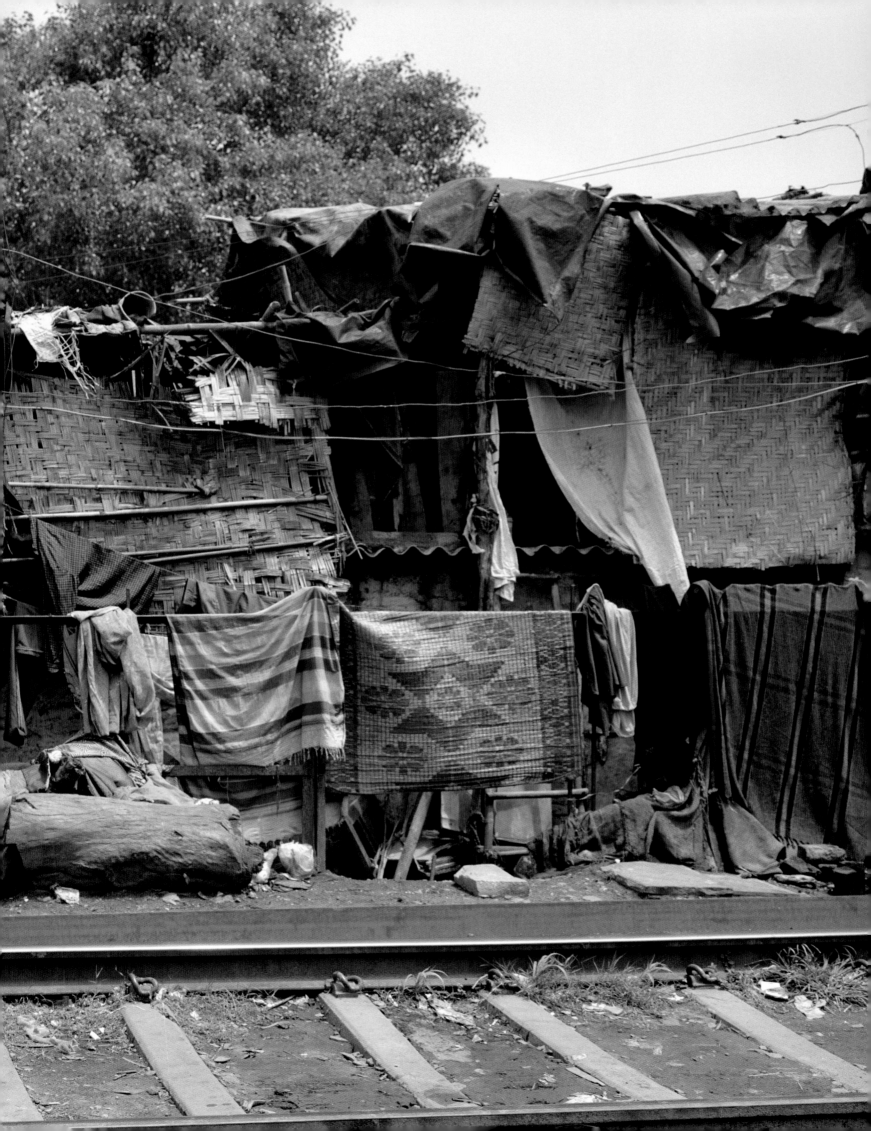

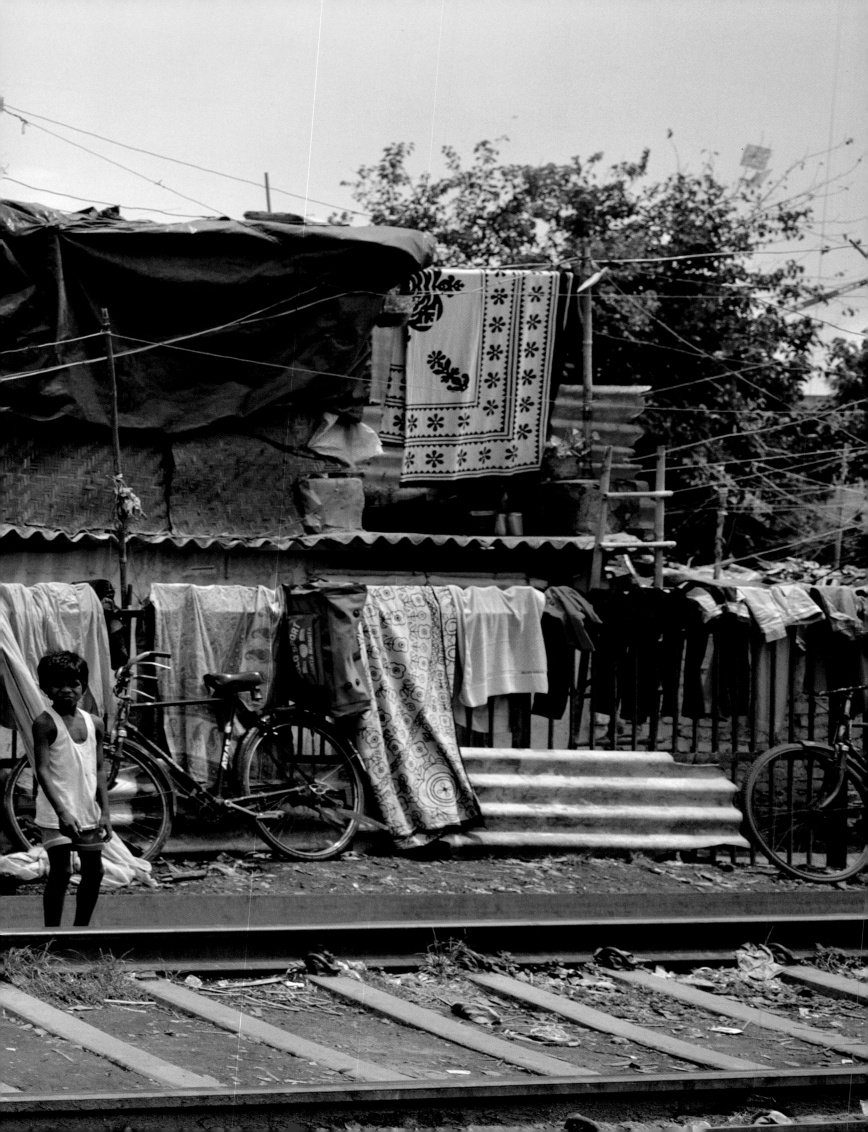

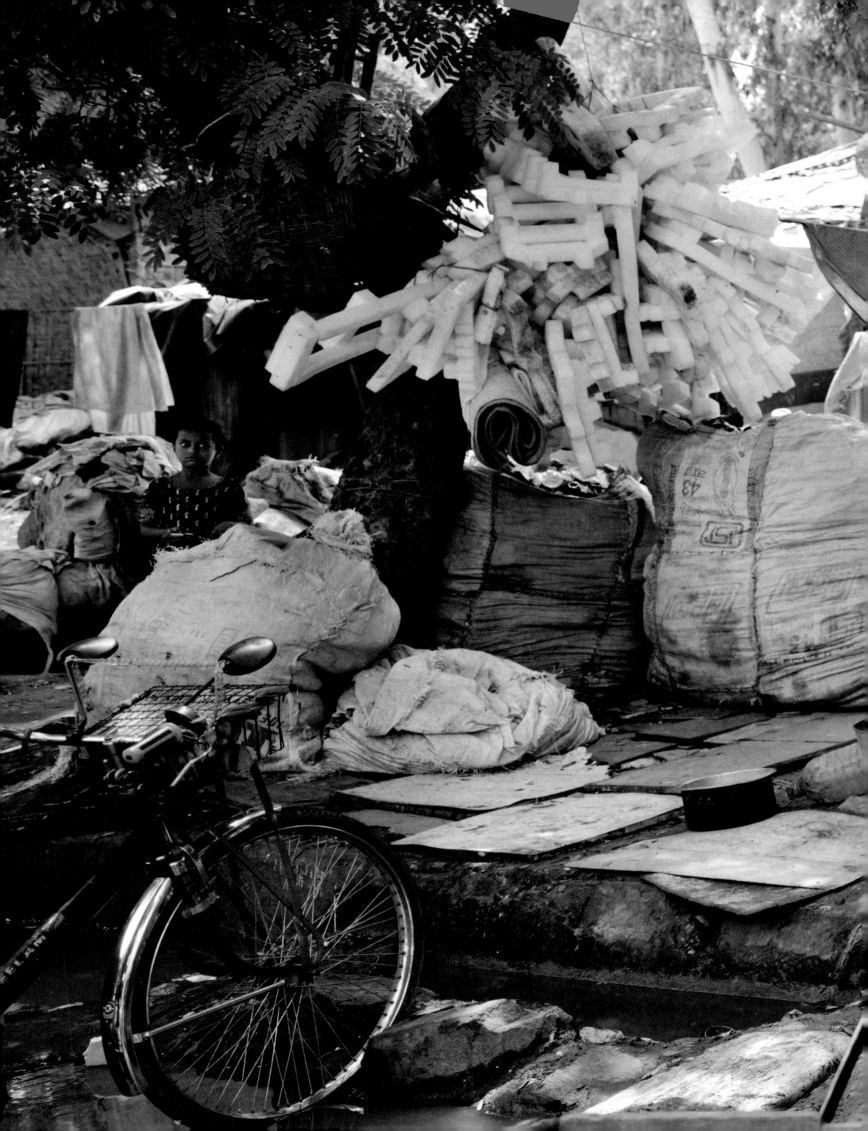

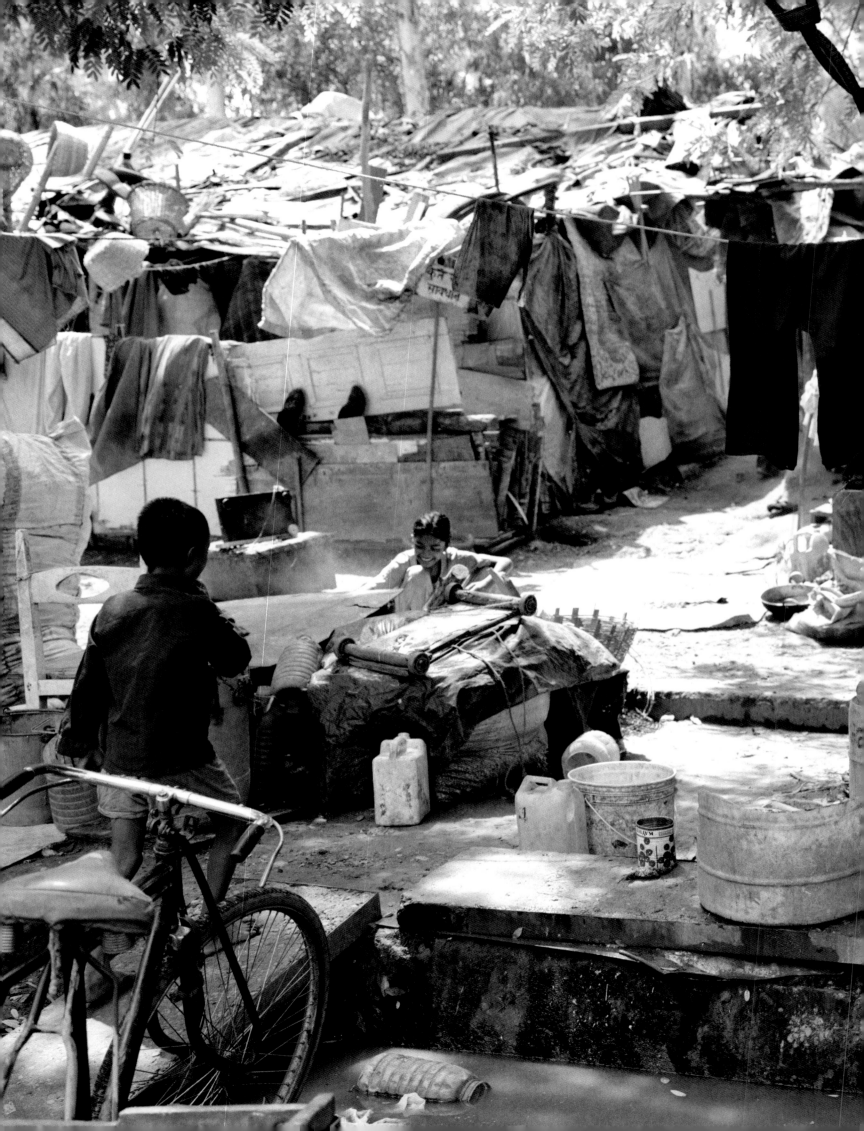

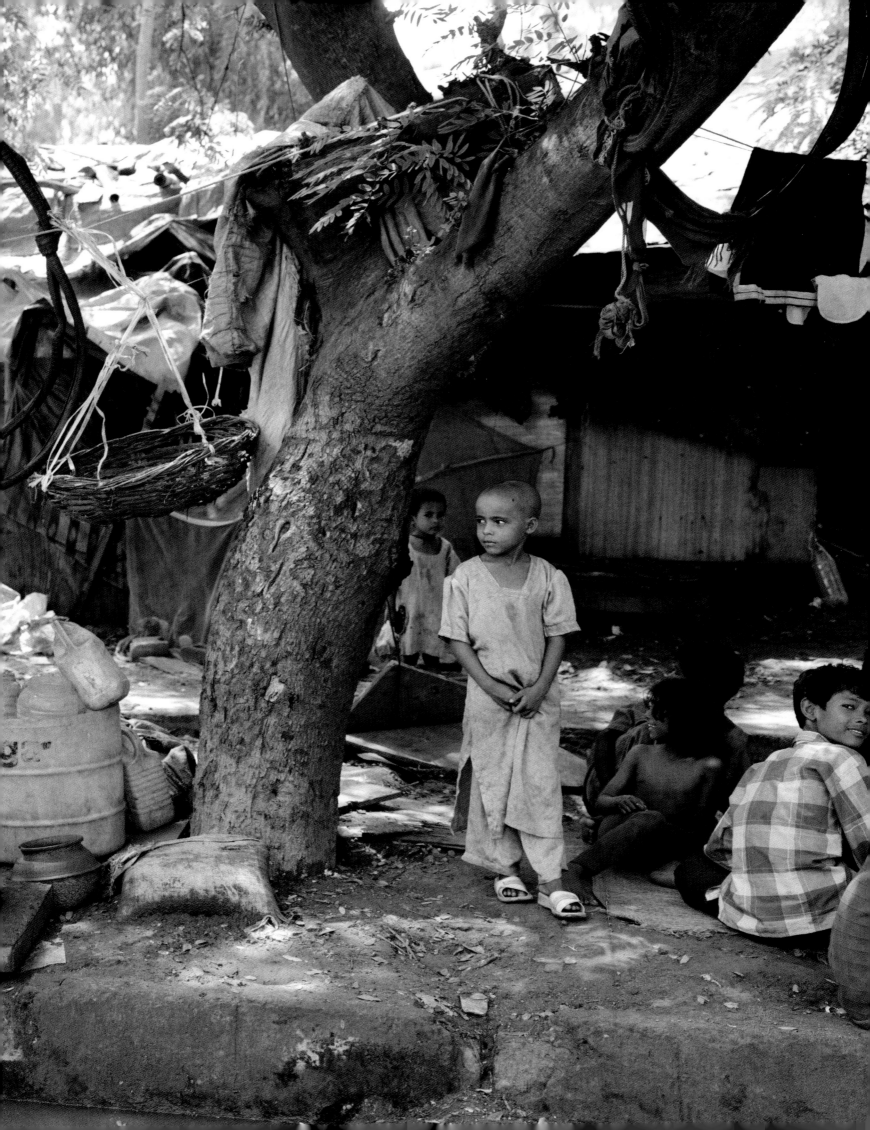

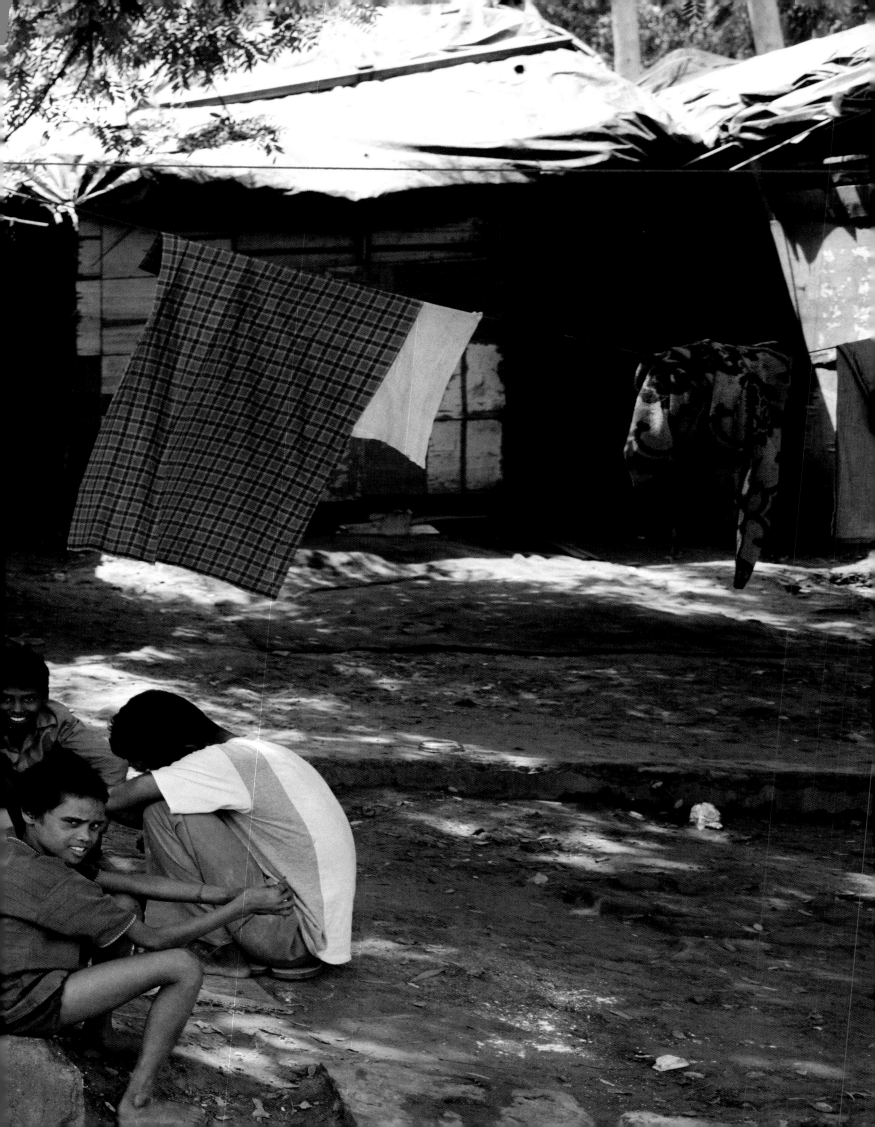

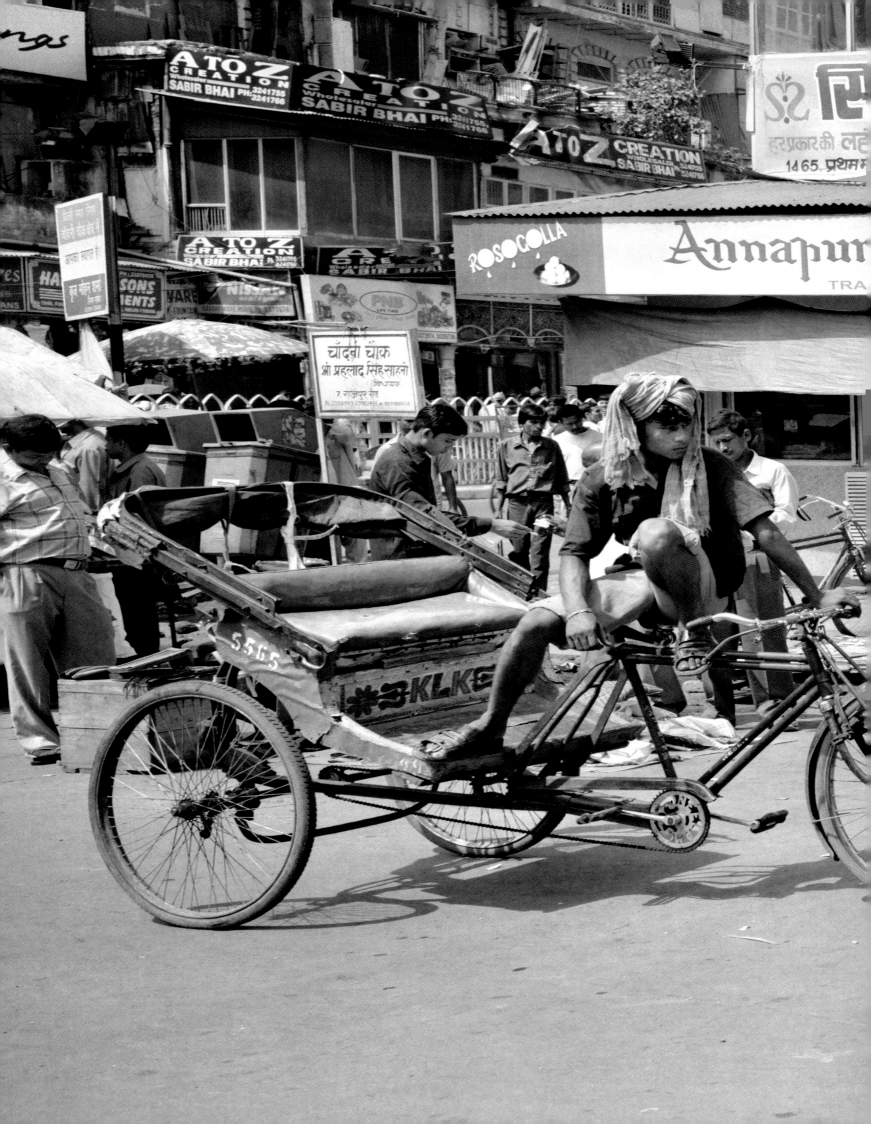

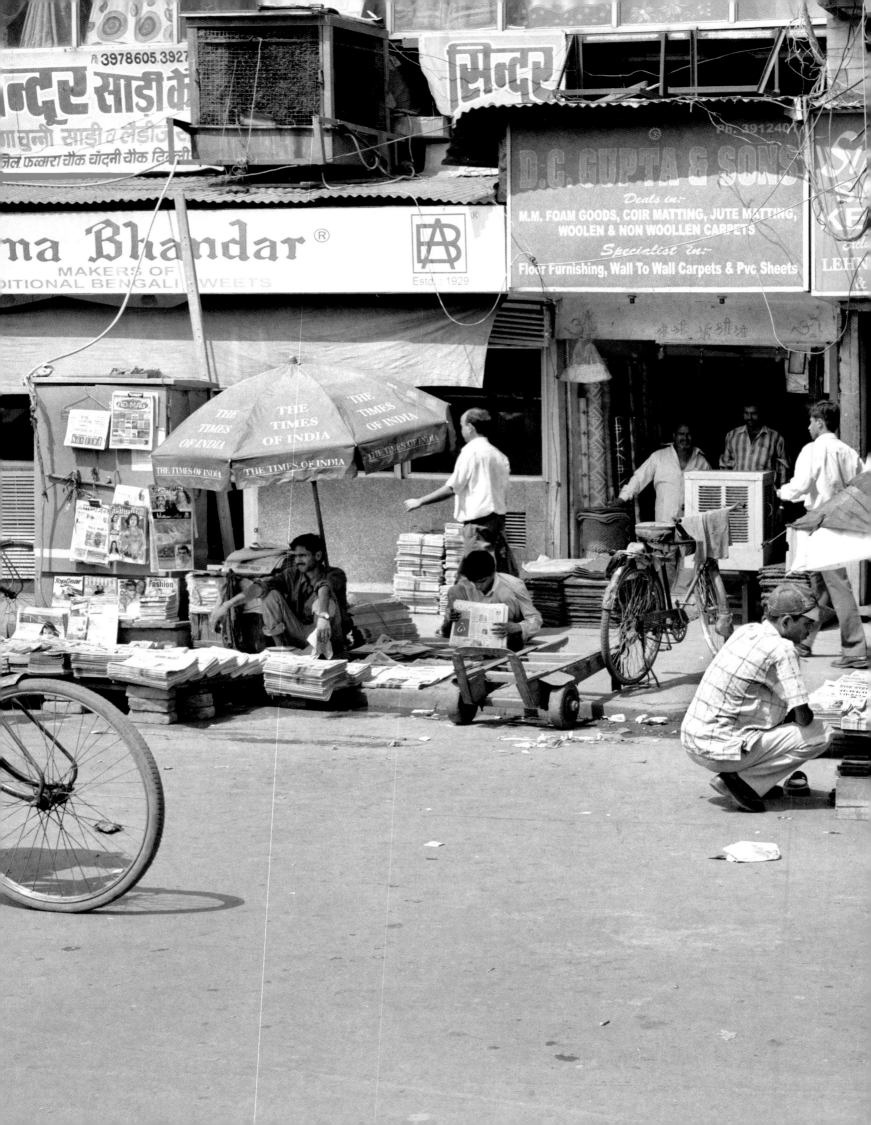

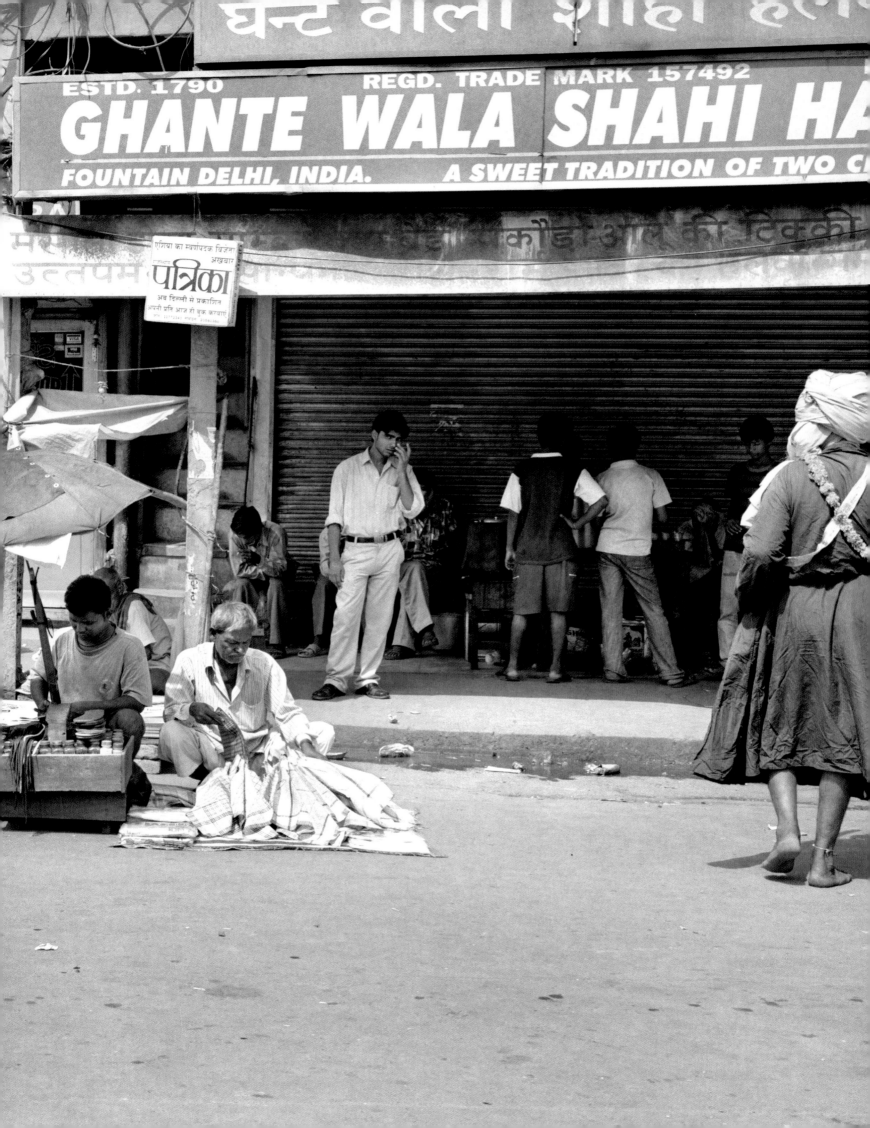

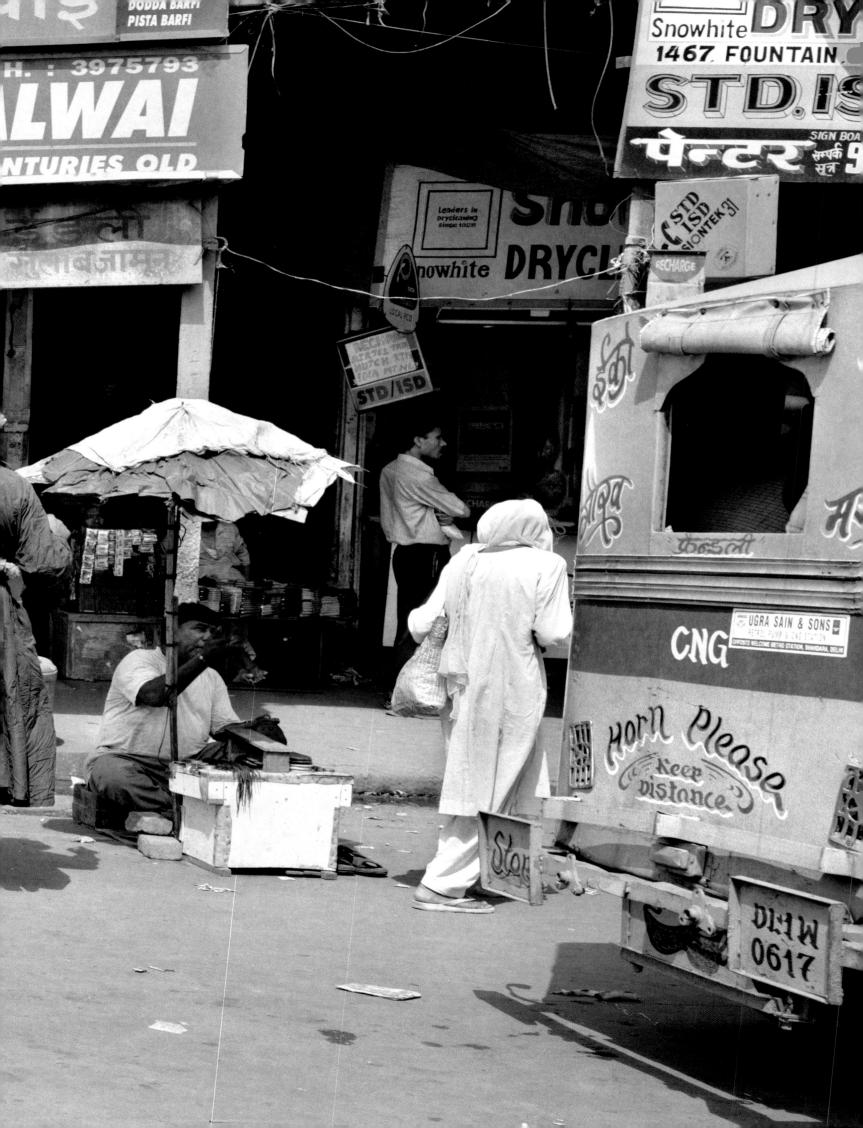

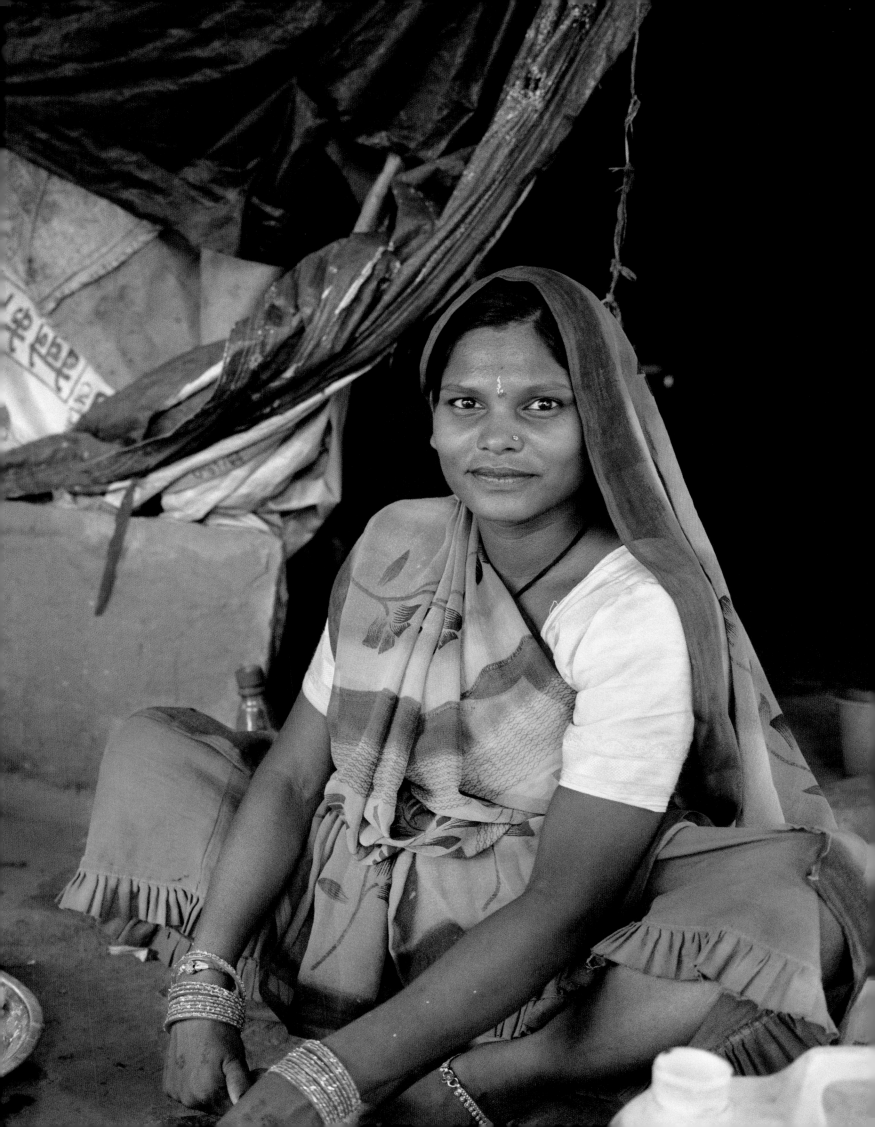

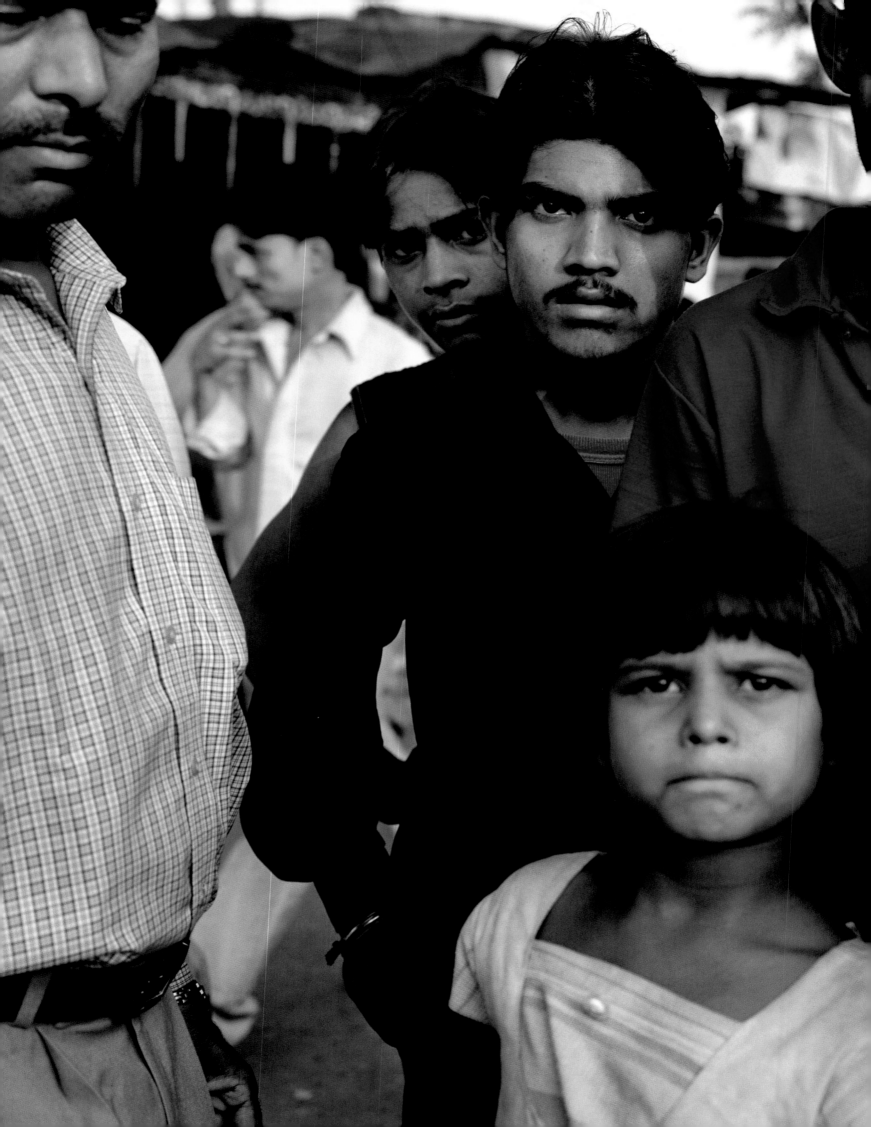

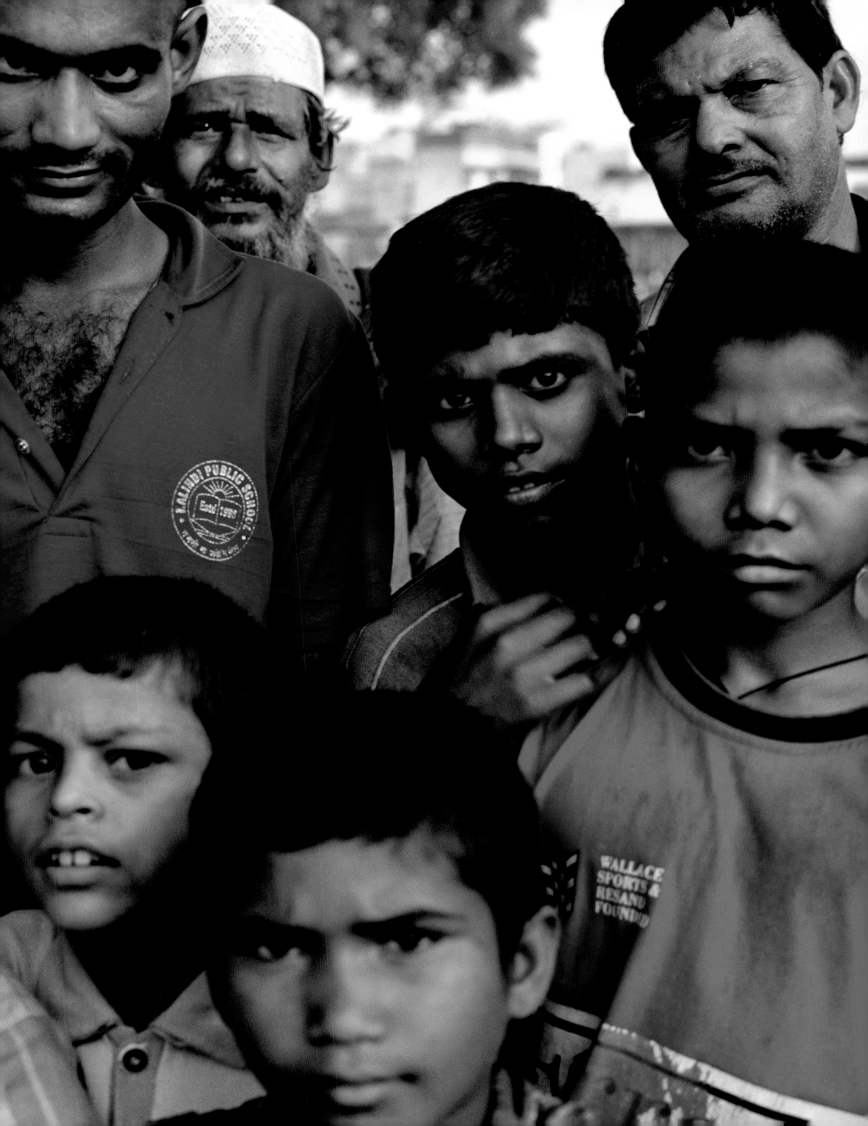

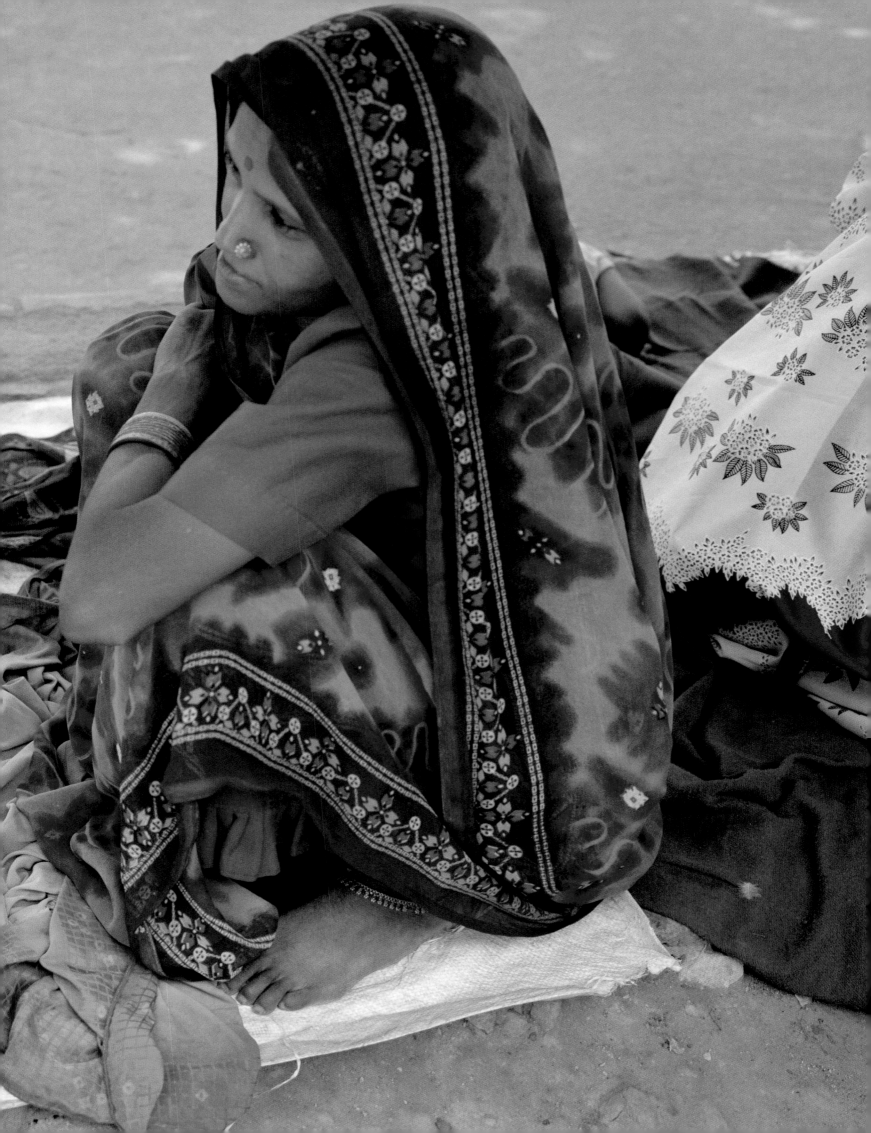

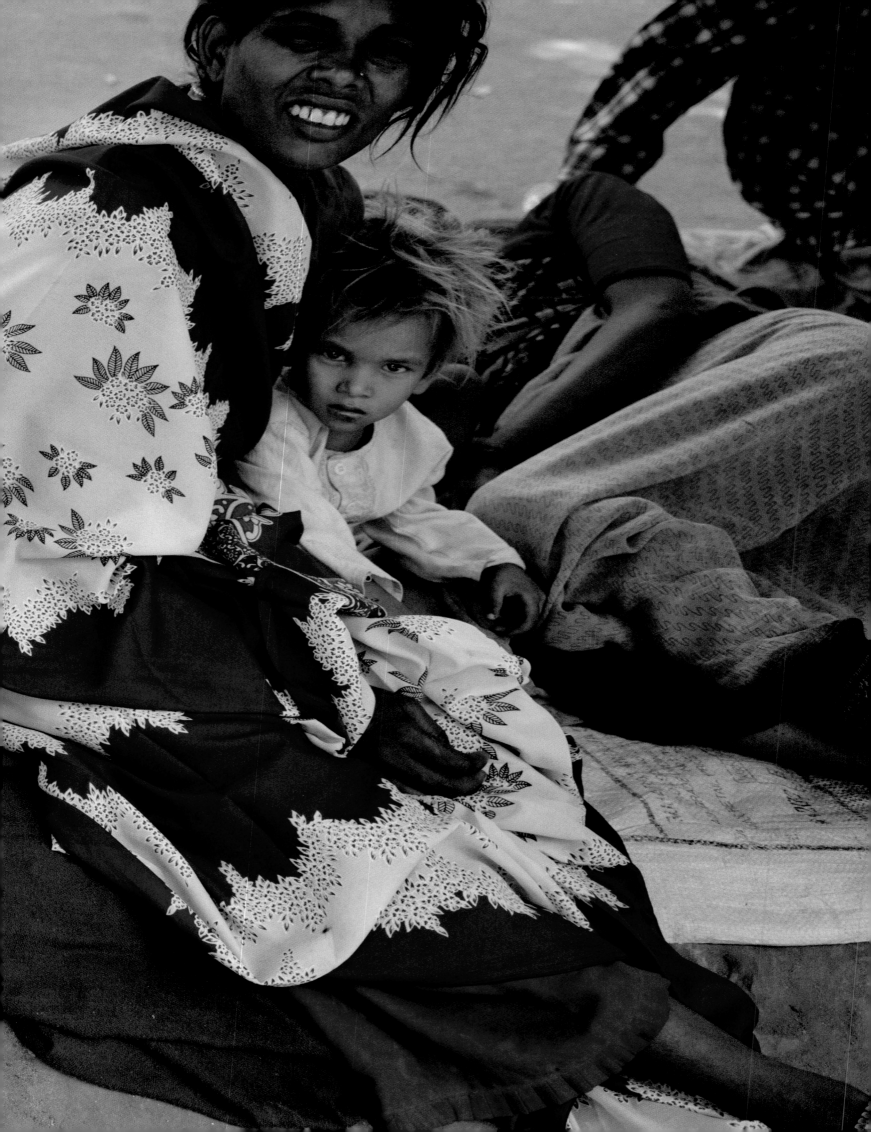

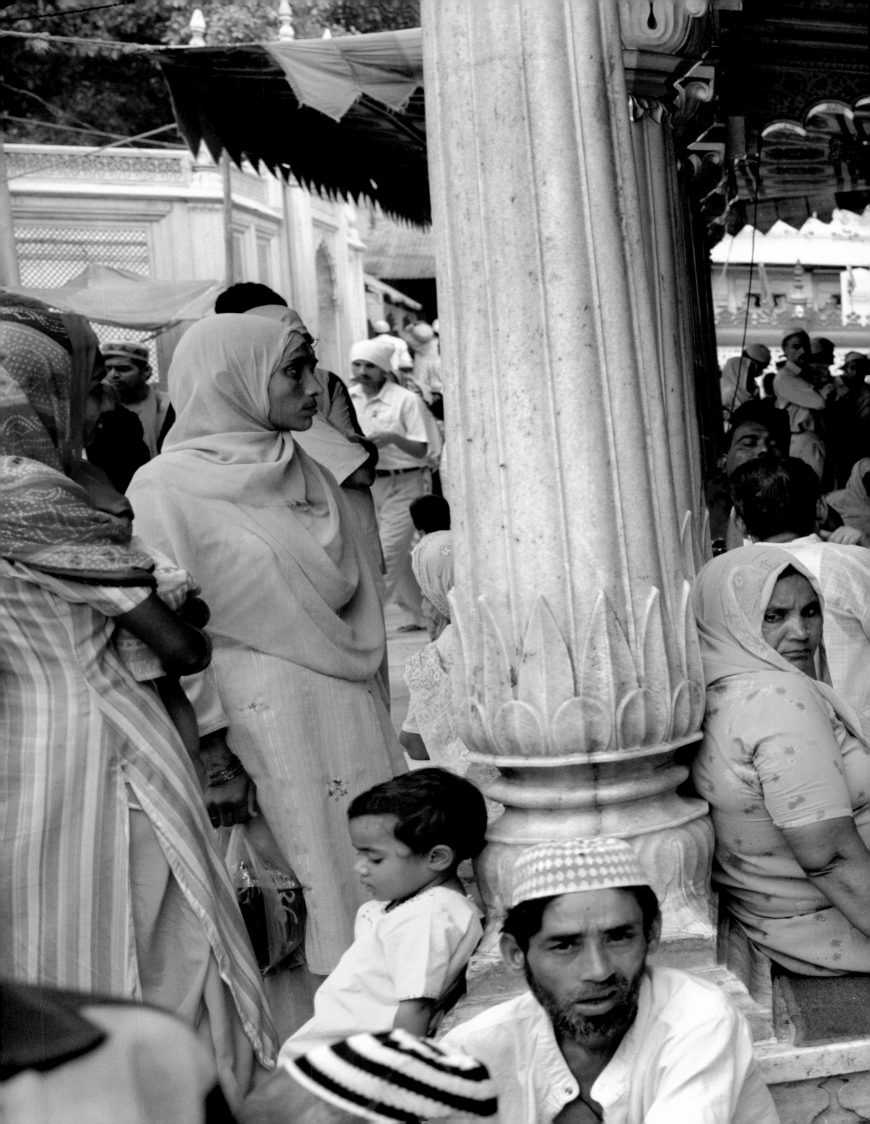

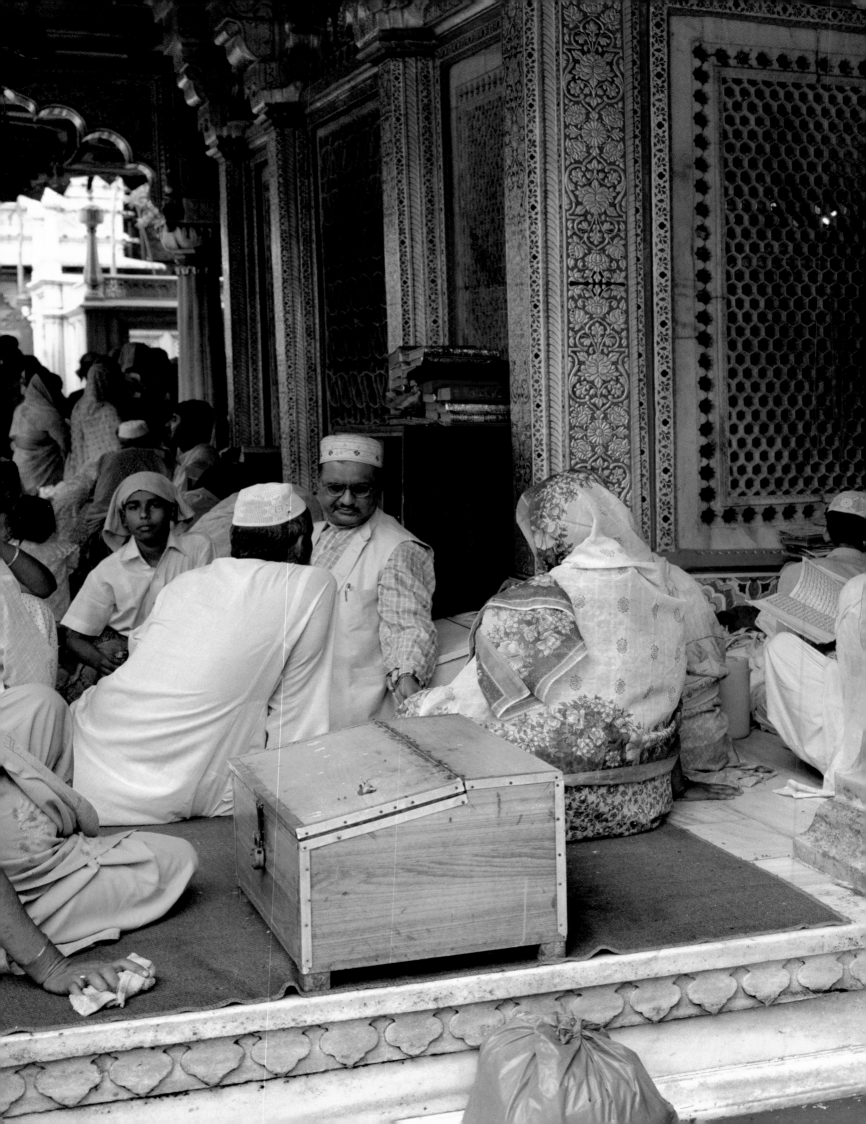

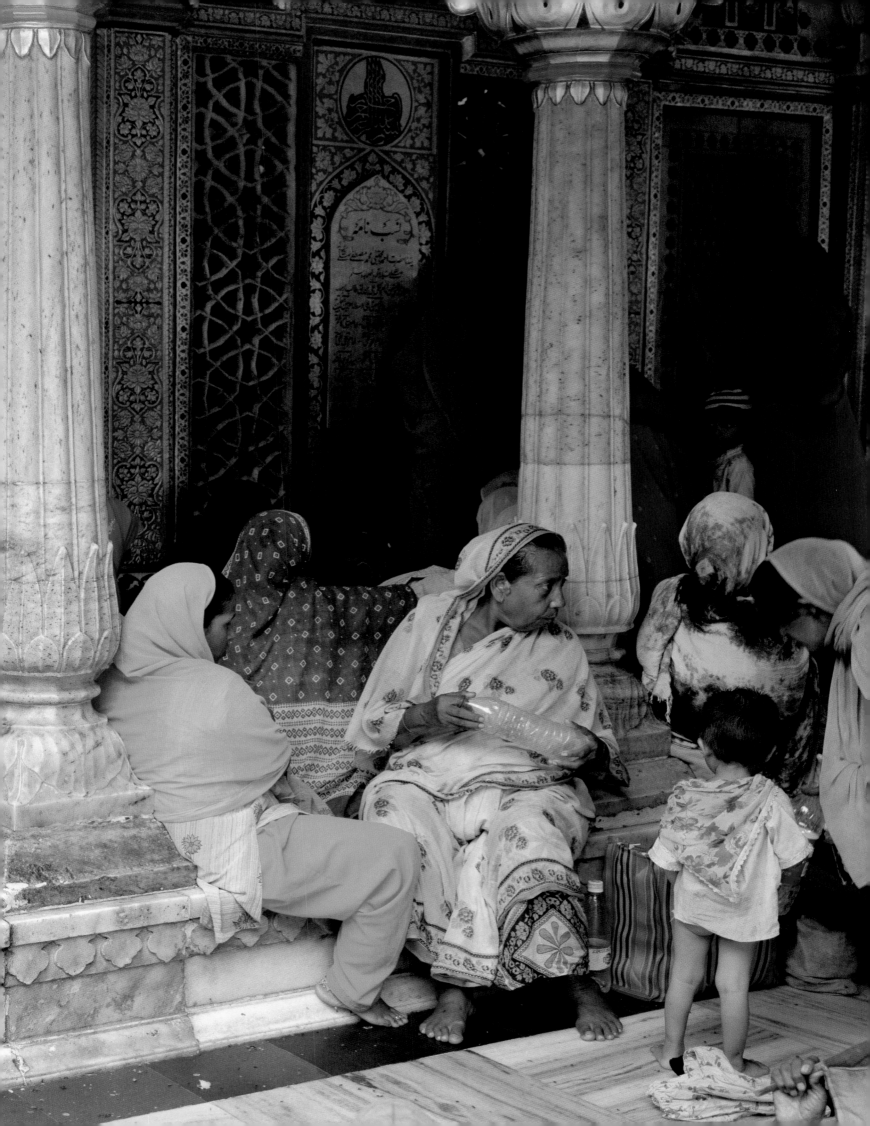

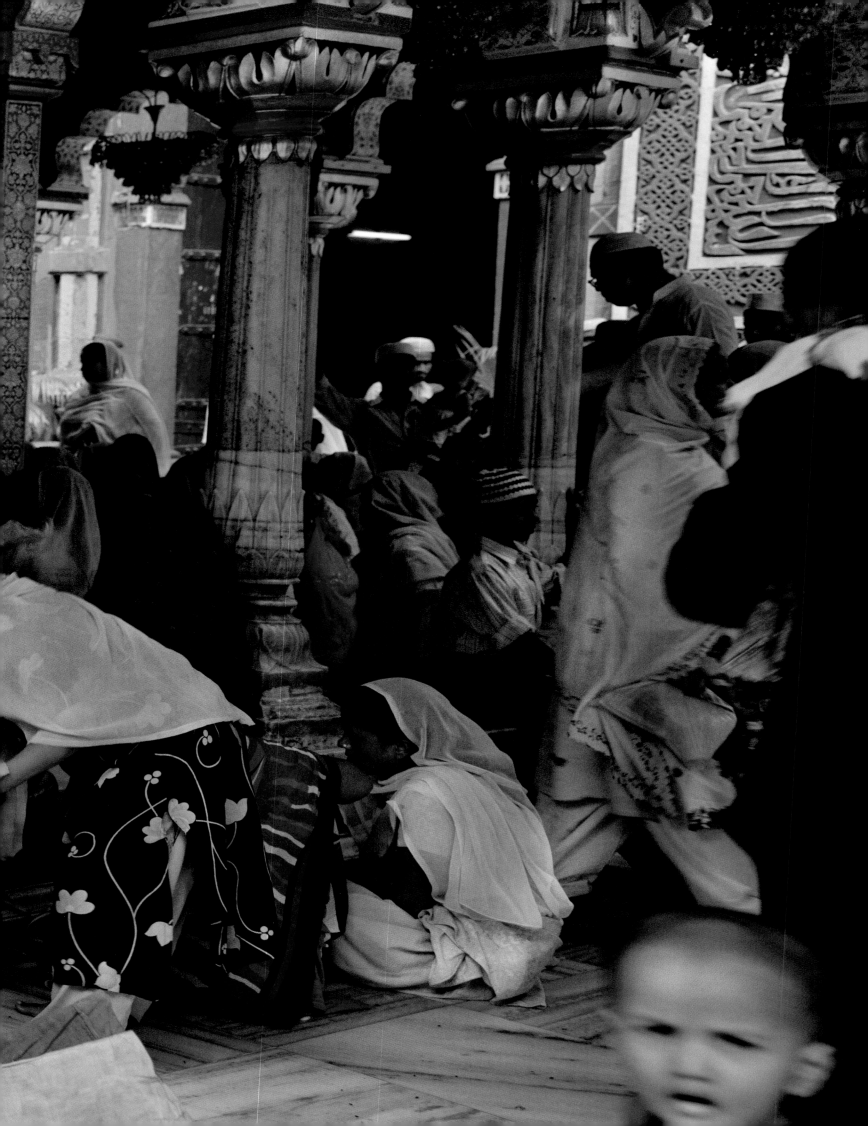

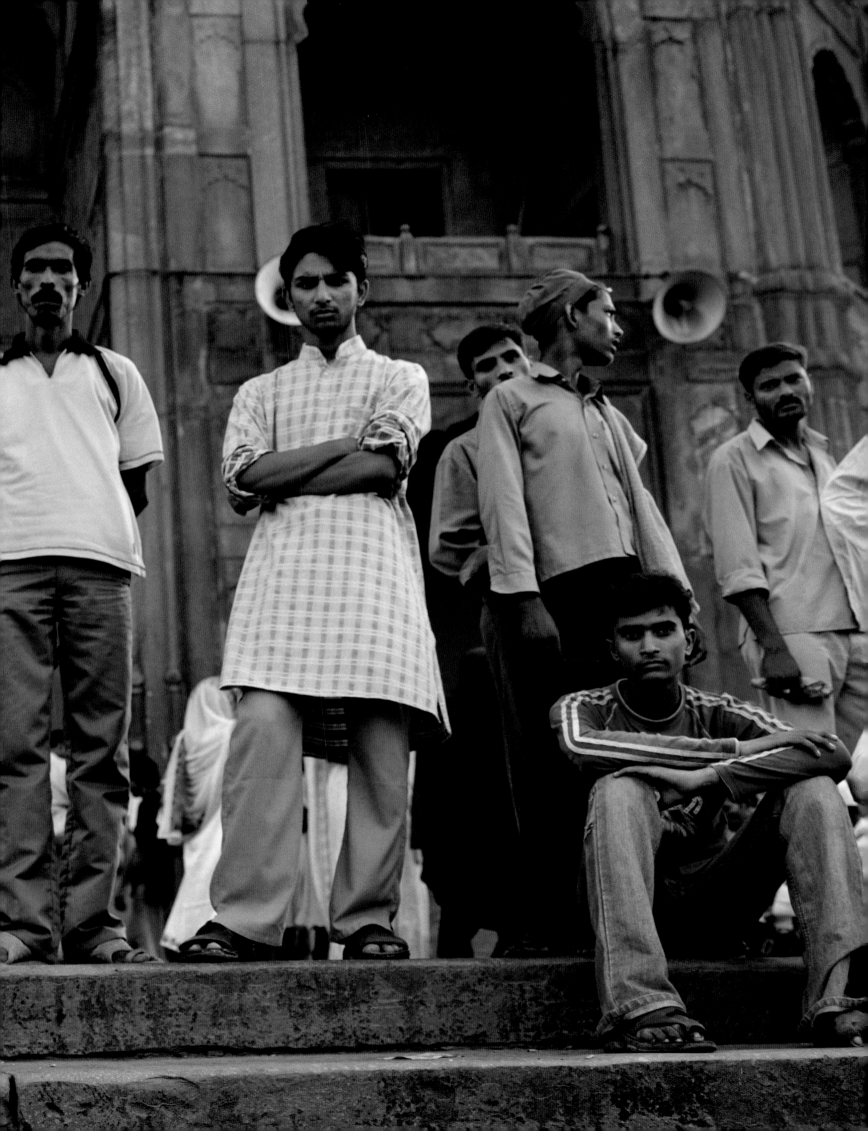

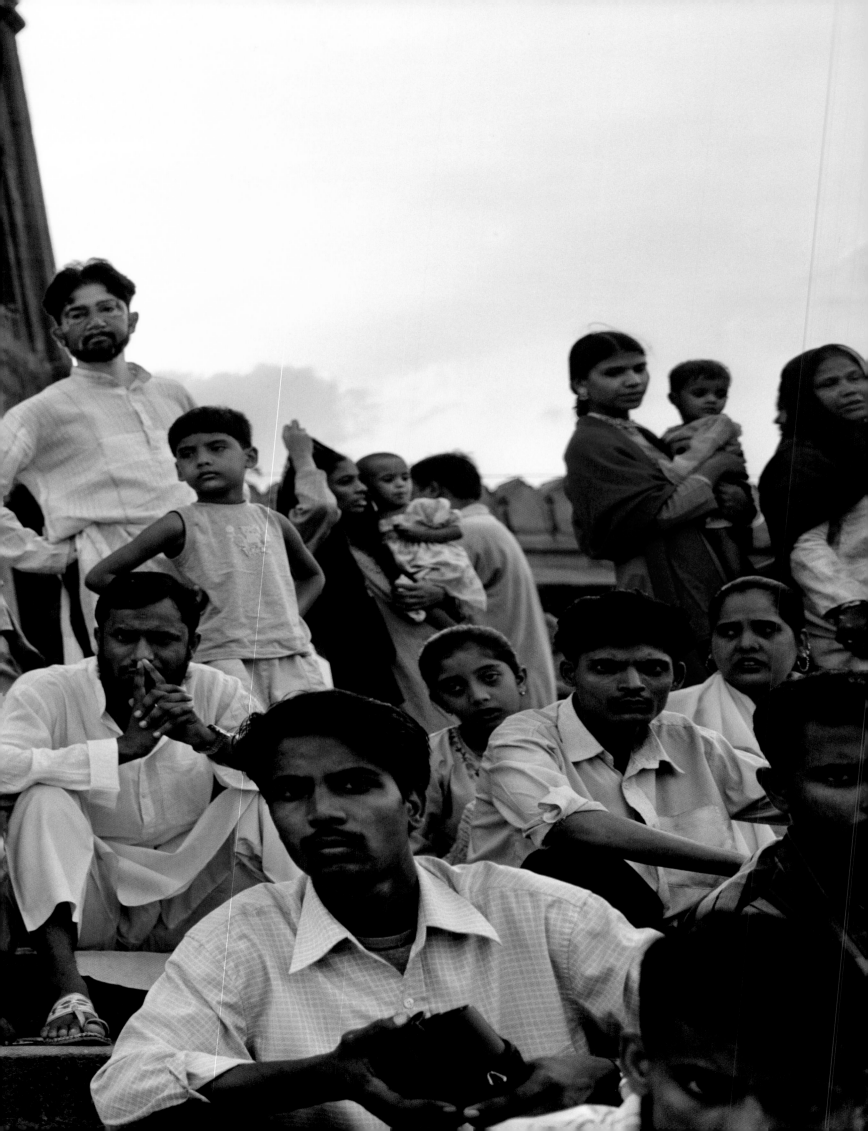

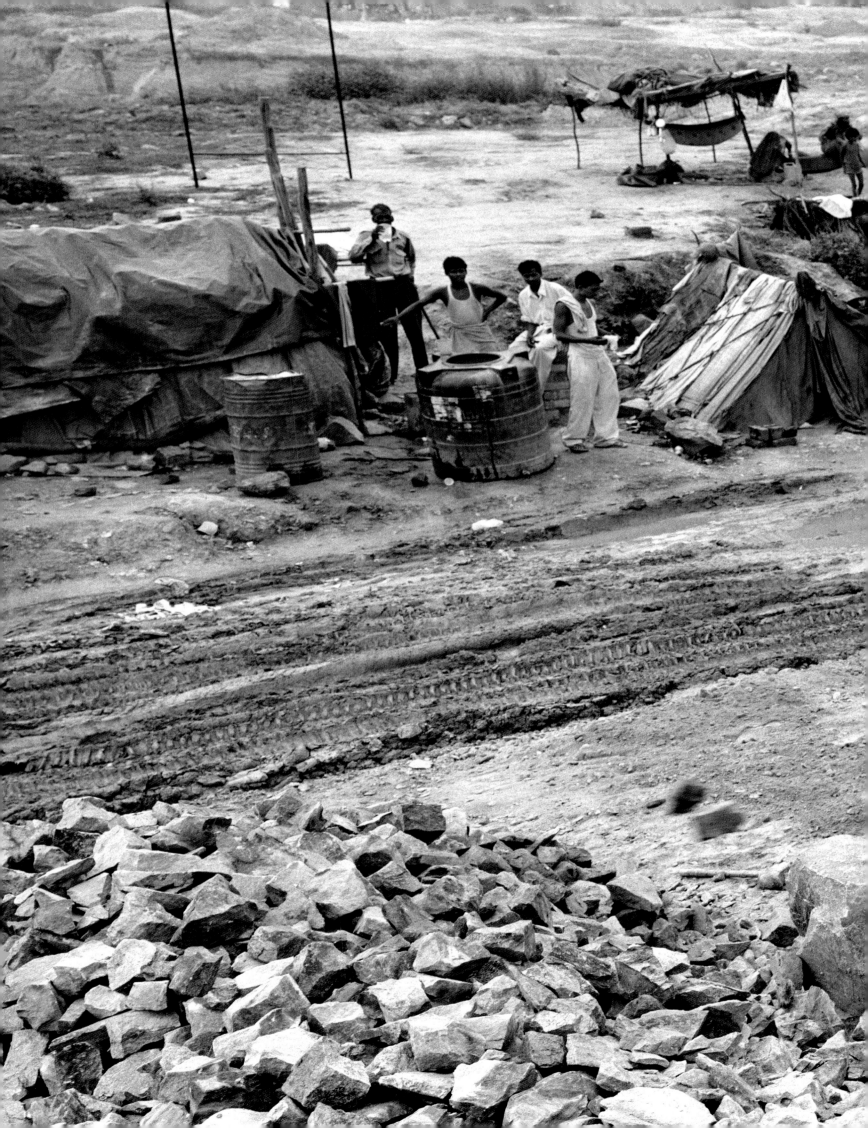

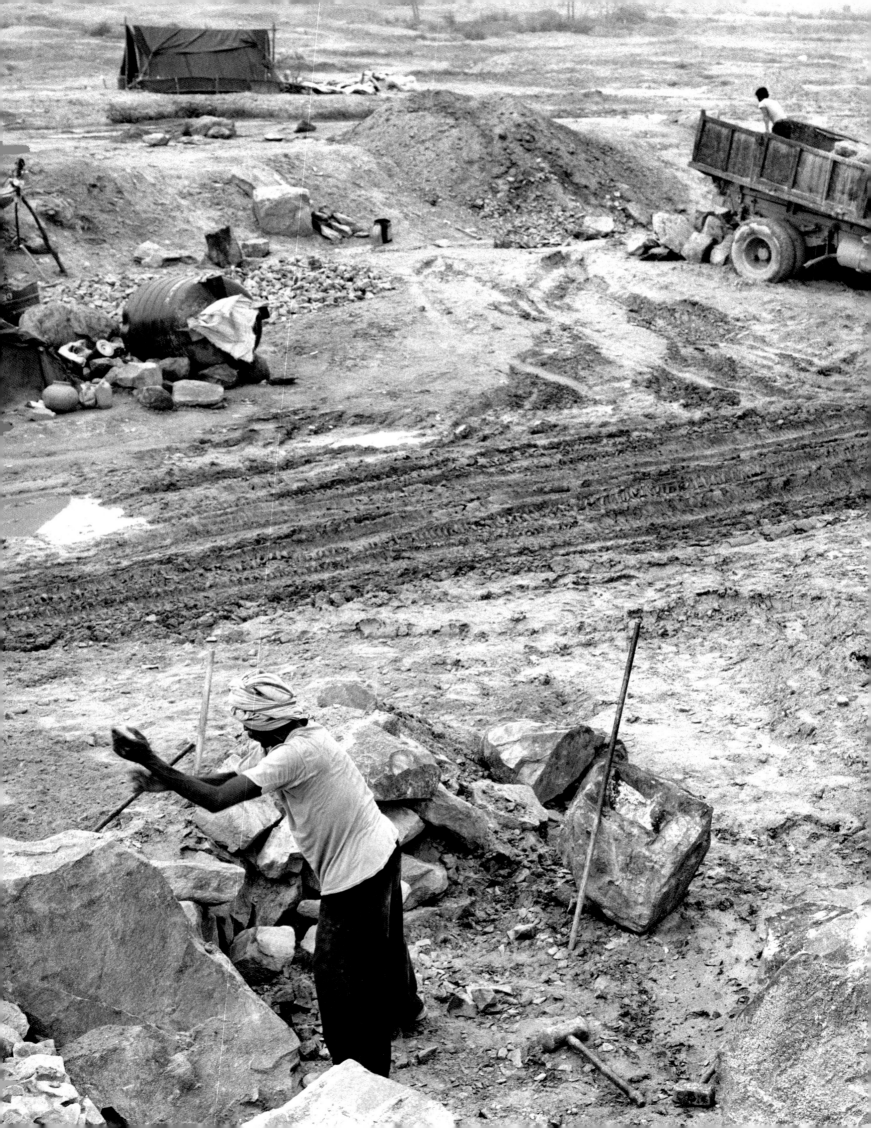

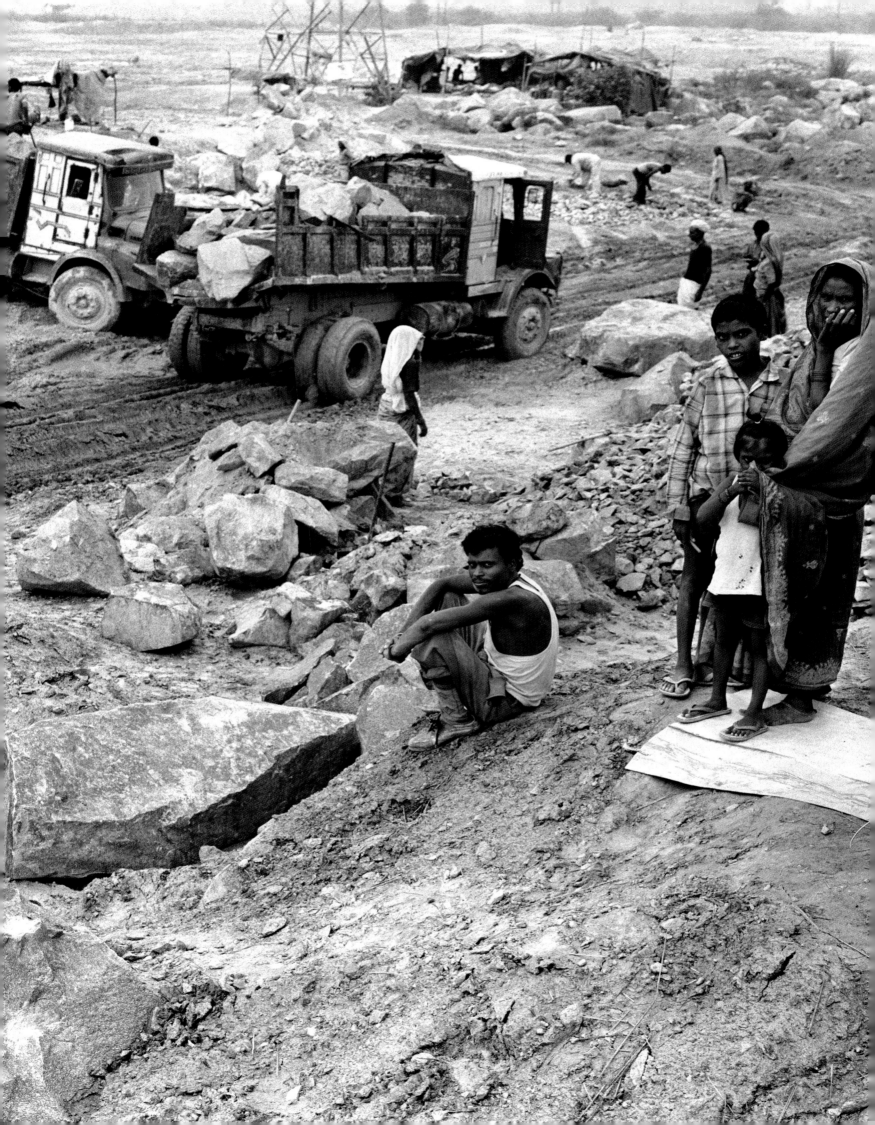

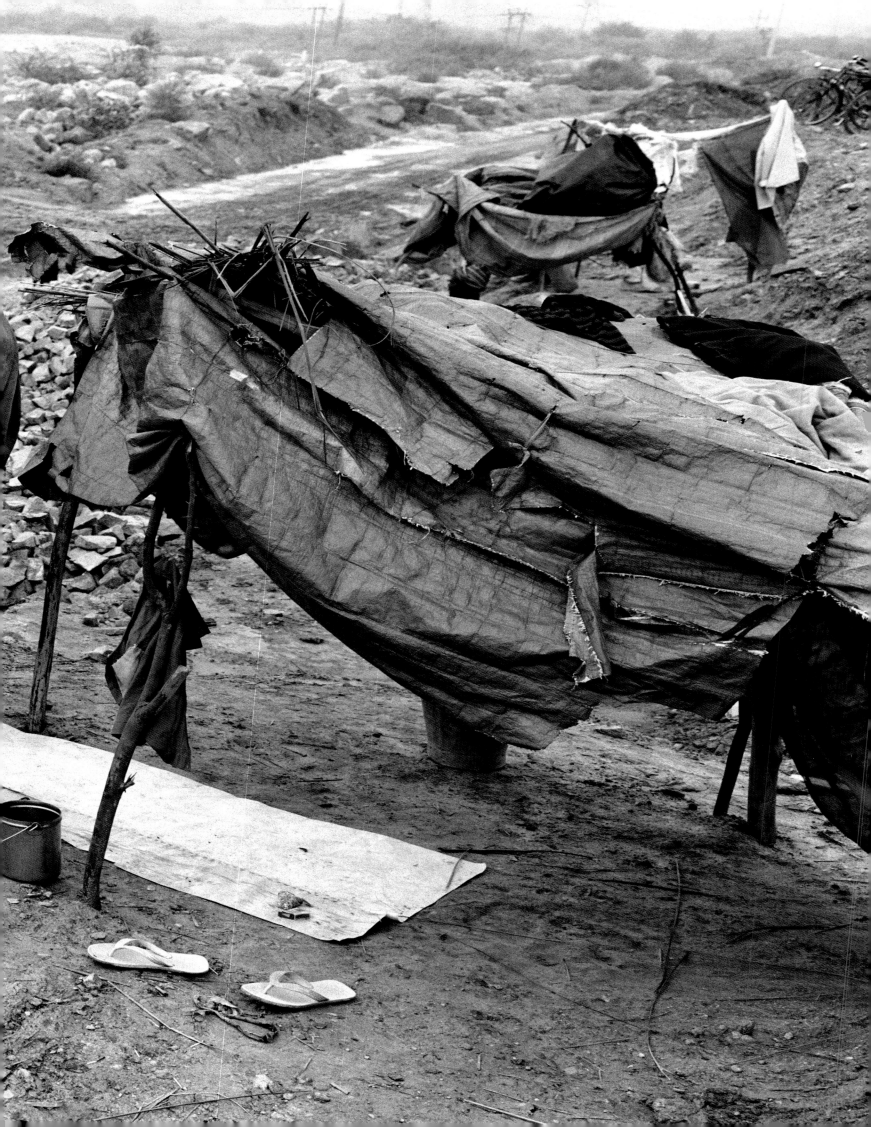

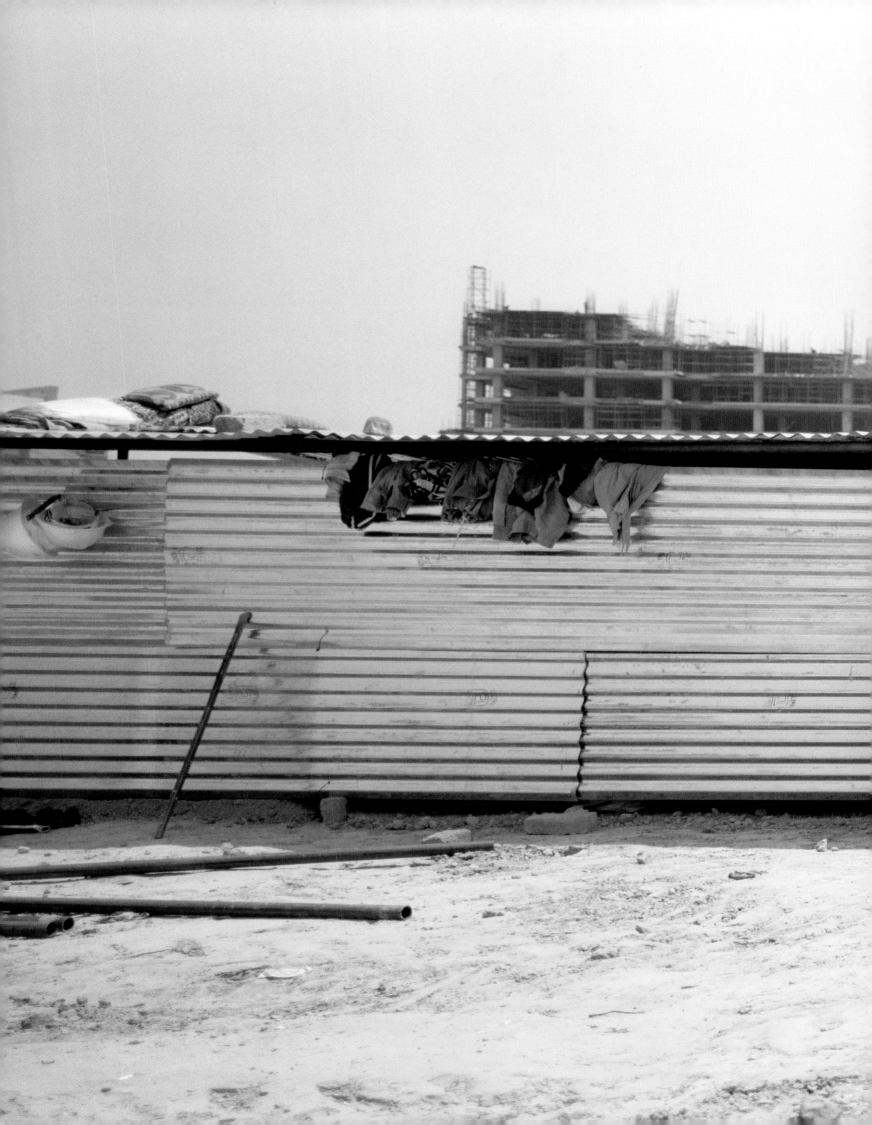

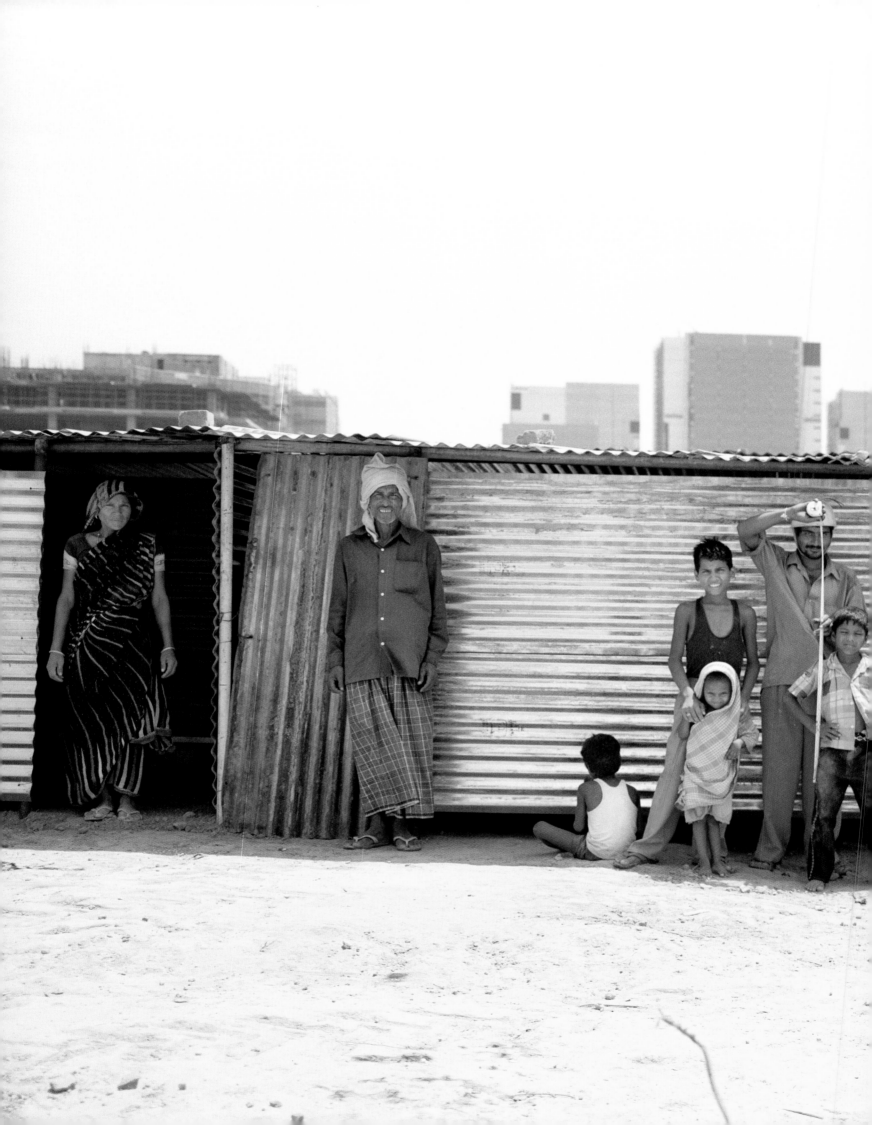

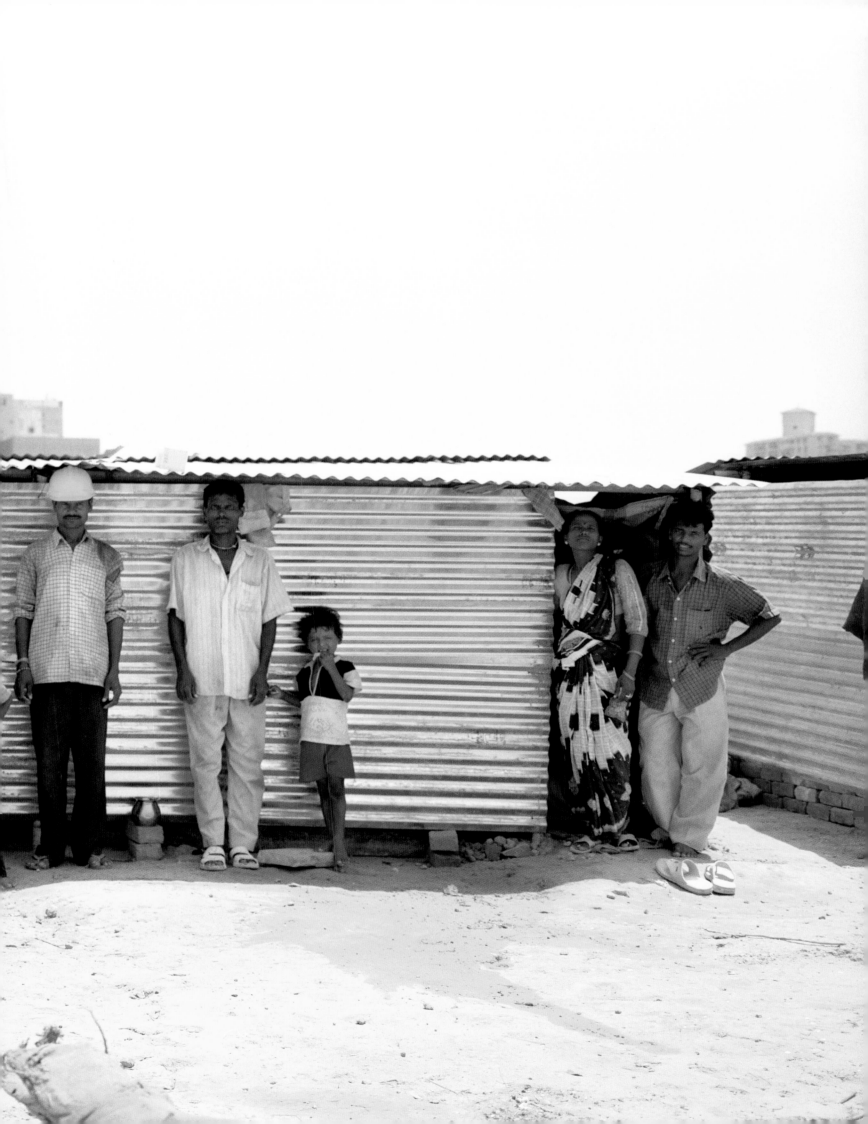

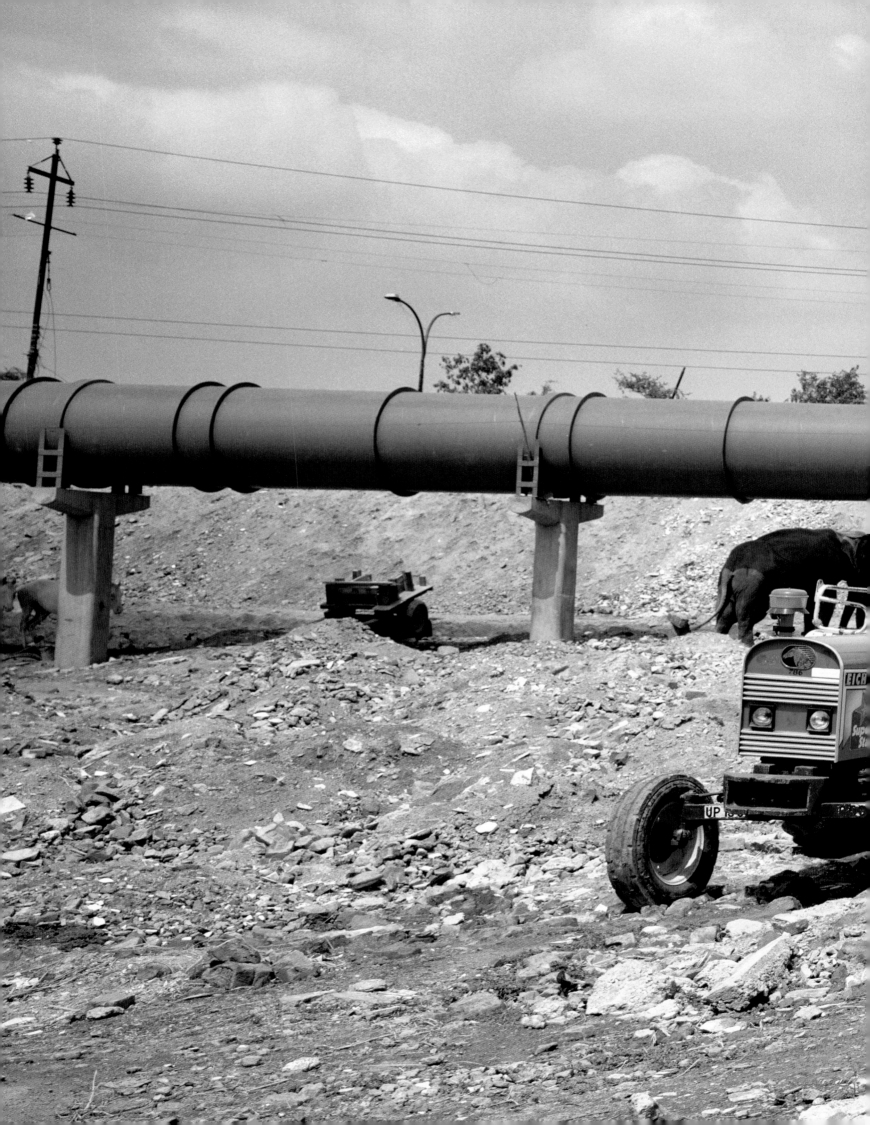

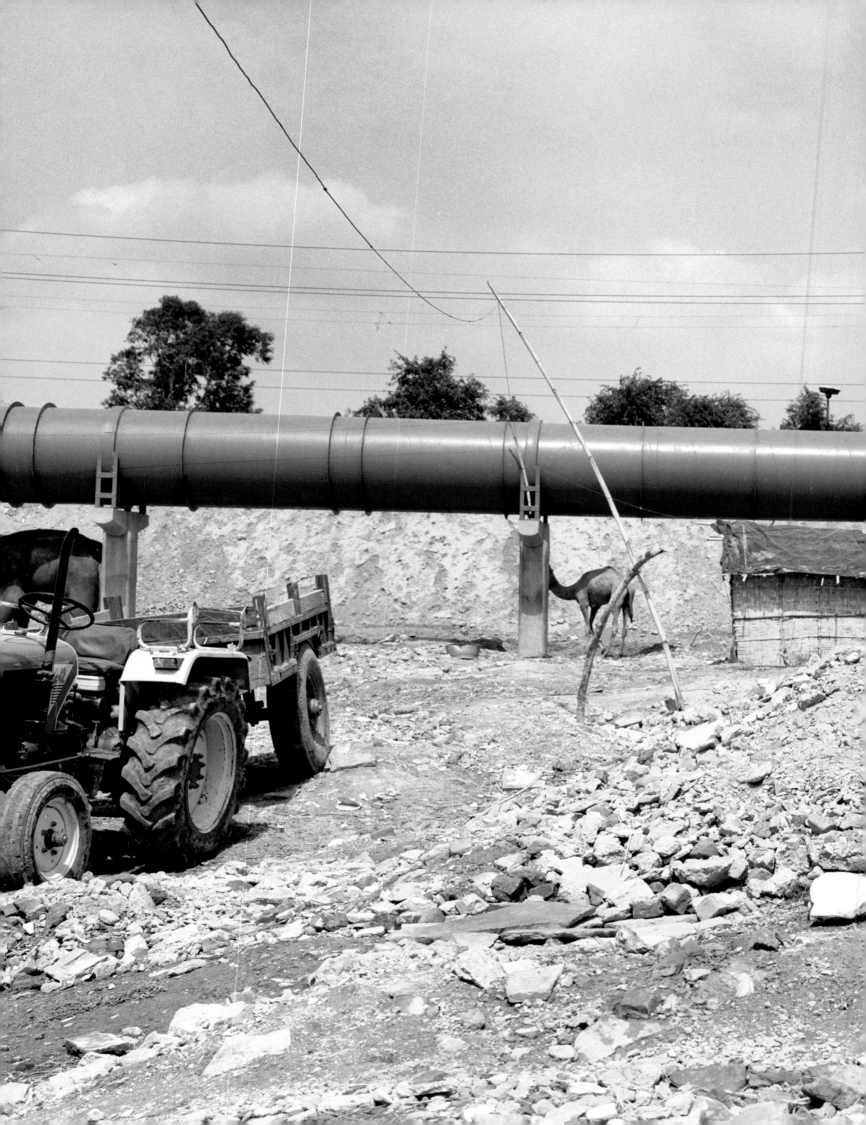

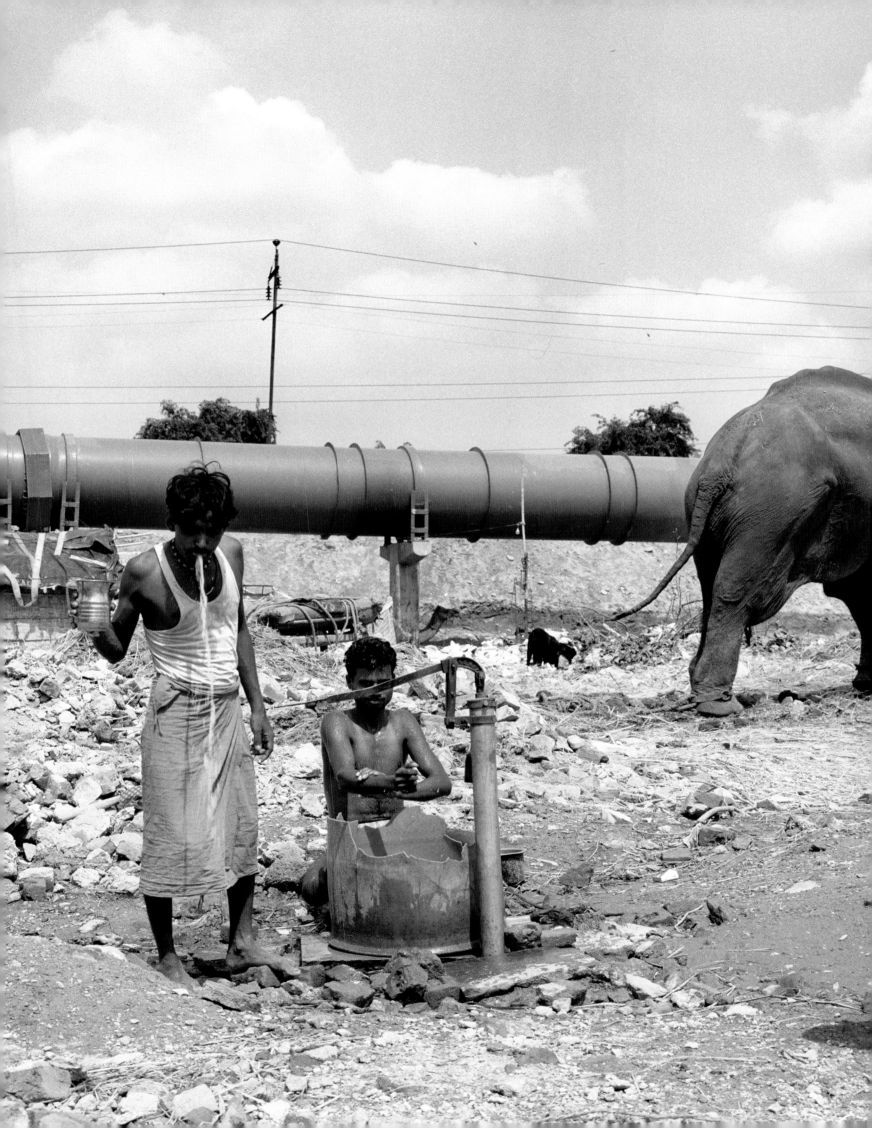

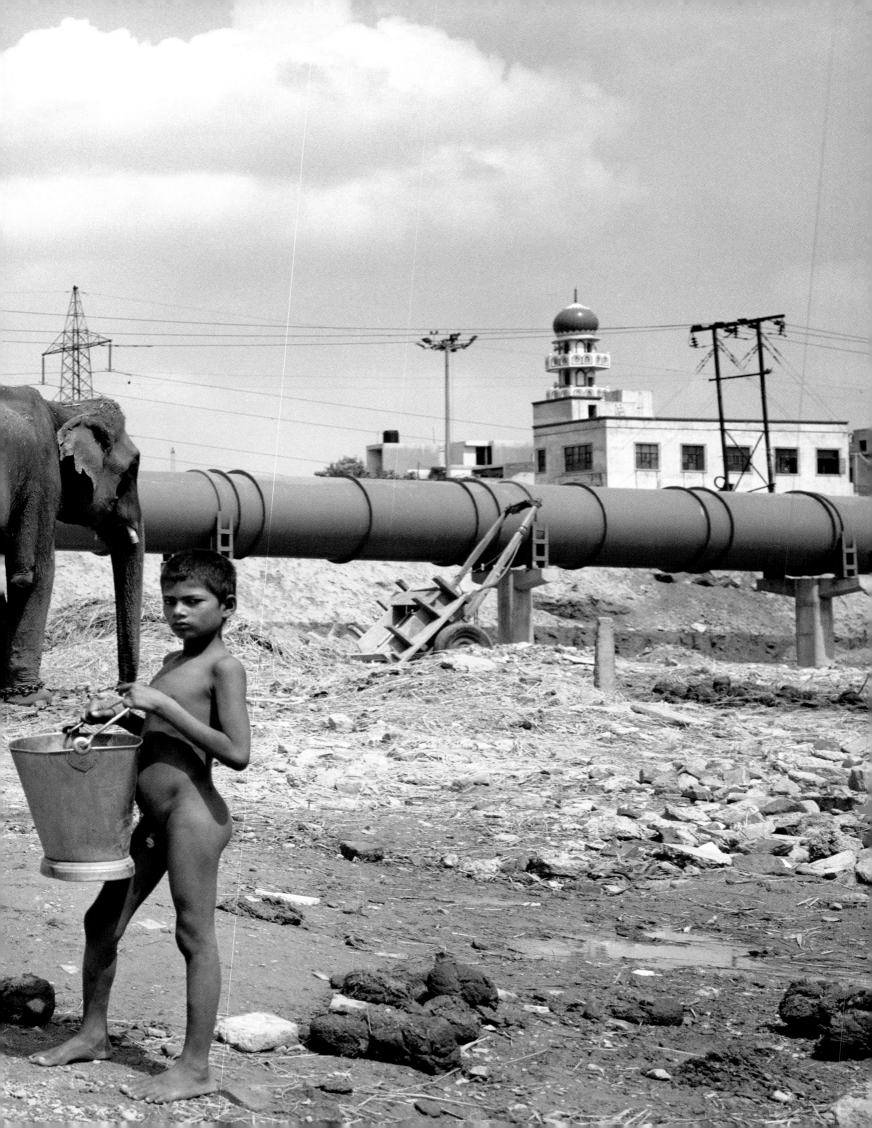

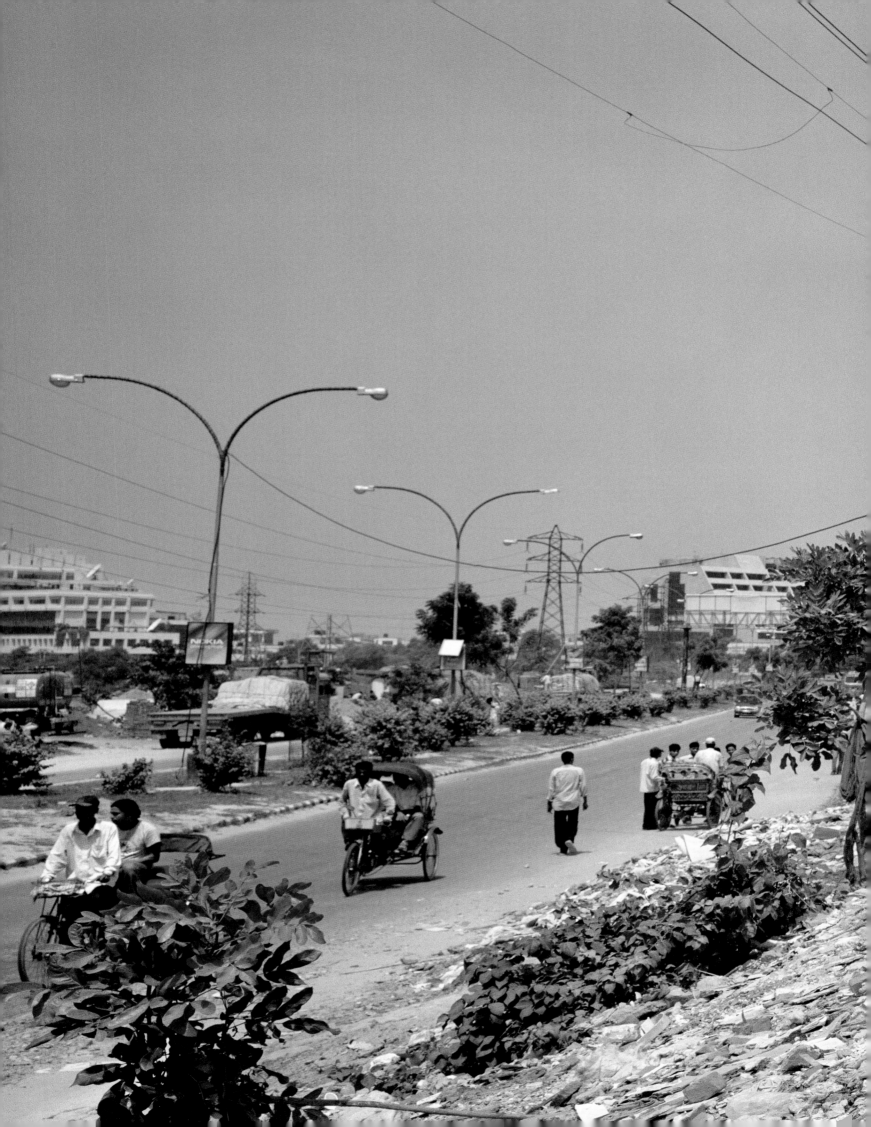

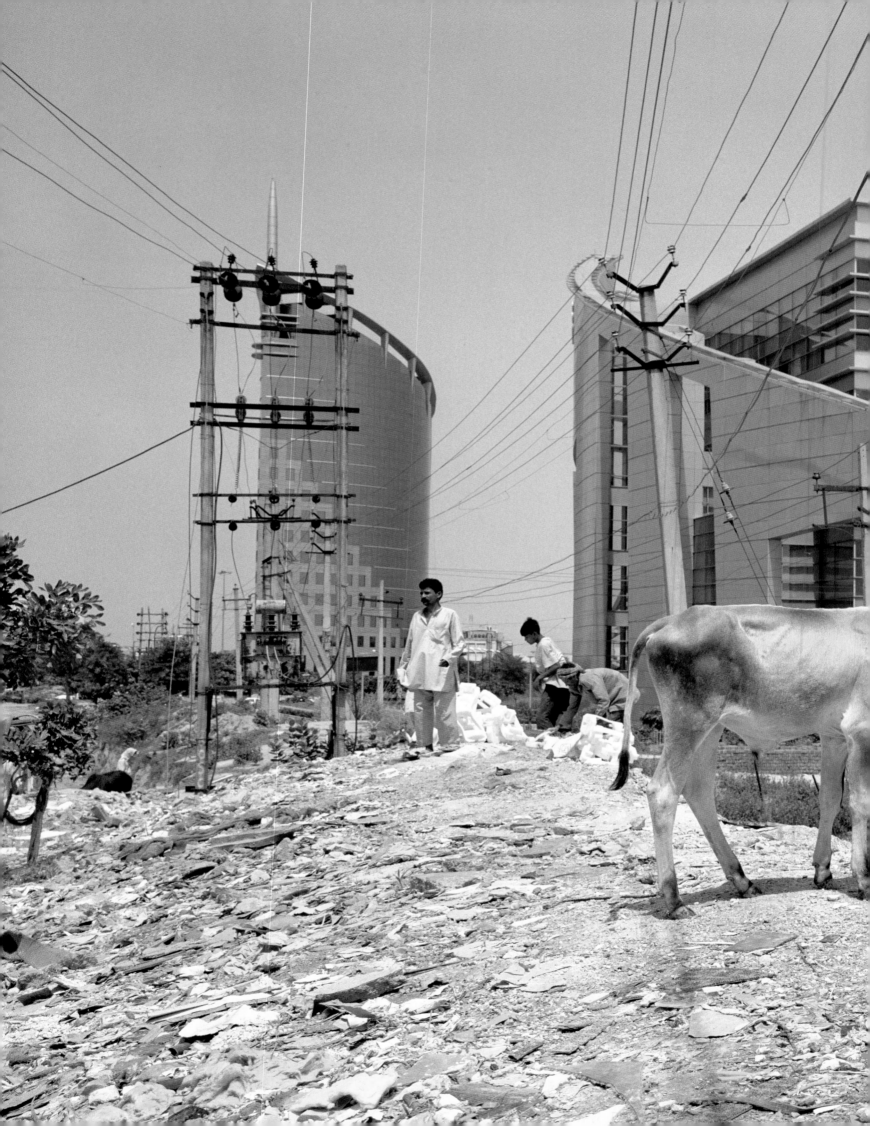

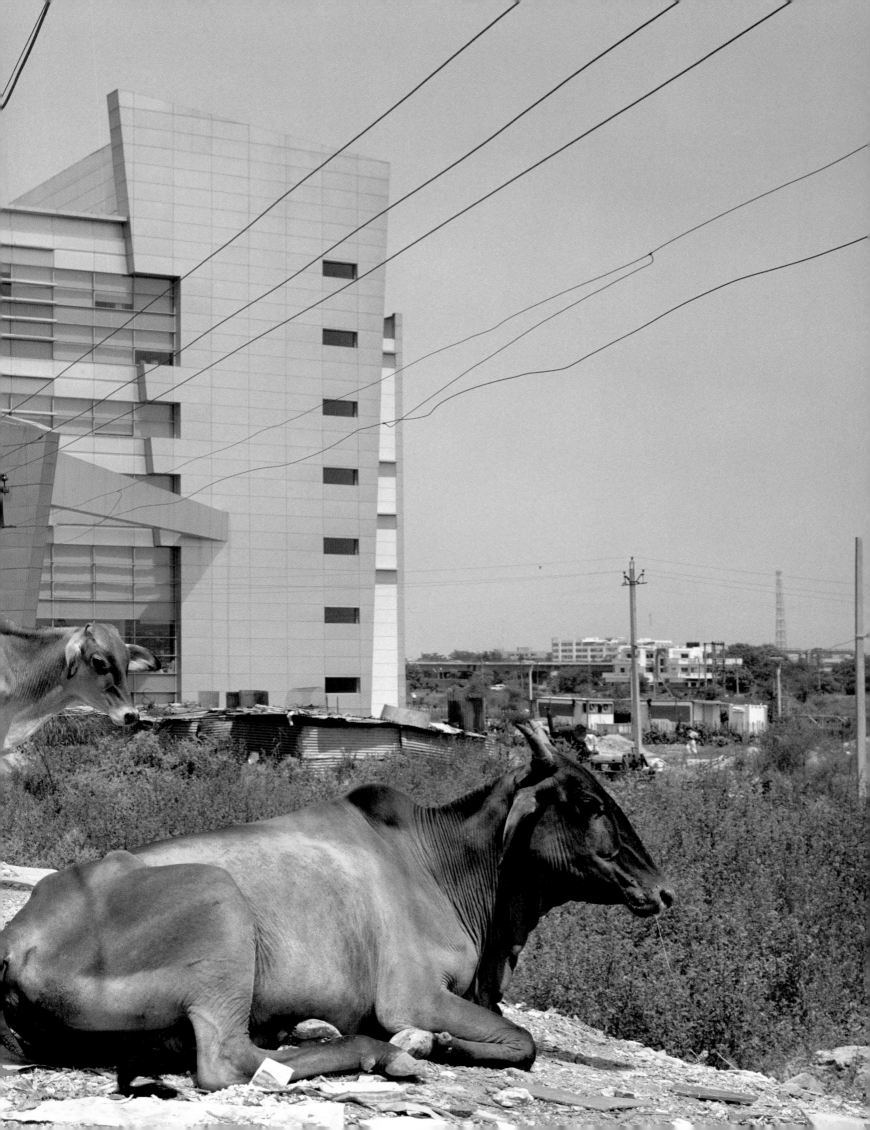

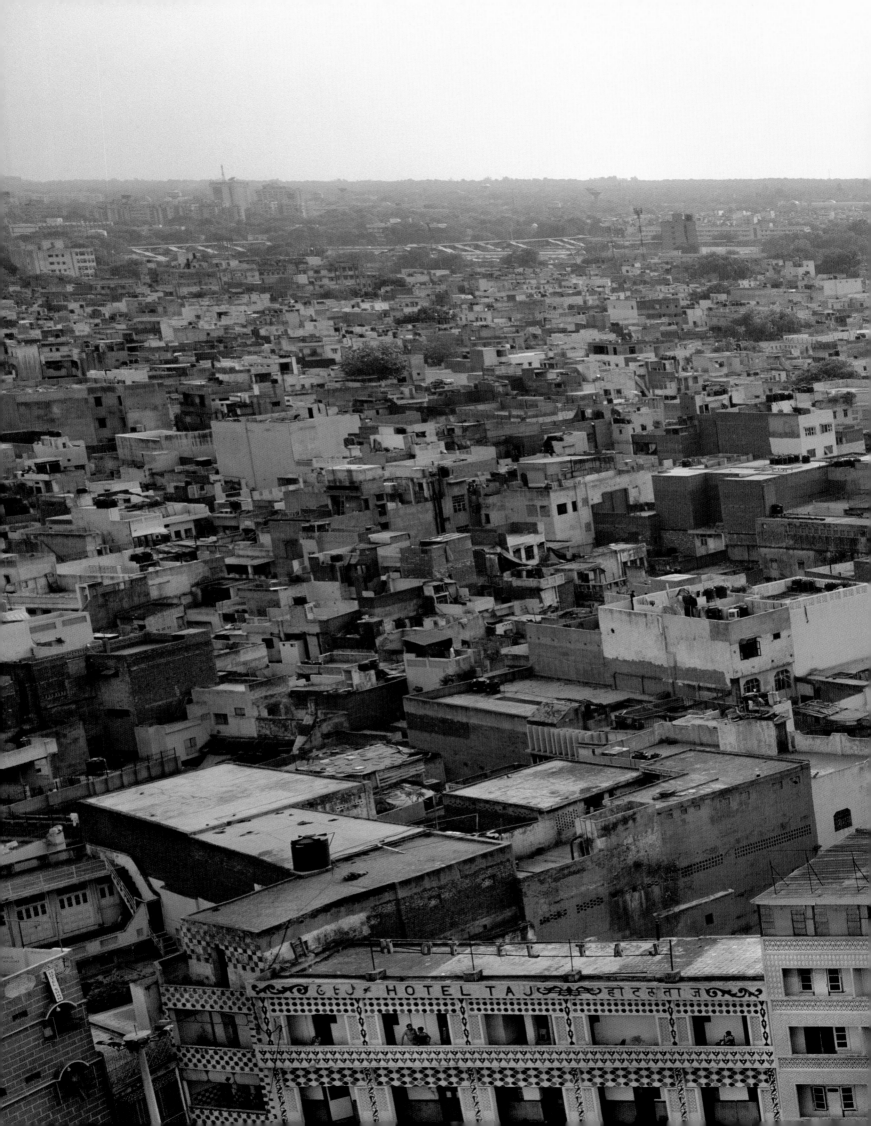

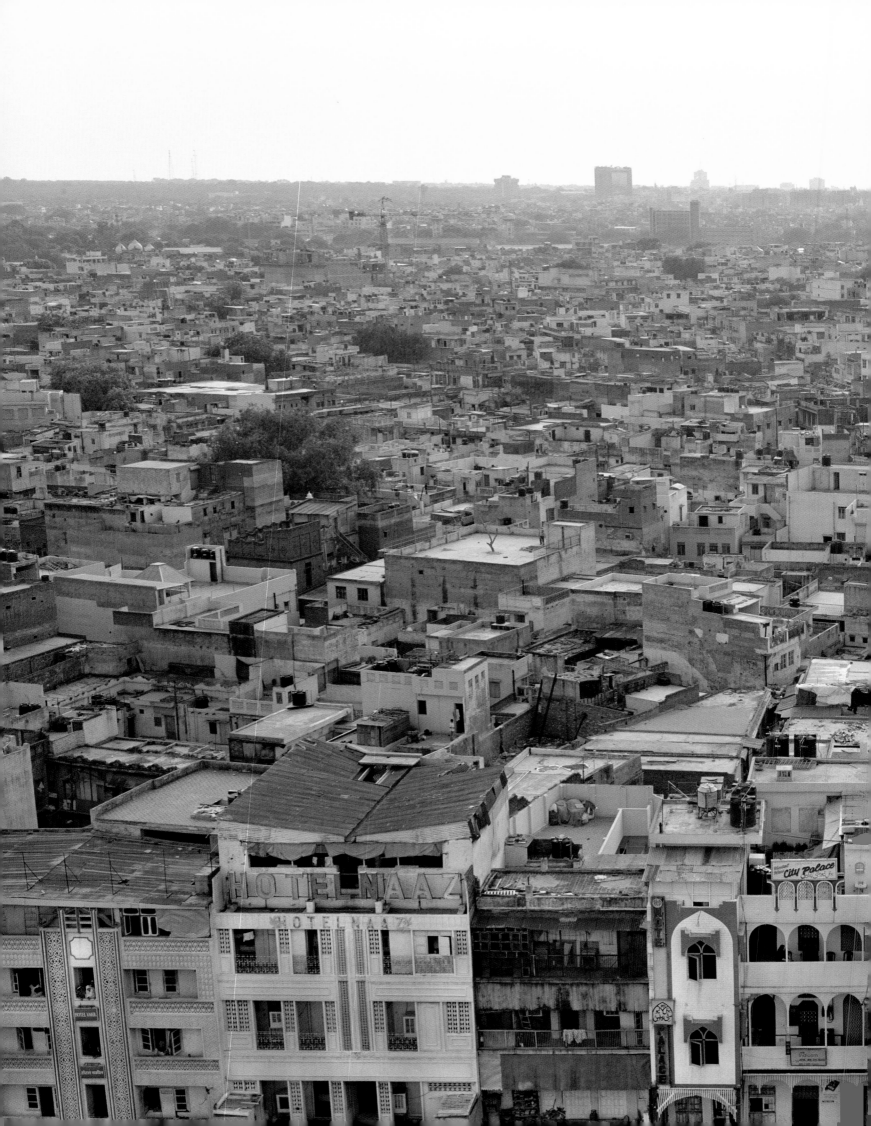

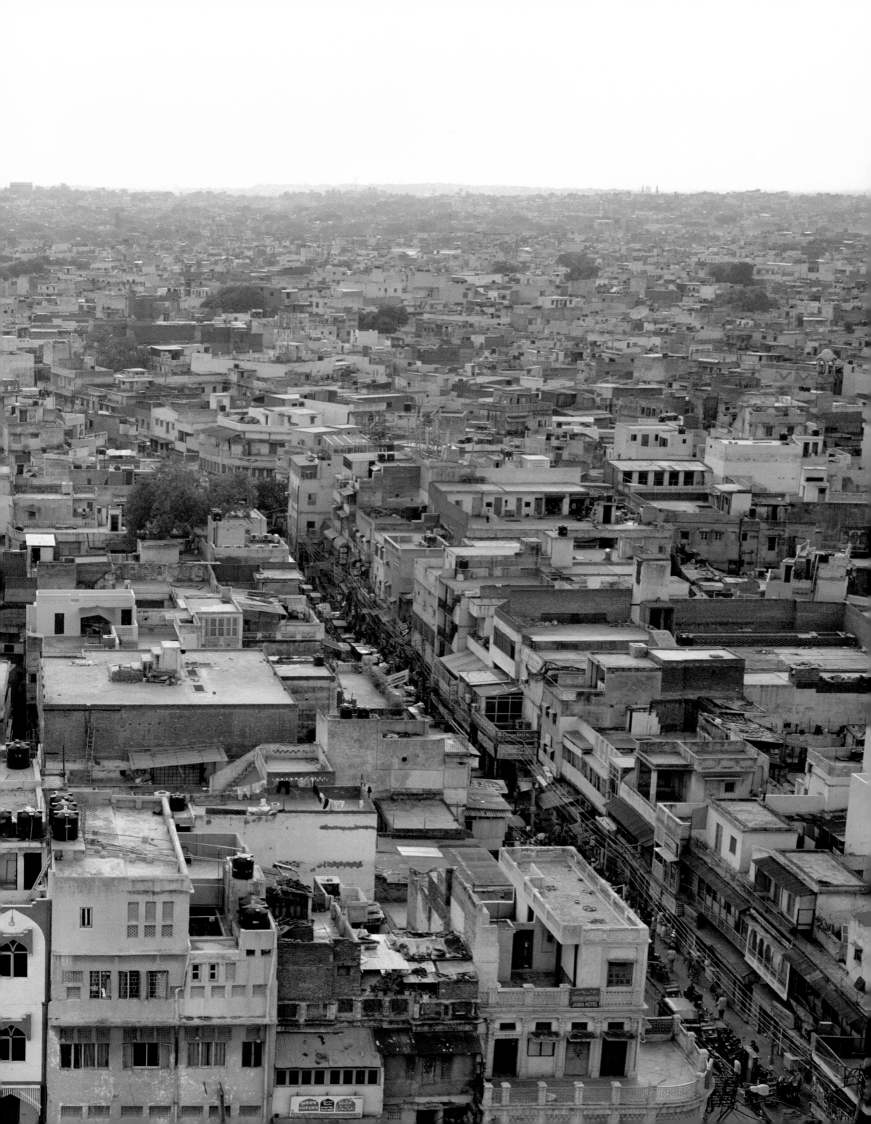

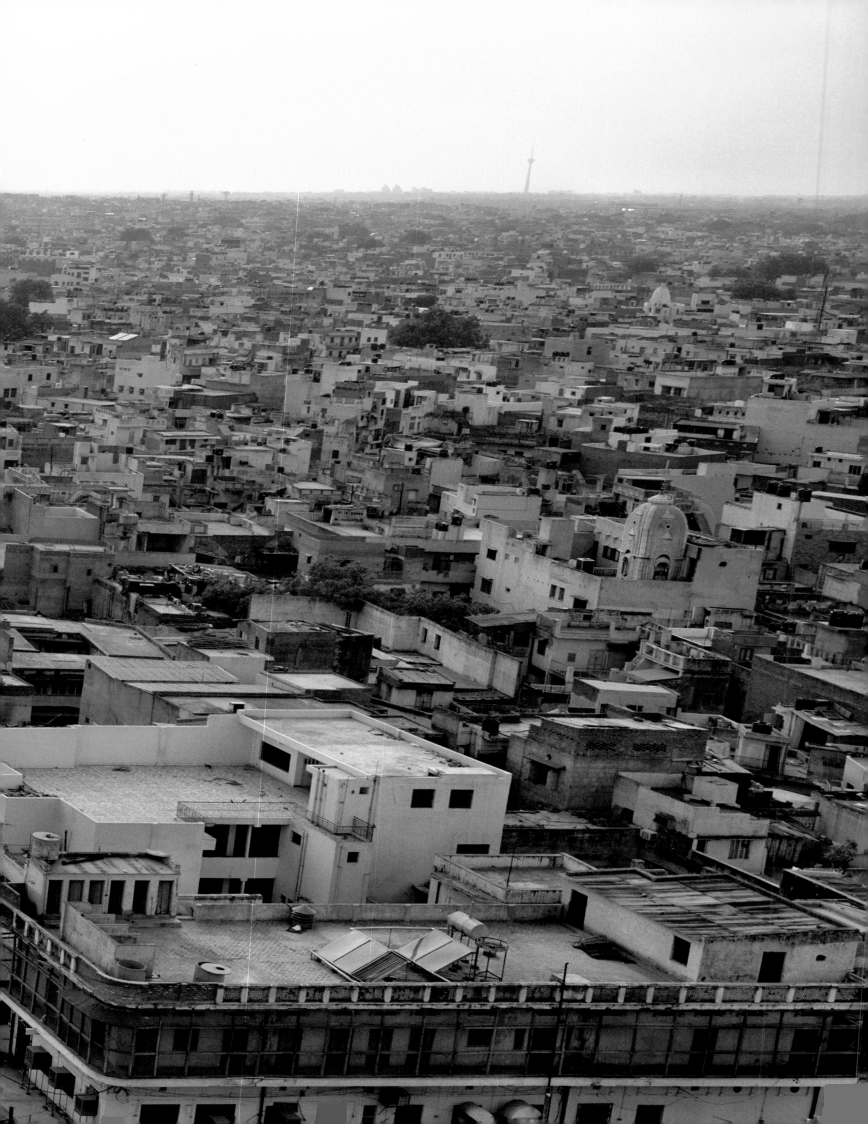

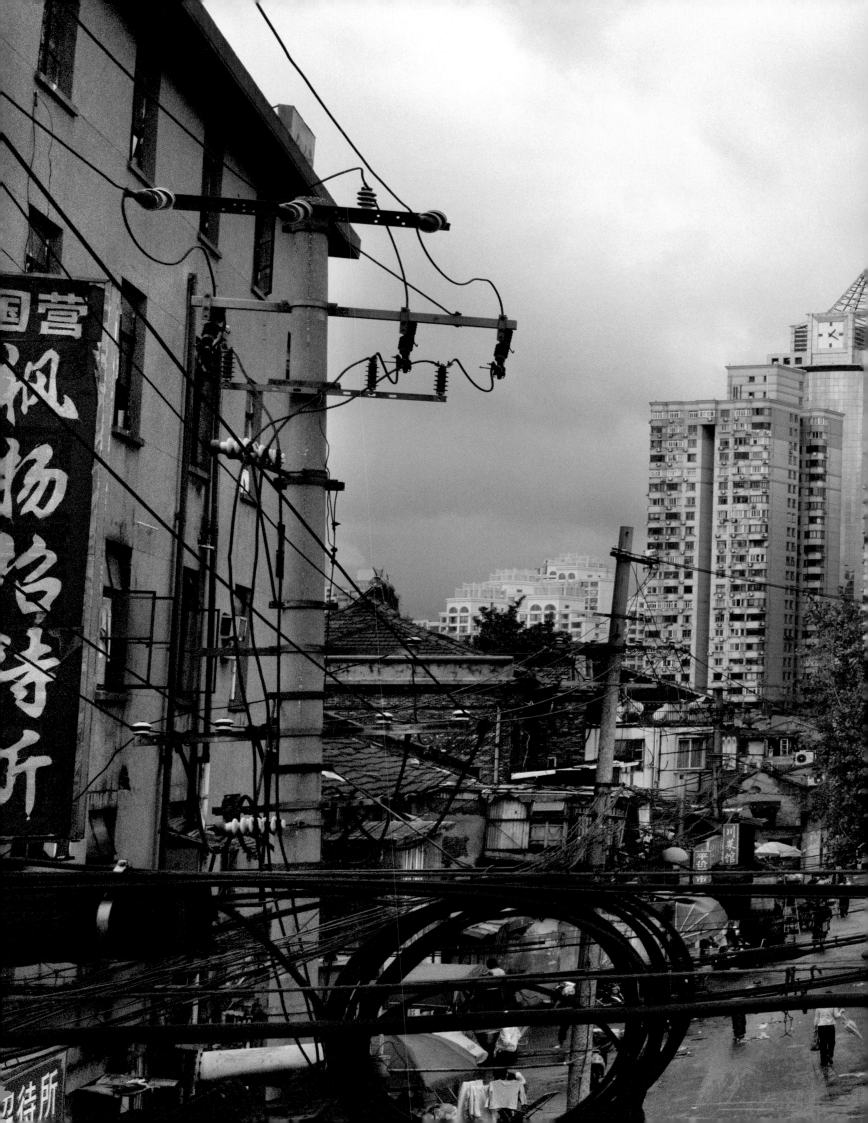

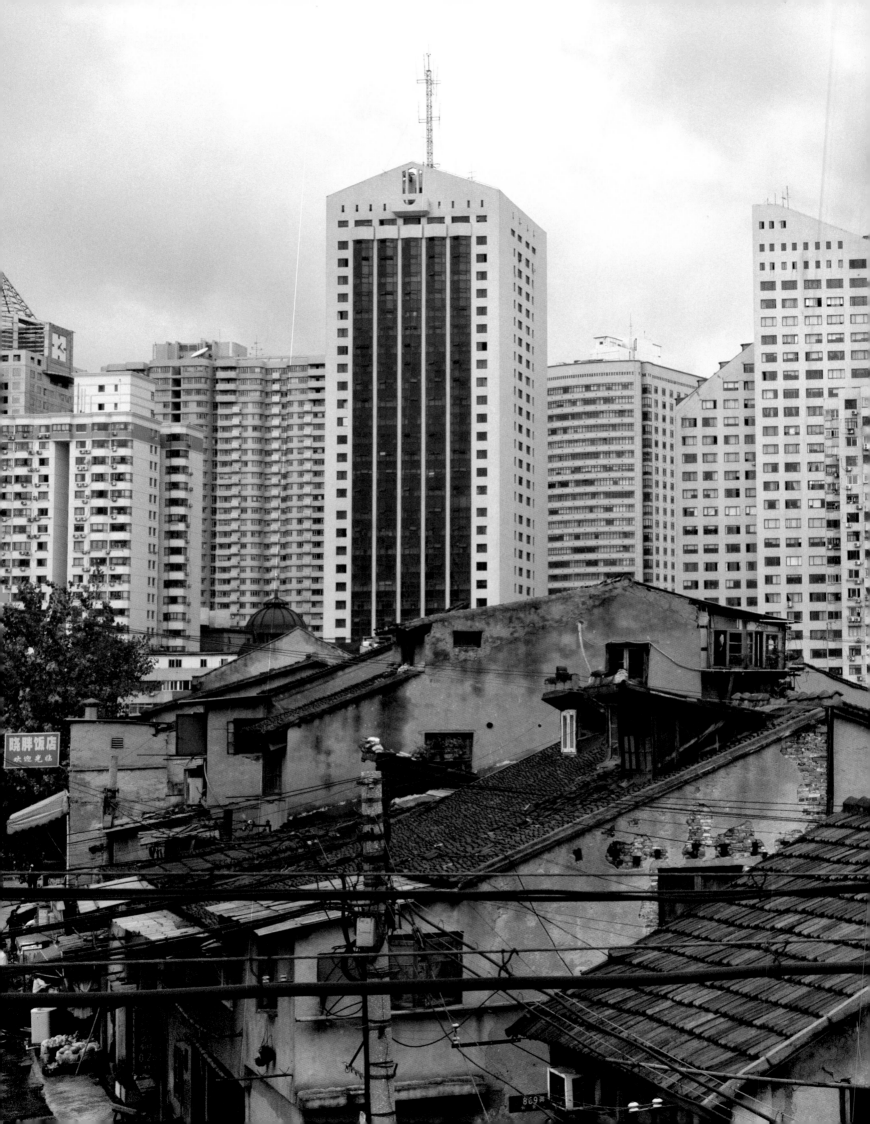

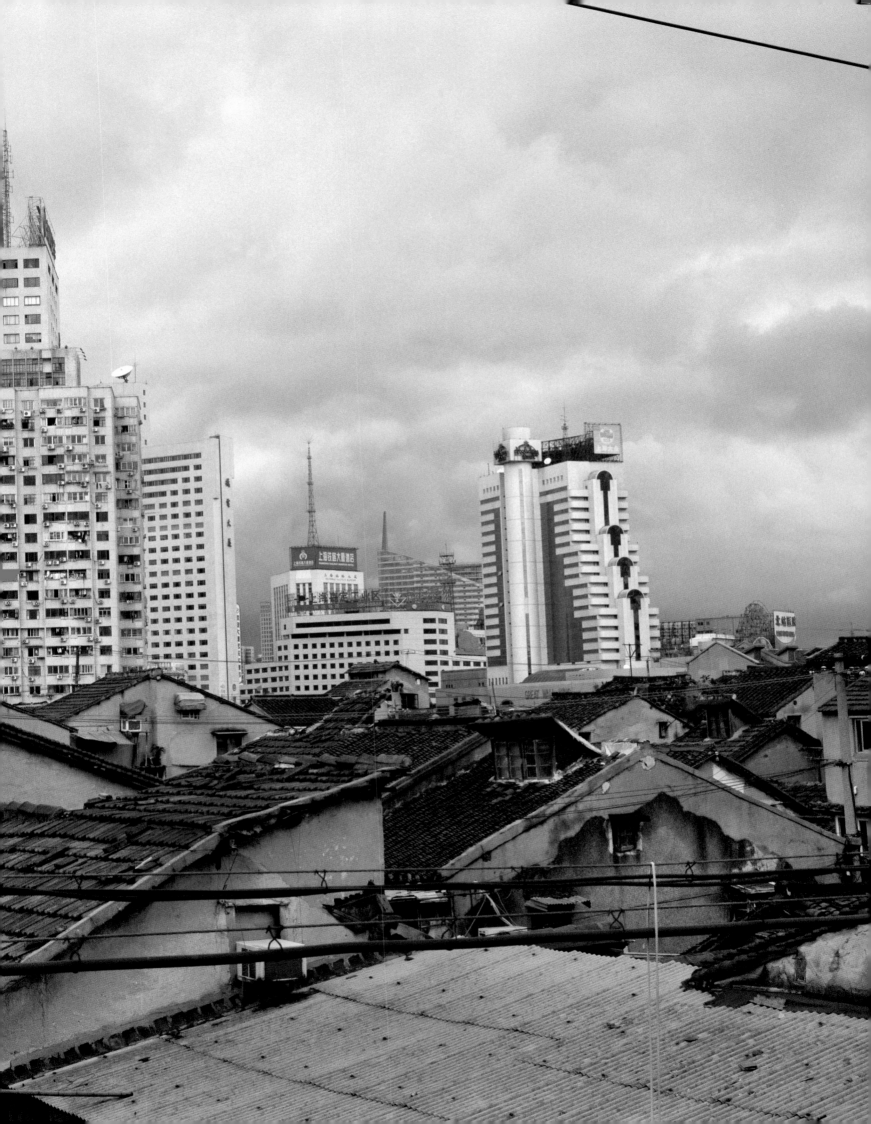

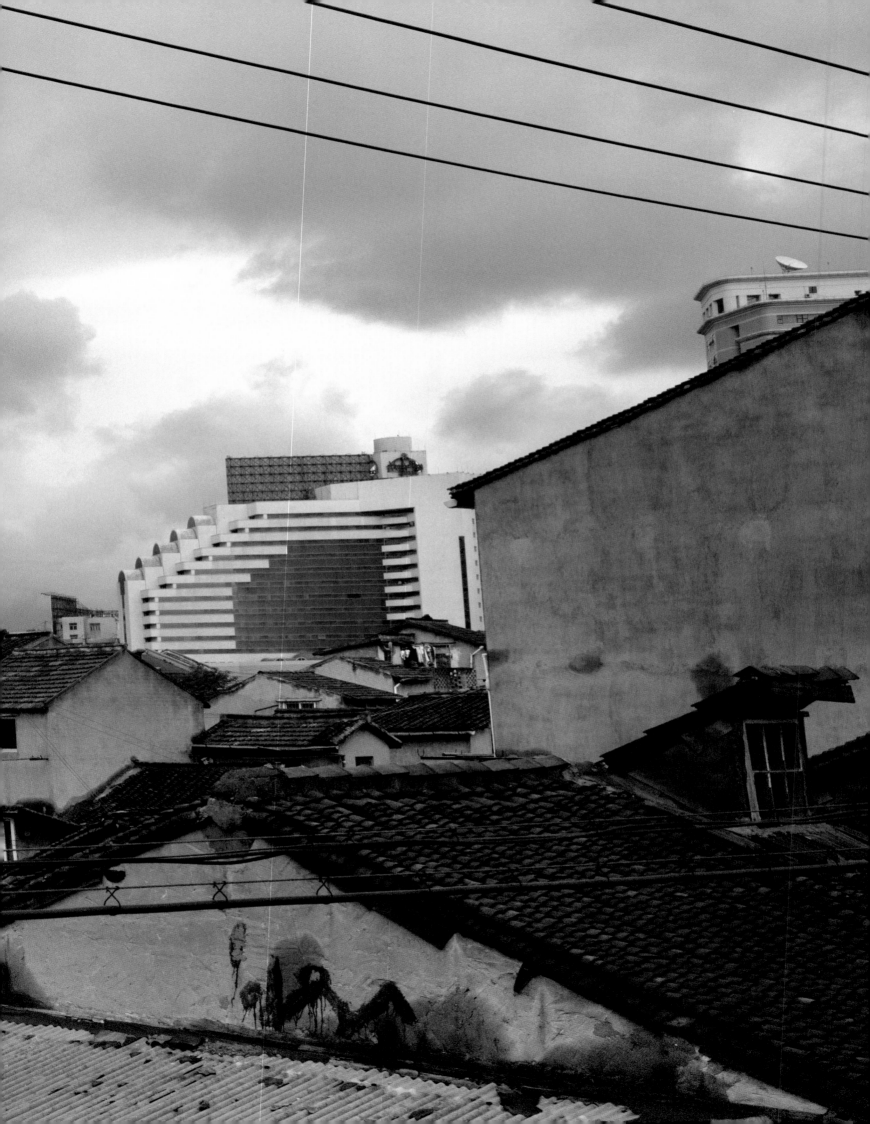

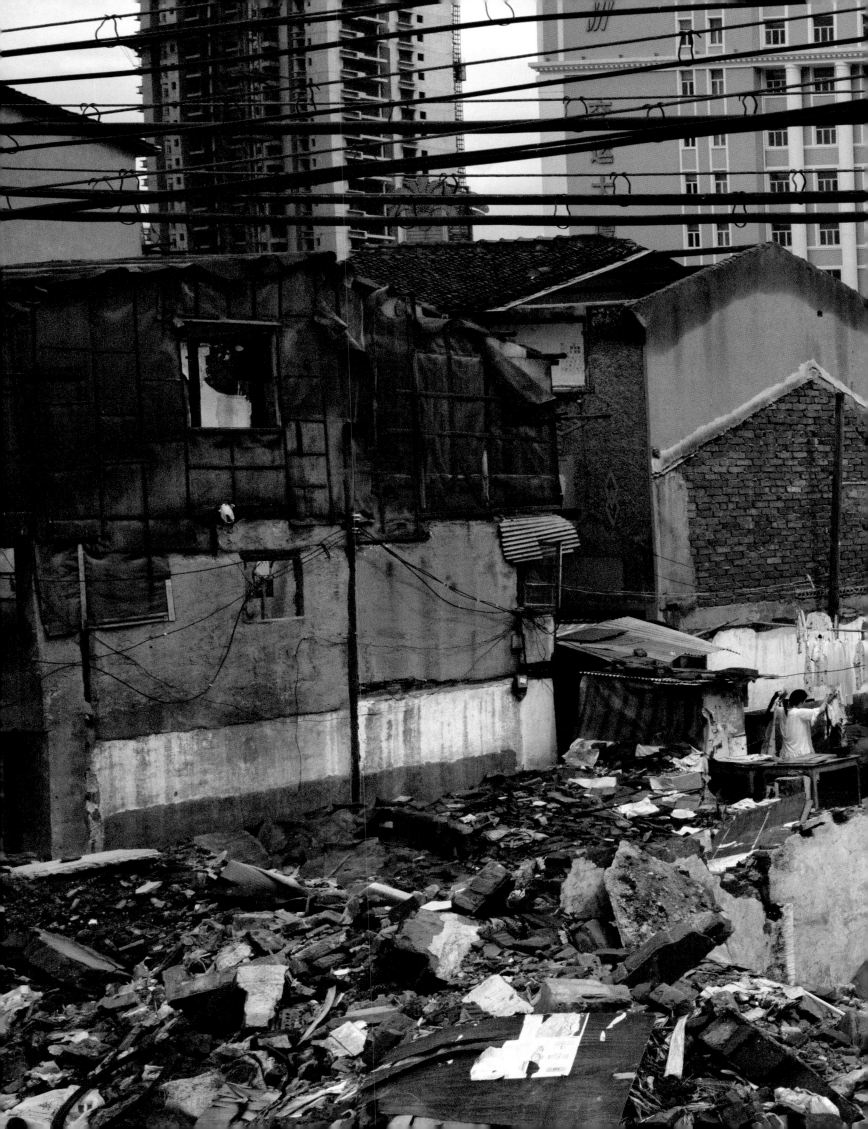

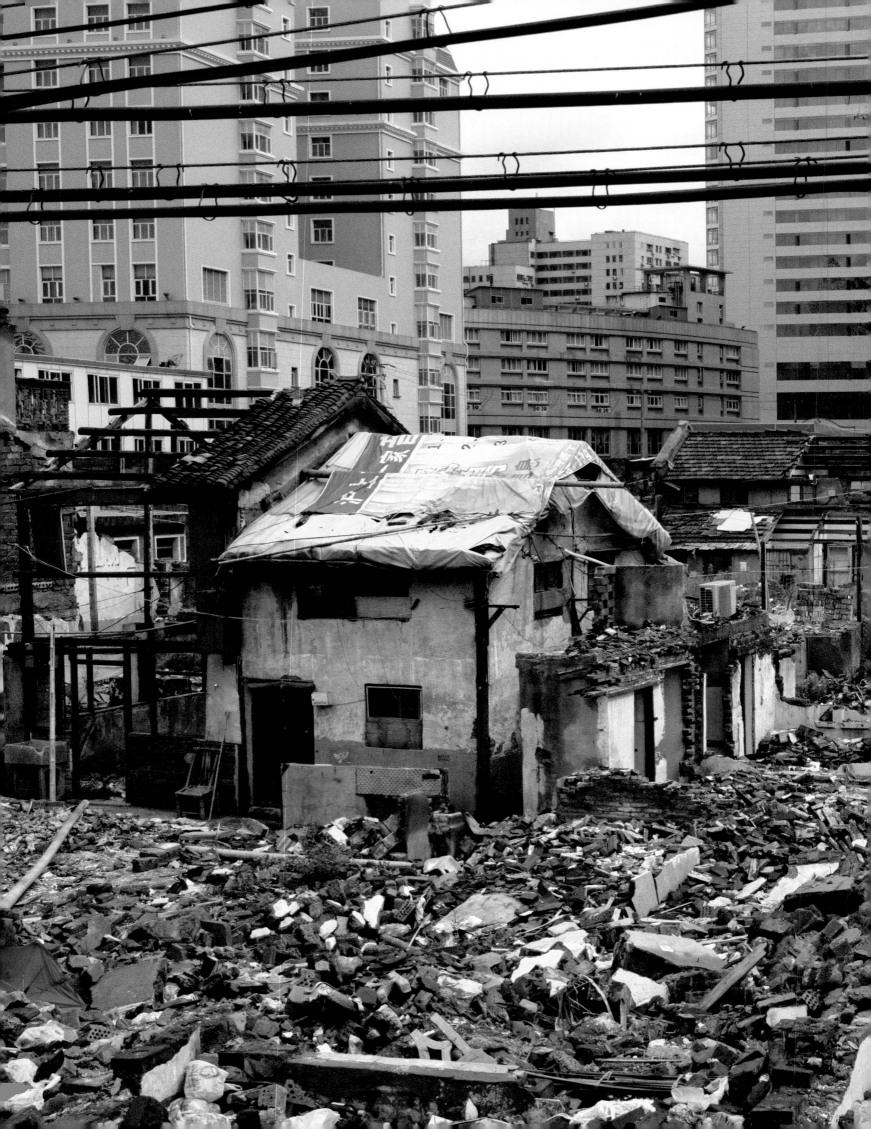

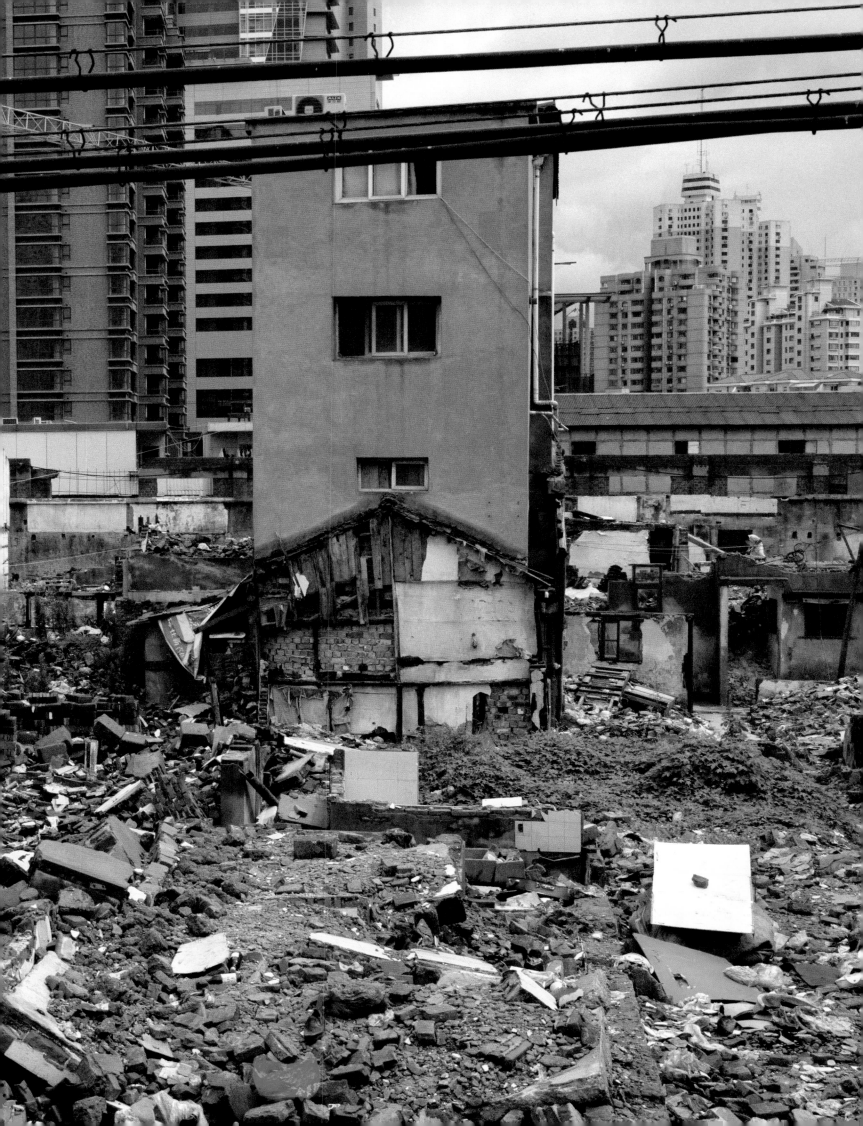

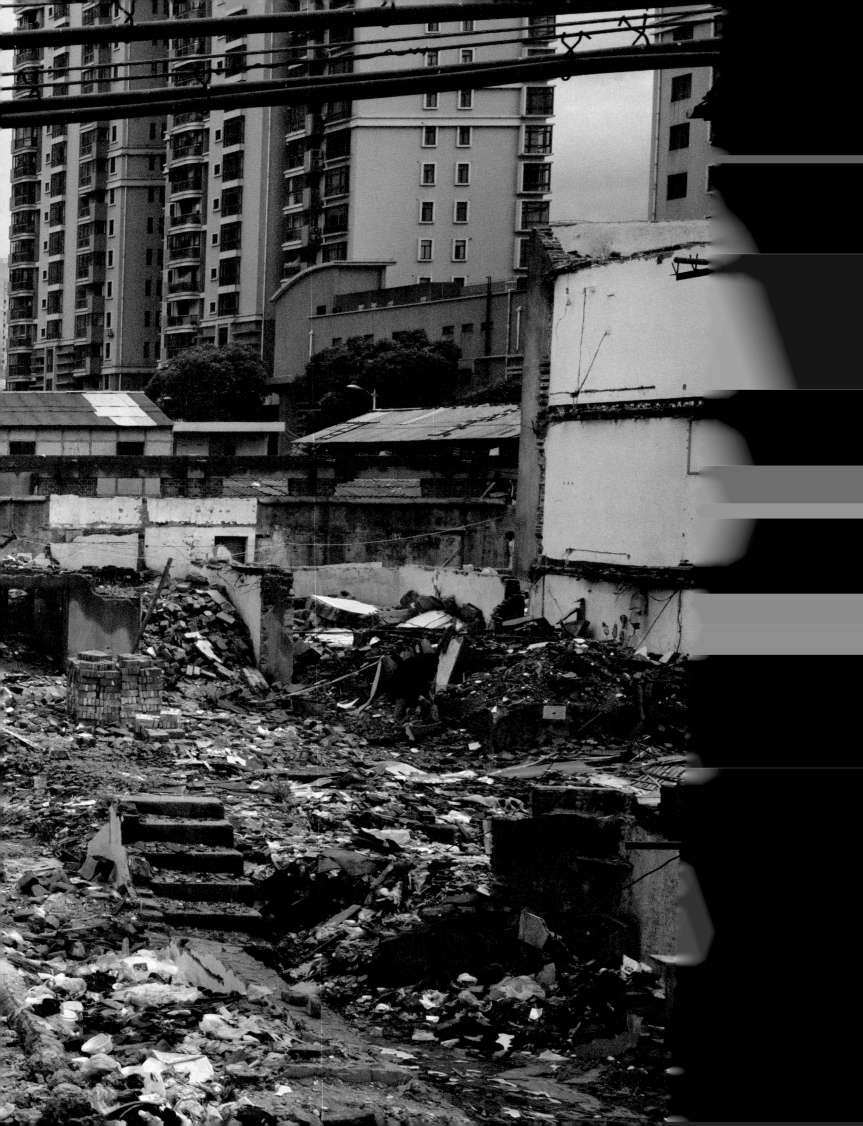

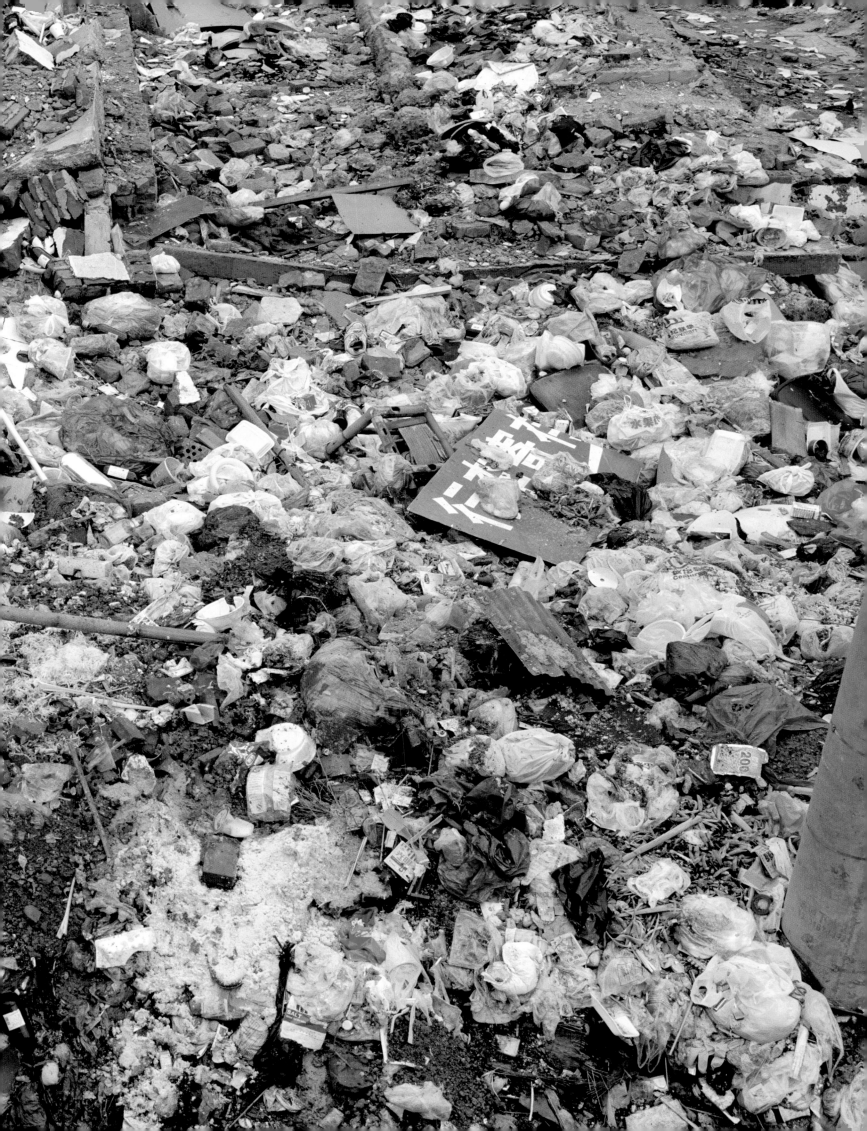

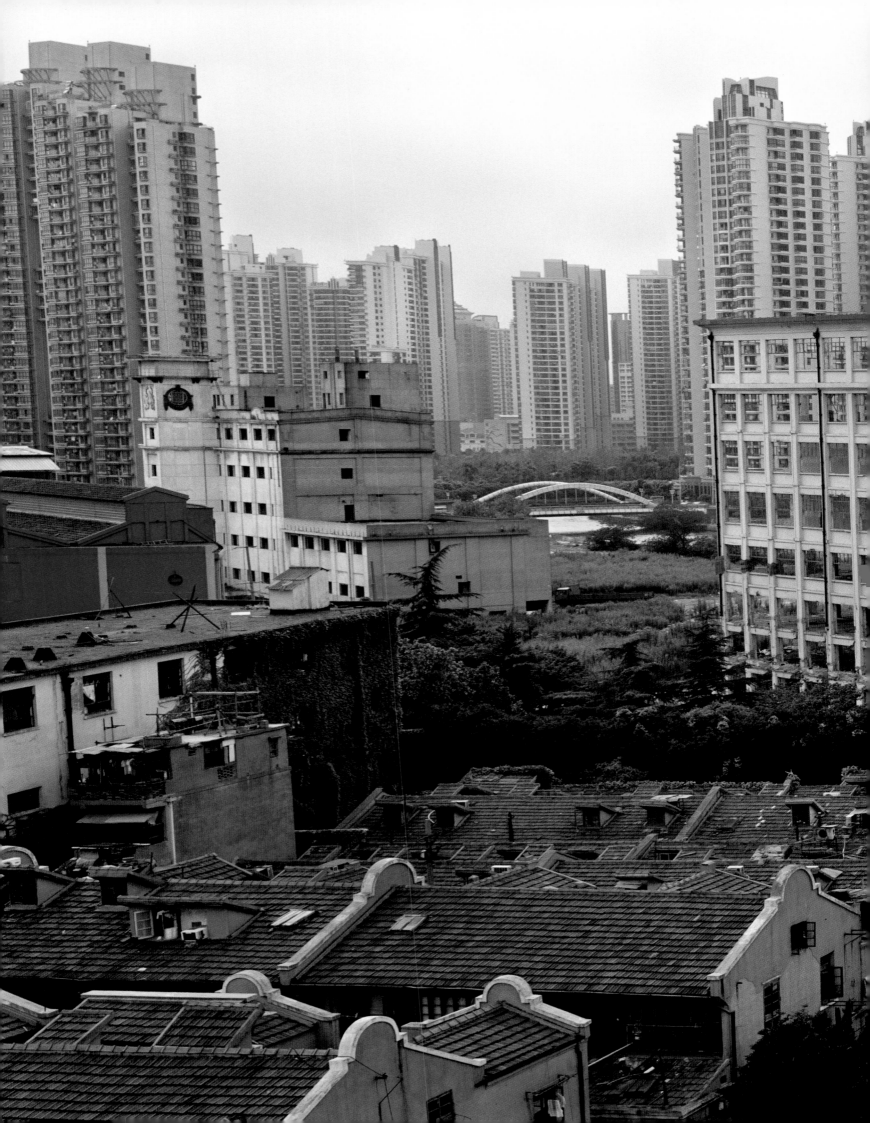

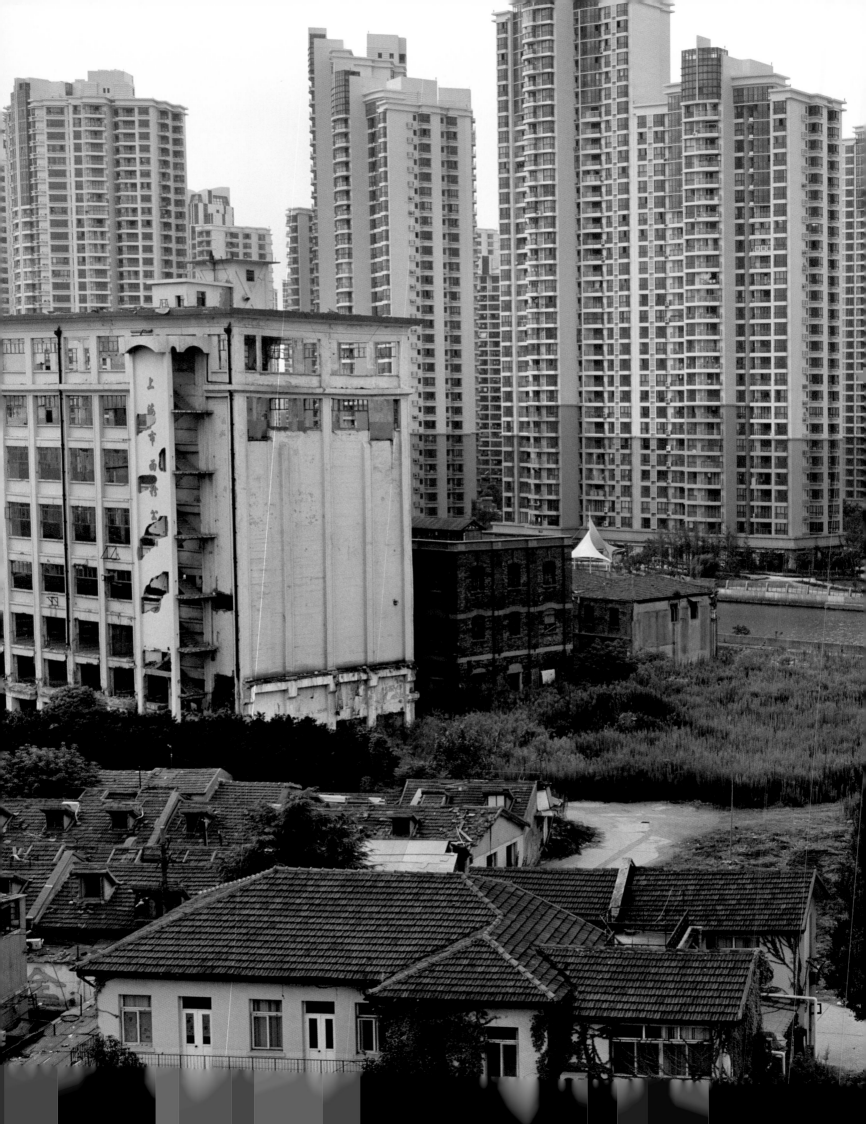

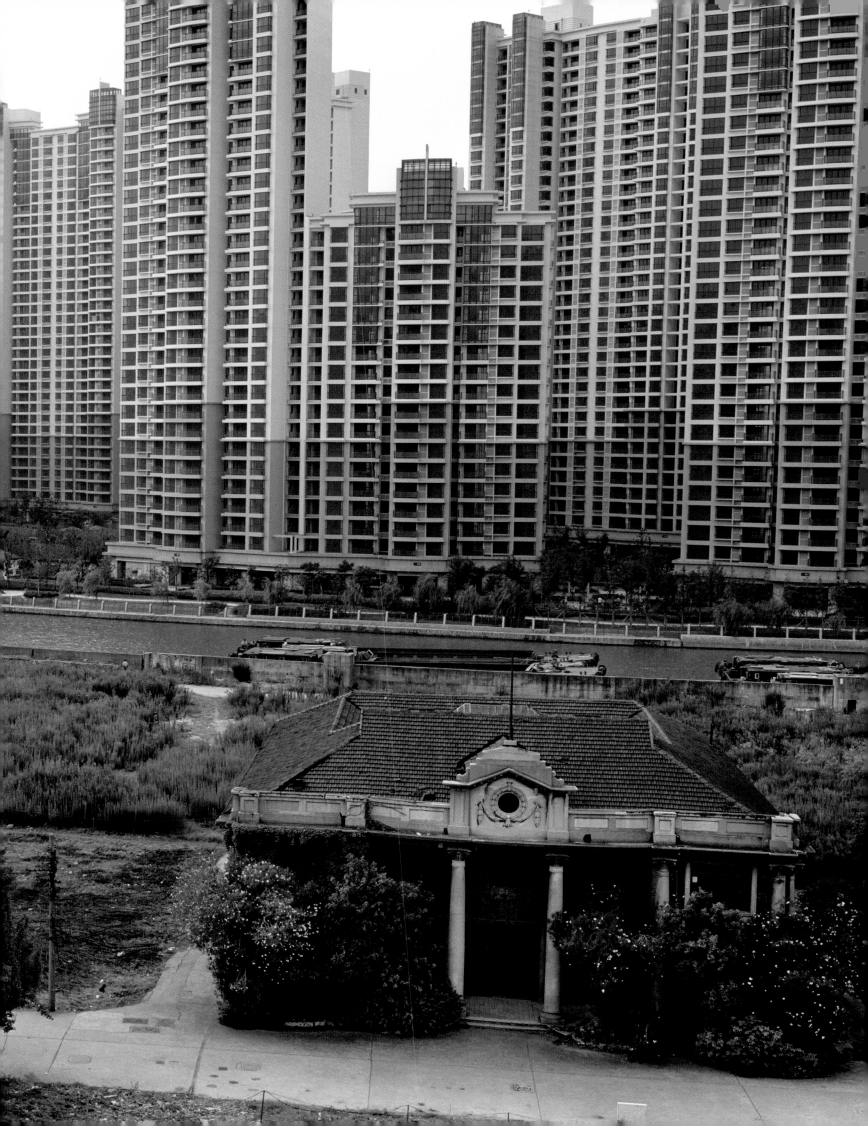

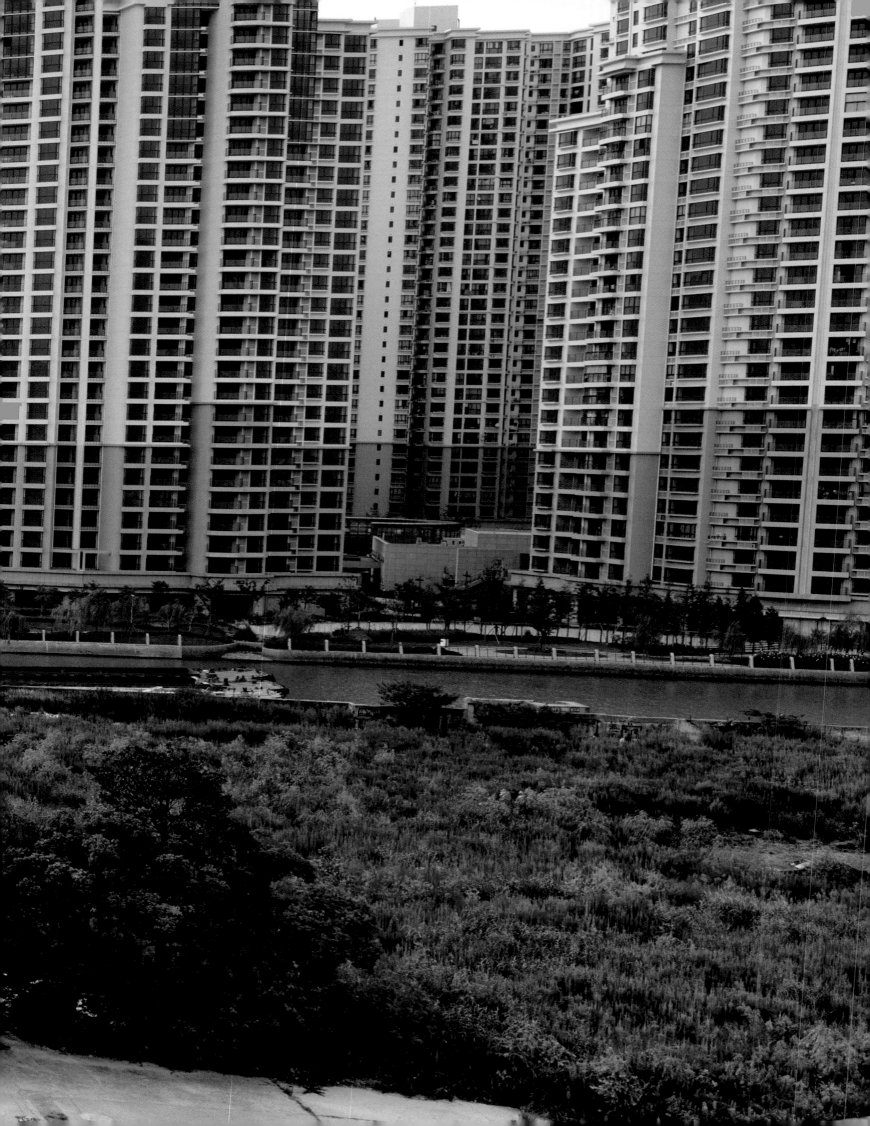

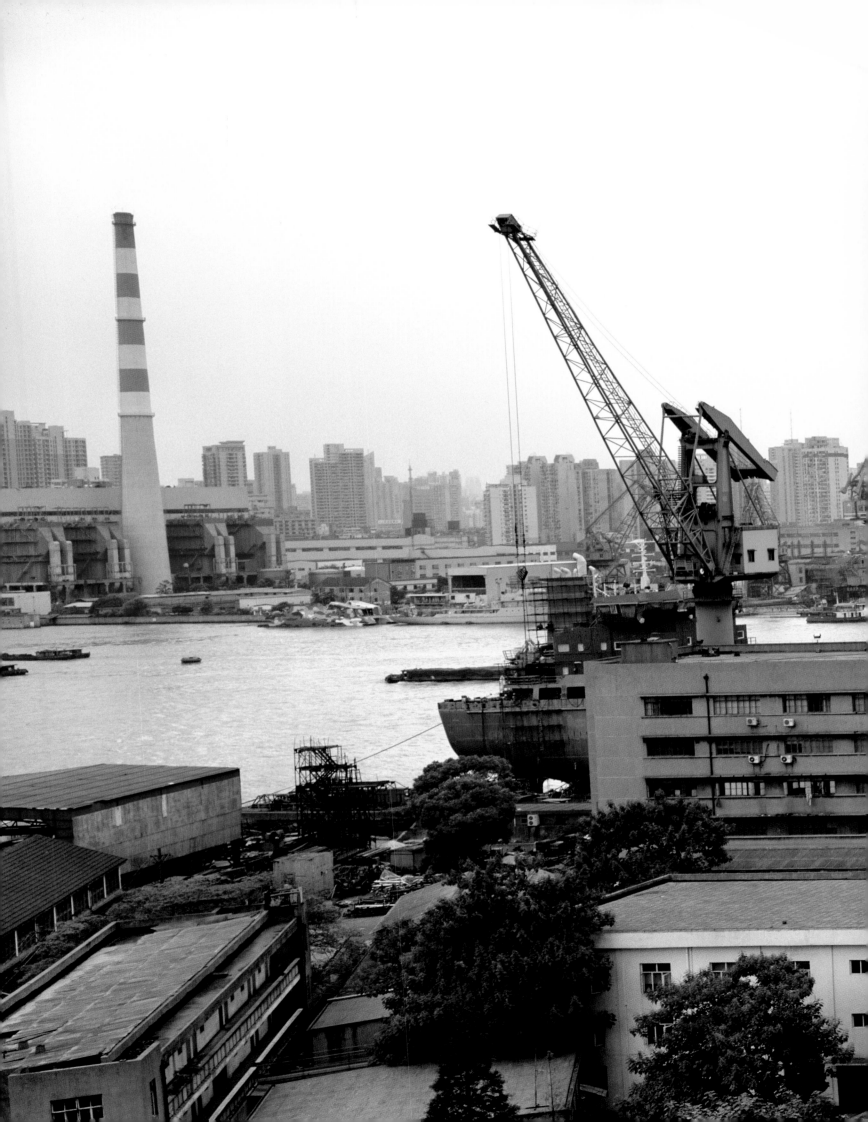

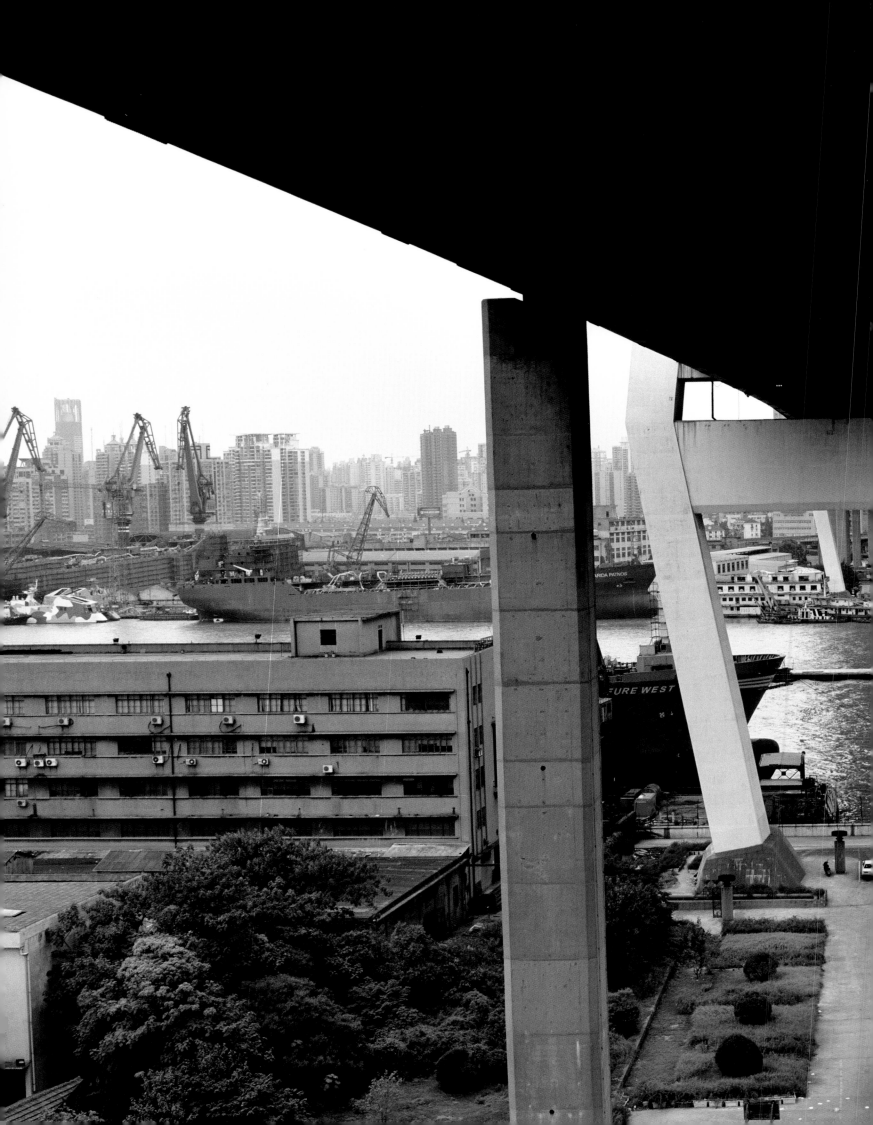

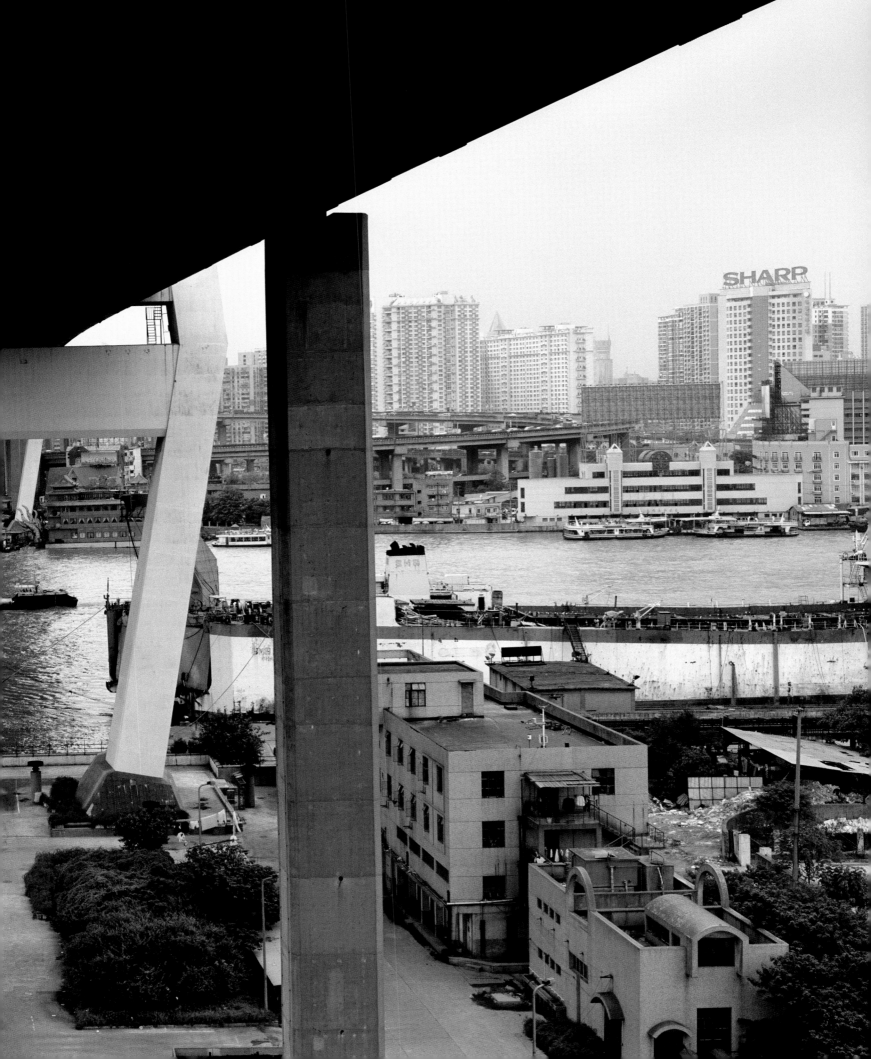

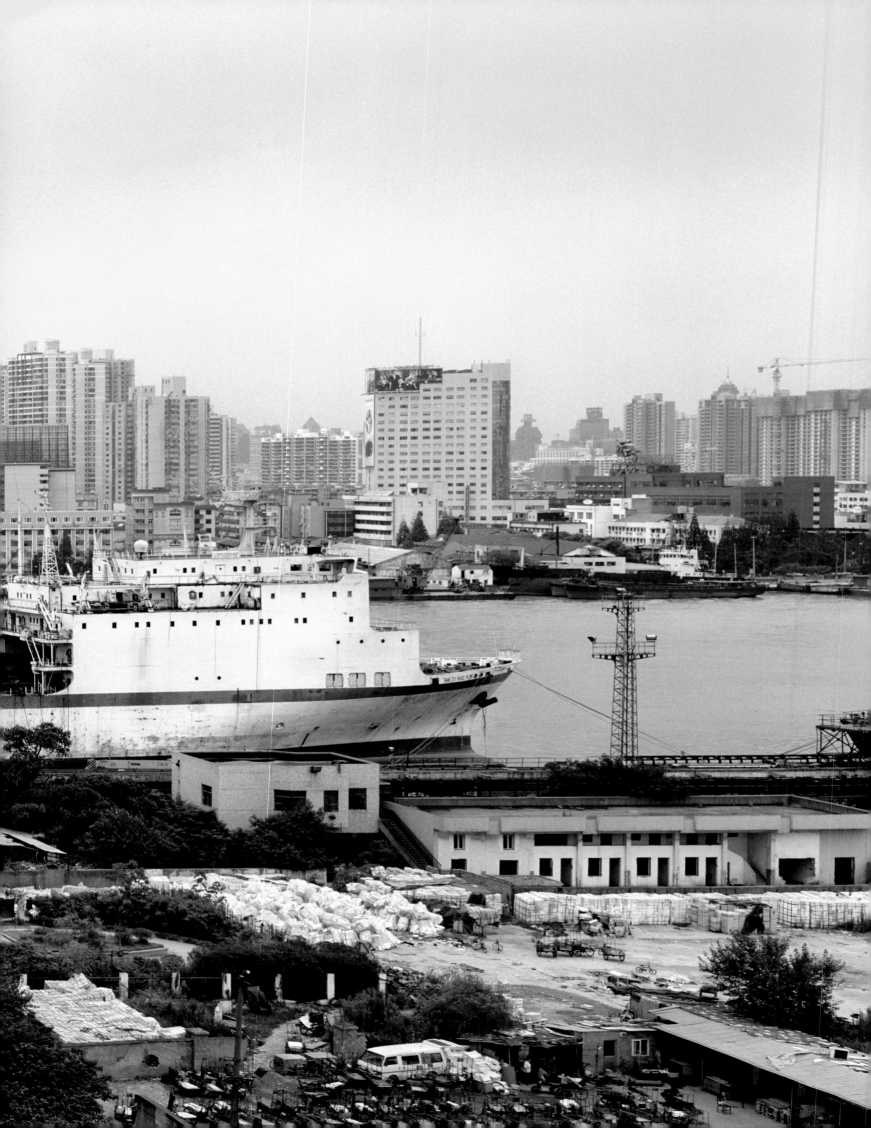

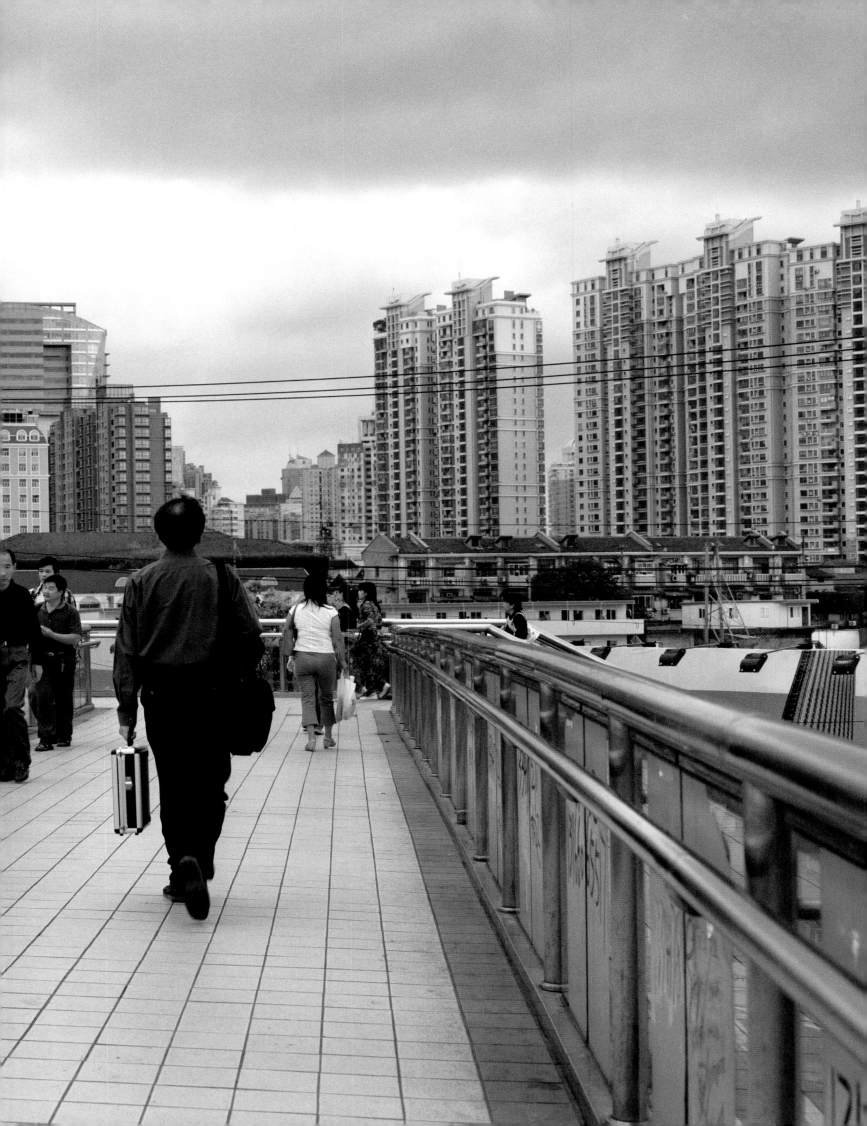

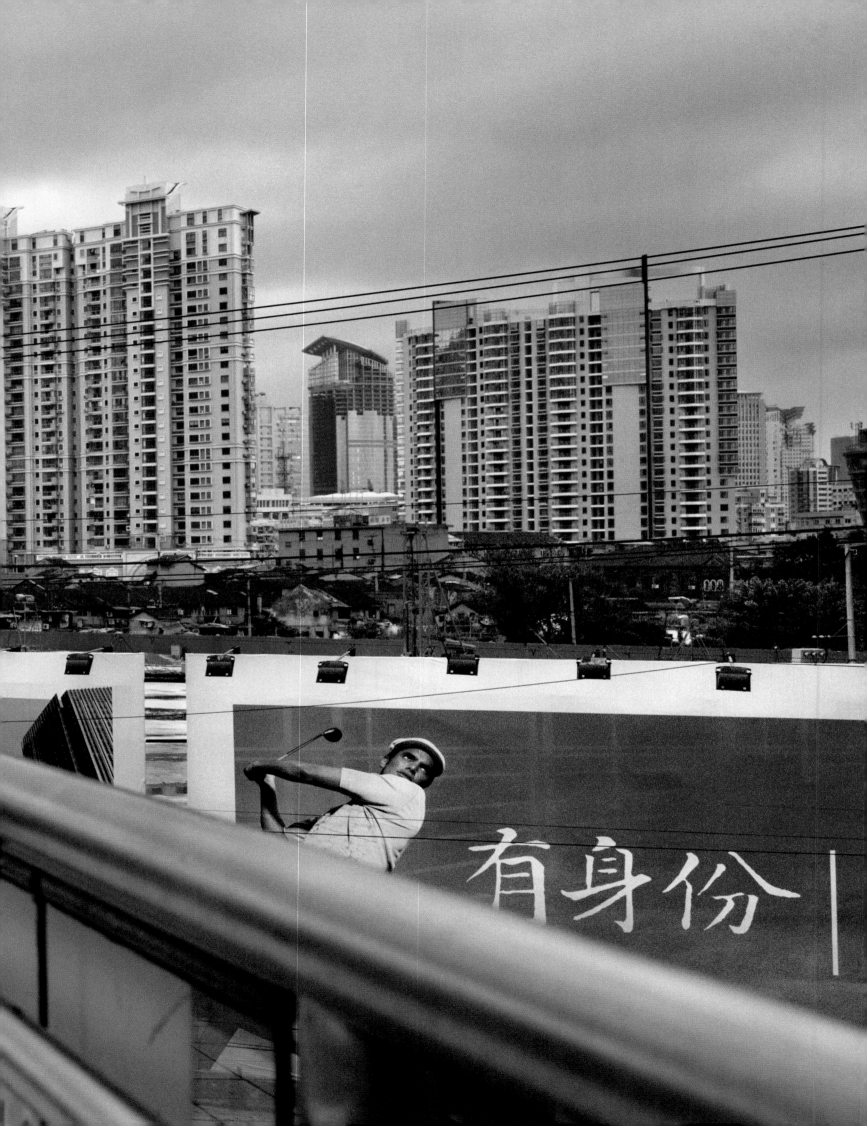

有身份

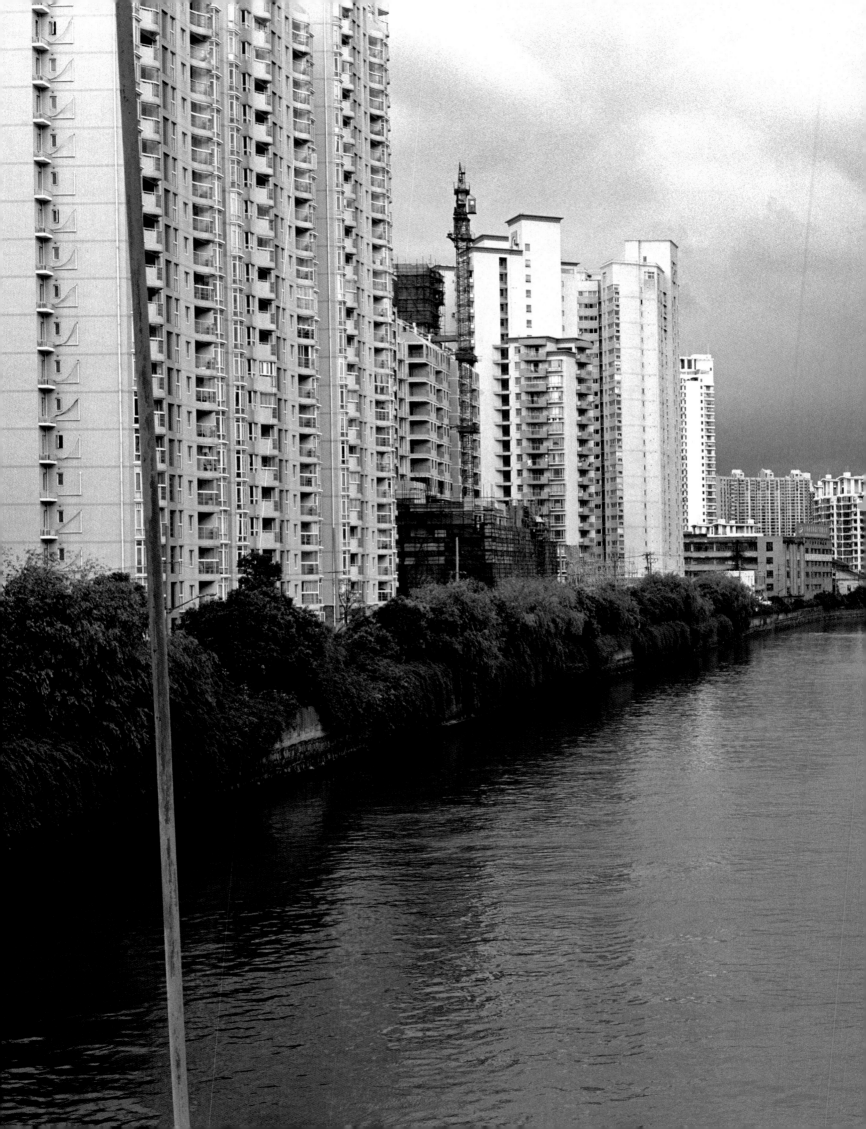

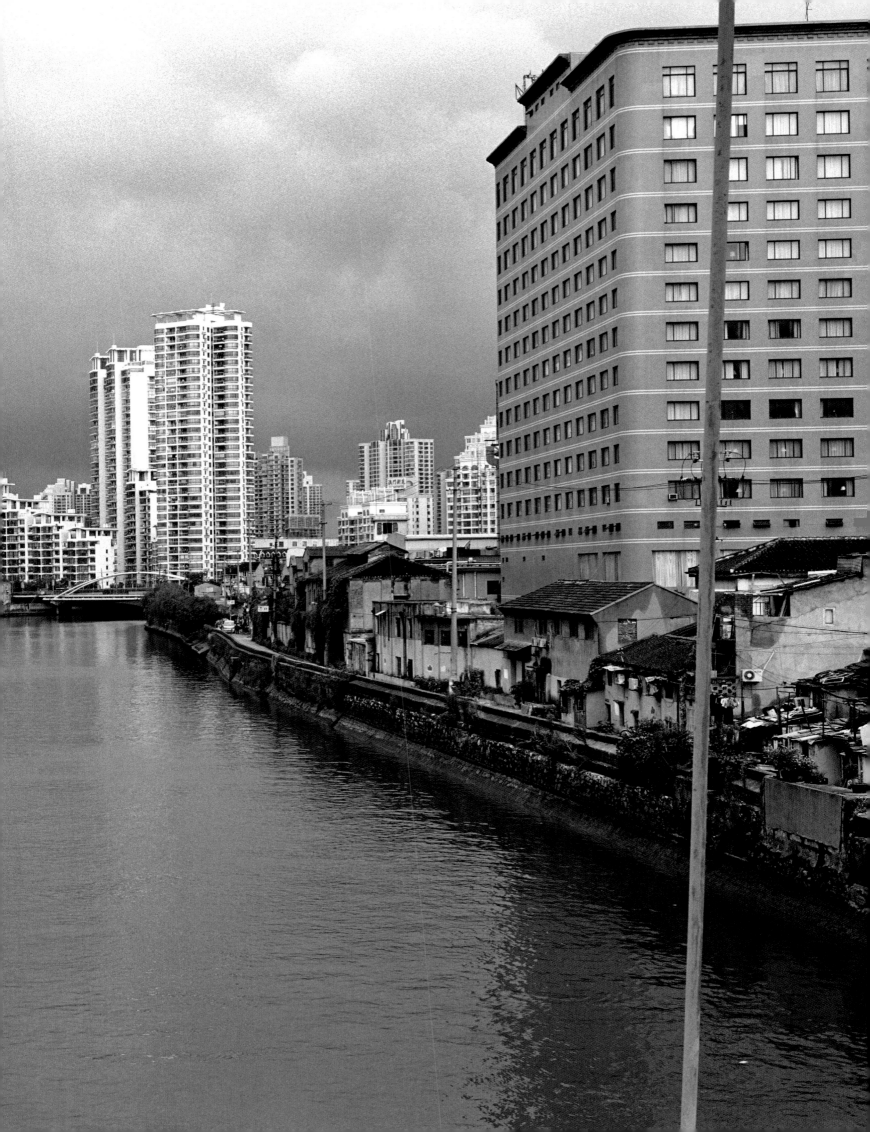

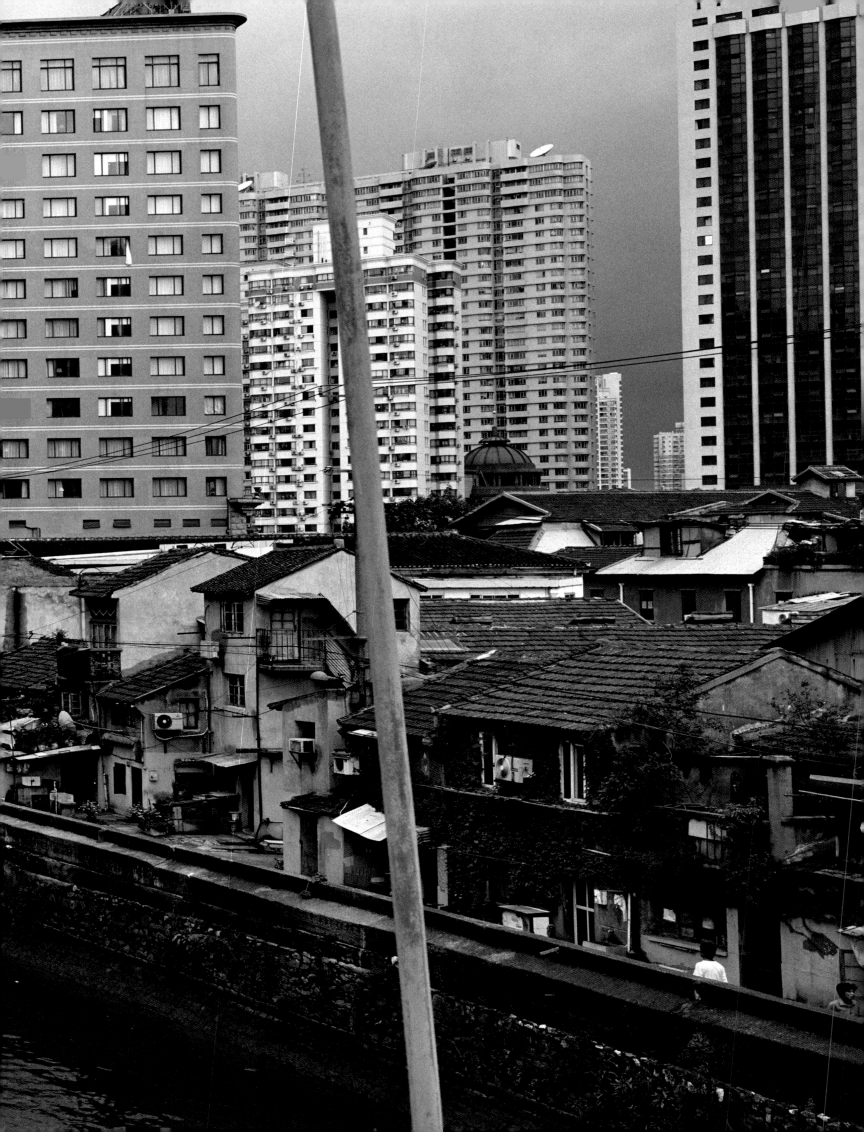

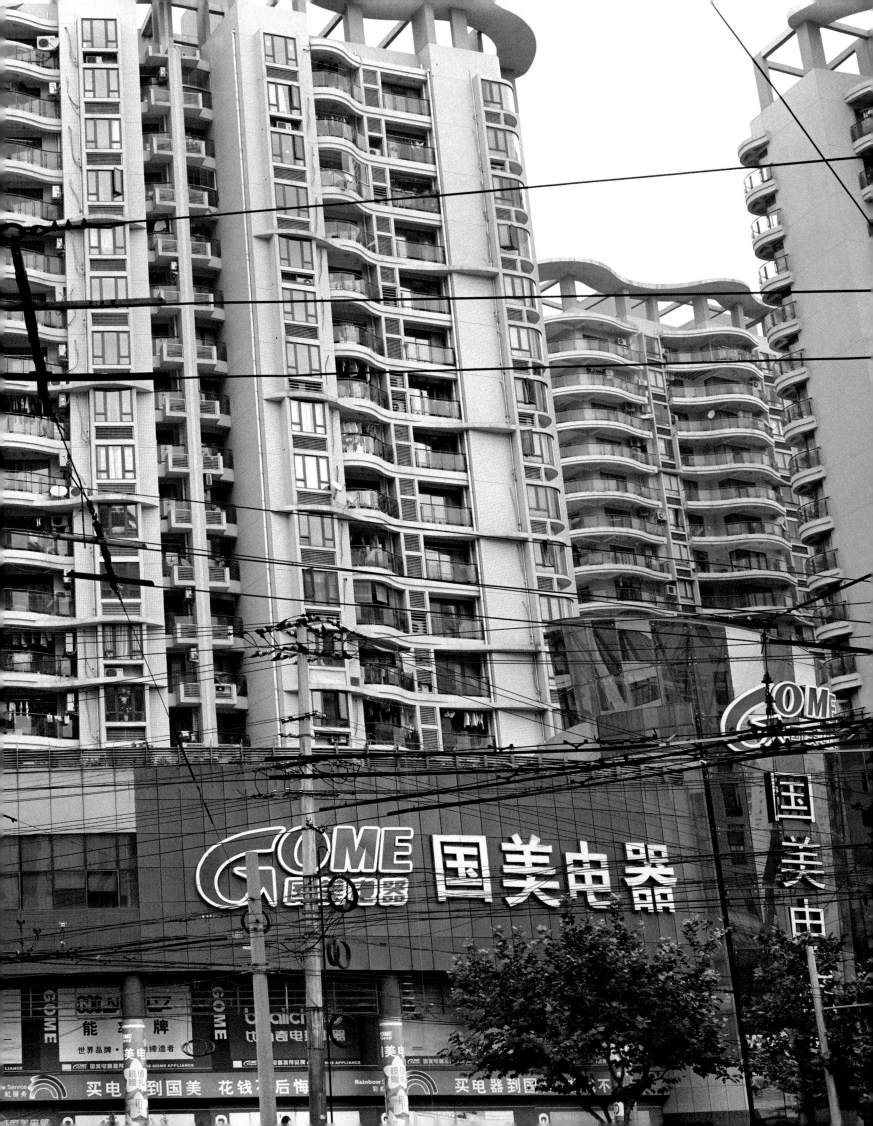

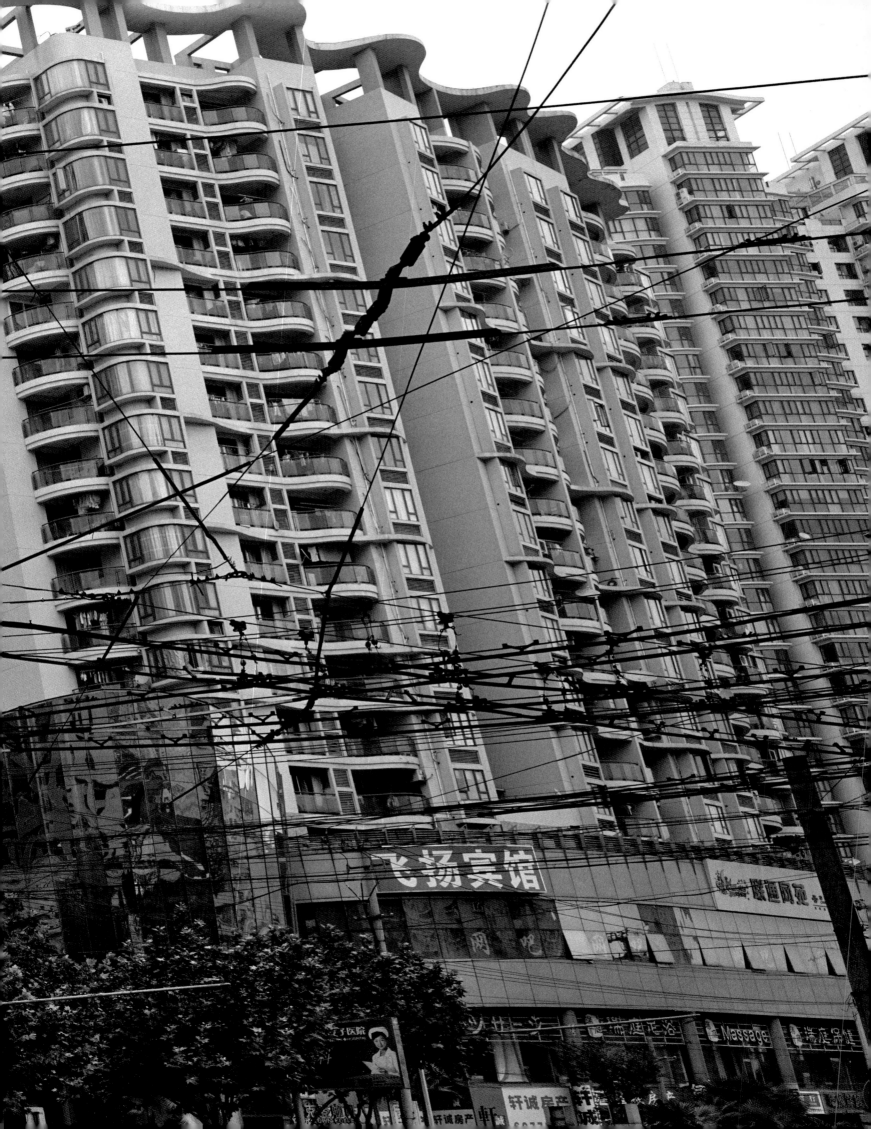

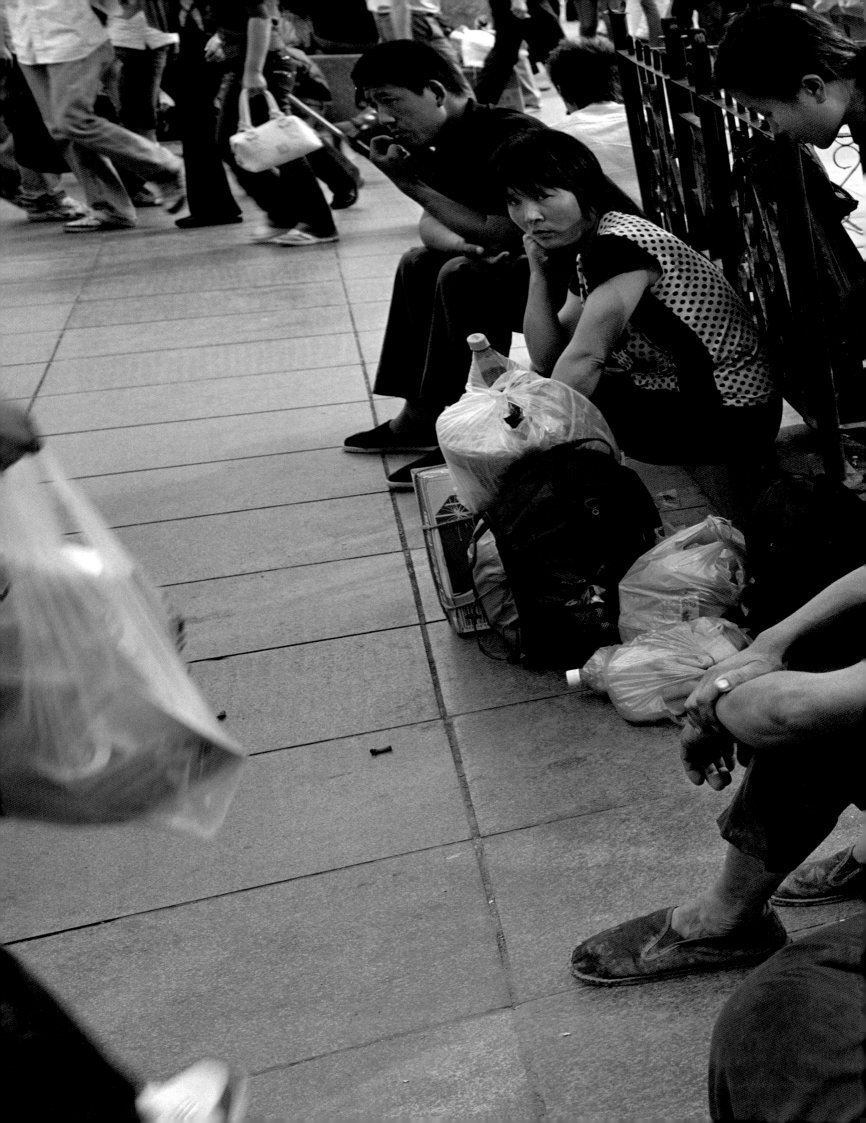

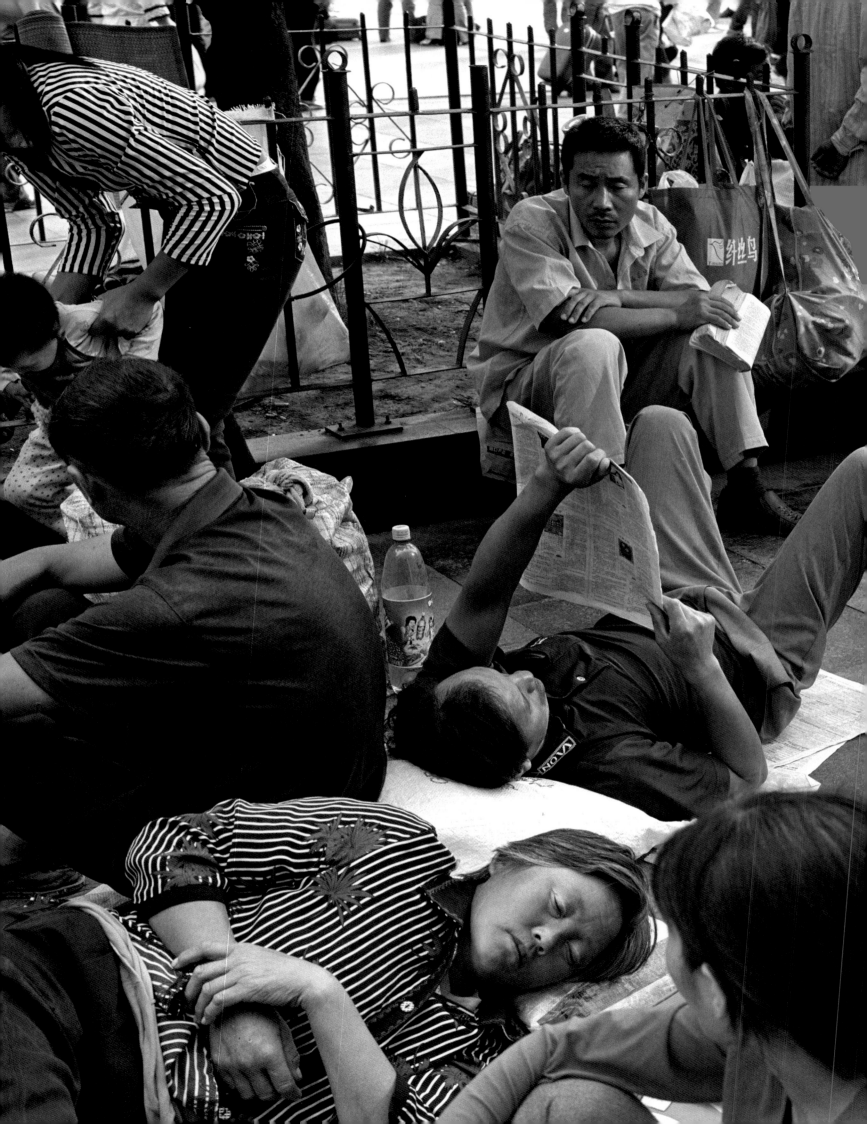

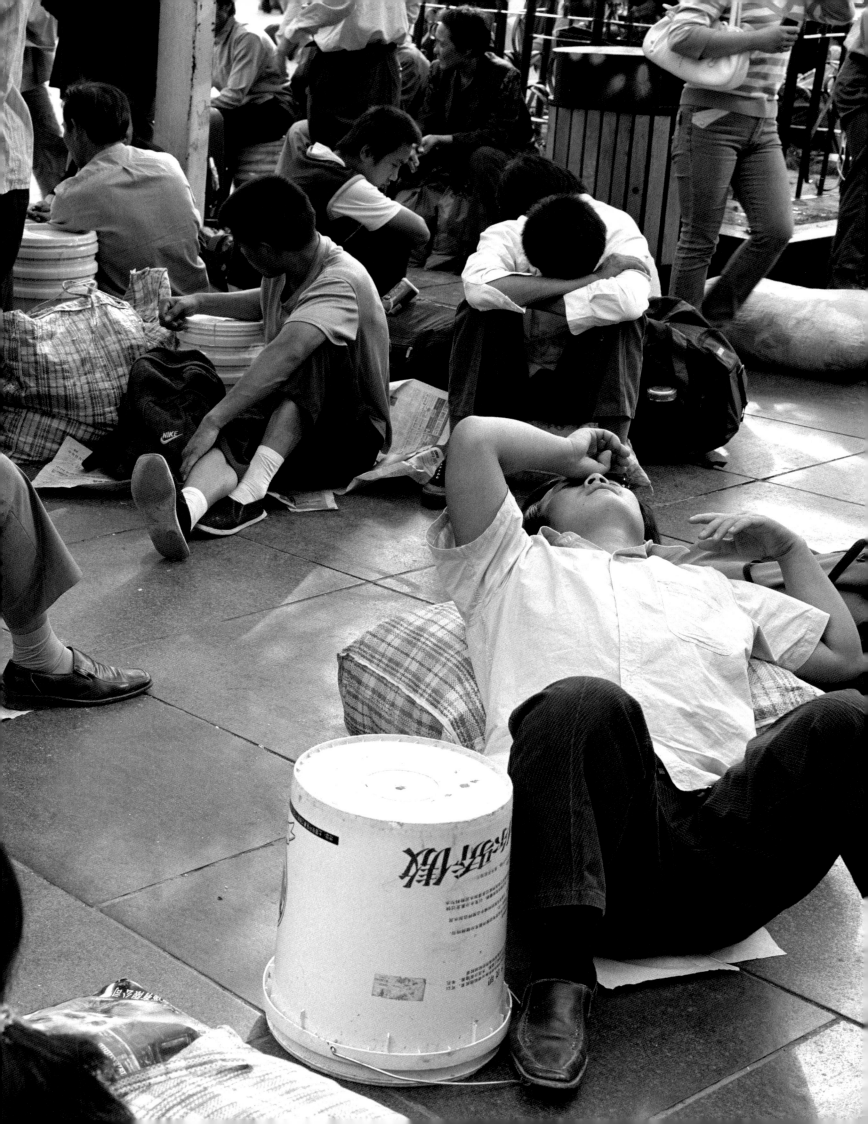

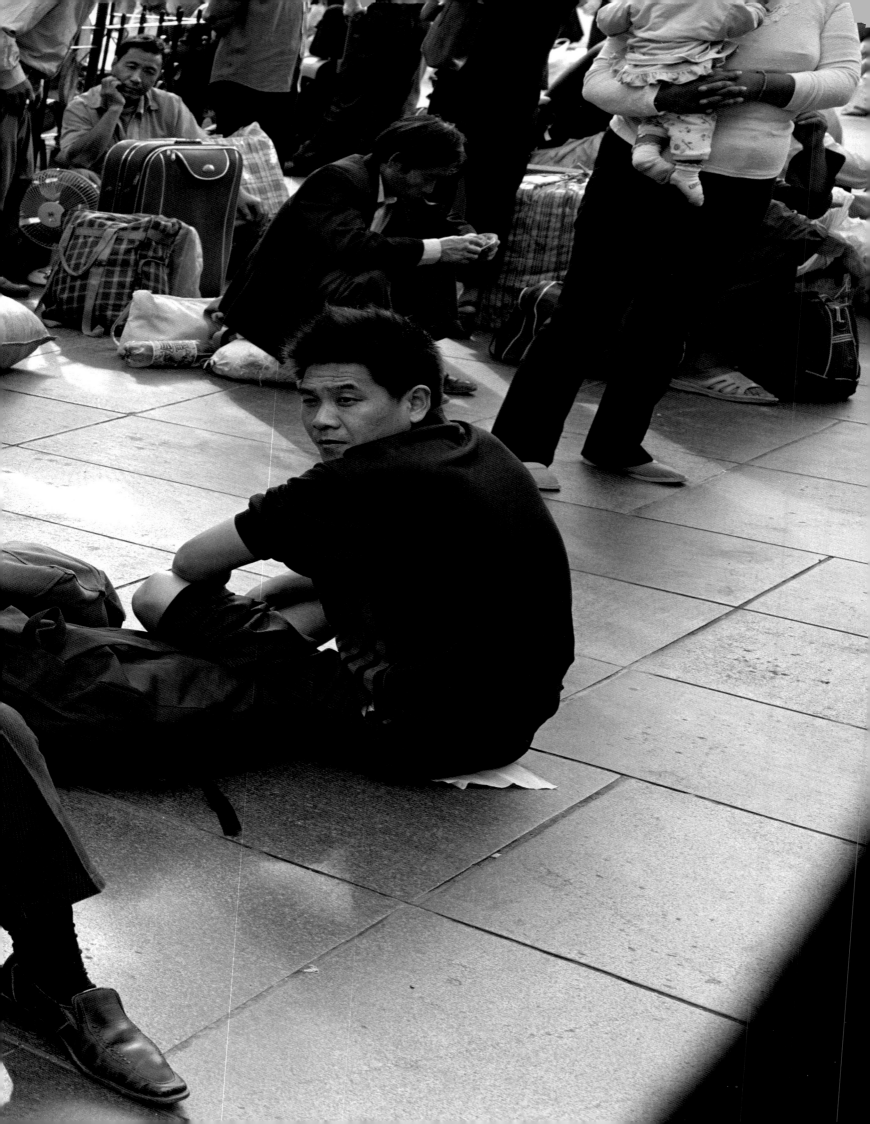

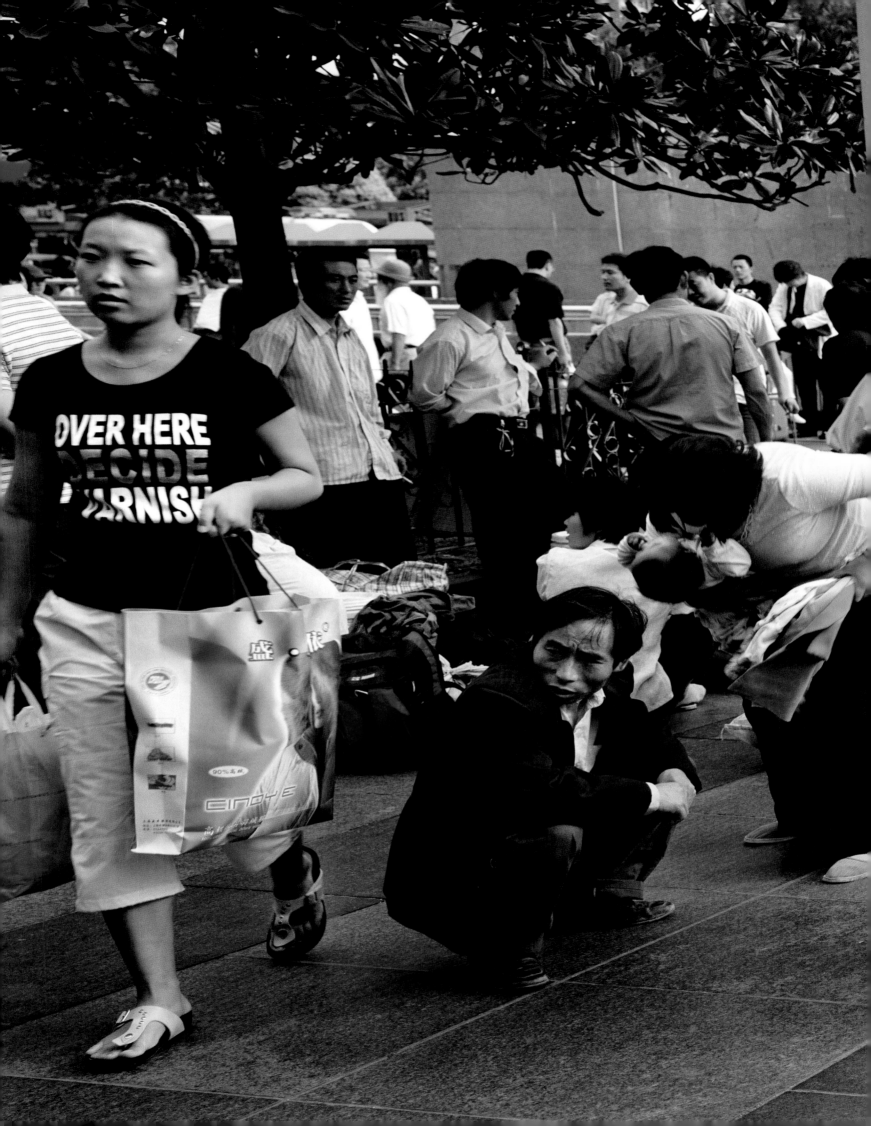

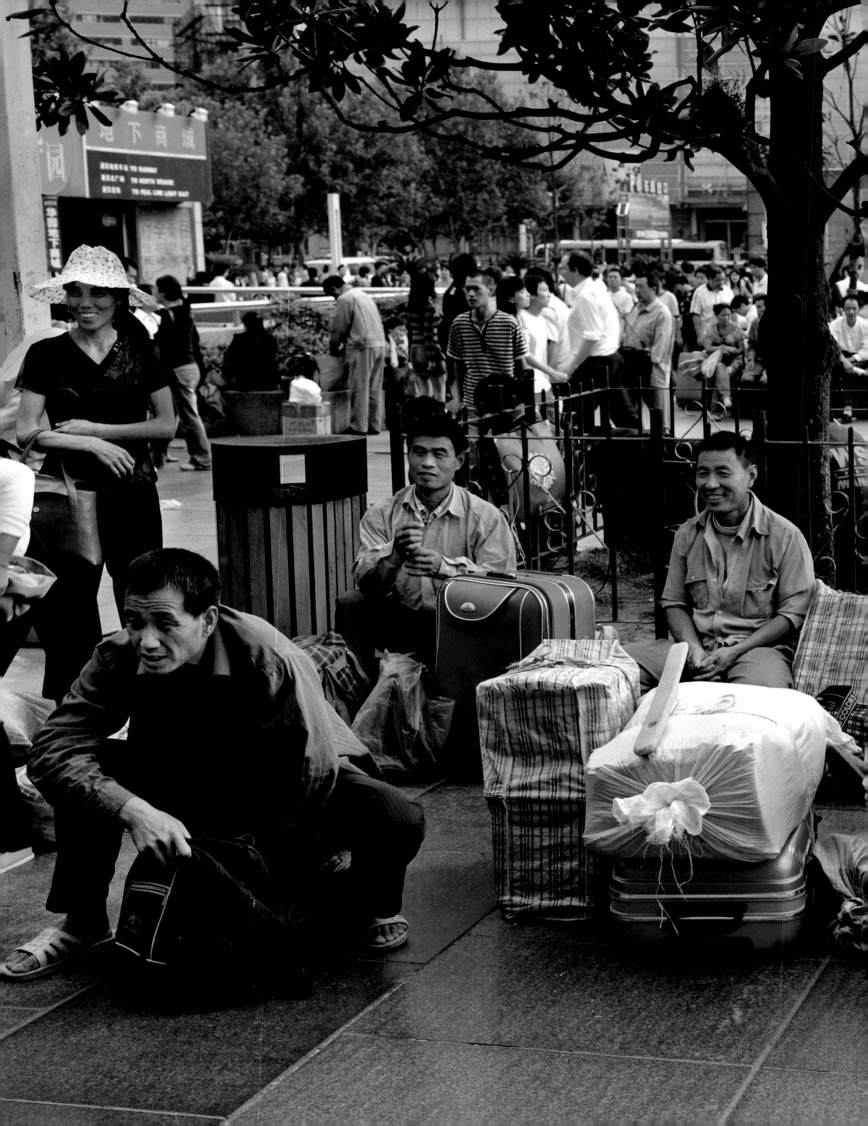

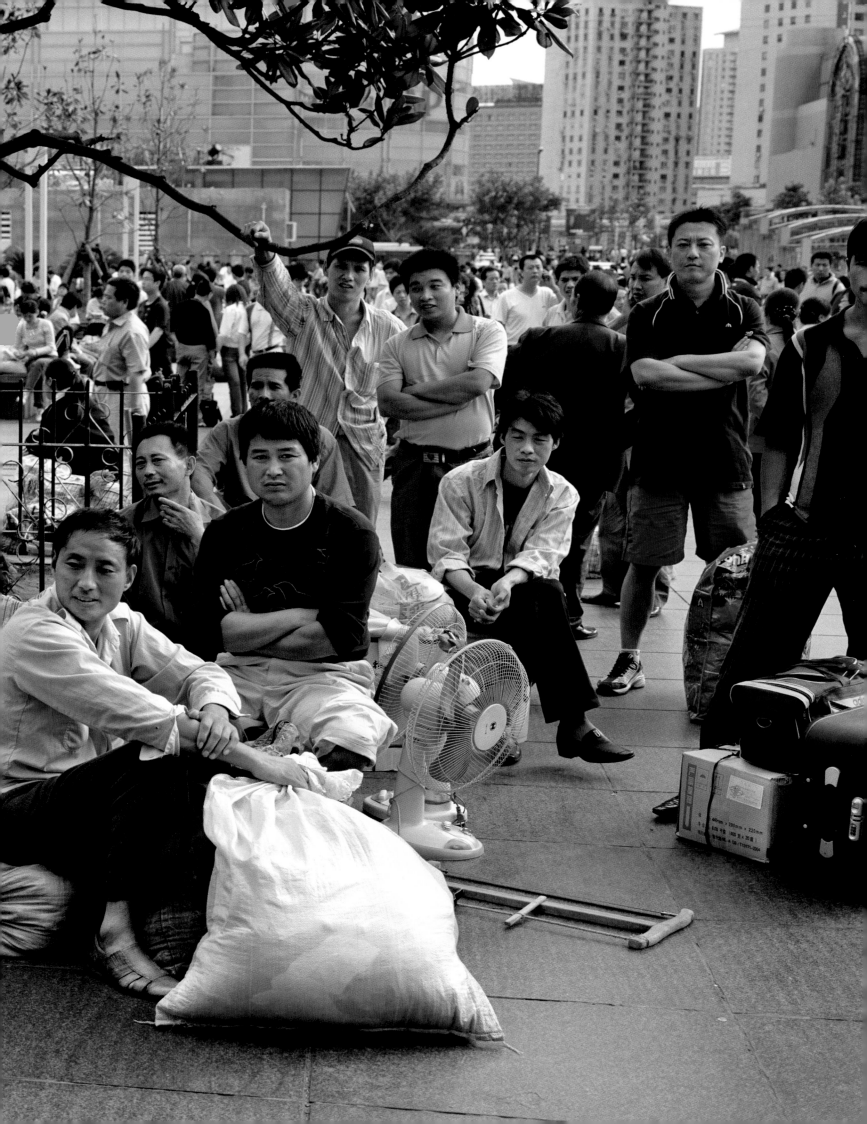

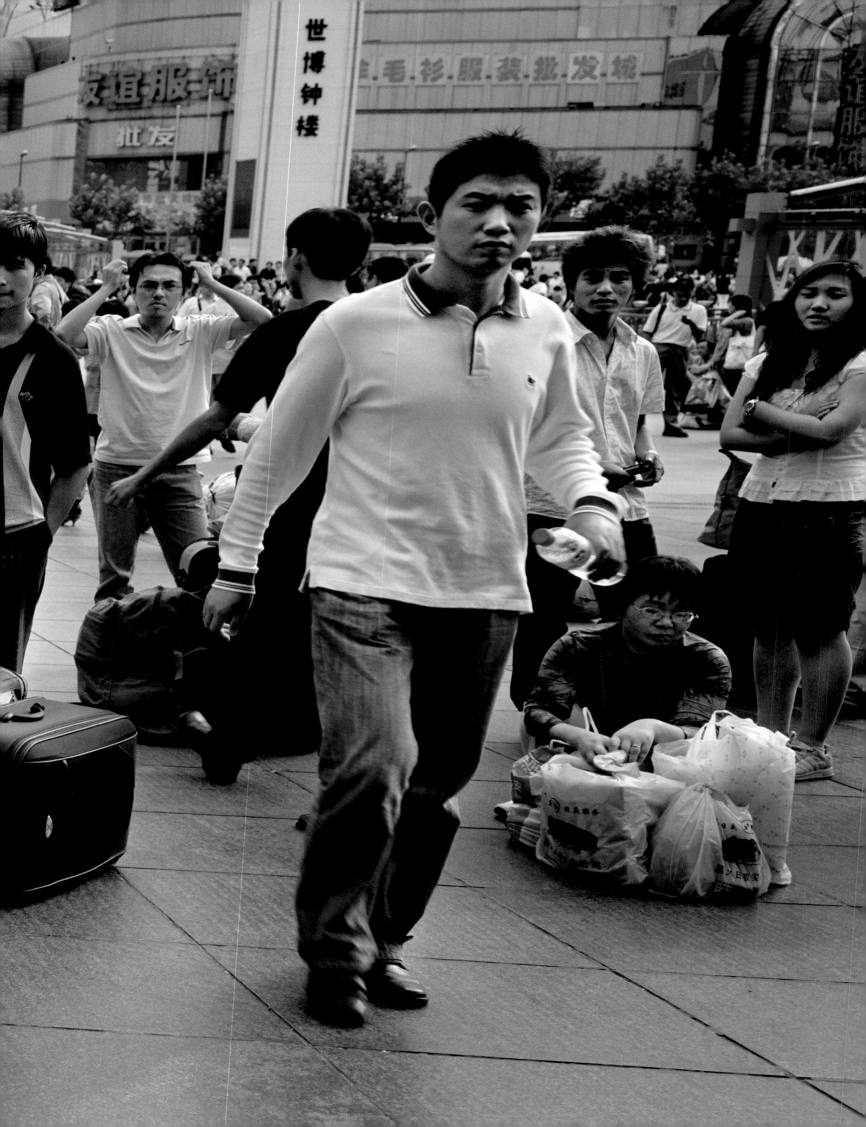

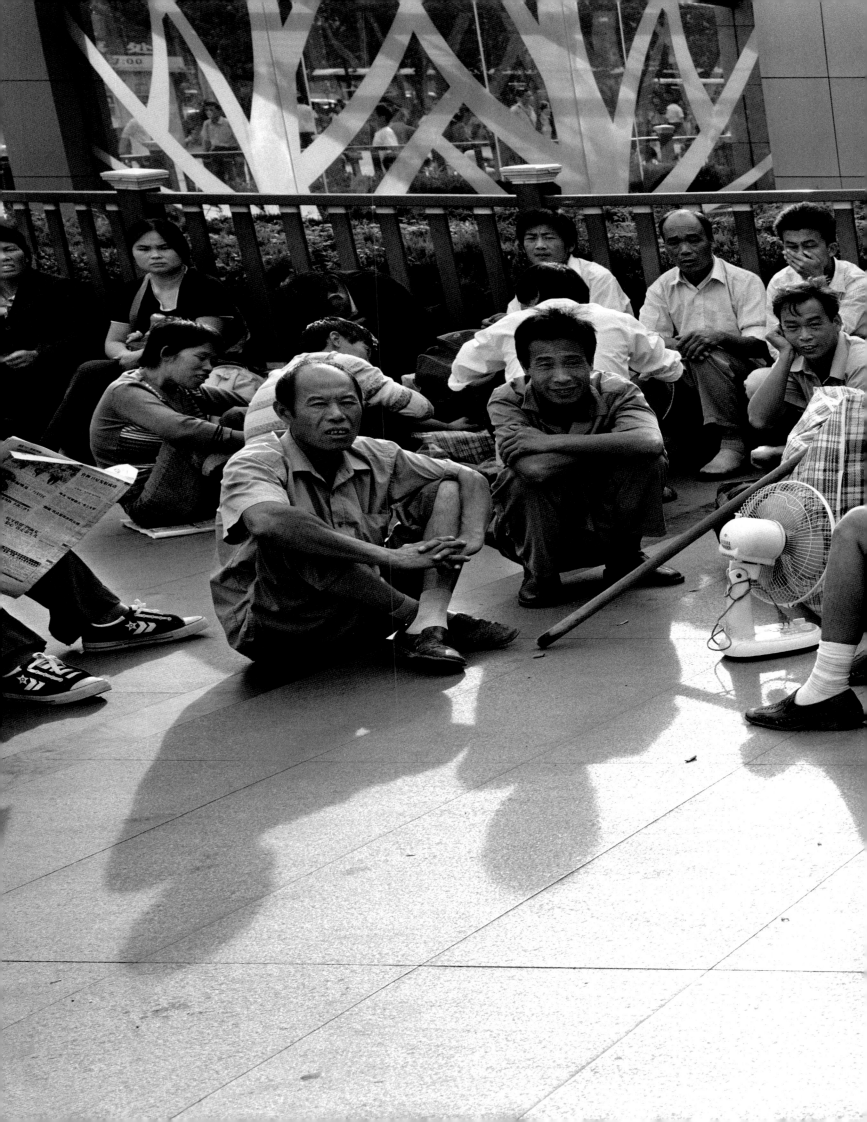

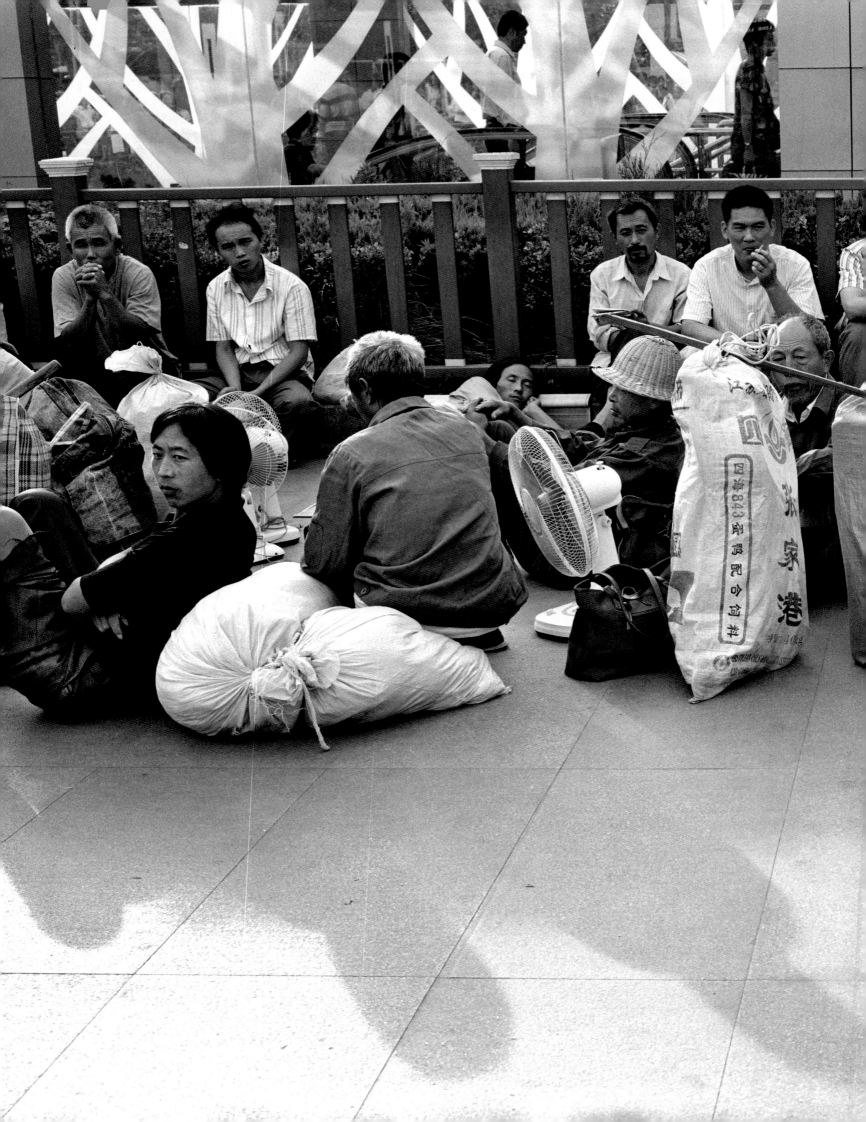

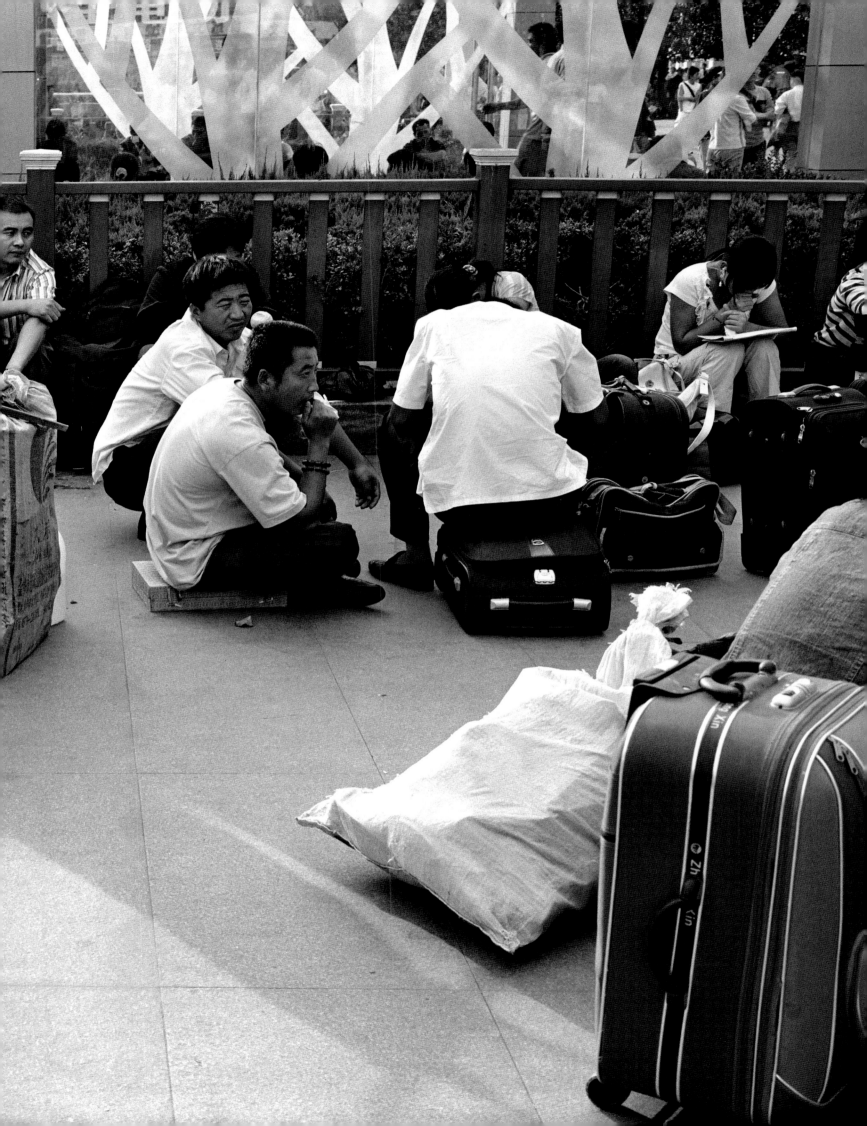

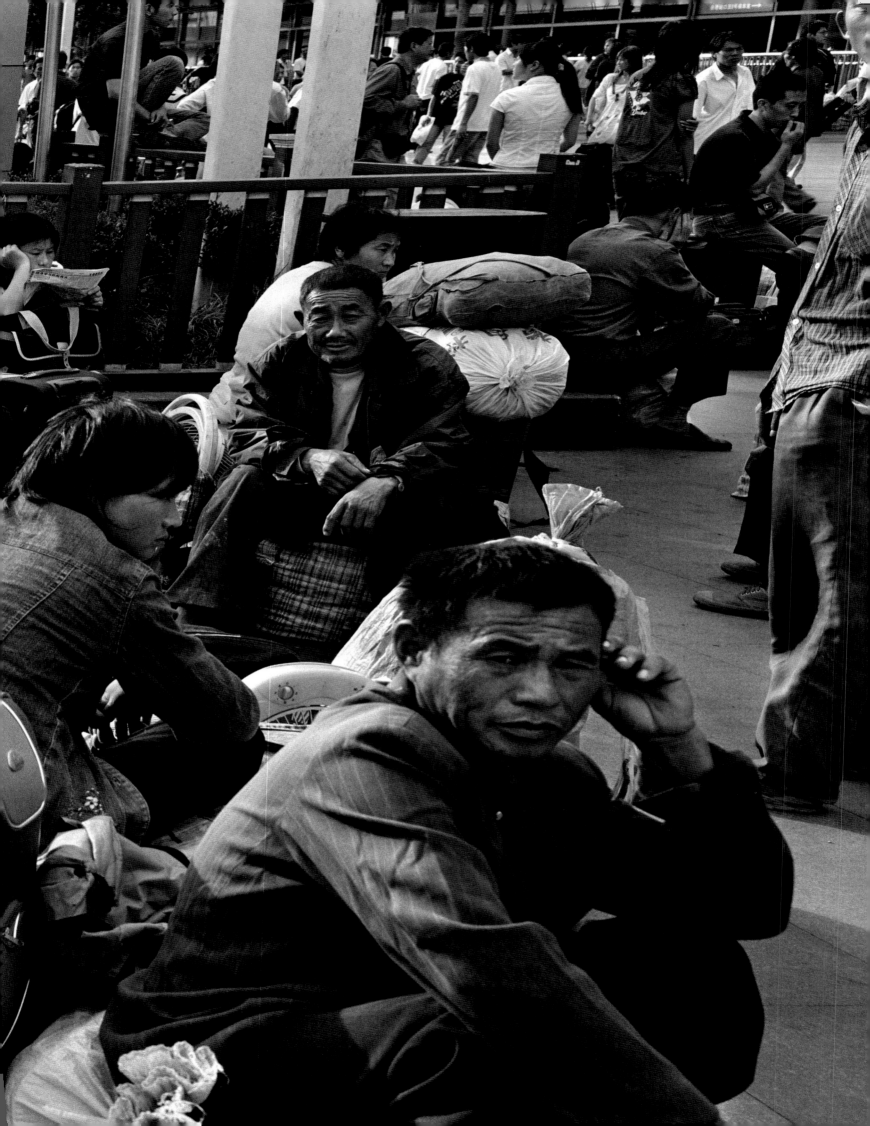

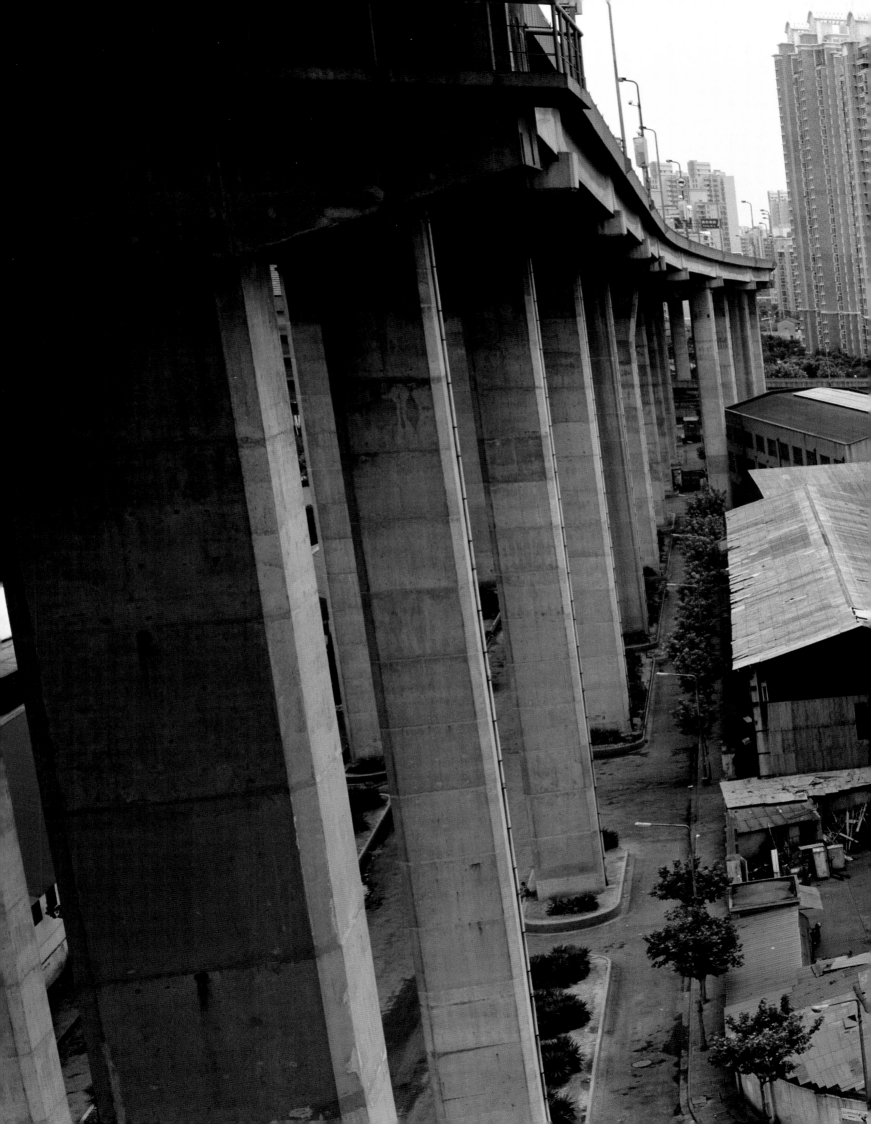

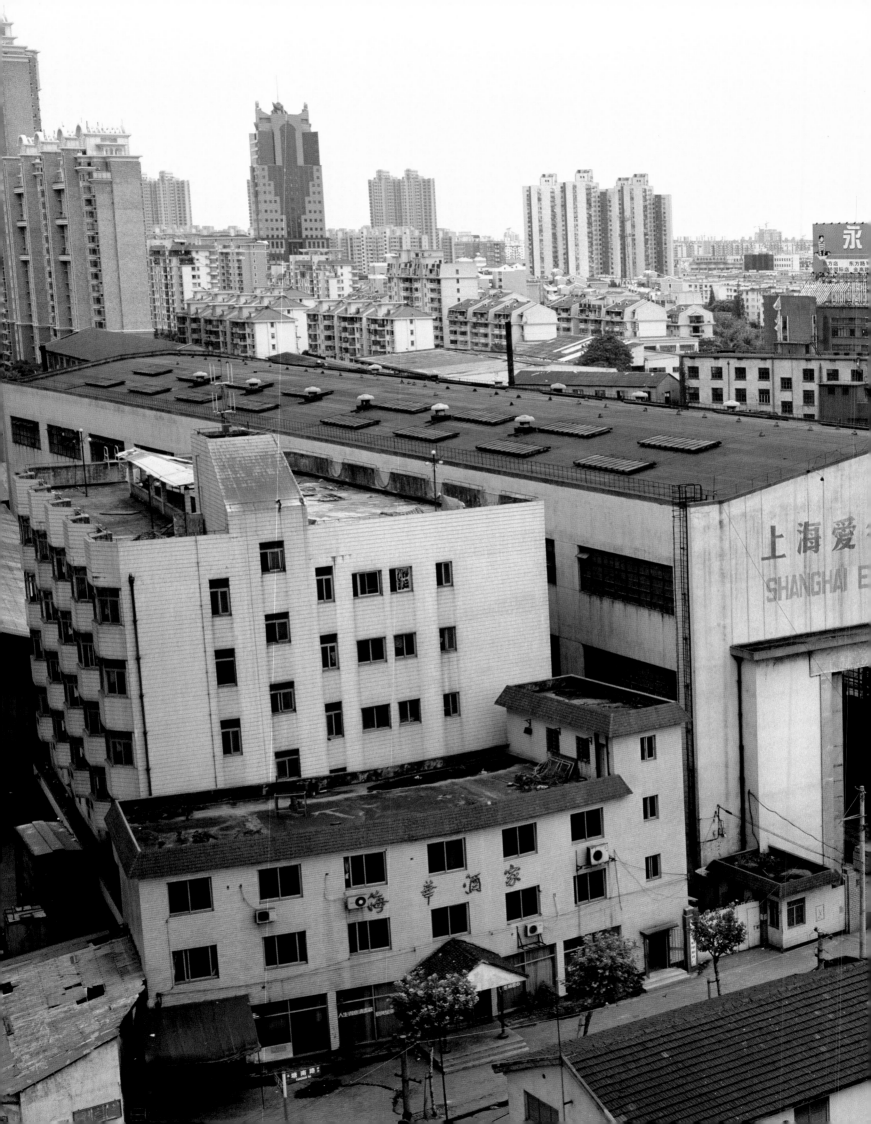

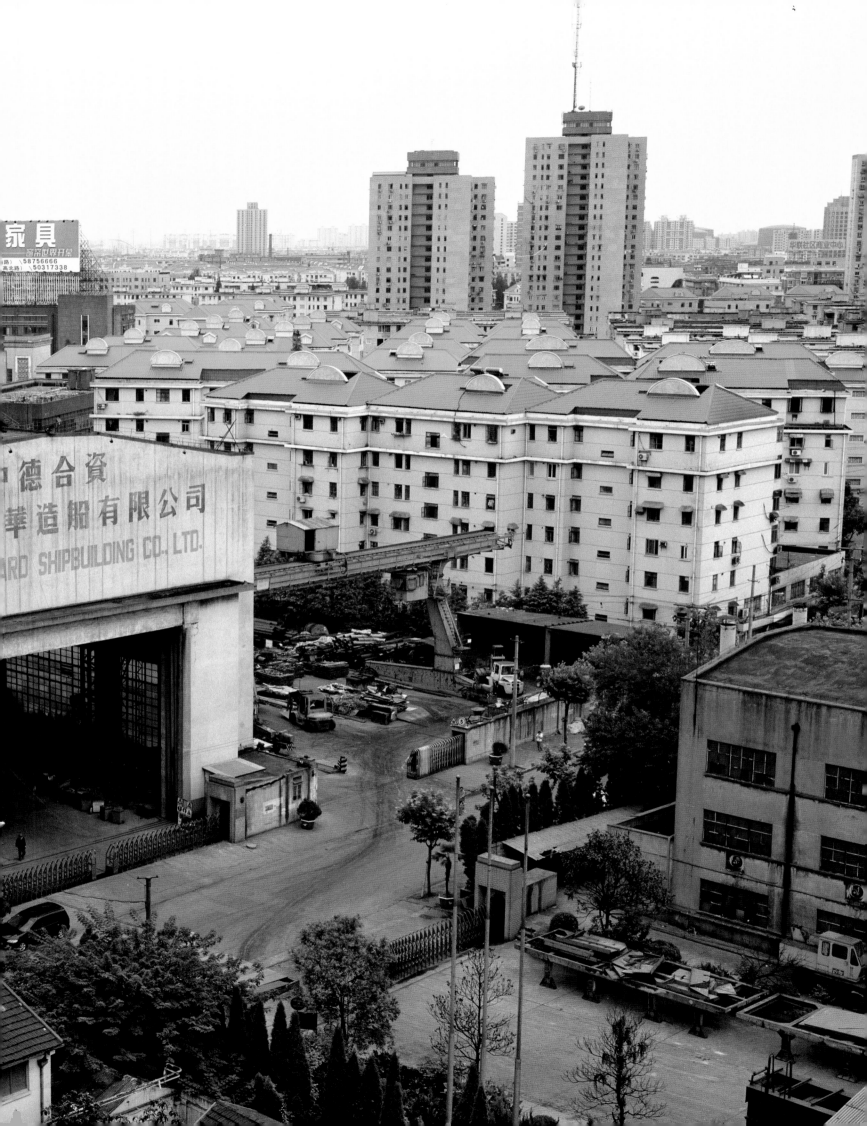

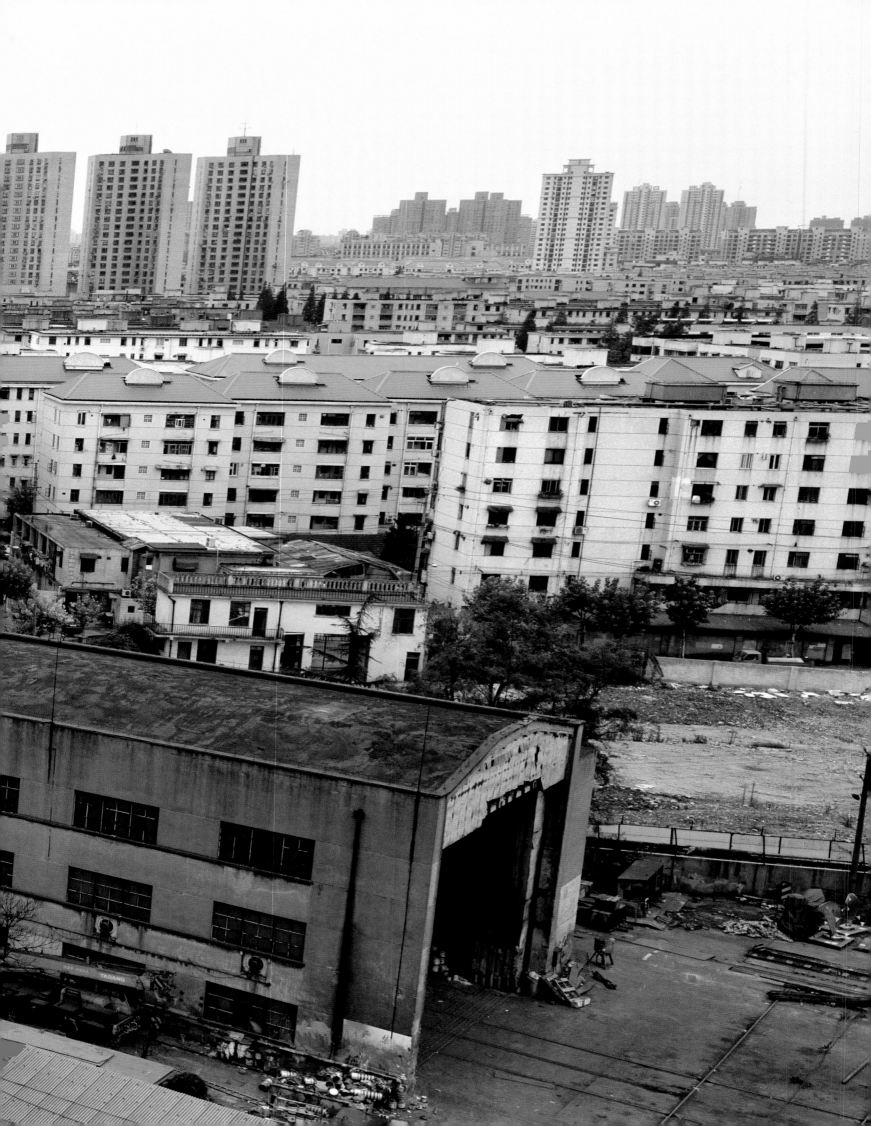

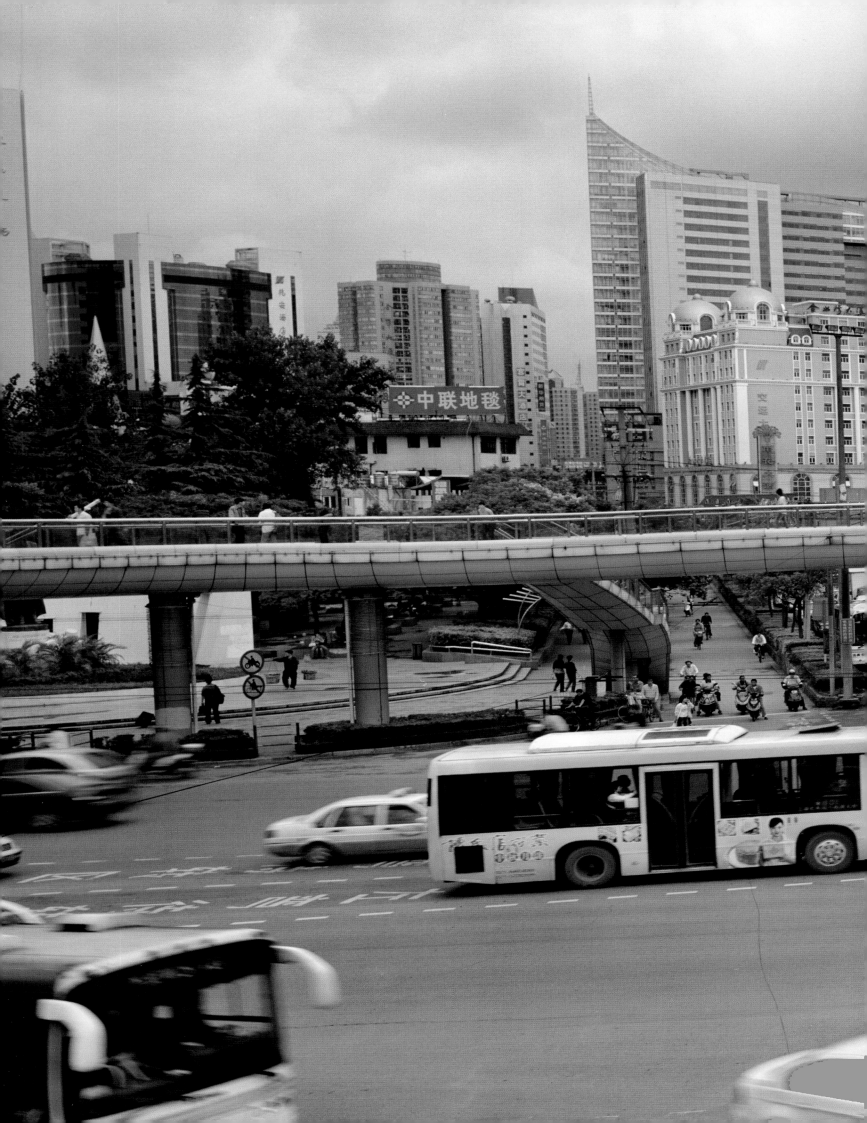

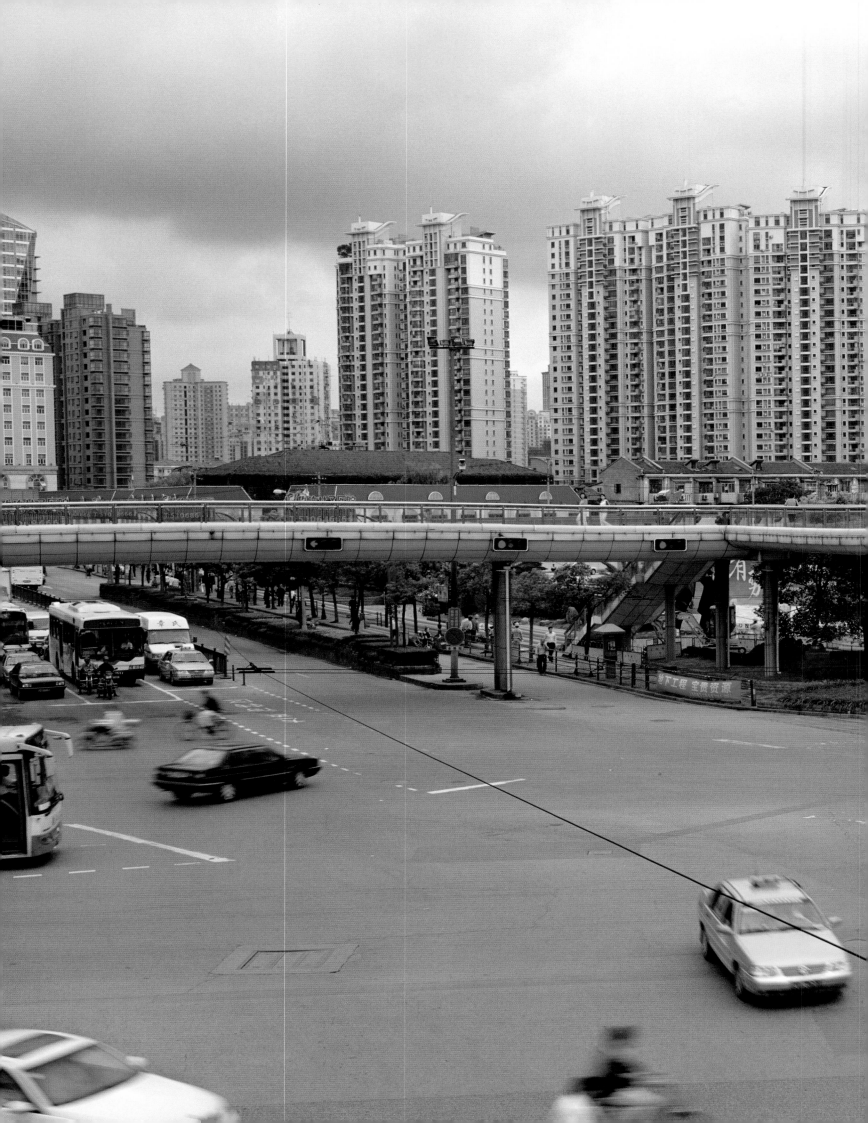

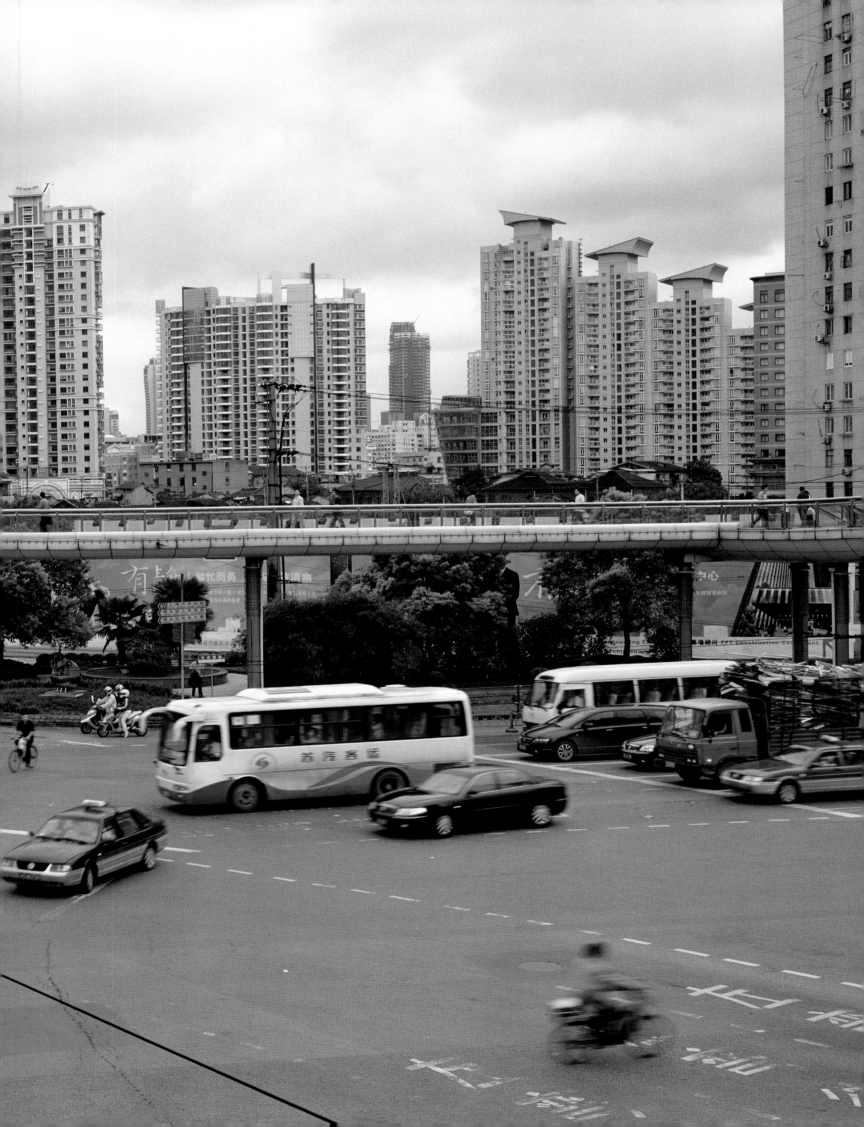

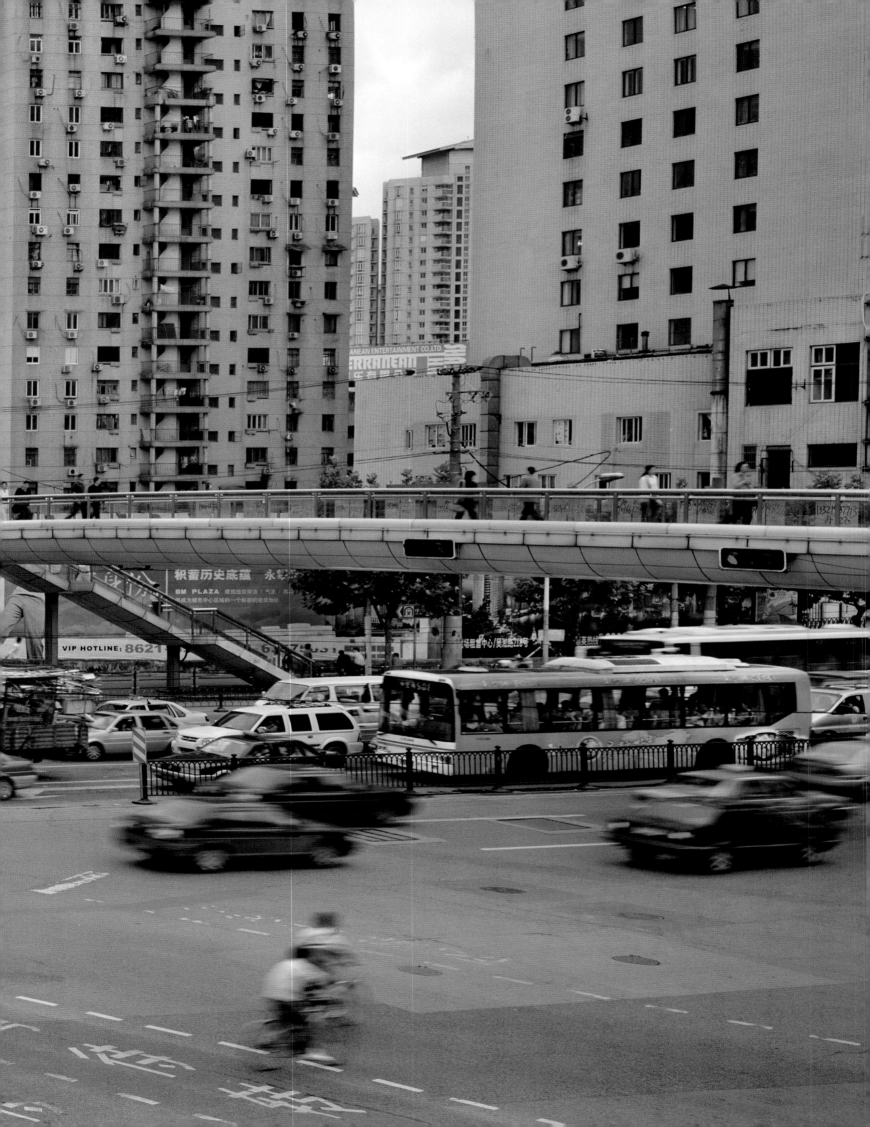

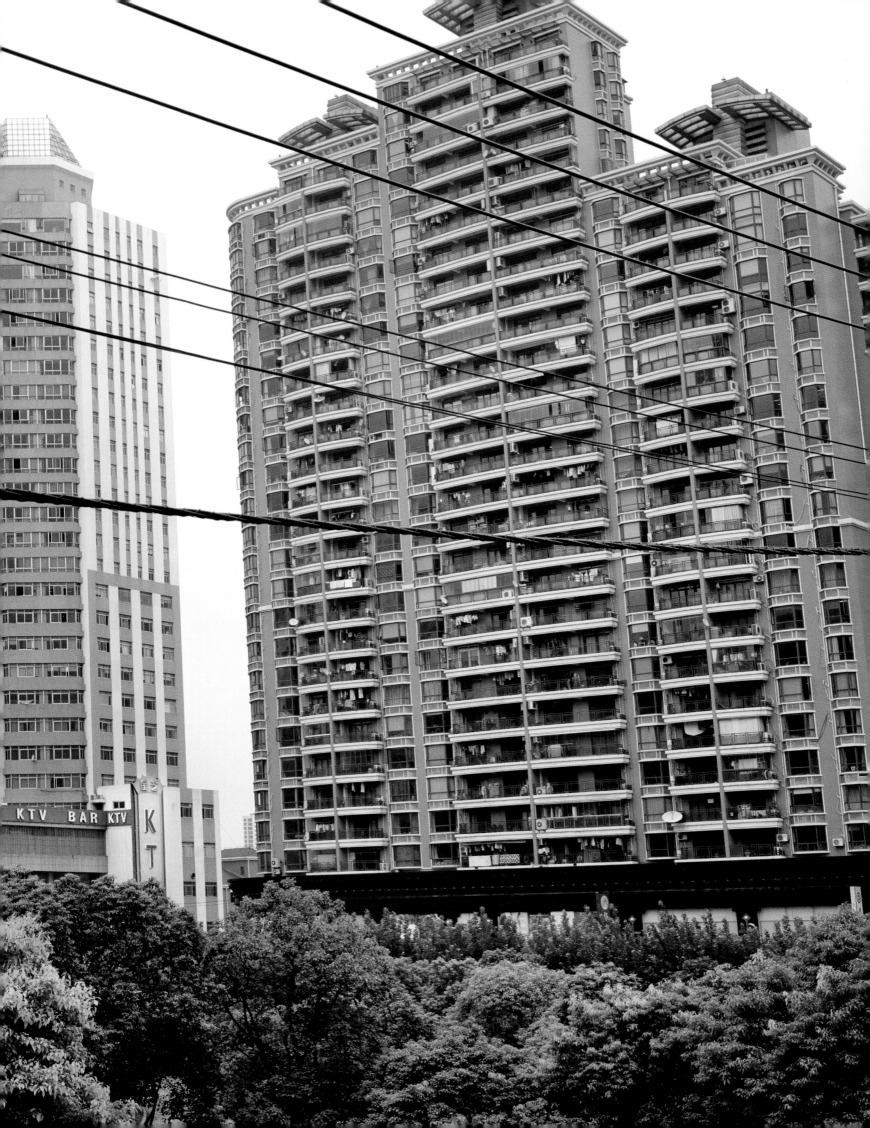

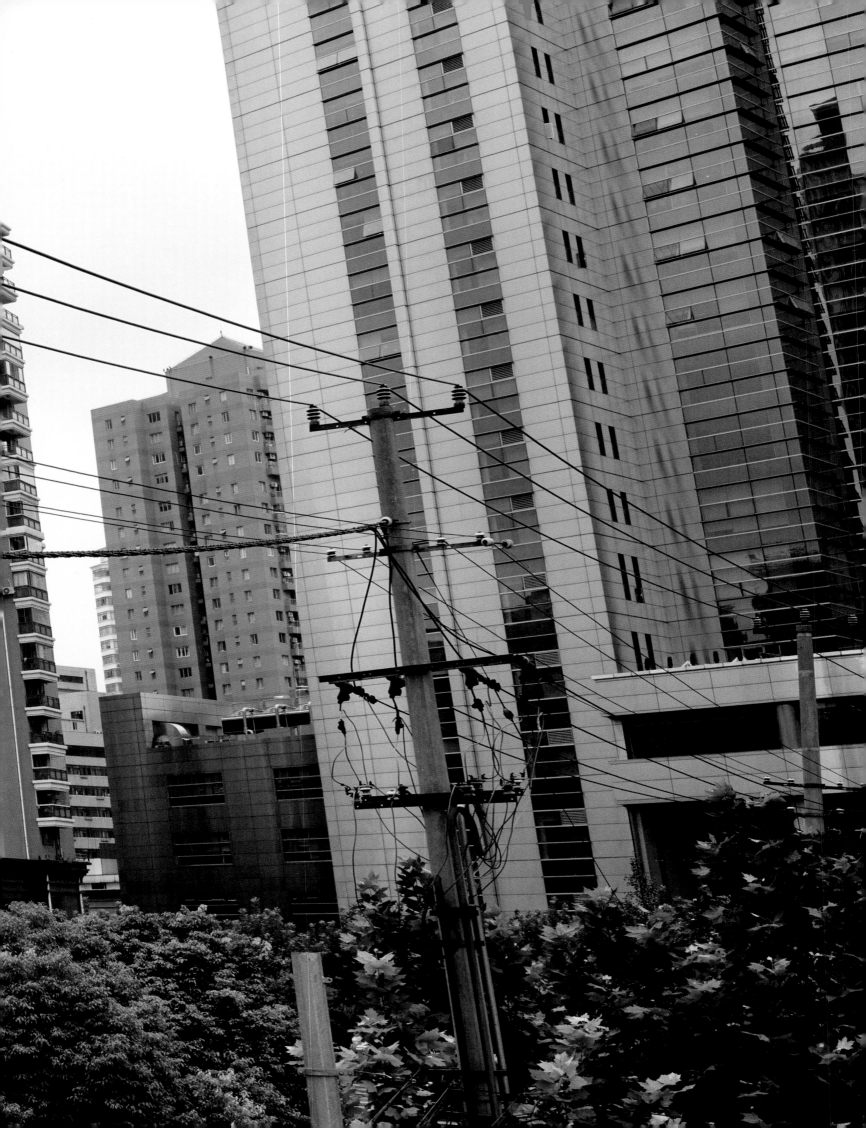

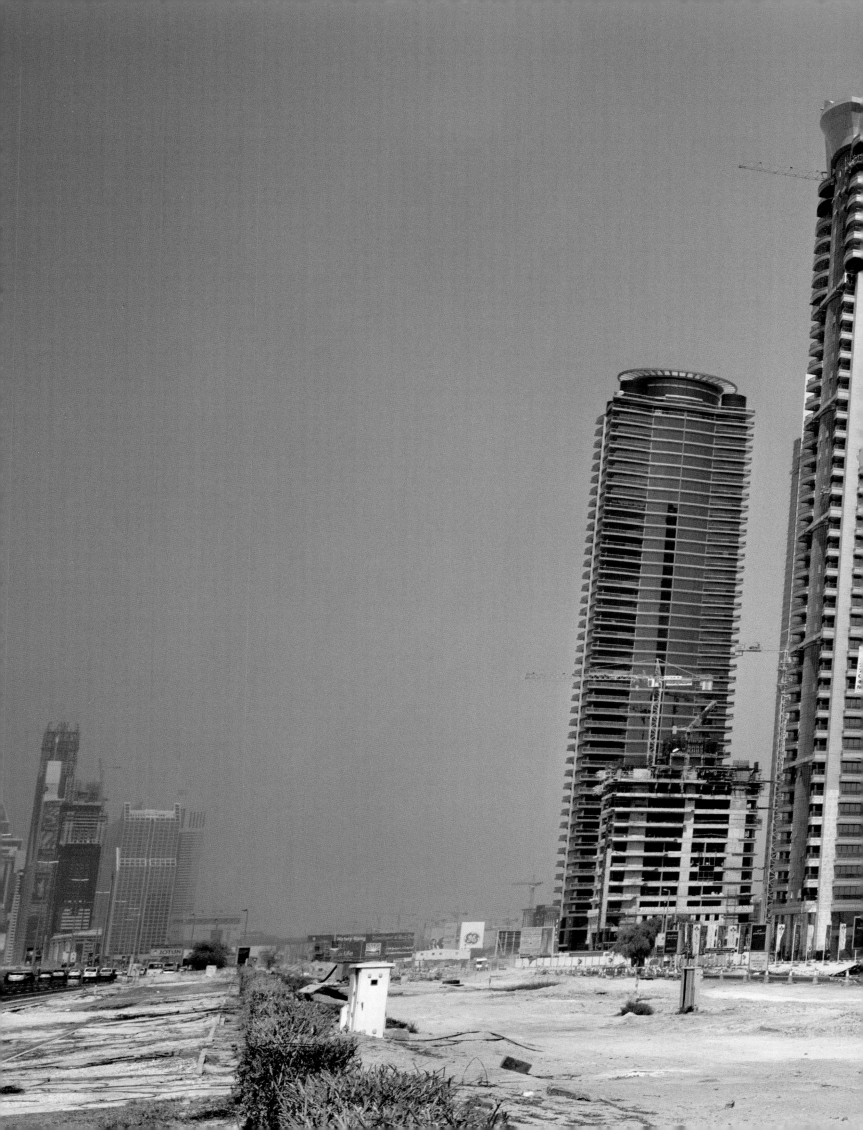

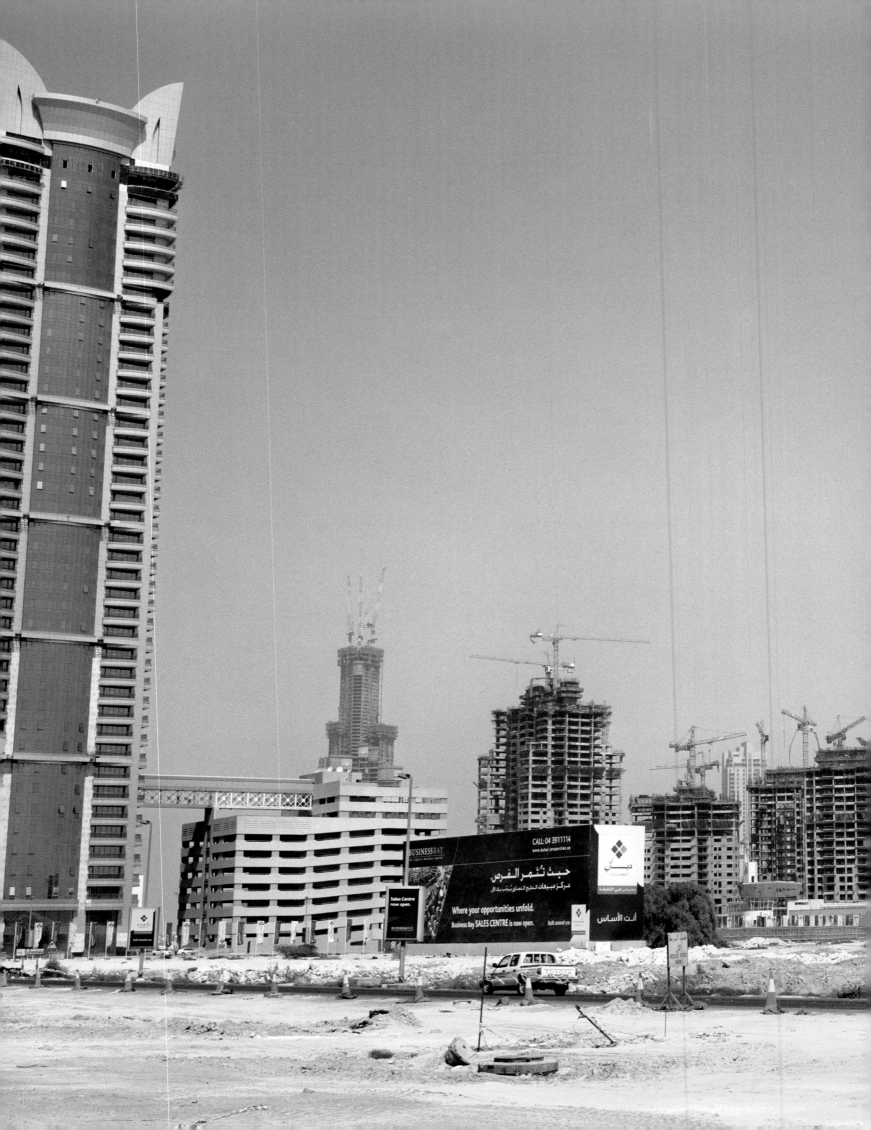

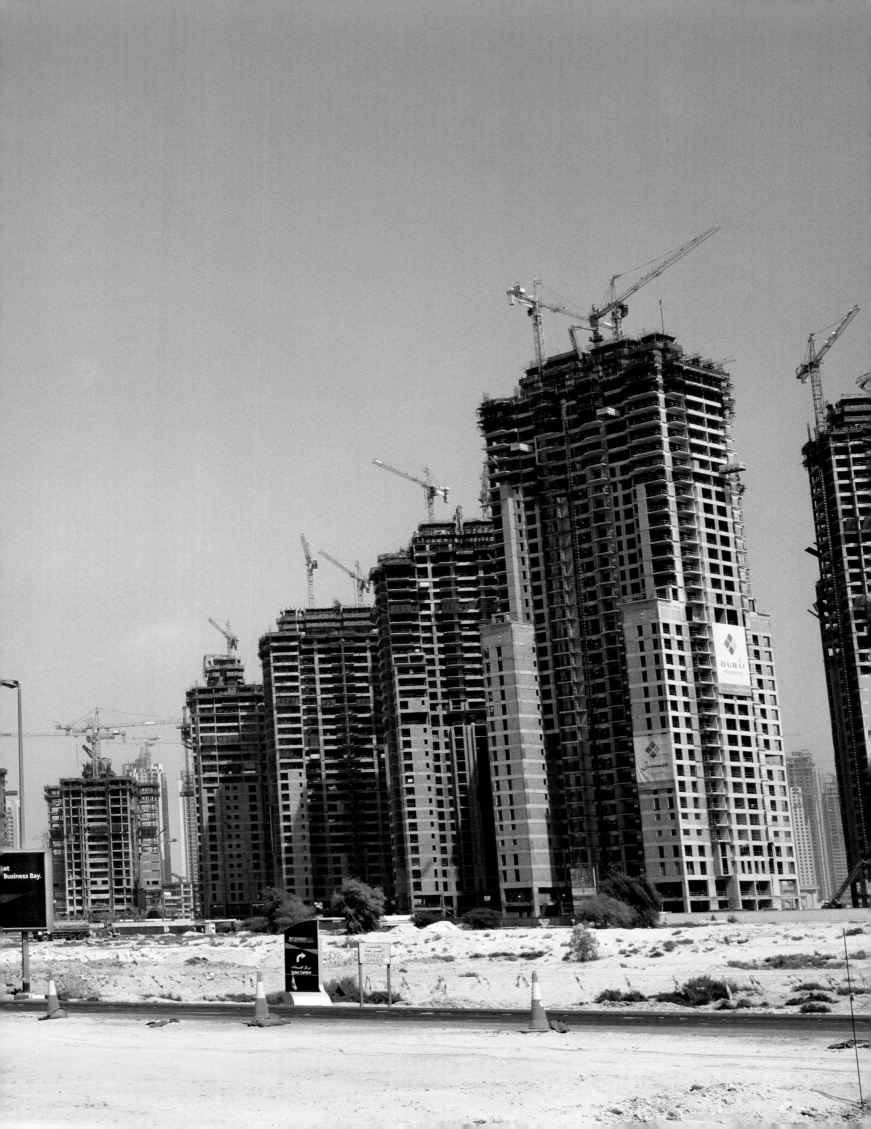

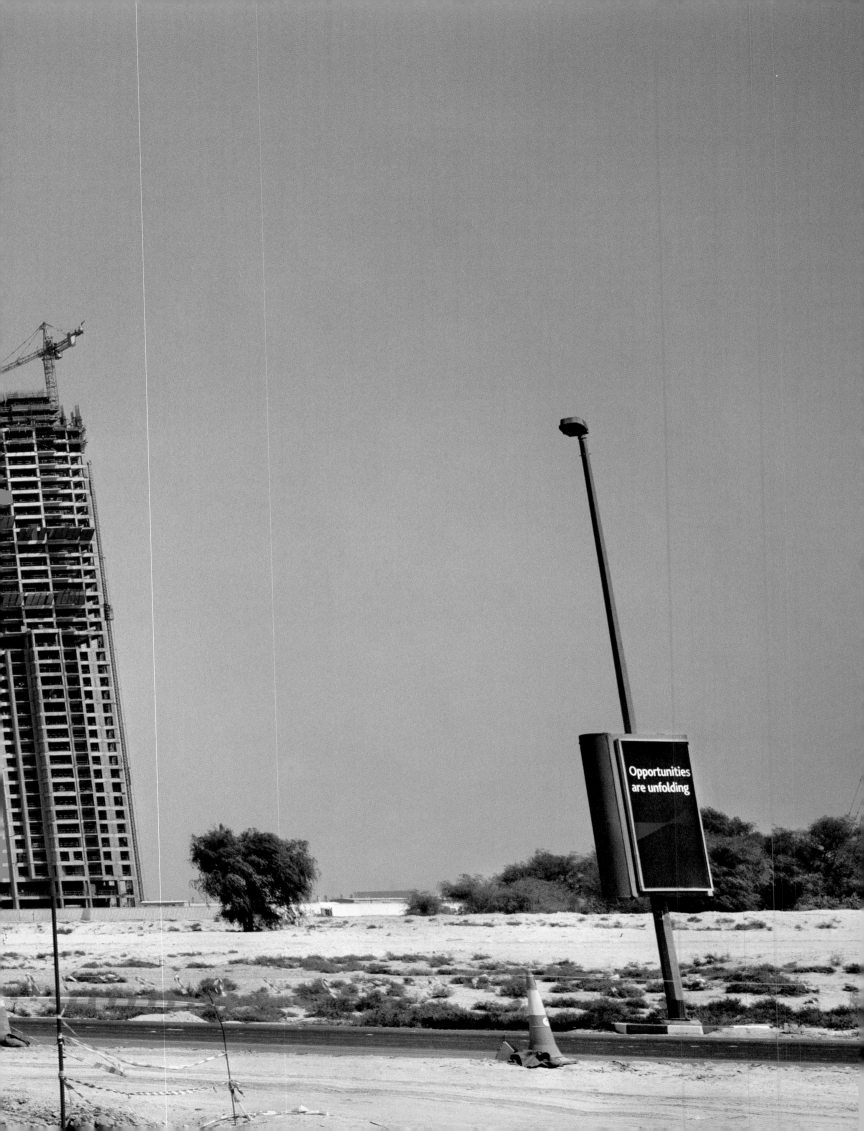

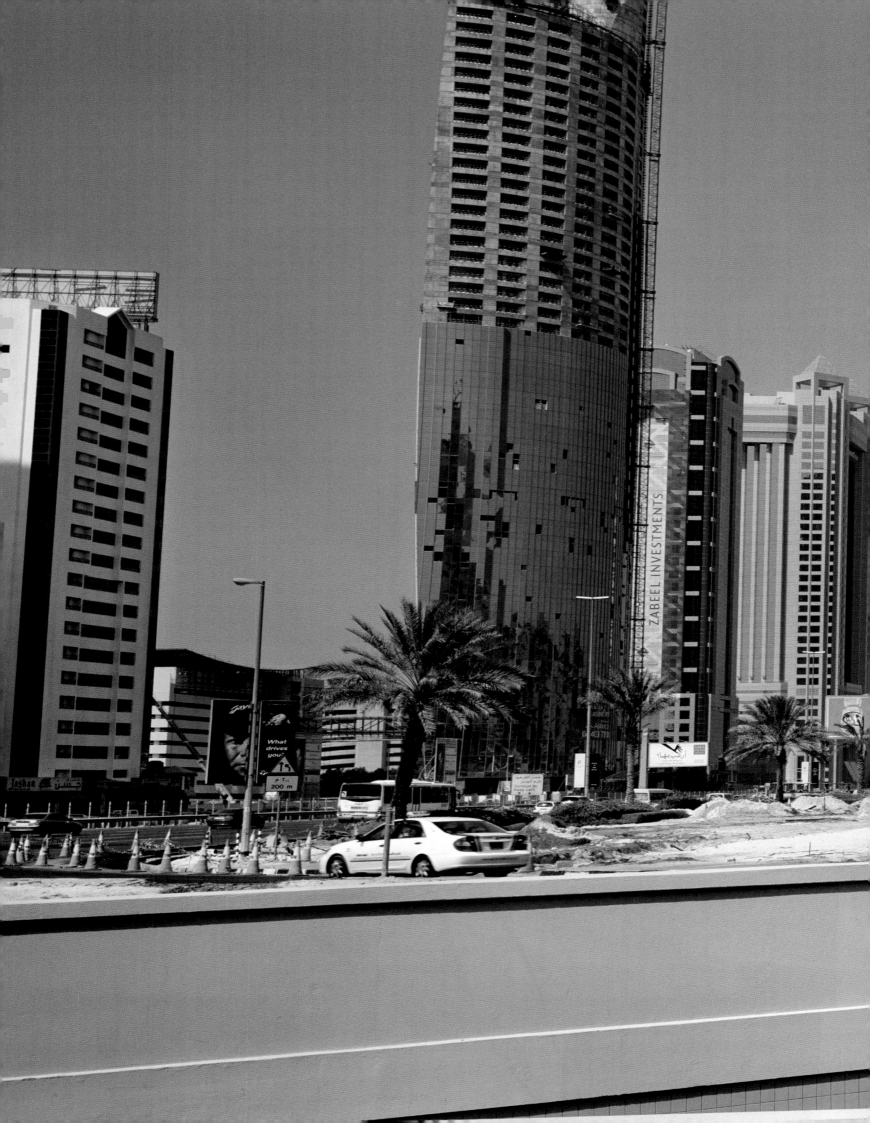

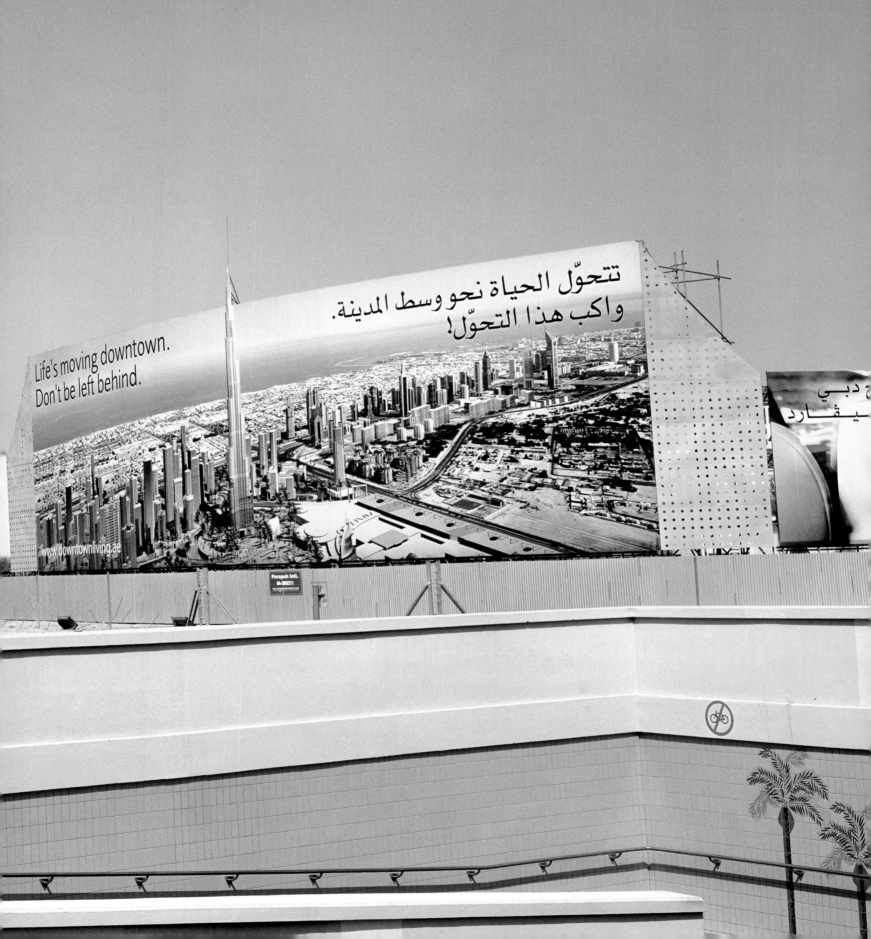

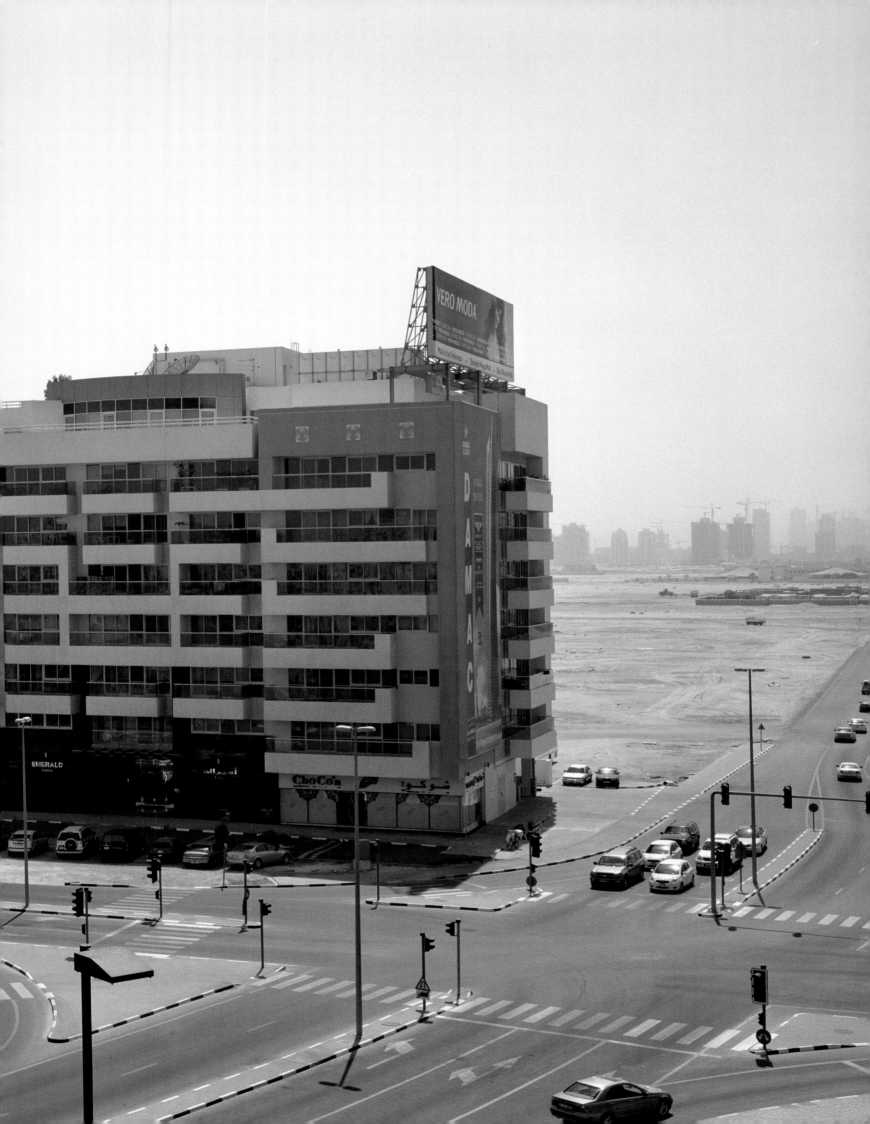

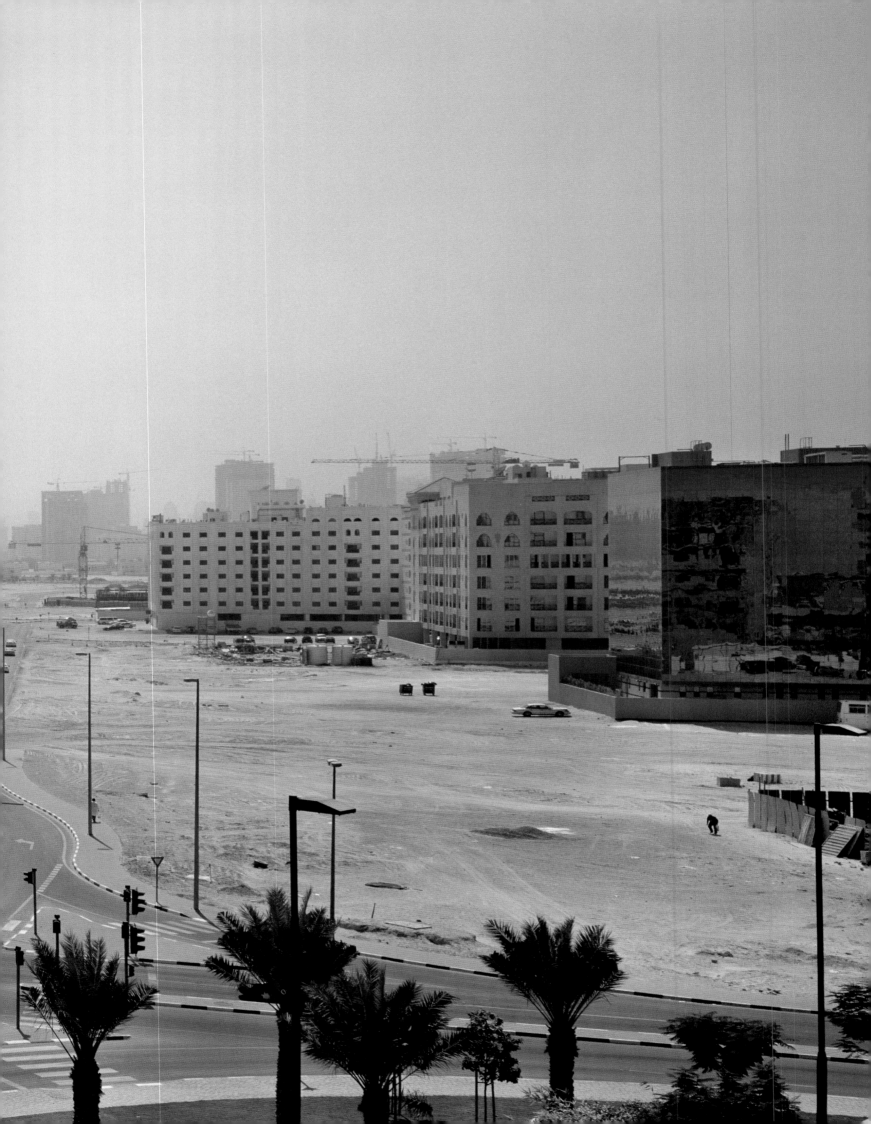

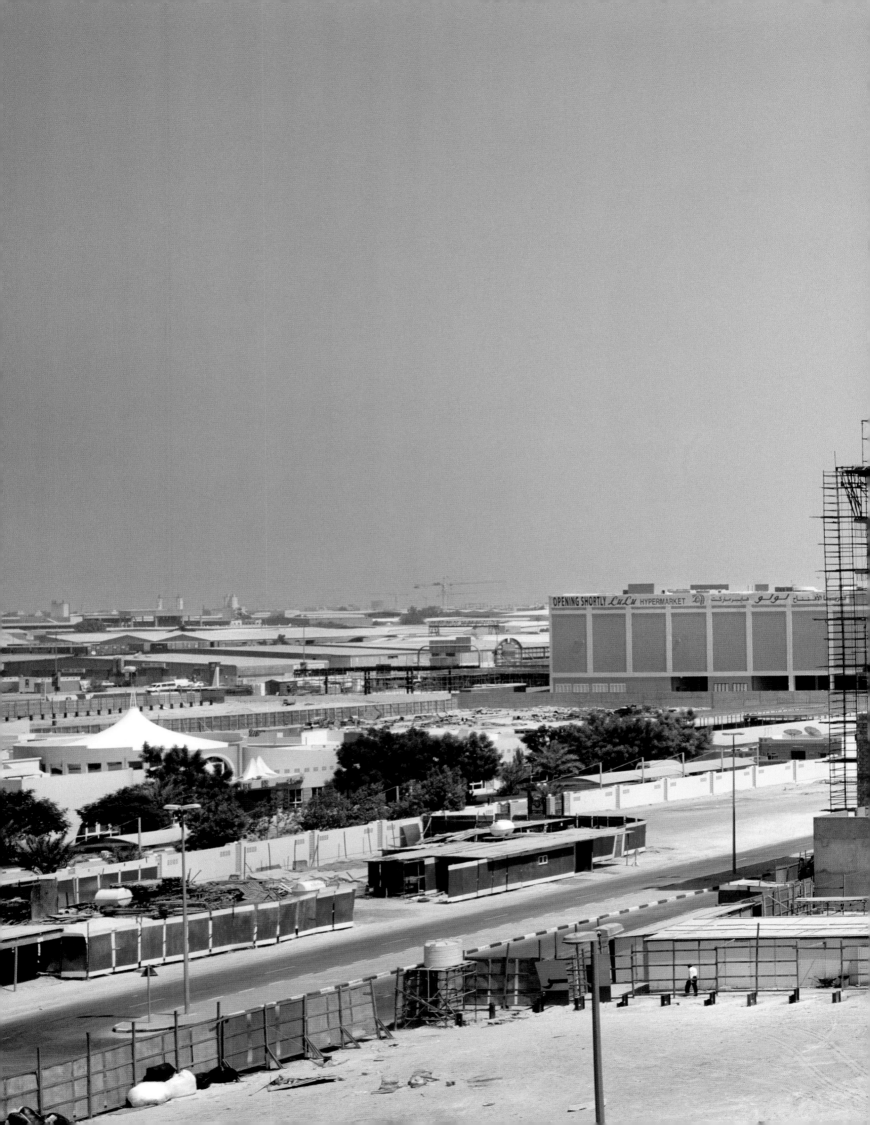

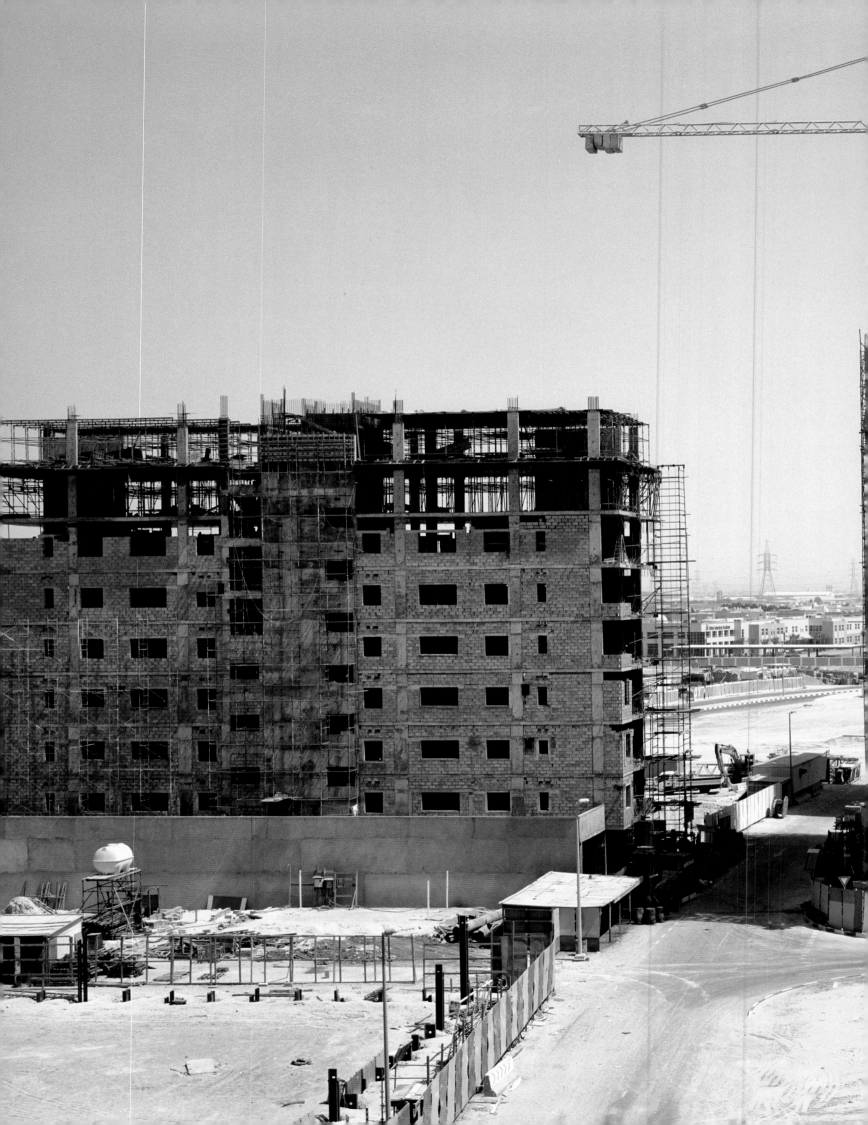

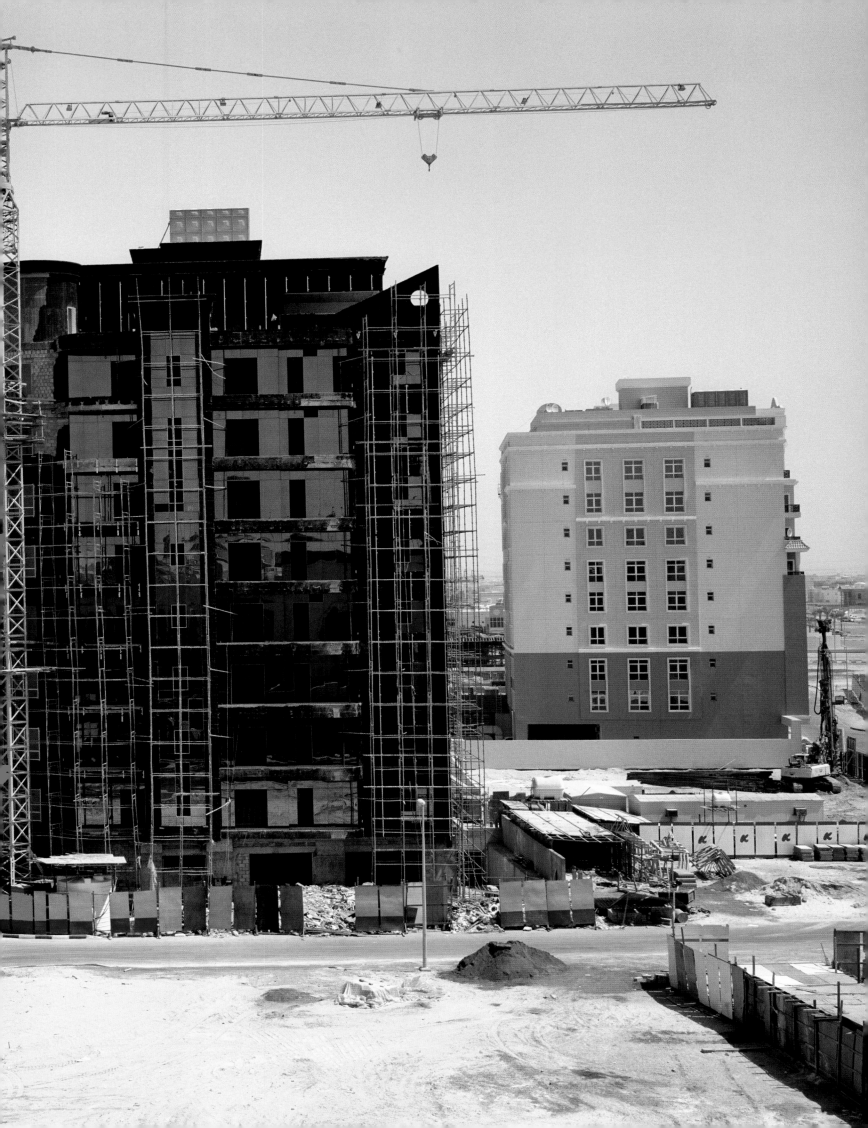

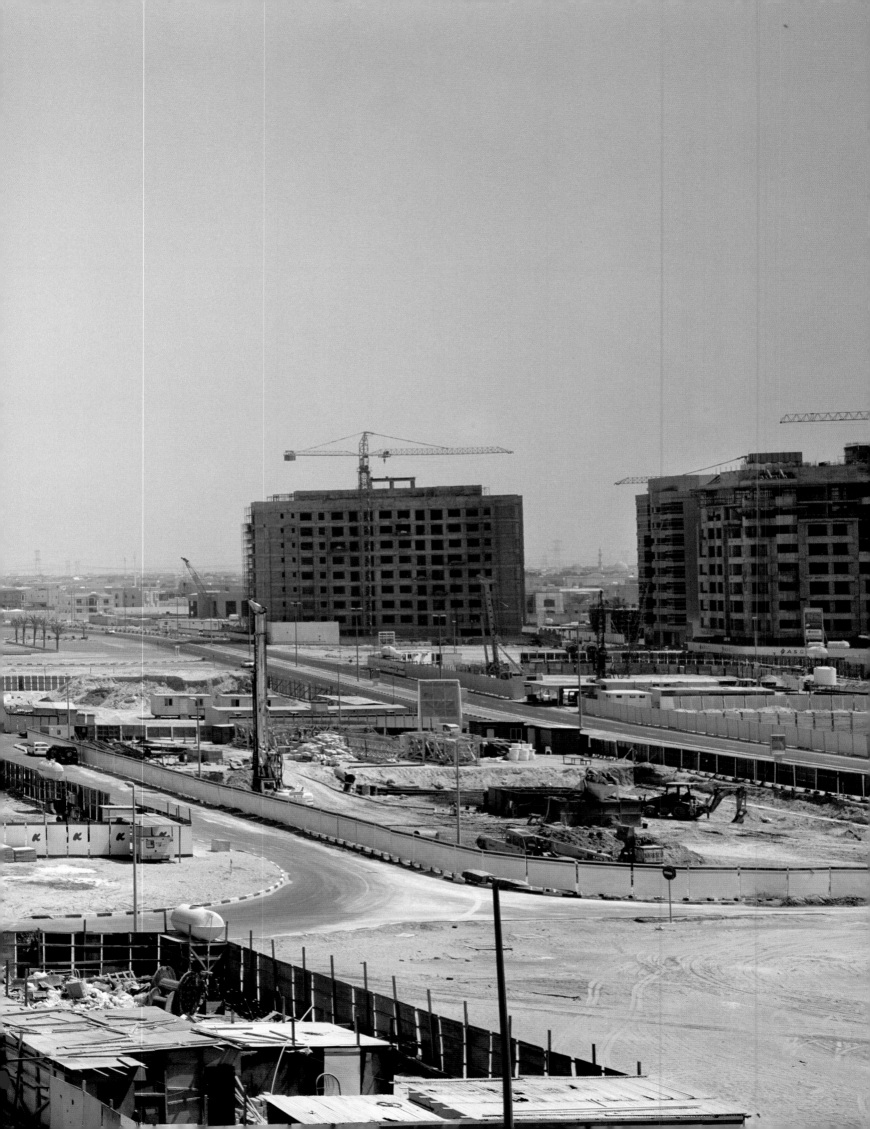

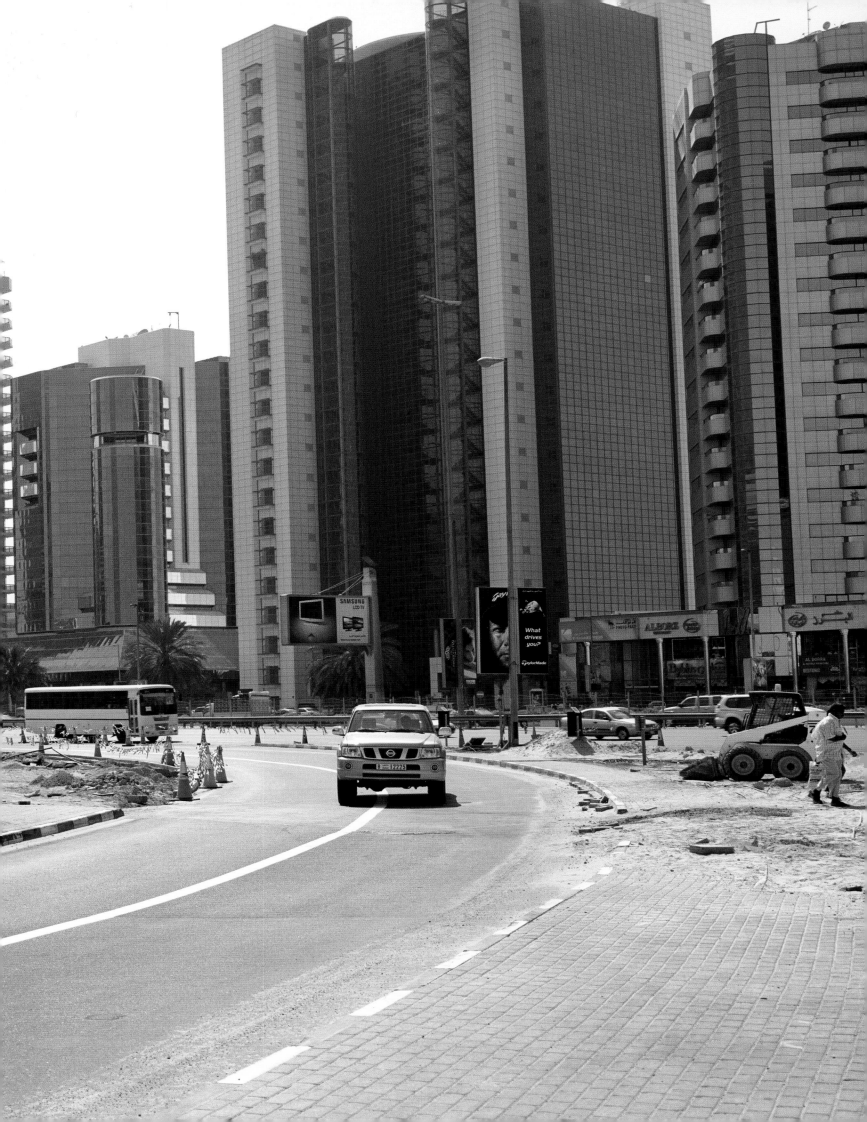

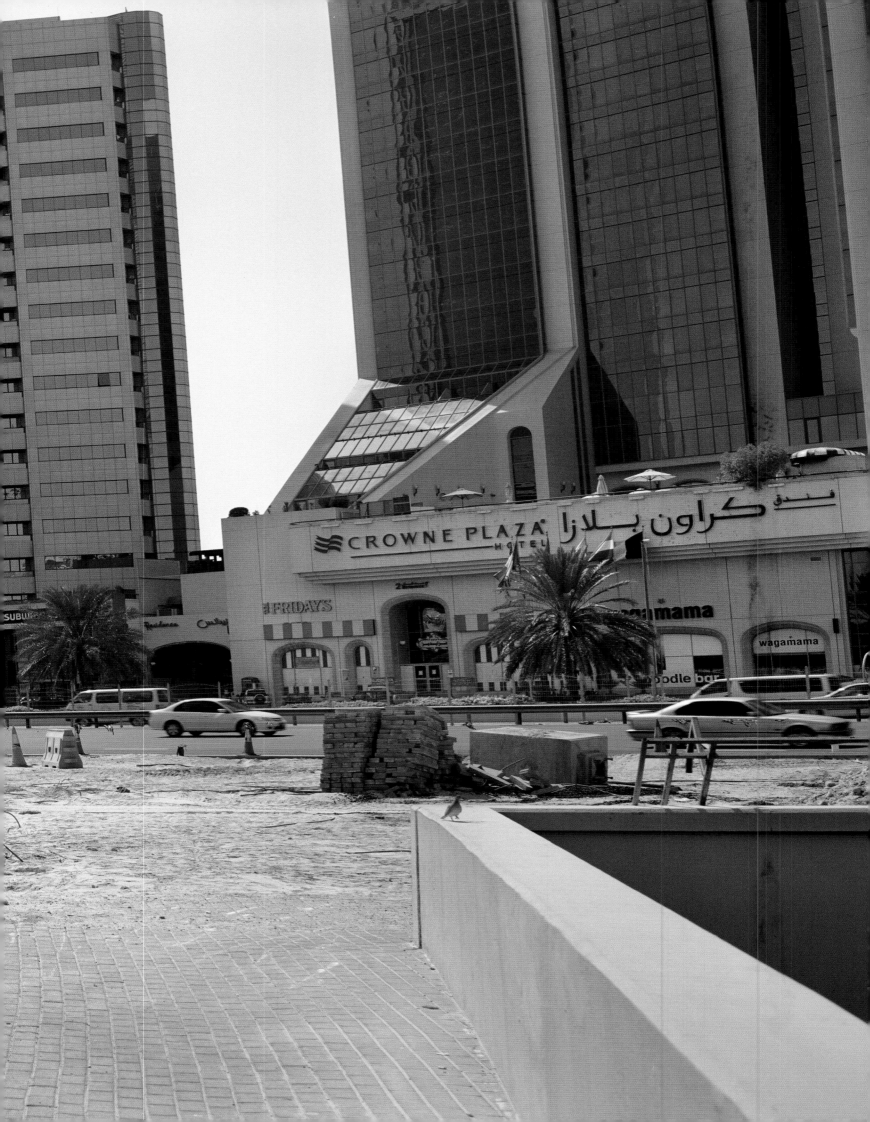

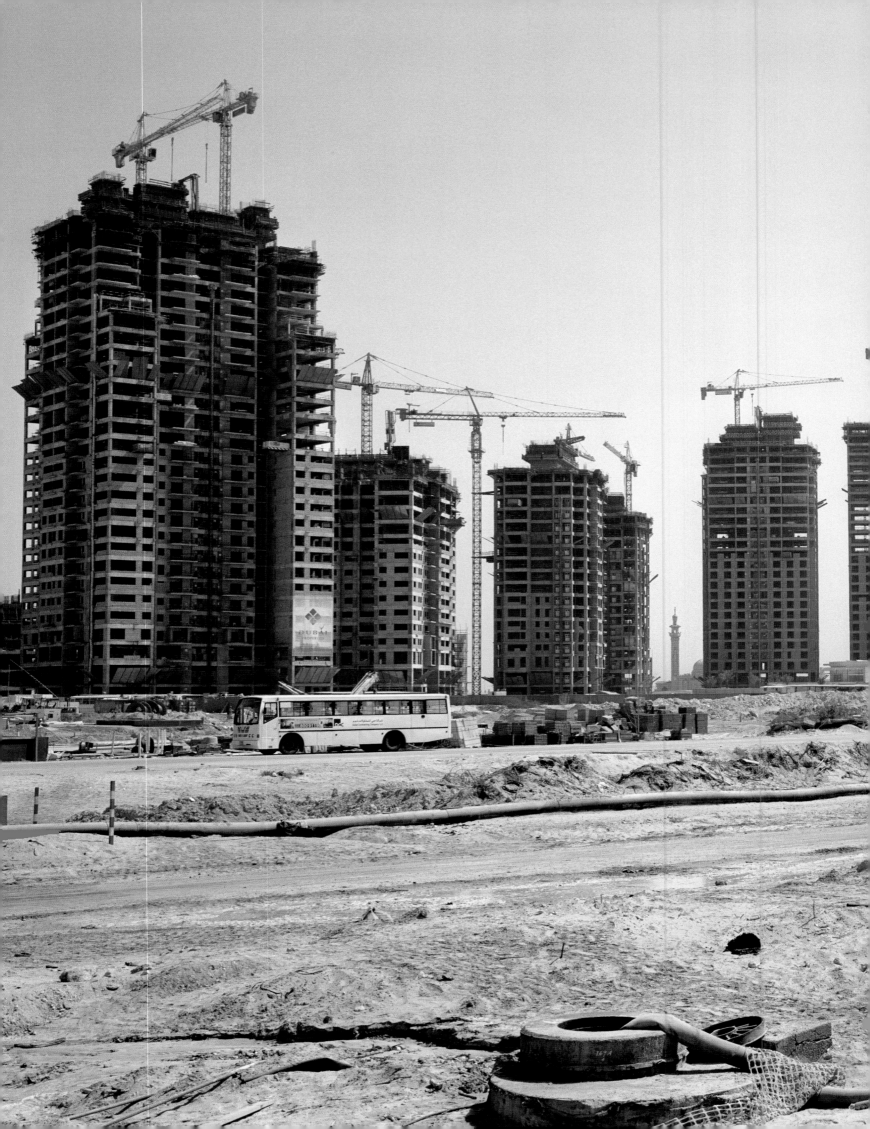

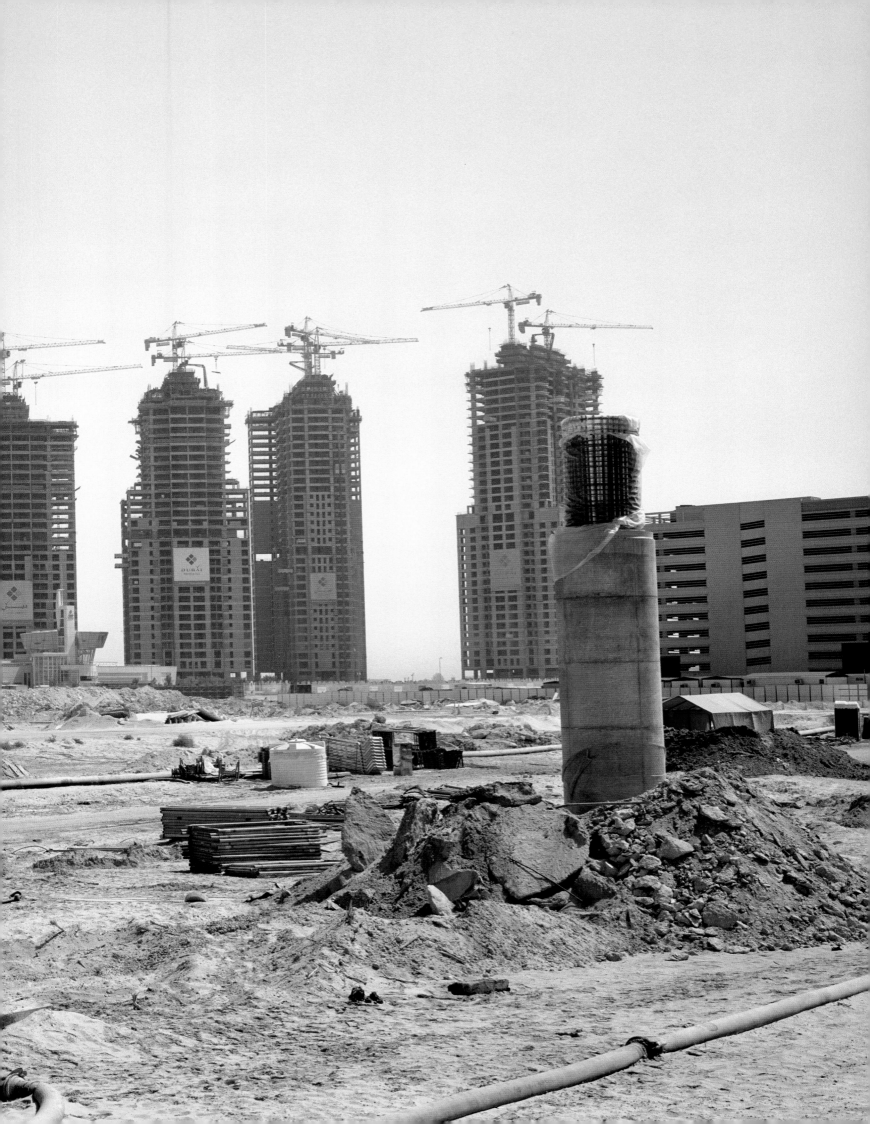

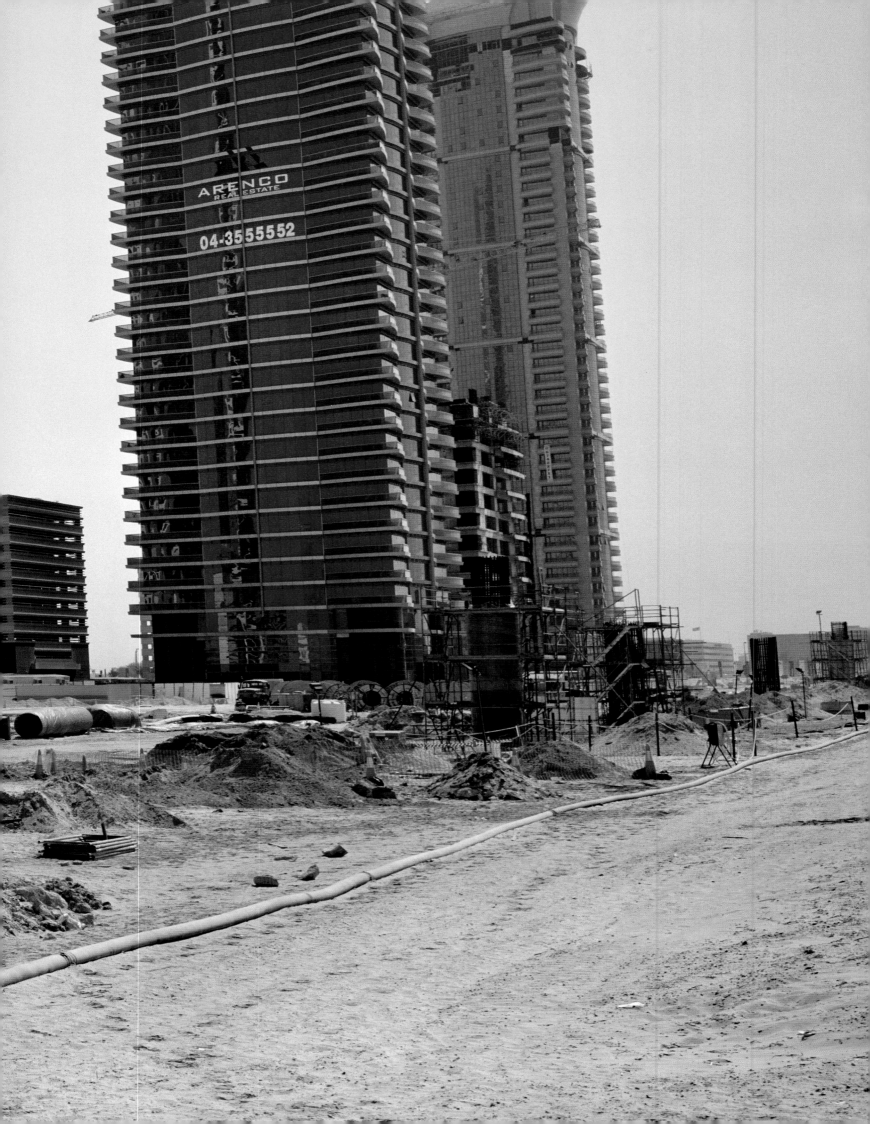

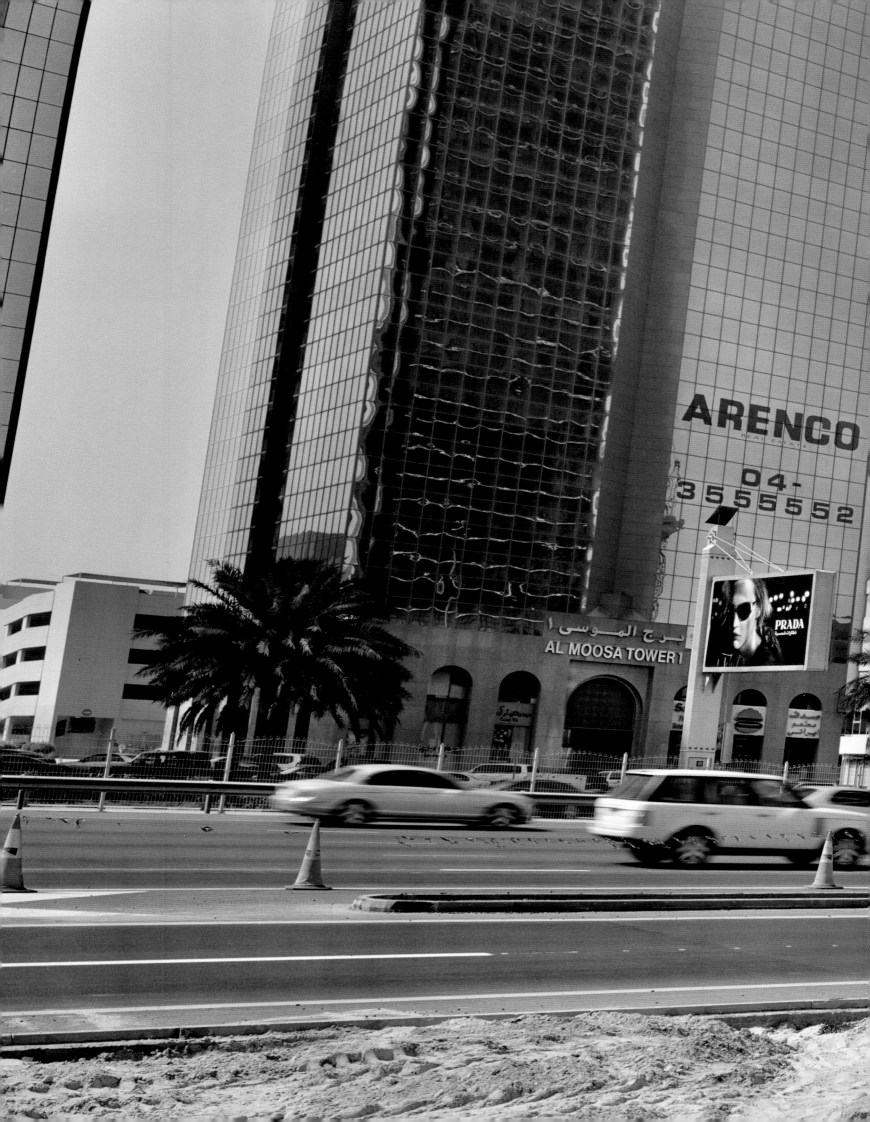

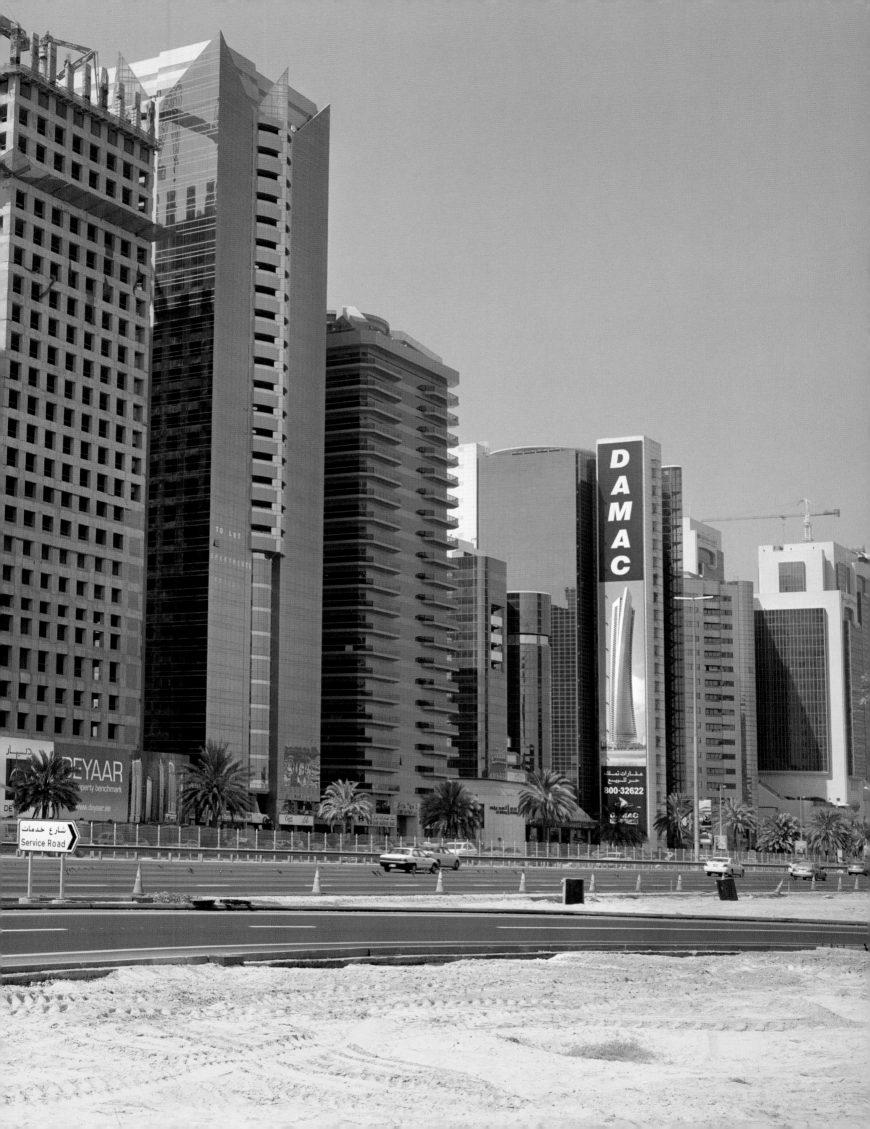

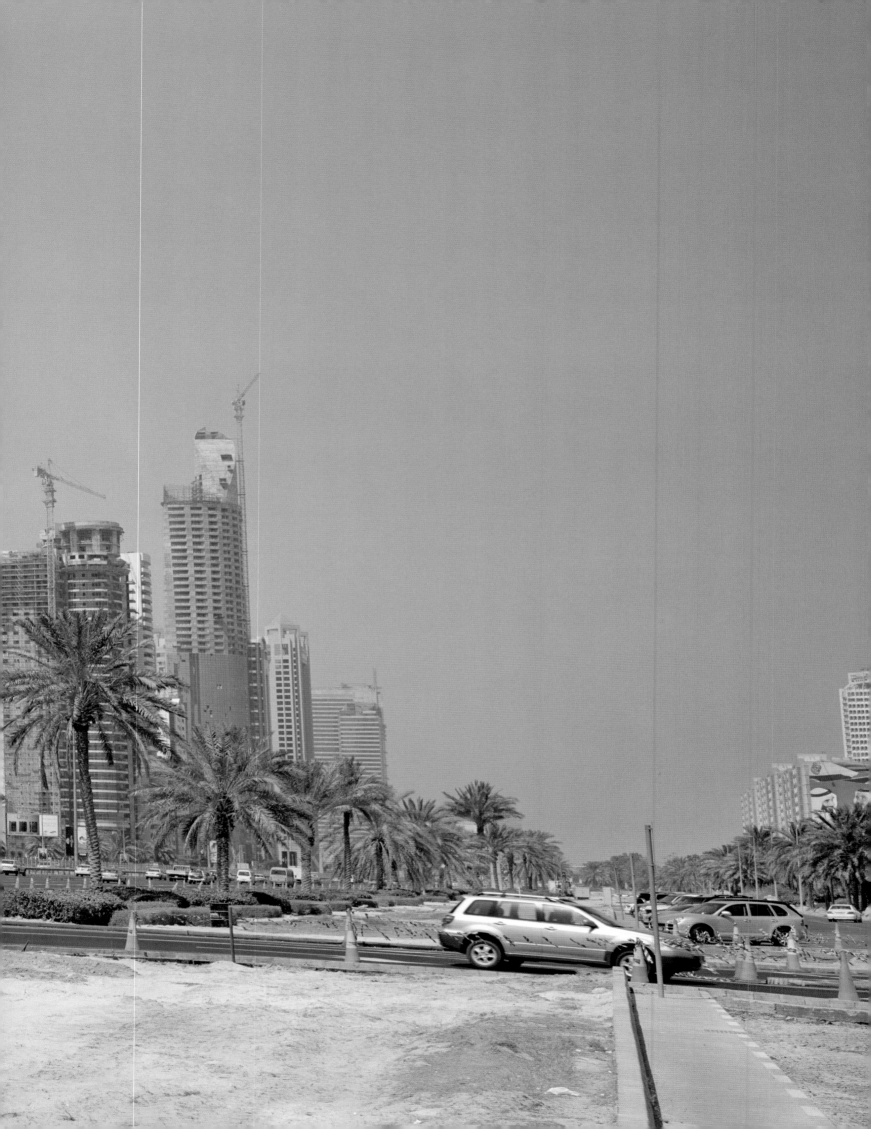

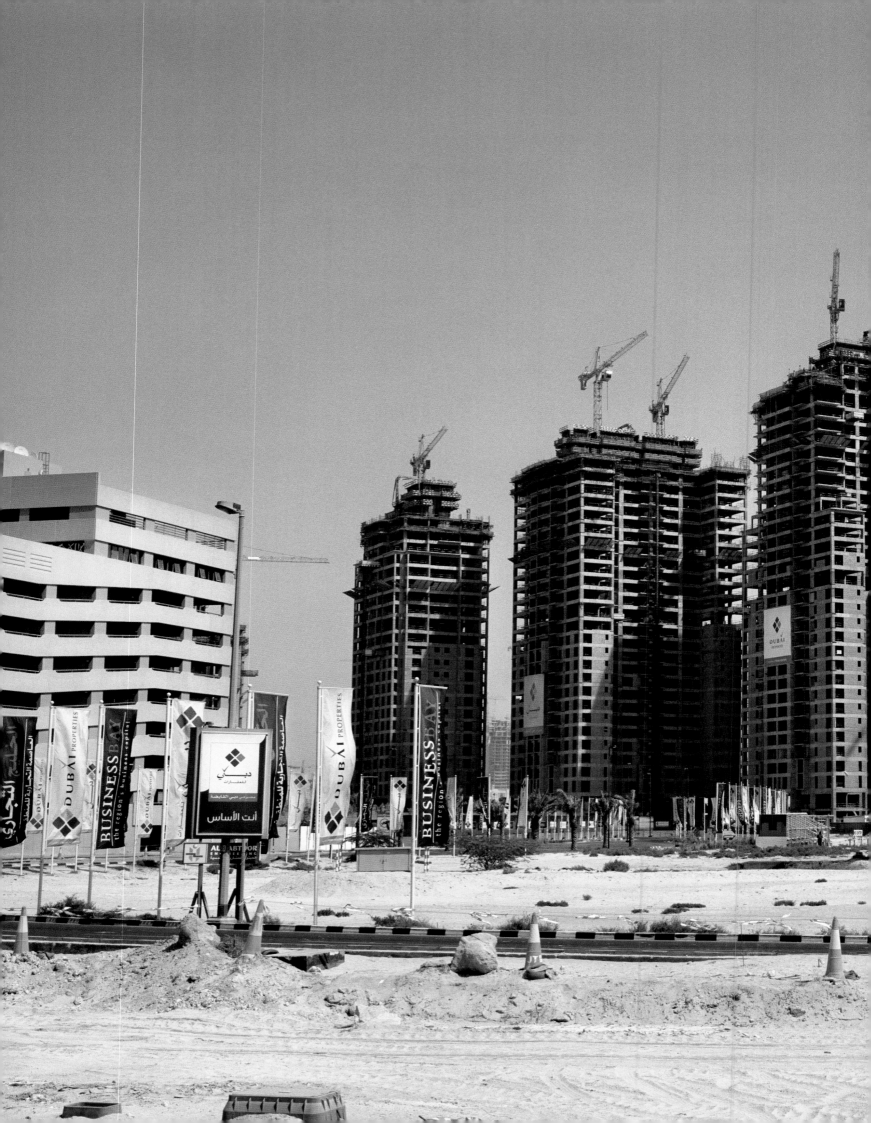

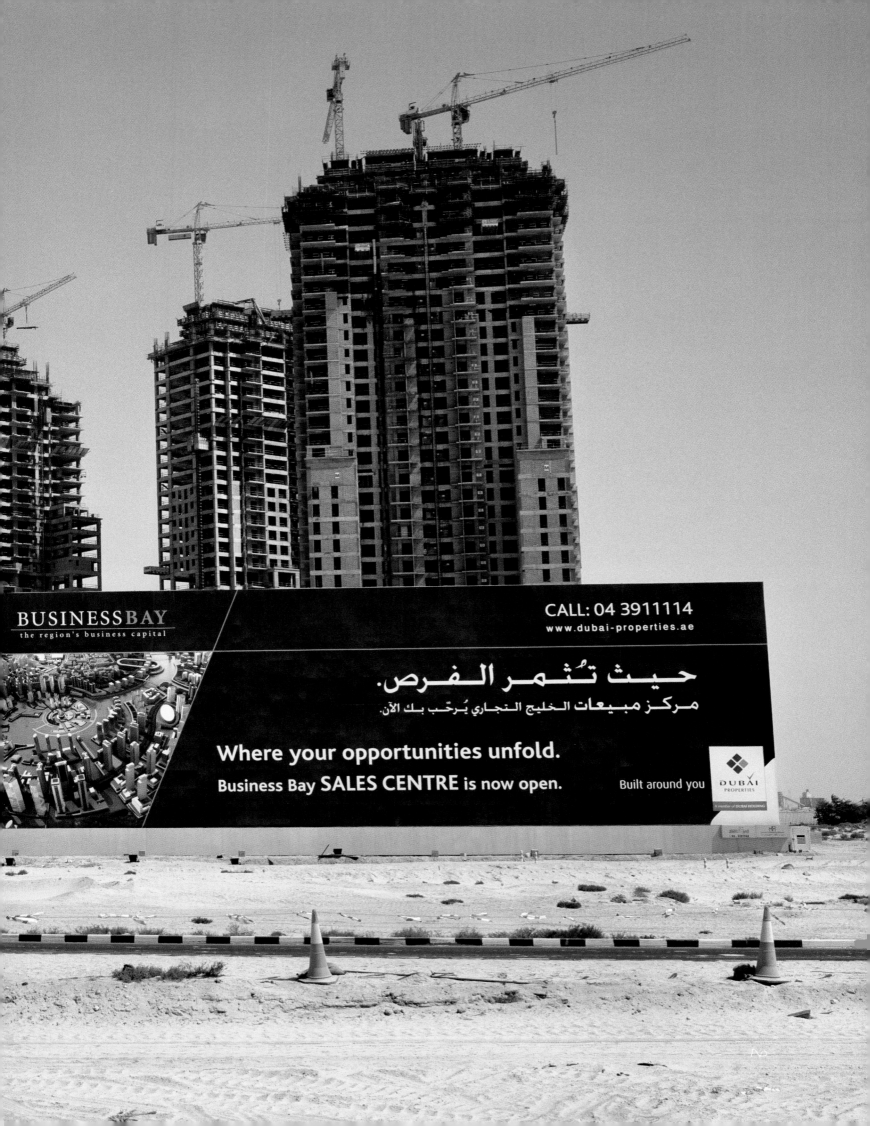

JULIAN HEYNEN / BHUTAN, KATHMANDU, DELHI, SHANGHAI, DUBAI

... das liest sich wie der Angebotsfächer eines Fernreiseveranstalters. Solche Orte sind ohne weiteres erreichbar, man kann sie per Internet buchen. Es ist kein Privileg mehr dorthin zu reisen, der Wagemut, den man dafür aufbringen muss, hält sich in Grenzen. Die einstmalige Faszination exotischer Orte, die meist aus ein paar Gemeinplätzen und viel Phantasie bestand, ist schon lange ihrer Verfügbarkeit gewichen. Die Chimären des Fremden stehen heute auf den Regalen des Warenhauses Welt. Orte wie die oben genannten liegen aber nicht nur in der physischen Reichweite der halbwegs Bessergestellten, sie haben weit mehr als noch vor ein paar Jahrzehnten einen Platz im allgemeinen Bilderhaushalt. Reiseberichte im Fernsehen, Bildstrecken in Magazinen, Hintergründe auf Werbefotos, vermischt dann und wann mit ein paar Fetzen aktueller Information über Katastrophen oder politische Ereignisse haben eine scheinbare Vertrautheit mit solchen Gegenden entstehen lassen, die als Bild abrufbar ist.

In der Mitte des vorigen Jahrhunderts hatte der Anthropologe Claude Lévi-Strauss Klage darüber geführt, dass selbst die Völker des tiefsten Dschungels nicht mehr unberührt wären von westlicher Zivilisation, dass der Traum von der Ursprünglichkeit, dem schlichtweg Anderen der eigenen Kultur zerplatzt sei. Der melancholische Blick auf die „Traurigen Tropen", so der Titel seines berühmten Buches, ist schon lange einem neuen Zwiespalt gewichen. Einerseits wissen und akzeptieren wir in den entwickelten Ländern, dass unsere Errungenschaften in alle Teile der Welt eingedrungen und dass sie im Positiven und im Negativen überall aufgegriffen worden sind. Man kann noch so weit reisen, das Erste, auf das man unter den unwahrscheinlichsten Umständen treffen wird, ist eine Coca-Cola-Dose oder ein Handy. Das gibt einem bei aller Verwunderung bzw. Enttäuschung ein Gefühl der Sicherheit, der Kompetenz. Daneben halten sich hartnäckig die Vermutung und der Wunsch, in den anderen Kulturen eben diesem Anderen doch noch zu begegnen, dort etwas auszumachen, das einen herausfordert und bereichert. Das mag für den einen der Reiz eines besonderen Klimas oder das Fluidum eines Alltagslebens sein, dem er als Flaneur aus der Distanz heraus folgt; ein anderer sucht womöglich Nahrung für seine spirituellen Bedürfnisse. Die Ernüchterung und gleichzeitig die gewisse Zufriedenheit darüber, dass die verschiedenen Welten nur noch Gegenden des gleichen Wirtschaftskosmos sind, und die Suche nach den dennoch vorhandenen Unterschieden sind nicht voneinander zu trennen. Die zeitgenössische Grundhaltung des kritischen Konsumenten scheint auch im Verkehr mit anderen Kulturen zu gelten.

Wenn ein Künstler wie Klaus Mettig solche Plätze aufsucht, von denen hier die Rede ist, um dort mit der Kamera Aufnahmen zu machen, ist er sich dieser und anderer Spannungen und Zwiespältigkeiten bewusst. Er geht vor Ort, er begibt sich in konkrete Situationen, von denen er zwar vorher eine gewisse Vorstellung hat, die er aber nicht ausrechnen kann. Das gilt sowohl für die Umstände, unter denen er seiner Arbeit nachgeht, als auch für die Bilder, die er dort gewinnt. Er ist überzeugt, dass es seiner Anwesenheit an den Stellen, die ihn interessieren, bedarf, um ein Bild zu machen. Er benutzt nicht die Bilder anderer, wie es viele tun, weil für sie Erfahrungen zweiter Hand im Medienzeitalter Realität geworden sind bzw. diese ersetzen. Solch einen Ansatz hat Mettig in früheren Arbeiten verfolgt. In den neueren Bildern vertraut er dagegen auf eine Haltung, die man mit Hinwendung umschreiben könnte. Sein Interesse gilt nicht den Metaphänomenen der Medien

und damit den Fragestellungen einer avancierten technikphilosophischen Kultur, sondern einer möglichen Nähe zu den primären Tatsachen. Die Betonung liegt hier auf dem Wort „möglich"; es drückt ebensoviel Wahrscheinlichkeit wie Skepsis aus.

Eine wesentliche Voraussetzung, in die Nähe des zu Photographierenden zu gelangen, sich den Orten und Menschen zuzuwenden, ohne sie zu bedrängen, ist die Art der Kamera. Mettig verwendete für die Aufnahmen in diesem Buch eine analoge „Technorama"-Kamera der Firma Linhof. Sie hat den Vorteil, dass sie eine hohe Bildqualität mit einer relativ leichten Handhabung verbindet. Mit ihr kann man aus der Hand heraus photographieren, aber da der Film häufig gewechselt werden muss, ist sie langsamer als eine Kleinbildkamera. Wer mit ihr umgeht, ist als jemand zu erkennen, der nicht alles und jedes aufnimmt, dem er begegnet, der die Welt vor ihm nicht unterschiedslos scannt, sondern Zeit mitbringt und auswählt. Das Gerät und seine Handhabung tragen so zu einer gewissen Integration des Photographen in die Situation bei, die notwendig ist, damit er überhaupt erkennt, was ihn interessieren könnte. Noch entscheidender sind selbstverständlich seine sozialen, psychologischen und kommunikativen Fähigkeiten im Umgang mit der Aufnahmesituation. Zumindest ein Stück weit und vorübergehend muss er Teil des Geschehens um ihn herum werden, um die Akzeptanz durch die Personen zu gewinnen, die er gemeinsam mit ihrer Umgebung aufnimmt. Der Photograph wird so nicht unsichtbar, und die Menschen bleiben nicht unberührt von seinem Tun. Es entsteht vielmehr eine Verbindung aus Zufall und distanzierter, temporärer Verbundenheit von Photograph und Umfeld.

Die von Mettig benutzte Kamera liefert panoramaartige Bilder mit einem Seitenverhältnis von 1:3. Diese eher ungewöhnliche Proportion entspricht zwar dem tatsächlichen Sehfeld des menschlichen Auges mehr als die Standartformate, unsere Gewöhnung an die Größenverhältnisse abendländischer Tafelbilder und in ihrer Folge der Photographie jedoch lässt das Format seltsam gestreckt, ja, ein wenig manipuliert erscheinen. Der gedehnte Überblick, den diese Bilder ermöglichen, scheint mit einer gewissen Emphase aufgeladen, die auch eine visuelle Entsprechung zum Erzählerischen beinhaltet. Man kennt das von friesartigen Wandmalereien älterer Kunst und seit dem 20. Jahrhundert besonders vom Film her. Auch bei einem deutlichen Abstand vor diesen fast vier Meter breiten Photographien wandert das Auge unwillkürlich wie bei einem Kameraschwenk von der einen zur anderen Seite. Ein weiterer Effekt des Formats ist, dass sich die Mitte des Bildes einem ganz leicht entgegen zu wölben scheint. Diese technischen Eigentümlichkeiten beeinflussen, besonders bei den Aufnahmen mit Menschen, die Beziehung des Photographen und Betrachters zur dargestellten Szene. Die Personen auf dem Bild erscheinen nicht in gleichbleibender Distanz, die Nähe oder Entfernung zu ihnen wechselt vielmehr, je nachdem auf welchen Abschnitt des Panoramas man blickt. Der Betrachter als Außenstehender vollzieht so die Situation des Photographen nach, der sich in einer grundsätzlich unentschiedenen und manchmal prekären Balance zwischen Teilhabe und Distanz dem Geschehen gegenüber befindet. Eine solche ungesicherte und selbstkritische Position ist die notwendige Folge der kulturellen und sozialen Begegnung, die hier stattfindet. Die Photographien versuchen, den Status dieser Beziehung zwischen Interesse und Fremdheit, zwischen Hinwendung und Ablehnung zu spiegeln und damit zugleich die Verdinglichung des Aufgenommenen als unumgehbares Problem auch in den scheinbar harmonischsten Szenen erkennbar zu machen. Die Bilder sind offen für solche Brüche und Widersprüche auch in den Fällen, wo die ärmlichen bis

katastrophalen Lebensbedingungen einem westlichen, von der Kunst sanktionierten Bildtypus wie etwa der Pastorale begegnen. Man denke an die unter einer kolossalen Autobrücke am Flussufer im Staub lagernden Menschen und Rinder oder an den Jungen mit seinem Lastenfahrrad auf der bewohnten Mülldeponie, beides in Delhi. Meist sind es wie hier ungewöhnliche Schnitte, die am oberen Rand des Formats die Vollendung des kanonischen Bildes verhindern und die Zufälligkeiten und Beschränkungen der realen Situation betonen.

Auch die Marktszenen in Bhutan, die Menschengruppen auf den Straßen in Kathmandu oder Delhi wecken vielfach die Erinnerung an Gemälde abendländischer Kunst, ohne dass man im Einzelnen konkrete Vorbilder benennen könnte oder der Photograph es gar darauf angelegt hätte, mit solchen Zitaten zu arbeiten. Historisch und künstlerisch geprägte Sehgewohnheiten scheinen vielmehr wie selbstverständlich auch in die Aufnahmen von Orten und Kulturen einzufließen, die diesen eher fremd sind. Wie anders kann es auch sein? Und dennoch: Schon bei den niederländischen Malern des 17. Jahrhunderts, die nach Südamerika gingen, oder bei den vielen Orientalisten des 19. Jahrhunderts fragt man sich, warum das Erlebnis der Fremde meist nur die Motive und mitunter das Farbklima, nicht aber die eigene Bildauffassung als solche verändert hat. Seitdem die Photographie unser Bild anderer Kulturen bestimmt, ist das Konzept der Dokumentation in den Vordergrund getreten. Es erfüllt das Bedürfnis nach ‚sachlicher‘ Information, weil es von einem objektiven Dreiecksverhältnis zwischen Betrachter, Gegenstand und Bildverfahren ausgeht. Die daraus resultierende Sichtweise wird als universal begriffen, und tatsächlich dürfte es kaum noch Kulturen auf der Welt geben, die Photographien nicht ‚lesen‘ können und ihnen nicht die Kraft eines visuellen ‚Beweises‘ zutrauen. Und dennoch: Es bleibt ein in ein bestimmtes Weltbild eingebettetes Verfahren, das sich zwar durch Kolonialismus und Globalisierung beinahe überall Geltung verschafft hat, aber vielfach im zumindest latenten Konflikt mit anderen Sichtweisen steht. Jemand, der dieses Instrument als Künstler anderen Kulturen als der eigenen gegenüber einsetzt, muss sich dieser Spannung bewusst sein und er wird versuchen, sie in seinen Bildern – die sich ja potentiell nicht nur an Menschen der eigenen Tradition richten – zu reflektieren. Bei Klaus Mettig geschieht das nicht nur durch die Wahl der Kamera und das daraus resultierende Oszillieren zwischen Nähe und Distanz, sondern auch z. B. durch die Blicke der Menschen in Richtung auf den Photographen bzw. den Betrachter. Diese Blicke signalisieren eine meist beiläufige Neugier und ein Einverständnis, das die Praxis des Photographiert-Werdens kennt und als Teil der eigenen Lebensumstände akzeptiert. Die Blicke antworten zwar in gewisser Weise dem Blick des Photographen, dennoch bleibt es ein asymmetrisches Verhältnis, weil das Bild als Zeugnis erst später sichtbar wird und dann in aller Regel auch nur für eine Seite der Begegnung. Die Transaktion, die in der Aufnahme stattfindet, hat nur noch wenig von der magischen Brutalität des geraubten Blickes und damit der geraubten Seele, wie sie bei früheren Begegnungen mit der noch unbekannten Photographie erlebt wurde. Was jedoch bleibt, ist eine gewisse Ernsthaftigkeit und Nachdenklichkeit der Blicke, in denen Ungleichheit und Verlust virulent sind. Die Blicke der vorübergehenden Partner bei der Entstehung des Bildes als Photograph weder zu meiden noch zu suchen, sondern als akzidentiell zu dulden, bedeutet, die grundsätzliche Unkontrollierbarkeit der Situation, die Zufälligkeiten ihrer Erscheinungen zu akzeptieren. Hierin kommt eine Haltung zum Ausdruck, die bei aller Gestaltungsabsicht dennoch Respekt vor der Autonomie der

photographierten Szene hat, die Hinwendung nicht mit Kontrolle verwechselt und die Autorität eines gleichsam zentralperspektivischen Blicks um die Heterogenität der Blicke ergänzt.

Klaus Mettig hat das Entstehen dieser Photos als die Verbindung zweier gleich wichtiger Prozesse beschrieben. Der erste Teil der Wegstrecke zum Bild, wie wir es vor uns sehen, ist die Wahl des Ziels, die Reise dorthin, die Eingewöhnung in die Verhältnisse, die Verhandlung der eigenen Anwesenheit vor dem Motiv und schließlich die Aufnahme. Der zweite Teil des Verfahrens ist davon räumlich, zeitlich und sozial getrennt. Er findet in der eigenen Dunkelkammer statt, wo aus der Seherfahrung vor Ort und dem Blick durch den Sucher die wandfüllenden Abzüge werden. Diese Zweiteilung ist zuerst einmal nichts weiter als eine Notwendigkeit der photographischen Technik. Schon immer stand in der Geschichte des Mediums der noch so genau vorbereiteten Aufnahme die Realisierung des Bildes im Studio gegenüber. Dem fixierten Moment folgt die Herrichtung des Bildes auf Dauer. Klaus Mettig überlässt die Herstellung der Abzüge nicht einem kommerziellen Labor. Die Dunkelkammer bleibt so in einem handwerklichen Sinne das traditionelle Atelier des Künstlers, in dem das Gesehene zum Bild konkretisiert wird. Auf die Inhalte der Bilder bezogen wird mit dem zweiten Teil des Prozesses ein größtmöglicher Abstand geschaffen. Wo am Anfang die Hinwendung stand, das sich Aussetzen der sozialen Realität gegenüber, ist der Photograph nun ganz Herr der Lage, mit sich und dem zu manipulierenden Objekt des Bildes allein. Wer dem zweiten, gleichsam introvertierten Teil des Verfahrens so viel Gewicht gibt, steht offensichtlich jedem einfachen Dokumentarismus skeptisch gegenüber. Er weiß um die unumgehbare Verankerung der Photographie im Subjektiven, und er will sie in der Darstellung der Außenwelt sichtbar halten. Worin aber besteht die Arbeit in der Dunkelkammer, außer den Photochemikalien ihren Verwandlungsprozess zu ermöglichen? Im Mittelpunkt stehen der Bildausschnitt, das Licht, die Farben und die Genauigkeit der Darstellung: alles zutiefst malerische Kriterien. Die Überarbeitung der Aufnahme löst ihren Zusammenhang nicht auf, das Ziel ist keine Verfremdung oder Umwertung, nicht das Hinzufügen einer Interpretation, die den photographischen Primärbefund deutet oder konterkariert. Was bei der Arbeit mit den quasi-malerischen Akzentuierungen in der Dunkelkammer geschieht, ist vielmehr ein zweites Sehen des schon Gesehenen. Der Künstler durchmisst erneut und in anderer Weise den Abstand, der ihn von den aufgenommenen Tatsachen trennt. Er stellt durch subtile Manipulationen das visuelle Eingeständnis her, dass das Bild nur ein partielles Echo der Realität ist.

„Don't be left behind", der Text auf einer Reklametafel in Dubai hat der Publikation der Photographien ihren Titel gegeben. Die Aufforderung lässt an Emphase, Bestimmtheit und an Gnadenlosigkeit nichts zu wünschen übrig. Es gibt nur eine Richtung, und die heißt Fortschritt. Die negative Formulierung der Devise macht unmissverständlich klar, dass es eine reale Gefahr gibt, zurückgelassen und vergessen zu werden. Ein Status quo, der so etwas wie Dauer genießen könnte, existiert nicht. Zurückbleiben heißt aber auch, dass es kein Zurück in irgendeinen von früher her bekannten, einen vertrauten Zustand gibt. Wer zurückbleibt, fällt in etwas, das nur schlimmer sein kann als das, was er kennt. Der Slogan möchte motivieren und wirkt gleichzeitig wie eine Drohung. Immense Bauprojekte in der arabischen Wüste, die bisweilen sciencefictionartige Dynamik der Entwicklung von Städten wie Shanghai, das harte Nebeneinander von Fortschrittssignalen und Erbärmlichkeit in Delhi oder die Inseln scheinbar traditionellen Lebens in Bhutan oder Kathmandu

– sie alle existieren gleichsam unter dieser Devise, nicht hinter der unabänderlichen Bewegung nach vorne zurückfallen zu dürfen, die auch den ‚letzten Winkel' der Welt erreicht hat. „Don't be left behind" gilt aber auch für den, der sich davon ein Bild machen will, für den Künstler. Seine Herausforderung ist es, nicht aus der vermeintlichen Sicherheit einer einmal entwickelten oder gar ererbten Bildvorstellung heraus eine Welt abbilden zu wollen, die sich verändert, sobald der Verschluss der Kamera sich schließt. Als Bildermacher kann er die realen Veränderungen nie einholen, er schafft stattdessen künstliche Pausen für eine Reflexion mit visuellen Mitteln. Die Photographien wollen jedoch nichts aufhalten, sie konservieren nicht. Mit ihrem im Wortsinn umfassenden Format und ihrer ‚malerischen' Durcharbeitung gestalten sie vielmehr das produktive Eingeständnis einer paradoxen Situation: Die Komplexität der realen Verhältnisse und unserer Haltung zu ihnen ist unüberschaubar, in manchen Augenblicken aber, wenn das unbeherrschbare Geschehen zum Bild gerinnt, scheint so etwas wie Einsicht möglich. Das ist nicht nur ein Widerspruch, in ihm steckt auch eine Verführung des Denkens durch das Auge. Die Bilder von Klaus Mettig lassen offen, ob das eine Hoffnung oder eine Gefahr ist, und sie machen deutlich, dass sie nichts anderes sein können als Teil dieser Fragen.

Anstelle einer bild- oder biografienahen Werkinterpretation sollen Klaus Mettigs neue Arbeiten aus 2005/2006 – großformatige Panorama-Ansichten asiatischer/arabischer Megacities und ihrer Bewohner – hier als spezifische Ausprägung der drei Konstituenten des zentralperspektivischen Bildes, Subjekt, Zeit und Raum, in den Blick genommen werden.

1. Subjekt Unter Bezug auf die These Sybille Krämers von der Zentralperspektive als visueller Metapher und epistemischer Bedingung einer Ermächtigung des neuzeitlichen Subjekts, das sich zur zentralen Ordnungsinstanz des zentralperspektivisch (re)konstruierten Raumes entwirft[1], ist in diesem Zusammenhang der These Jonathan Crarys von der Entkörperlichung und damit Entsubjektivierung des Sehens durch das zentralperspektivisch fixierte und singularisierte Auge zu widersprechen.[2] Als Fluchtpunkt bzw. visuelle Null des Bildes repräsentiert es vielmehr den Standpunkt des Betrachters in Bezug auf das Gesehene bzw. Dargestellte. Schon Brunelleschi (1377–1446) bewies in seinem berühmten Experiment die Richtigkeit des zentralperspektivischen Sehmodells: Ein Betrachter blickt darin mit einem Auge durch ein Guckloch auf einen Spiegel, der einen gemalten Ausschnitt seines (natürlichen) Blickfeldes reflektiert und in dessen Zentrum das Auge des Betrachters erscheint. Der gemalte Wirklichkeitsausschnitt fügt sich – in seiner gespiegelten Form – übergangslos in das natürliche Bild des Sehens ein, das sich folglich als kongruent mit dem künstlichen Bild des Sehens erweist.

Ähnlich wie der einäugige Betrachter Brunelleschis blickt auch der Fotograf durch das eine Auge seiner Kamera auf die zu fotografierende Szene und legt auf diese Weise den eigenen Standpunkt in der Konstruktion des Bildes selbst offen. Das fotografierende, den Gesetzen der Optik unterworfene *subjectum*, wird so zum eigentlichen Schöpfer des Bildes, indem es Raumrelationen in Flächenrelationen transformiert, die wiederum trotz aller Kalkülisierung von der Singularität der Beobachtung/Aufnahme und damit der raumzeitlichen Situierung des Beobachters/Fotografen zeugen. Wenn Mettig in seinen Panorama-Aufnahmen zumeist nur leicht von der Normalperspektive abweichende Auf- oder Untersichten verwendet, so geschieht dies, um die Kommunizierbarkeit seines jeweiligen Standpunktes zu unterstreichen[3]: Die Subjektivität des Fotografen, verstanden als Ausgangspunkt des optischen Sehkegels, ist dem Prinzip nach eine „leere" Subjektivität, die im Akt des Betrachtens, der vor und nach dem eigentlichen fotografischen Akt des Auslösens stattfindet, mit Inhalt, d.h. mit einer über das rein Optische hinausgehenden Beziehung zum Objekt gefüllt wird. In dieser prinzipiellen Wiederholbarkeit der einmaligen Beziehung von *punctum* (Subjekt als Augenpunkt) und *focus* (Objekt als Brennpunkt) liegt denn auch die soziale Dimension des fotografischen Bildes, die seiner performativen, weltherstellenden Dimension zu Grunde liegt.

Die Fotografie, der aufgrund ihrer mechanischen Umsetzung des zentralperspektivischen Kalküls subjektive Expressivität geradezu abgesprochen wurde, kann so in einem völlig neuen Licht gesehen werden: Versteht man Subjektivität in einem raumrelationalen und damit geometrischen Sinne, ist jede Fotografie subjektiv, weil Resultat der raumzeitlichen Positionalität des Fotografen, seines Vor-Ort-Gewesen-Seins. Die Frage nach dem subjektiven Ausdruck bzw. dem Wie der Darstellung (Stil) tritt in diesem Zusammenhang vor der Frage nach dem Wie der Darstellbarkeit, nach den Bedingungen der Wahrnehmung und Darstellung von Raum in den Hintergrund: Raum ist,

entsprechend der von Leibniz in seiner *Monadologie* entwickelten Ontologie des individualisierten Perspektivismus, die Ausfaltung endlich-unendlich vieler individueller Positionen des Subjekts im Verhältnis zur Welt.

Gerade Mettigs Arbeiten verlangen nach einer solchen Definition fotografischer Subjektivität, ist er doch keiner, der die Fotografie als Mittel zum Zweck benutzt, als bloßes Sichtbarmachen von etwas, als Medium, das die Verschiedenheit der Objekte einem gleichen Maß unterwirft: So wie die Zahl und das von ihr abgeleitete Geld ermöglicht auch die Fotografie die Quantifizierung des qualitativ Verschiedenen, was sie in logischer Konsequenz zum bevorzugten Medium der Dokumentation bzw. Archivierung von Gegenständen und Ereignissen avancieren ließ.

Genauso fremd wie die Glorifizierung des Referenten, wie sie insbesondere von der Neuen Sachlichkeit propagiert wurde, ist Mettig der (moralische) Konzeptualismus, der die Fotografie einem konzeptionellen und/oder moralischen *a priori* unterwirft, das sie lediglich bildhaft umzusetzen hat. Er betont weder den indexikalischen Aspekt der Fotografie (Dokumentarismus) noch ihren symbolischen Aspekt (Fotografie als Ausdruck persönlicher Befindlichkeiten, politischer Konzepte oder moralischer Haltungen), sondern versucht sich in einer ikonisierenden Synthese von Referenz und (auf referenzieller Erfahrung gründendem) Urteil. Er ist kein neutral aufzeichnendes Foto-Auge, sondern zuallererst subjektiver Betrachter/Fotograf. Als solcher urteilt er, aber diskret, und wirft so eher Fragen auf, anstatt diese schon im Vorfeld selbst zu beantworten. In strategischer Distanz zum zeitgenössischen Fotografie-Diskurs, der das Konzept dem Perzept voranstellt, verfolgt Mettig mit seinen Fotografien das umgekehrte Ziel, entsprechend der aristotelischen Seelenlehre das Konzept aus dem Perzept langsam aufsteigen zu lassen: Seine Bilder sind nicht bildgewordene Erkenntnis, sondern lediglich bildhafte Voraussetzung möglicher Erkenntnis.

Seit seinen künstlerischen Anfängen in den 1970er Jahren hat Mettig die Fotografie in den drei großen, miteinander seit jeher in produktiver Konkurrenz stehenden Diskursfeldern eingesetzt. Seine Arbeiten lassen sich sowohl dem Feld „Kunst mit Fotografie" als auch den Feldern „Fotografie als Kunst" und „Fotografie als Fotografie" subsumieren, ohne dass sie je vollständig darin aufgehen würden. Wenn hier dennoch der Versuch unternommen wird, ausgewählte Werkserien in den drei Diskursfeldern zu verorten, dann nur, um den transdiskursiven Aspekt des gesamten fotografischen Werks aufzuzeigen.

Als „Kunst mit Fotografie", die, wie Rosalind Krauss in ,Notes on the Index I' (1976) feststellte, zum Paradigma der (postmodernen) Kunst der 1970er Jahre avancierte, sind Mettigs frühe politische Arbeiten aus eben dieser Zeit zu bezeichnen, insbesondere *1-214/1979-1981 (and such a press of people)*, für die er S/W-Fernsehbilder im Rückgriff auf kommunistische Strategien der „Sichtagitation"[4] mittels Fotocollage (vgl. El Lissitzkys Fotofries auf der Internationalen Presseausstellung in Köln 1928) zu einem Panoptikum terroristischer/islamistischer/atomarer Bedrohung rund um die iranische Revolution und die RAF zu einer 65 Meter langen Wand/bild/zeitung montierte.

Mettigs nächste Arbeit, *Berlin/Ost-West/1981-1983 (Zwischen Gestern und Morgen)*, in der das geteilte Berlin in einer gemeinsamen Melancholie versunken scheint, ist hingegen eher dem Kontext der „Fotografie als Kunst" zuzuordnen, wo die von der postmodernen „Kunst mit Fotografie" verworfenen Kriterien gelungener (fotografischer) Bildgestaltung weiterhin ungebrochen gelten. Jenseits aller politischen Implikationen ist die Serie hier nur so stark wie das schwächste Einzelbild,

das seine ästhetische Qualität aus Lichtführung, Komposition, Farbmodulation und dem Spiel mit der Unschärfe bezieht.

Als „Kunst mit Fotografie" müssen insbesondere die Arbeit *I-VII/China 1987 (Die Explosion ist lautlos)* und die Arbeit *Vor dem Licht (Stahlnetz) 1985* gesehen werden: Während Mettig in *Die Explosion ist lautlos* die einzelnen, vollkommen ent-indexikalisierten Bilder durch die räumliche Anordnung der Bilder einer künstlerischen Narration auf zweiter Ebene überantwortet, ist eben diese narrative Ebene in *Vor dem Licht* durchsetzt mit Leerstellen, die Sichtbarkeit des Bildes als (jeweils ungenügende) Sichtbarmachung des Unsichtbaren markierend.[5] Faktische wie fiktive Referenz sind auf diese Weise der *aisthesis* entzogen. Jedoch: Es ist ein Spiel mit dem Entzug, denn das über den Bildern liegende Stahlnetz verbirgt diese wie durch einen Schleier, um sie gleichzeitig einer erhöhten Aufmerksamkeit preiszugeben.

Das letzte der drei oben genannten Diskursfelder, in deren Koordinatensystem sich Mettigs künstlerische Praxis bewegt, die „Fotografie als Fotografie", könnte, ähnlich wie schon zu Beginn des letzten Jahrhunderts geschehen, in Form einer Gegenbewegung zum aktuellen neopikturalistischen Trend als Ausdruck einer vielerorts konstatierten neuen Sehnsucht nach dem Wirklichen und einer Renaissance künstlerischer Autorschaft in den nächsten Jahren gerade in der künstlerischen Fotografie verstärkt an Kontur gewinnen.

Mettigs Serien *N.Y. 2004* und *O.T. 1992 (Shanghai)* machen diese der „Fotografie als Fotografie" eigene, produktive Spannung zwischen Referenzialität und künstlerischer Autorschaft deutlich. Sie funktionieren unabhängig von ihrer Größe als Konvolut an Bildern, aus denen immer wieder einzelne (Details) hervorstechen und im Sinne des Barthes'schen *punctum* den Betrachter fesseln. Zugleich funktionieren sie als Ensemble monumentaler Einzelbilder, deren Motive sich nur langsam aus dem Filmkorn lösen, um ins affektive Bewusstsein aufzusteigen.

2. Zeit Spezifikum der Fotografie, so Barthes in der *Hellen Kammer*, sei die Kollision von Vergangenheit (der fotografierten Szene) und Gegenwart (des fotografischen Bildes). Gleichzeitig werde aufgrund der Transparenz des fotografischen Zeichens, das den Blick auf den Referenten freigibt, durch die Fotografie hindurch die Vergangenheit als Gegenwart erfahren und ihr so das (gegenwärtige) Wissen über ihre (bereits eingetretene) Zukunft eingeschrieben. Ohne Barthes widersprechen zu wollen, muss an dieser Stelle doch betont werden, dass diese Vergegenwärtigung des Vergangenen nichts Fotografisches an sich hat, sondern in der Natur menschlicher Zeiterfahrung selbst begründet liegt.

Folgt man der schlüssigen Argumentation von Augustinus im 11. Buch seiner *Confessiones*, existieren weder Vergangenheit noch Zukunft an sich, sondern werden vom menschlichen Bewusstsein (der Gegenwart der Gegenwart) als Gegenwart der Vergangenheit bzw. Gegenwart der Zukunft bloß imaginiert.

In diesem Sinne ist auch die im chinesischen Pearl River Delta erfundene Zeitform der *future perfect tense*[6] zu verstehen, auf die Mettig in seinen 2003 in China entstandenen *Unspecified Landscapes (Airplane Views)* Bezug nimmt: Nur durch permanente Vergegenwärtigung existiert das Vergangene im menschlichen Bewusstsein, nur um den Preis der Aufgabe seiner Abgetrenntheit vom Jetzt ist es imaginär erfahrbar. Historisches Bewusstsein kann folglich erst dann entstehen, wenn ein vergangenes Ereignis nicht mehr Subjekt individueller und kollektiver Vergegen-

wärtigung vergangener Ereignisse in Form ihres affektiven Auftauchens aus dem Gedächtnis (remembrance) ist, sondern das Resultat willentlicher und beliebig oft wiederholbaren Rückrufaktionen (recollection) in der Tradition der antiken *ars memoriae*.[7]

Aufgrund ihrer indexikalischen Natur kann die Fotografie Fremdes/Vergangenes als deren optisch-chemische Spur in Raum und Zeit vergegenwärtigen: Sie ist mithin nicht nur Mittel (Medium bzw. Bildträger), sondern auch Gegenstand (Referent bzw. Bildinhalt) subjektiv-affektiven Gedenkens. Gleichzeitig kann sie aufgrund ihrer zeitlichen Distanz auch als Gegenstand historisch-kritischer Reflexion dienen, ebenso wie sich die Welt nur unter der Bedingung ihrer räumlichen Distanz dem menschlichen Auge als Gegenstand des Sehens darbietet.

Aufgrund ihrer engen, quasi materiellen Verbundenheit mit dem (vergangenen) Gegenstand bei gleichzeitigem Wissen um die dem Medium eigene chronologische Differenz von Referent und Bild hat sich die Fotografie seit jeher mehr der Aufzeichnung des Vergänglichen und weniger dem Erschaffen idealer Welten gewidmet. Das Bewahren visueller Eindrücke, ist, ähnlich wie das Bewahren von Kultgegenständen in der *salvage ethnology*, auch eine der wichtigsten Triebfedern der Reisefotografie, die sich vorwiegend am vorgegebenen Kanon besonders pittoresker Motive abarbeitet. Mettig hingegen verfolgt in seinen Stadtporträts des Mittleren und Fernen Ostens ein ganz anderes Anliegen, nämlich Menschen und Tiere als Funktionen städtischer Architektur zu zeigen. Der von ihm seit den 1970er Jahren wiederholt in den Blick genommene urbane Wandel erschließt sich dem Betrachter im diachronen Vergleich der 1978, 1992, 2002/2003 mit den 2006 entstandenen Arbeiten: Steht auf der Fotografie *O.T. IV Shanghai 2003* noch ein Überrest kolonialer Vergangenheit inmitten einer Industriebrache, ist derselbe Platz auf einem Bild aus der aktuellen Shanghai-Serie 2006 schon von dichtem Gras überwuchert, „durchbrochen vom eindringenden Land", was den Städter, so Benjamin in der *Einbahnstraße* (1928), „vollends in jene undurchsichtige und im höchsten Grade grauenvolle Situation" versetzt, in der er unter den Unbilden des vereinsamten Flachlandes die Ausgeburten der städtischen Architektonik in sich aufnehmen muss".

Trotz aller sozialpolitischen Brisanz der Kollision verschiedener ideologischer Ebenen (kolonialer Kapitalismus bis 1949, Sozialismus bis 1980 und globaler Kapitalismus ab 1980) in Form ihrer jeweiligen Architekturen, sollten diese Bilder nicht als Kapitalismuskritik missverstanden werden, die nur zu oft eine rein ästhetisierende Haltung, nämlich die pittoreske Wertschätzung städtischen Elends kaschiert.[8] Vielmehr sind sie Resultat eines relativ spontanen Reagierens auf Gegenstände und Ereignisse im öffentlichen Raum, das als Fortsetzung der politisch engagierten Reportagefotografie gedeutet werden könnte, wie sie in Europa von den Magnum-Fotografen Erich Lessing oder Luc Delahaye[9] und in den USA von den FSA-Fotografen Walker Evans und Dorothea Lange sowie späterhin von Helen Levitt, Gordon Parks oder Bruce Davidson betrieben wurde.

Während in den Aufnahmen aus Bhutan, Kathmandu Valley und Delhi die (mehr oder weniger) urbane Umgebung nur den Hintergrund für (Gruppen)porträts bildet, dominiert in den Fotografien aus Shanghai und Dubai die den Menschen umgebende und bezeichnende urbane Architektur. Wenn aber diese in Shanghai noch als Ausdruck ihrer jeweiligen Ära (kolonialistisch, kommunistisch, globalkapitalistisch) gedeutet werden kann, sind in Dubai die verschiedenen Schichten des Neuen kaum noch ideologisch/stilistisch bestimmten Epochen/Dekaden zuordenbar: Dubai repräsentiert, so der Befund des von Rem Koolhaas geleiteten Forschungsprojekts zur arabischen Küste OMA-AMO

den Prototyp der *emerging, non-western city*, die nicht auf eine lange Geschichte und entsprechende architektonische Palimpseste zurückblicken kann, sondern sich in einem permanenten Werden befindet, das jedoch nicht als Widerspruch zum linearperspektivischen Zeitkonzept zu sehen ist, sondern vielmehr als dessen logische Konsequenz: als Resultat des zwanghaften Wunsches nach einer Zukunft der Superlative oder zumindest des Komparativs, der das Früher von vorneherein mit dem Weniger bzw. Geringer gleichsetzt. Wenn schon die kapitalistische Gesellschaft den Großteil ihrer Zeit damit verbracht hat, zurückzuschauen und Pläne zu machen, so wandelt sich in Zeiten des Turbokapitalismus individuelles Sein als Tun vollends zum Sein als Vorhaben, womit nicht zuletzt die Illusion ständigen Fortschritts aufrecht erhalten wird, denn ein Projekt ist im buchstäblichen Sinne nie abgeschlossen, sondern immer im Stadium des *has becoming*. Wie aber einen solchen Zustand fotografisch darstellen? Sicherlich nicht im *moment décisif*, der die Essenz eines Ereignisses fähig wäre, auszudrücken, sondern in der tätigen Erkenntnis, dass nicht der vergebliche Versuch, das Zeitfluidum fotografisch zu arretieren, den eigentlichen Impetus fotografischer Praxis darstellt, sondern es vielmehr jene raumzeitliche Inkommensurabilität des fotografischen Bildes und seines Gegenstandes ist, die zu immer neuen Bildern des *moment raté* antreibt.

3. Raum Mettig benutzt für seine neuen Arbeiten das Panoramaformat, weil es dem menschlichen Blickfeld besser entspricht als das übliche, eher quadratische Bildformat der Großformatkamera, deren umständlicher Gebrauch spontanen Bildfindungen im Wege steht. Mit der Technorama von Linhof hingegen ist es möglich, unter Beibehaltung einer hohen Abbildungs-qualität nicht nur relativ spontan zu fotografieren, sondern vor allem auch näher an das Motiv heranzugehen als mit der Großformatkamera. Die so entstandenen Fotografien gerieren sich aber weder als Produkte einer teilnehmenden, sozialanthropologischen Beobachtung noch als Bilder des Fremden im Sinne der visuellen Anthropologie, sondern als Bilder des Fremdseins. Und bleiben doch Ansichten, im fotografischen Sinne wie im übertragenen Sinne: Sie zeigen nicht nur, was ist, sondern bringen auch die Haltung des Fotografen zum Ausdruck. Ganz besonders deutlich wird das bei den Bildern aus Shanghai und Kathmandu. Da ist auf der einen Seite die Sehnsucht nach dem Einfach-Menschlichen bzw. dem Einfach-Naturhaften und auf der anderen Seite die Erkenntnis, dass dieses bukolische Idyll von eben dem Fortschritt zerstört wird, der sein Bereisen und Foto-grafieren erst ermöglicht. Mettigs neue Arbeiten zeigen so den Grundwiderspruch fotografischer Praxis auf, die sowohl Funktion als auch Voraussetzung technologischer Innovationen ist, deren sozioökonomische Folgeerscheinungen sie dokumentiert.

Trotz ihrer Ikonisierung durch die großformatige Präsentation sind es immer Aufnahmen konkreter, vorgefundener Orte, Ereignisse und Menschen, die durch Auswahl und Anordnung in Wandbild-Formationen oder als zumeist 4-teilige Diaprojektionen in metareferenzielle Sinnzusammenhänge gestellt und damit in den Rang verallgemeinerbarer Aussagen erhoben werden, der ihnen als jeweils unverbundenen Einzelbildern verwehrt bliebe. Das einzelne Bild trägt in sich nur eine stumpfe Einzelbedeutung und ist affektiven Assoziationen im Sinne des Barthes'schen *punctum* ausgeliefert. Erst in der Kombination mit anderen Bildern (oder Texten) kann es etwas über sich selbst, über seine materielle Präsenz und den indexikalischen Verweis auf die körperliche Kopräsenz von Fotograf und Fotografiertem Hinausgehendes bezeichnen und damit vom bedeutungsunterscheidenden Element (Phonem) zum bedeutungstragenden Element (Morphem) des fotografischen Bild-Satzes werden.

Die einzelnen Panoramen ergänzen sich so zu einem Panoptikum, einer Gesamtschau des Phänomens der *emerging non-western city*, ohne pittoreske Klischees wie Überbevölkerung und mangelnde Hygiene der *shantytowns* bzw. Anonymität und Kälte der *central business districts* mit ihren verspiegelten Glasfassaden zu bemühen. Während die Bilder aus Shanghai und Dubai Menschen primär als Funktionen der urbanen Architektur zeigen, überwiegen in den Bildern aus Kathmandu und Delhi Landschaftsaufnahmen und Gruppenporträts. In fast arkadisch anmutenden Szenen finden sich immer wieder Mensch und Tier in Eintracht am Wasser liegend. Jedoch: Ein Detail, wie z.B. eine über den Fluss führende Autobahn, unterläuft jedes Mal das pittoreske Klischee und lenkt das Augenmerk des Betrachters auf die sozioökonomische Problematik dieser Orte: das auch von den besten (zumeist am Vorbild der westlichen Stadt orientierten) Stadtplanern nicht zu homogenisierende Gegen- bzw. Nebeneinander agrarischer, industrieller und postindustrieller Gesellschaften. Deren Konfliktzonen sind es, die Mettig in den Megacities des Mittleren und Fernen Ostens studiert, jene Orte des „Nicht mehr/noch nicht", an denen das Alte dem Verfall preisgegeben wird und das Neue erst im Begriff ist, zu entstehen. Trotz der überwältigenden Präsenz von Rohbauten bzw. bereits fertig gestellten Büro- und Wohngebäuden auf den Fotografien aus Shanghai und Dubai bleibt die Bildmitte häufig leer, gleichsam als Metapher des künstlich erzeugten inneren Mangels, aus dem heraus die kapitalistische Wachstumsideologie ihre Legitimation bezieht. Mettig positioniert sich eindeutig gegen die Ideologie der Superlative, wie sie Dubais frenetische Bauaktivität kennzeichnet, favorisiert aber auch nicht undifferenziert das Alte, dessen hässliches und ungesundes Chaos er genauso emotionslos schildert wie die Ausgeburten genuin asiatisch/ arabischer metropolitaner Ambitionen. Im Gegensatz zu seinen frühen Arbeiten der 1970er Jahre, in denen das sozialistische China als Alternative zum Kapitalismus US-amerikanischer Prägung dargestellt wurde, präsentieren sich Mettigs neue Arbeiten als kontemplative Projektionsfläche mit dem Ziel, über die Ansichten von Stadtlandschaften und ihrer Bewohner zu einem Bild dessen zu kommen, was Menschsein im 21. Jahrhundert ausmacht oder ausmachen könnte.

Das Gesamtkorpus an Bildern aus fünf verschiedenen urbanen Regionen des Mittleren und Fernen Ostens ist weniger eine Veranschaulichung sozioökonomischer Strukturen und Prozesse, sondern ein im wörtlichen Sinne komponiertes, aus Einzelbildern zusammengesetztes Gesamtbild der Phänomene, die sich dem Blickfeld des Fotografen jeweils „auf einmal" erschlossen haben. Anstatt mit immer demselben Abstand zum Motiv, zur immer gleichen Tageszeit, mit immer derselben Zeit/Blendenkombination zu fotografieren und so die verschiedenen Orte, Gegenstände und Ereignisse einem gemeinsamen Maß zu überantworten, ordnet Mettig seine spontan entstandenen (wenn auch alle mit derselben Kamera und dem gleichen Filmformat aufgenommenen) Fotografien erst nachträglich zu sinngebenden Einheiten, die über strenge regionale und kulturelle Grenzen hinweg das Gesicht des globalen Kapitalismus zeigt, wie es sich den städtischen Ballungszentren und den in ihnen lebenden und arbeitenden Menschen aufprägt.

Coda Thema der Ausstellung *Extension Turn 2* in der eastlinkgallery, Shanghai, an der sich Mettig 2006 mit seinen *Unspecified Landscapes (2003)* beteiligte, war die wissenschaftliche und künstlerische Erfassung eigendynamischer Prozesse (wie z.B. des unkontrollierten horizontalen und vertikalen Städte-Wachstums), deren strukturelle Prinzipien unverständlich geworden sind. Im Phänomen der Wolkenbildung finden solche Prozesse eine besonders sinnfällige visuelle

Entsprechung: Wolken können zwar fotografiert werden, entziehen sich aber einer zeitindifferenten Begrifflichkeit, was die wissenschaftliche Zuordnung konkreter Wolkenformationen zu den von ihnen durch fotografische Aufzeichnung generierten Modellen seit jeher vor große methodologische Probleme gestellt hat.

Genauso wie Le Gray und Stieglitz vor ihm ist auch Mettig vom Naturphänomen Wolke fasziniert. Im Gegensatz zu ihnen fotografiert er diese aber nicht von unten, sondern von oben, beim Überfliegen eines chinesischen Gebirges, das von den es umgebenden Wolkenmassen kaum zu unterscheiden ist: Wolken und Gestein bilden auf diese Weise eine von ihm zu Recht als „unspezifisch" bezeichnete Landschaft.

Wenn aber Wolken zentraler Bestandteil einer nicht genauer definierten und damit nicht genau lokalisierbaren Landschaft sind, bedeutet dies eine Neudefinition fotografischer Referenz, die sich nicht im Dagewesensein des fotografierten Gegenstandes erschöpft, sondern auch physikalische Prozesse umfasst, die nicht auf einen bestimmten Ort bzw. Zeitpunkt und damit auf einen Begriff reduzierbar sind.

Womit dieser Text schlussendlich, sozusagen von der Kehrseite, dem nicht-gegenständlichen bzw. prozessualen Referenten her kommend, wieder an seinem Ausgangspunkt, den drei Konstituenten des fotografischen Bildes angelangt ist, dem Subjekt, verstanden als zentrale Ordnungsinstanz des geometrischen Raumes, der Zeit, verstanden als Vergegenwärtigung des Vergangenen im menschlichen Bewusstsein, und dem Raum, verstanden als Grundlage individuell-subjektiver Objektrelation im natürlichen Bild des Sehens und dessen fotografischer Repräsentation.

1 Vgl. Krämer, Sybille. 2003. Die Rationalisierung der Visualität und die Visualisierung der Ratio. Zentralperspektive und Kalkül als Kulturtechniken des „geistigen Auges". In. Schramm, Helmar (Hg). *Bühnen des Wissens. Interferenzen zwischen Wissenschaft und Kunst*. Berlin: Dahlem University Press, S. 50-67

2 Vgl. Crary, Jonathan. 1990. *Techniques of the Observer: On Vision and Modernity in the Nineteenth Century*. Cambridge, MA: MIT Press

3 Vgl. Kemp, Wolfgang. 1978 (2006). 2. Das Neue Sehen: Problemgeschichtliches zur fotografischen Perspektive In: Ders. *Foto-Essays zur Geschichte und Theorie der Fotografie*. München: Schirmer/Mosel, S. 51-101

4 Vgl. Kemp, Wolfgang. 1978 (2006). 1. Quantität und Qualität: Formbestimmtheit und Format der Fotografie. In: Ders. *Foto-Essays zur Geschichte und Theorie der Fotografie*. München: Schirmer/Mosel, S. 10-50, Zitat S. 37

5 Vgl. Rancière, Jacques. 2005. Über das Undarstellbare. In: Ders. *Politik der Bilder*. Berlin: diaphanes, S. 127-159

6 Die future perfect tense (*has becoming*) kombiniert den (soeben erfolgten) Abschluss einer Handlung (*has become*) mit deren gegenwärtigem Andauern (*becoming*). Vgl. Chung, Chuihua Judy; Inaba, Jeffrey; Koolhaas, Rem; Leong, Sze Tsung (Hg). 2001. *Great Leap Forward. Harvard Design School Project on the City*. Köln: Taschen, S. 706

7 Vgl. Lewis, Rhodri. 2006. *From Athens to Elsinore: The Early Modern Art of Memory, Reconsidered*. Berlin: Max-Planck-Institut für Wissenschaftsgeschichte (Preprint 319)

8 Vgl. Kemp, Wolfgang. 1978 (2006). 3. Bilder des Verfalls: Die Fotografie in der Tradition des Pittoresken. In: Ders. *Foto-Essays zur Geschichte und Theorie der Fotografie*. München: Schirmer/Mosel, S. 102–143

9 Vgl. Delahayes Bildband *L'autre* (Phaidon 1997) mit heimlich gemachten Aufnahmen von Passagieren der Pariser Metro aus den Jahren 1995-1997. Genauso wie Mettig mit seinen Aufnahmen in der New Yorker U-Bahn aus 2004/2005 nimmt auch Delahaye ganz selbstverständlich Bezug auf Walker Evans *Subway Portraits* aus den 1930er Jahren, ohne dass im Aufgreifen eines „besetzten" Themas die Eigenständigkeit seiner Bildfindigkeiten auch nur ansatzweise beeinträchtigt würde.

Don't Be Left Behind" vereint eine große Anzahl atemberaubender Panoramafotografien asiatischer Ballungszentren und ihrer Bewohner. Bhutan, Kathmandu Valley, Delhi, Shanghai und Dubai sind die Stationen, die der Künstler Klaus Mettig für sein Forschungsprojekt zur Gegenwart und Zukunft der Welt ausgewählt hat. Die Kamera streift durch Straßen, über Märkte, fängt präzise Lebensmomente ein und konfrontiert uns mit der Existenz anderer Menschen, ihren unterschiedlichen Kulturen und der Vielfalt ihrer Identitäten. Die Fotoarbeiten erscheinen wie unbehandelte Dokumente aus alltäglich Gesehenem. Jedoch wird schnell klar, wie bedacht das einzelne Bildmotiv, der Ausschnitt und das endgültige Format gewählt sind, wie die schon komplexen Einzelbilder zu einer mehrteiligen Komposition, zu Sequenzen und Blöcken zusammengefügt werden. Klaus Mettig rhythmisiert die Abfolge der Panoramen ähnlich dem Prinzip des Breakbeats und verschränkt die Motive, dem literarischen Montageverfahren des Cut-Ups folgend. Er bringt mit dem Takt der Bildabfolge die Zeit ins Spiel. Es ist nicht nur der festgehaltene attraktive Augenblick, sondern auch die Zeit zwischen den Motiven, die zwischen den Aufnahmen liegt, zwischen den verschiedenen Regionen und der sich in unterschiedlichem Tempo anbahnenden, nicht allein der Globalisierung geschuldeten Veränderung sowie die reale Zeit des Umblätterns im Buch.

Der Titel des Projektes „Don't Be Left Behind" gemahnt zum Aufschließen, zur Eile. Er taucht in einer Fotografie als Werbeslogan für ein luxuriöses Leben in Dubai auf und setzt ein mit dem Reichtum der Bilder kaum in Einklang zu bringende Geschwindigkeit fest. Die Opulenz des Werkes bringt den Betrachter fast zum Straucheln. Die Frage nach der Bewertung des Festgehaltenen stellt sich mit jedem einzelnen Bild sowie mit der wachsenden Komplexität des Ganzen. Die Diskrepanz zwischen dem vorgegebenen Tempo des Betrachtens und der von Mettig getroffenen Entscheidung, jene erwähnte Fotografie erst gegen Ende des Buches einzuordnen, zeugt weniger von einer Pointe im Aufbau des Bildbandes als von dem Dilemma, Veränderung in ihrer raschen, man könnte sagen galoppierenden Entwicklung, erst sehr spät wahrzunehmen. Es erlaubt kaum die Frage, „Wer bleibt zurück?"

Klaus Mettig dokumentiert eine Welt, deren Ordnung in einer nicht linearen Bewegung mit großer Geschwindigkeit einer radikalen Veränderung unterworfen wird. Dem Begriff der Globalisierung gibt der Künstler mit der stupenden Aneinanderreihung seiner Fotografien die in der politischen Diskussion oft vermisste Komplexität zurück. Um diese Vielschichtigkeit zu erhalten und abzubilden, entwickelt er eine ebenso konzise wie ungewöhnliche Struktur. Diese konzeptionelle Methode schlägt sich in der Aufnahmetechnik und in ihrer Präsentation im Buch nieder.

Die für das Buch aus einem Pool von über 600 Belichtungen ausgewählten 67 Panoramafotografien ordnet Klaus Mettig nach den Ländern Asiens, in denen sie entstanden sind. Bei genauer Betrachtung der fünf Fotokonvolute wird deutlich, dass Delhi vom Verfasser zum Zentrum erklärt wird, während Bhutan und Dubai, von denen weit weniger Aufnahmen existieren, Auftakt und Coda bilden. Dazwischen schieben sich die etwas größeren Komplexe Kathmandu und Shanghai mit der jeweils gleichen Anzahl von Bildern. Alle Kapitel beruhen auf einer ähnlichen Dramaturgie vom Landschaftspanorama zu dichten Menschenansammlungen und zurück zur Megastadtkulisse. Allein in Dubai verharrt die Kamera in der Distanz, die menschenleeren Räume zwischen den Hochhausagglomerationen fixierend.

Alle Fotografien verbindet ein tiefes Interesse am Alltag der Menschen in einer Welt, die uns, medial bedingt, vertraut scheint, die aber stets auch als eine fremde wahrgenommen wird.

Mit ihrer hohen Auflösung und Präzision entfalten die Fotografien einen faszinierenden Reichtum an Details. Die Großbildpanoramakamera erfasst alle Bereiche des Motivs mit gleicher Genauigkeit bzw. Distanz, sodass flache Hierarchien in der Beziehung der einzelnen Bildelemente und Ereignisse zueinander entstehen. Es sind Teilansichten von Landschaften, von Behausungen, von alltäglichen wie rituellen Verrichtungen, Begleitumstände von denen wir zuweilen gar nicht in Bann gezogen werden wollen, da sie zu selbstverständlich ein uns unbekanntes, deprimierendes Elend zeigen.

Architekturen wie Pfeilerhallen, Viadukte, Brücken, Pipelines sind allgegenwärtig. Sie bilden die festen Strukturen um die sich endemisch Leben ordnet, chaotisch, wild, provisorisch. Auffällig hingegen ist, wie wenig das Automobil, überhaupt Fahrzeuge, in diesen dichten Stadtquartieren eine Rolle spielt. Mettig entwickelt ein eigentümliches Bild von gebremster Mobilität: Er hält Besonnenheit im Chaos und Gelassenheit im Tumult fest.

Das extreme Querformat und die Art und Weise der Komposition jedes Bildes, das meist durch wenige vertikale Elemente wie Pfeiler oder Stützen gegliedert wird, erklärt das Festgehaltene zur Bühne für eine noch zu entwickelnde Story oder zum Schauplatz einer uralten Geschichte und ihrer Tradition. In einem Bild lehnen die monumentalen Räder eines Zeremonienwagens an einem Gebäude, in einem anderen sind Fahnen als Markierung eines rituellen Ortes aufgesteckt. Die vielen Märkte und Plätze, auf denen die Menschen in großer Ruhe ihren Geschäften nachgehen, erinnern an behutsam choreografierte Massenszenen und Auftritte großer dramatischer Chöre.

Mettig entwirft das Szenario einer im Wandel begriffenen Welt, deren Veränderungen sich zunächst kaum wahrnehmen lassen. Beim Durchblättern des Buches steigert sich mit dem Blättern und dem Aufrufen der einzelnen Schauplätze die Rastlosigkeit, und in den Abschnitten mit Fotografien aus Shanghai wird in den Bildern ein Fortschrittsdenken manifest, das die Zukunft einzuleiten scheint. Es ist merkwürdig, welche Ruhe von den bevölkerten Plätzen in Shanghai ausgeht und wie alt und unelegant die im Rohbau stehenden Hochhäuser Dubais im Licht erscheinen, als seien sie, kaum erbaut, schon Ruinen einer neuen Zeit. „Dont Be Left behind", der Slogan einer für ein neues Stadtzentrum werbenden monumentalen Reklametafel, setzt ein Ausrufezeichen hinter die von Investoren und Wirtschaftsunternehmen erhoffte urbane Entwicklung unserer globalisierten Welt, deren gefürchtete Sterilität und menschenverachtender Traum von Perfektion und Reichtum von Mettig visionär ins Bild gesetzt sind.

Die fünf Regionen samt ihrer Bewohner, haben wenig miteinander gemein. Die Verbindung entsteht durch das harte Aneinanderschieben der einzelnen Kapitel, durch abstandloses Verschränken der Fototafeln und den Verzicht auf einen akzentuierten Übergang. Für die Ausstellungsprojekte zu diesem Werkkomplex hat Klaus Mettig eine, im Vergleich zur Konzeption des Bildbandes, ähnlich radikale Präsentationsart entwickelt, die nur jeweils eines oder zwei dieser Panoramen für sich neben die anderen Städte stellt. Die Beschäftigung mit den Lebenswelten anderer Kulturen wird als Konfrontation inszeniert. Das verbindende Element ist die Gegensätzlichkeit, die sich nur noch medial assoziativ zusammenfügen lässt. Mettig interessiert der stetige Fluss der Bilder und die Kreativität menschlichen Lebens, die er nur im Kontext vieler Motive erfassen und damit in neuen

Bilderfolgen reflektieren kann. Jedes Bild hat seine Bedeutung und ist einem bestimmten Interesse geschuldet. Er kann das Disparate festhalten und das Gemeinsame kenntlich machen. Ähnlichkeiten festzuhalten, daran ist er nicht interessiert. Seine fotografischen Resultate beschränken sich nicht darauf, Kulturen zu umschreiben, die das Elend ordnend gestalten, oder Gemeinschaften zu erfassen, deren Puls am Leben ausgerichtet ist und nach einem uns nicht nachvollziehbaren Plan funktioniert. Er positioniert sich und sein sorgfältig ausgewähltes Material souverän innerhalb der komplexen Informationsdichte unseres Medienzeitalters.

Schon in einer Arbeit für die 7. documenta 1982 hat Klaus Mettig eine Flut von Bildern ausgestellt. Über 2568 Einzelfotografien von Nachrichtensendungen, die er direkt, einem bestimmten inhaltlichen Prinzip folgend, im Verlauf von drei Jahren vom Bildschirm aufgenommen hat, setzt er hintereinander und entwickelt einen sich ständig verändernden und damit paradoxen Rapport einer Wandbespannung. Die Nachrichtenbilder ergeben eine 2,52 m hohe und 65m lange Wandzeitung – der deutsche Herbst, Nachrüstungsbeschluss und Afghanistan als kleinteilige fast endlos erscheinende Fotowand. Mettig stellt nicht in Frage, ob diese Bilder Nachrichten vermitteln und Zeitereignisse Gestalt annehmen, aber er begreift sie als ein Modell, eine Hülle, in der wir leben. Bildgewordene Zeit, in der die menschlichen Körper miteinander agieren, in ihnen, vor ihnen, der vielfältigen Ereignisse ihrer politischen und gesellschaftlichen Realität bewusst oder nicht.

Diese Visualisierung einer komplexen Sozialisierung, die Inflation, welche Singularität erst ermöglicht und dennoch belanglos wirken lässt, erscheint uns im Motiv der asiatischen Ausprägung der Zivilisation gleichzeitig passend und seltsam fremd. Die Kamera als Werkzeug für seine Exkursionen nutzend, unterbreitet uns Mettig erneut, dass die mediale Vermittlung des Lebens und der Kulturen durch das fotografische Bild letztendlich ihre gelebte Wirklichkeit und ihre Kreativität ausblendet.

Mettig entwickelt eine ungewöhnliche Form der Einpassung der Panoramafotografien in das Buchformat – er schlägt die Ränder der Fotografien nach hinten weg und lässt sie, indem die Bildtafeln dreimal über den Bruch laufen, wieder als eine neue Bildkomposition nebeneinander ruhen. So wechseln sich Zentrum und Peripherie im Buch stetig ab und stiften eine Kontinuität des Disparaten. Mettig konstruiert so formal das Thema, das er auch in seinen Bildinhalten und dem damit geschaffenen Kontext bearbeitet. Er erklärt die Ränder als der Mitte gleichwertig und entscheidet sich bewusst für die Technorama-Kamera, die immer auch abbildet, was sich im Augenwinkel abspielt.

Sobald man am Ende eines der nie vollständig erfassbaren Panoramen beschäftigt hat, schiebt sich schon das nächste gleichwertig daneben. Manchmal gestaltet sich der Unterschied nur minimal, und man ist gewillt, die beiden unterschiedlichen Teile als ein Bildganzes wahrzunehmen. Wie ein lineares Memory scheinen die Bildelemente auf und untersteichen in ihrer Fragmentierung die Komplexität des Bildgeschehens und damit die Komplexität dessen, was wir Realität nennen.

Eine solche Radikalität der Systematik birgt auch eine Obsession. Sie folgt der Spur des Zwangs und der Besessenheit, nach immer neuen Anschlüssen zu suchen, scheinbar Unbedeutendes fest im Blick zu haben und gleichzeitig nie den Zusammenhang aus den Augen zu verlieren. Es ist die Methode des Serienkillers, der immer aufs Neue, um seine Phobien zu besiegen, auf hochartifizielle Art und Weise indizienreich Leben auslöscht – nur, dass es sich bei Mettig umgekehrt verhält. Er versucht das Leben festzuhalten, es für sich zu klären, indem er seine Abbilder zer-

schneidet, portioniert und unterschiedliche Kulturen und Traditionen schonungslos aneinanderreiht und gegenüberstellt. Hat man umgeblättert, ist das Bild noch nicht völlig erfassbar – man muss sich Mettigs Fotografien durch zweimaliges Blättern erschließen, aber auf Wiederholungen oder Variationen eines Motivs wird verzichtet.

Die Varianz der Stadtlandschaft lässt sich lange nicht mehr über eine oder eine Anzahl von Fotografien und über einen harmonisierenden Blick erschließen. Gleichzeitigkeit lässt sich kaum fotografisch festhalten, und was wäre damit gewonnen, eher wäre der Blick aufs Neue verstellt. Wir erfahren über die ins Visier genommenen Wohnhochhäuser nicht, wer darin wohnt oder später einmal wohnen wird – wir können nur ahnen, dass es nicht die Menschen sein werden, deren Gesichtern wir andernorts im Fotokonvolut begegnet sind.

So entlarvt Mettig mit seiner Methode des Schnitts und der Fragmentierung auch den trügerischen Anspruch des Panoramas, vermeintlich alles zeigen zu können und somit einen Mythos von Ganzheit und Totalität entstehen zu lassen. Gerade deshalb nutzt der Künstler die Form des Panoramas und lässt Großraum und Detail als vitale Antagonisten ineinander fallen. Distanz und Nähe, Vermittlung und Abseitiges, Landschaft und Portrait finden darin einen Ausgleich. Das vertikal angeordnete Portrait löst sich aus der horizontal erfassten Landschaft.

Oft wirken die Fotografien, als seien sie an einer Horizontlinie aufgehängt und als ließe sich das Foto, über die Präsentationsform der zweimaligen vertikalen Faltung hinaus, auch der Länge nach falten. Die Struktur des Bildaufbaus beruht auf zwei formal gleichwertigen horizontalen Bildstreifen. Der Nähe und dem Detail zugeordnet, die untere Bildhälfte, die den Bildraum erfahrbar, begehbar, begreifbar macht und die obere Bildhälfte, die ein allgemeineres Prinzip der Weite und Offenheit repräsentiert. Das glückt noch bei den Bildern aus Dubai, obwohl der untere Teil so karg und unwirtlich erscheint und nicht dazu einlädt, in das Bild einzutauchen. Nur bei diversen Repräsentationen von Müllhalden funktioniert jenes Schema nicht. Oben und unten haben sich so weit angenähert, dass sich ein Gleichgewicht einstellt: Die Dynamik kommt zum Stillstand, Enge und Unübersichtlichkeit macht sich breit.

Klaus Mettig beschäftigt sich seit 35 Jahren mit Gesellschaftsporträts und der Politik von urbanen Ökonomien in den großen Metropolen. In seinem neuesten Fotoprojekt verdichtet er die im Clash der politischen Systeme entstehende, zur Lebenswelt erklärte Misere und entwickelt über Grenzen hinweg Vergleichssituationen. Im Zeitalter der Globalisierung werden diese Gegenüberstellungen immer aberwitziger. Seine Methoden des Vergleichs und der Durchdringung der fotografischen Oberfläche durch Prinzipien des Artifiziellen, lassen uns die variante Struktur der fortwährenden Kontextverschiebung gewahr werden, die wir selbst in der internationalen Politik und der Wirtschaft konstatieren. Was bedeutet ein kritischer Blick auf die Welt heute noch? Welche Erkenntnisse können wir aus den uns verdächtig gewordenen personalen wie den medialen Abbildern noch gewinnen?

Klaus Mettig lässt uns viel Zeit zum Entdecken von Einzelheiten und Zusammenhängen und drängt mit seinem Cut-Up-Prinzip zugleich, die Spuren der Veränderung im Realen wahrzunehmen.

JULIAN HEYNEN / BHUTAN, KATHMANDU, DELHI, SHANGHAI, DUBAI

... that reads like the picture window of a travel agency. Places like these are easy to reach. You can book travel to them on the Internet. It is no longer a rare privilege to get there. The courage one must muster for the trip is now rather limited. The erstwhile fascination of exotic places, derived for the most part from a few platitudes and a great deal of fantasy, evaporated long ago. Today, the chimeras of the foreign have been relegated to the shelves of the department store of the world. Places like those in the list above not only have come within the physical range of the halfway well-to-do; they also have much more of a place, even compared to a few decades ago, in our common store of images. Travel reports on television, photo essays in magazines, backgrounds in advertising photographs mix here and there with the occasional shred of new information on catastrophes or political events to create a seeming familiarity with these places, a familiarity retrievable as an image.

In the middle of the last century, the anthropologist Claude Lévi-Strauss assailed the fact that even peoples from the deepest jungle were no longer untouched by Western civilization. The dream of naturalness, of simple otherness from one's own culture, had been dashed. The melancholy gaze on the Tristes Tropiques, the title of his famous book, has long since yielded to a new conflict. On the one hand, we in developed countries know and accept that our achievements have penetrated all parts of the world, and that those achievements have been taken up everywhere, with both positive and negative effects. One can travel exceptionally far and still find that the first thing one encounters, under the most improbable circumstances, is a Coca-Cola can or a mobile phone . This gives one, alongside astonishment and disappointment, a sense of security, of authority. Doggedly persistent, however, are the belief in and the desire for an encounter with just this sort of Other in other cultures, to discern in them something that will challenge and enrich us. Some may be drawn to the attraction of a particular climate, to the fluid of a daily life to experience from afar as a flâneur. Others may quest after nourishment of their spiritual needs. The disillusionment, which to an extent is also a satisfaction, that different worlds are now merely regions of a single economic cosmos, cannot be separated from the search for what remains of difference. The contemporary attitude of the critical consumer seems to apply to contact with other cultures as well.

When an artist like Klaus Mettig seeks out places like the ones we speak of here to photograph them, he is aware of these tensions and conflicts, among many others. He goes on-site. He delves into specific situations with a certain idea of what they are, but not able to calculate them out fully in advance. This is true both for the circumstances in which he does his work as well as the photographs that he harvests there. He is convinced of the need, to get a picture of the sites that interest him, for his presence there. Unlike many, he does not use others' images. For those others in this media age, experiences at second hand have become, have replaced reality. Mettig used such an approach in his early works. In his more recent photographs, by comparison, he takes an approach that might be called engagement. He is interested not in the metaphenomena of media and the concomitant questions of an advanced technological-philosophical culture, but rather in the possibility of nearness to the primary facts. The emphasis here is on the word "possibility"; it expresses probability and skepticism in equal measure.

An essential precondition to getting close to what is to be photographed, to moving in on the places and people without pressuring them, lies in the sort of camera chosen. For the photographs

in this book, Mettig has used an analog Linhof "Technorama." An advantage of this camera is that it combines high image quality with relative ease of operation. The Technorama allows handheld photography, although the need to change the film frequently renders it slower than a 35mm camera. Someone who travels with a Technorama can be recognized as someone who does not photograph anything and everything that comes his way, scanning the world before him without distinction, but rather takes time and makes selections. The implement and its use thus contribute to a certain integration of the photographer into the situation, an integration that is necessary for the photographer to recognize at all what might interest him. More decisive yet, of course, are his social, psychological, and communicative capacities in interacting with the situation to be photographed. At least to an extent and for a time, he must become part of what is happening around him to gain acceptance from the people whom, together with their surroundings, he will photograph. This does not make the photographer invisible, nor will the people be untouched by his actions. What comes about instead is a connection between coincidence and a reserved, temporary connectedness between photographer and milieu.

The camera that Mettig has used provides panorama photographs with an aspect ratio of 1:3. This rather unusual proportion is, to be sure, closer than the dimensions of standard photographs to the actual field of vision of the human eye. Our habituation to the proportions of the panel painting of the West and its successor photography makes the format seem strangely stretched, even a bit manipulated. The lengthened view made possible by these photographs is charged with a certain emphasis, one which also contains a visual correspondence to narrative. This is familiar to us from frieze-like wall paintings in ancient art and, from the twentieth century onwards, especially in film. Even at a substantial distance from these photographs, which are nearly four meters long, the eye wanders involuntarily, like a camera panning across a scene, from one side to the other. Another effect of the dimensions is that the middle of the image seems to curve very slightly out towards the viewer. In partiular in the photographs with people, these technical peculiarities influence the relationship of the photographer and viewer to the scene portrayed. The persons in the photograph do not seem to stay at a constant distance. Instead their proximity or distance changes depending on which part of the panorama one looks at. The viewer, standing on the outside, thus comes to comprehend the situation of the photographer, who finds himself striking a fundamentally undecided, sometimes precarious balance between participation in, and distance from, the action. An unsecured and self-critical position of this kind is the necessary consequence of the cultural and social encounter taking place. The photographs seek to reflect the status of this relationship between interest and foreignness, engagement and rejection. In so doing, they also seek to make apparent that the reification of what has been photographed is an unavoidable problem even in the seemingly most harmonic scenes. The images are also open to such ruptures and contradictions in those instances in which living conditions ranging from the poverty-stricken to the catastrophic meet up with a genre, like the pastoral, sanctioned by the traditions of Western art. There are the people and cows on the side of a river, encamped in the exhaust coming off a colossal highway bridge, and the boy with his freight-bearing bicycle atop the inhabited garbage dump, both in Delhi. For the most part, as here, the unusual cuts at the upper edge of the photograph are what prevent the completion of the canonical image, and they emphasize the chance occurrences and limitations of the real situation.

Likewise, the market scenes in Bhutan and the groups of people on the streets of Kathmandu and Delhi call to mind the paintings of Western art, without, however, permitting one to name specific precursors, or even to assert that the photographer had intended to work with such quotations at all. Instead, historically and artistically conditioned habits of seeing have flowed, as though a matter of course, into photographs of places and cultures very foreign to those habits. How could it be otherwise? And yet: The question arose with Dutch painters who went to South America in the seventeenth century, as it did with the many Orientalists of the nineteenth century, of why the experience of foreignness for the most part changed only the choice of subjects, and sometimes of palette, but not the artist's pictorial thinking as such. The concept of documentation has been in the foreground ever since photography came to define our view of other cultures. The concept fulfills the need for 'objective' information, as it comes out of an objective triangular relationship between viewer, subject, and pictorial process. The resulting way of seeing is believed to be universal, and indeed there can hardly be human cultures left that cannot 'read' photographs and confer on them the power of visual 'evidence.' Still: The process remains embedded in a particular world view. Though it has, between colonialism and globalization, achieved acceptance nearly everywhere, it is often in at least latent conflict with other ways of seeing. Anyone who deploys this instrument as an artist to depict cultures other than his own must be aware of this tension, and seek to reflect it in his photographs, which have the potential to reach people beyond the artist's own tradition. With Klaus Mettig, this occurs not only through the choice of camera and the resulting oscillation between nearness and distance, but also, for example, through the gazes of the people in the direction of the photographer or viewer. These gazes signal a usually casual curiosity, as well as a consent that grasps the practice of being photographed and accepts it as part of the individual subject's circumstances. The gazes reply to a certain extent to the gaze of the photographer, though it remains an asymmetrical relationship, in which the image as evidence will not become visible until later, and then in all likelihood as evidence for only one side of the encounter. The transaction that takes place in the photographic exposure has little to do with the magical brutality of the stolen gaze and stolen soul, the way in which photography was experienced in early encounters when the new art was still unknown. There nonetheless remains a certain seriousness and pensiveness about the gazes, laden with inequality and loss. Neither to avoid nor to seek the gazes of the photographer as a temporary partner in the creation of the image, tolerating them instead as accidental – this means accepting the fundamental uncontrollability of the situation, the coincidences of its manifestations. In this is expressed an attitude that, despite every intention of visual ordering, has respect for the autonomy of the photographed scene, does not confuse engagement with control, and supplements the authority of a more or less orthogonal view with the heterogeneity of gazes.

Klaus Mettig has described the creation of these photos as the union of two equally important processes. The first part of the path to the image in front of us is the selection of the destination, the journey there, settling into its social circumstances, negotiating one's own presence in front of the subject, lastly the exposure. The second part of the process is separated from the first spatially, chronologically, and socially. It occurs in the artist's darkroom, where the visual experience on-site and the look through the viewfinder are made into wall-filling prints. This dichotomy is, on one level, nothing more than a necessity of the photographic process. Throughout the history of the

medium, the precisely prepared exposure has faced off against the realization of the print in the studio. The fixing of the moment in time is followed by the creation of the lasting photographic image. Klaus Mettig does not entrust a commercial photo lab with the production of prints. The darkroom thus remains, in an artisanal sense, the traditional artist's studio, in which what has been seen is concretized into an image. In the second part of the process, the greatest possible distance is maintained from the content of the pictures. Where at the beginning there was engagement, the exposing of the self to social reality, there is now the photographer as total master of his surroundings, alone with himself and the manipulation of the image as object. A person who places so much emphasis on the second, introverted part of the process is clearly skeptical of any simple documentarism. He knows the unavoidable anchoring of photography in subjectivity, and he wants to keep this visible in his depiction of the outside world. Yet what is there to darkroom work other than to make it possible for the chemicals to carry out their transformative process? At the center are the choices of image detail, light, colors, and precision of presentation: all deeply painterly criteria. The reworking of the exposure does not undo its context, nor is the goal an alienation or reassessment, the addition of an interpretation to construe or counter the primary photographic findings. The work of quasi-painterly accentuation in the darkroom is instead a second seeing of what has already been seen. The artist traverses again, in a different way, the distance that separates him from the photographed facts. With subtle manipulations, he produces the visual confession that the image is only a partial echo of reality.

"Don't be left behind" is the Dubai billboard text that provided the photographs with their title. This imperative leaves nothing to be desired in terms of emphasis, decisiveness, or mercilessness. There is only one direction, and its name is progress. The motto's negative formulation makes unmistakably clear that there is a real danger of being left behind and forgotten. A status quo that might be in some way lasting does not exist. Staying behind also means that there can be no return to any sort of previously known familiar condition. Anyone who stays behind will stumble into something that can only be worse than what he knows. The slogan seeks to motivate, but at the same time has the effect of a threat. Immense construction projects in the Arabian desert, the sometimes science-fiction-like dynamics of development in cities like Shanghai, the way signs of progress jut up against wretchedness in Delhi, or the pockets of seemingly traditional life in Bhutan or Kathmandu – all of these seem to exist under the sign of this slogan, of not being allowed to fall behind in the inexorable motion forward, motion that now extends to the 'last corner' of the globe. "Don't be left behind" also holds true for the artists who wish to depict this. The challenge for the artist is not to use the supposed security of a previously developed, perhaps even inherited, idea of the image to depict a world that will change the moment the camera's shutter closes. As an image-maker, the artist can never catch up with the changes in reality. Instead he generates artificial intermissions for reflection with visual means. The photographs, however, do not seek to stop anything in place. They do not preserve. With their literally comprehensive format and their 'painterly' preparation, they shape the productive confession of a paradoxical situation: The complexity of real circumstances and our attitude towards them is unconquerably vast. In certain moments, however, when unmasterable events coagulate into an image, something in the nature of insight appears possible. This is more than a contradiction. In it lies hidden a seduction of thought by the eye. The photographs of Klaus Mettig leave open whether this is an aspiration or a danger, and they make clear that they can be nothing other than a part of these questions.

Klaus Mettig's new works from 2005 and 2006, large format panorama photographs of Asian and Arab megacities and their inhabitants, should not be interpreted pictorially or biographically. Rather, they are to be seen as a specific expression of the three constituents of the orthogonal image, subject, time, and space.

1. Subject It is the thesis of Sybille Krämer that perspective, as a visual metaphor and epistemic condition for an enablement of the modern subject, presents itself as the central ordering authority of perspectivally (re)constructed space[1]. With Krämer, then, we may counter Jonathan Crary's thesis of the disembodiment and concomitant de-subjectification of vision through the perspectivally fixed and singularized eye.[2] In fact, the vanishing point, the visual zero of the image, represents the observer's point of view in relation to what is seen or represented. In his famous experiment, Brunelleschi (1377–1446) proved the rightness of the perspectival model of vision: Through a peephole, a viewer gazed at a mirror that reflected a painted segment of the viewer's (natural) field of vision, with the viewer's eye at its center. In mirrored form, the painted segment of reality joined together seamlessly with the natural seen image, which was thus proven to be congruent with the artificial image of vision.

Like Brunelleschi's one-eyed observer, the photographer looks through his camera's single eye at the scene before him. In this way he reveals his own standpoint in the construction of the image. This is how the photographing *subjectum*, who must comply with the laws of optics, becomes the real creator of the image, namely by transforming relations of space into relations of surfaces, relations which, despite all calculation, stand witness to the singularity of the observation/photographed moment, and with it the situating of the observer/photographer in space and time. By angling his panorama photographs slightly above or below normal perspective, Mettig emphasizes the communicability of his various standpoints[3]: The subjectivity of the photographer, understood as the point of departure for the optical visual cone, is that of the principle of an "empty" subjectivity, one that is filled with content, namely with a relationship to the object that goes beyond the purely optical, through the act of observation that occurs before and after the actual photographic act of triggering the shutter. This fundamental repeatability of the singular relationship of *punctum* (subject as eye-site) and *focus* (object as focal point) also contains the social dimension of the photographic image, which underlies its performative, world-generating dimension.

Photography, all but altogether denied subjective expressivity by its mechanical implementation of the perspectival calculus, can thus be seen in an entirely new light: If one understands subjectivity in the sense of spatial relations, and thus geometrically, every photograph is subjective, since it results from the positionality of the photographer in space and time, his having-been-there. In this connection, the question of the subjective expression, that is, of the how of representation (style), is prior to the question of the how of representability, of the conditions of perception and representation of space in the background: Space, in the ontology of individualized perspectivism developed by Leibniz in his *Monadology*, is the unfolding of finitely-infinitely many individual positions of the subject in relation to the world.

Though Mettig's works demand such a definition of photographic subjectivity, he is not one to use photography as a means to an end, as a mere making visible, as a medium to conform the

variousness of objects to a single measure: Like numbers, and the money that derives from them, photography is also an enablement of the quantification of the qualitatively different, in consequence of which photography has come to be the preferred medium for the documentation and archiving of objects and events.

Mettig is equally free from the glorification of the referent, as particularly propagated by the New Objectivity, and from the (moral) conceptualism that subjects photography to a conceptional and/or moral *a priori* that it is to be realized solely visually. He emphasizes neither the indexical aspect of photography (documentarism) nor its symbolic aspect (photography as the expression of personal existential orientations, political concepts or moral positions). Instead, he seeks an iconizing synthesis of reference and judgment (based in referential experience). He is not a neutrally recording photo-eye, but above all a subjective observer/photographer. As such he makes judgments, though discreetly, and suggests questions, rather than presenting his own answers in advance. At a strategic distance from contemporary photography discourse, which privileges conception over perception, Mettig uses his photographs to pursue the reverse goal. He follows the Aristotelian doctrine of the soul, letting conception slowly rise forth from perception: His images are not insights rendered into visual form, but rather simply the visual precondition to possible insight.

Since his artistic beginnings in the 1970s, Mettig has engaged with photography in the three great fields of discourse that have long profited from productive competition. His works may be subsumed into the field of "art with photography," as well as into the fields of "photography as art" and "photography as photography," though none of the three alone is sufficient for his oeuvre. If we will attempt nonetheless to situate selected series of works in the three fields of discourse, we do so only to display the transdiscursive aspect of the artist's photographic oeuvre as a whole.

Mettig's early political works from the 1970s may be termed "art with photography," which grew to become, as Rosalind Krauss established in ‚Notes on the Index I' (1976), the paradigm of (postmodern) art for the decade. Of particular note is *1-214/1979-1981 (and such a press of people)*, for which he made a 65-meter long wall-image-newspaper montage of black and white television images, drawing on Communist strategies of "visual agitation"[4] through photo collage (recalling El Lissitzky's photo frieze at the International Press Exhibit in Cologne in 1928) to create a panopticon of the terrorist/Islamist/atomic threat surrounding the Iranian revolution and the RAF.

Mettig's next work, *Berlin/Ost-West/1981-1983 (Zwischen Gestern und Morgen)*, in which divided Berlin appears sunk in a shared melancholy, can be attributed in turn to the context of "photography as art," in which the criteria condemned by postmodern "art with photography" of successful (photographic) composition continue to reign, uninterrupted. All political implications aside, this series is only as strong as the weakest single picture, taking its aesthetic quality from the use of light, composition, color modulation, and gaming the use of blur.

It is particularly necessary to see the works *I-VII/China 1987 (Die Explosion ist lautlos)* and *Vor dem Licht (Stahlnetz) 1985* as "art with photography": In *Die Explosion ist lautlos*, Mettig uses the spatial hierarchy of the separate and fully de-indexicalized images to entrust them to a second level of artistic narration, whereas in *Vor dem Licht* it is just this narrative level that is realized

through voids that mark out the visibility of the image as an (in each case inadequate) making-visible of the invisible.[5] This method of *aisthesis* takes away factual and fictive references alike. Yet – the removal is itself a game. The steel net over the pictures hides them like a veil, at the same time exposing them to heightened attention.

The last of the three aforementioned fields of discourse whose systems of coordinates Mettig's artistic praxis traverses is "photography as photography." In the form of a movement against the current neopictorialist trend, it could parallel the movements at the beginning of the last century and express, in the course of the coming years, a new desire, stated often and by many people, for the real, and for a renaissance of artistic authorship. It may take on shape precisely in the area of artistic photography.

Mettig's series *N.Y. 2004* and *O.T. 1992 (Shanghai)* make clear a productive tension particular to "photography as photography," the tension between referentiality and artistic authorship. Regardless of the images' size, the series function as a bundle of pictures out of which particulars (particular details) repeatedly emerge and capture the viewer's attention in the sense of the *punctum* for Barthes. At the same time, they function as an ensemble of monumental individual images, the subjects of which resolve only slowly out of the film grain to rise up into the affective consciousness.

2. Time The specific characteristic of photography, says Barthes in his *Camera Lucida*, is the collision between the past (of the photographed scene) and the present (of the photographic image). At the same time, the transparency of the photographic sign, letting the gaze pass through to the referent, permits the viewer to pass through photography and experience the past as the present, inscribing (present) knowledge onto the (already happened) future. Without wishing to contradict Barthes, we must emphasize that the making-present of the past is not in itself photographic, but lies in the nature of the human experience of time itself.

If one follows Augustine's compelling argumentation in the eleventh book of his *Confessions*, then neither the past nor the future exist in and of themselves. Rather, they are merely imagined in human consciousness (of the present of the present) as the present of the past, or as the present of the future.

In this spirit we may understand the *future perfect tense*[6], invented in the Pearl River Delta of China, and which Mettig references in his *Unspecified Landscapes (Airplane Views)*, made in China in 2003: The past exists in human consciousness only through the permanent making-present; it can be experienced in the imagination only at the cost of surrendering its separateness from the now. In consequence, historical consciousness can only come about when an event in the past ceases to be a subject of individual and collective making-present in the form of its affective surfacing through *remembrance*, and becomes instead the result of deliberate *recollection*, repeated at will, in the tradition of the ancient *ars memoriae*.[7]

Photography, through its indexical nature, is able to bring into the present time and space the foreign or past things of which it, photography, is the optical-chemical trace: Photography, therefore, is not only a means (a medium, as well as an image carrier), but also an object (the referent, that is, the contents of the image) of subjective-affective memory. At the same time, photography, through its chronological distance, can serve as an object for historical-critical reflection, just as

the world exposes itself to view only on the condition of its spatial distance from the human eye as the object of vision.

Photography has long been devoted more to the recording of the ephemeral than to the creation of ideal worlds. This is because of its close, quasi-material connectedness to the (past) object, with simultaneous knowledge of the difference, particular to the medium, between referent and image. The preservation of visual impressions, like the preservation of cult objects in *salvage ethnology*, is also one of the most important mainsprings of travel photography, which most often uses, and uses up, a fixed canon of particularly picturesque motifs. Against this, Mettig's portraits of cities in the Middle and Far East pursue an entirely different end. Namely, he shows people and animals as functions of urban architecture. The viewer can see for himself the urban transformation that Mettig has observed repeatedly since the 1970s, making diachronous comparisons between works from 1978, 1992, 2002/2003, and 2006: If some remains of the colonial past are still visible in the middle of an industrial sector in the photograph *O.T. IV Shanghai 2003*, an image from the latest Shanghai series, from 2006, shows the same site overgrown by thick grass, "broken through by the encroaching land," as Walter Benjamin wrote in *One-Way Street* (1928), placing the city dweller "entirely into that unfathomable and most dreadful situation" in which he "must absorb into himself, among the rigors of the isolating lowlands, the evil spawn of urban architecture."

Despite the socially and politically explosive collision of different levels of ideology (colonial capitalism through 1949, Socialism until 1980, and global capitalism from 1980 on), each expressed in its own architectures, these images should not be misunderstood as a critique of capitalism, something that only too often obscures a purely aestheticizing approach that prizes the picturesqueness of urban destitution.[8] The images are in fact the result of a relatively spontaneous reaction to objects and events in the public sphere, which may be read as a continuation of the politically engaged photo journalism that has been done in Europe by the Magnum photographers Erich Lessing and Luc Delahaye[9], and in the United States by the Farm Security Administration photographers Walker Evans and Dorothea Lange, work carried on later by Helen Levitt, Gordon Parks, and Bruce Davidson.

In the photographs from Bhutan, the Kathmandu Valley, and Delhi, the (more or less) urban surroundings form only the background for (group) portraits. Urban architecture dominates, by contrast, in the photographs from Shanghai and Dubai, surrounding and characterizing the people. Though architecture in Shanghai can still be seen as an expression of various eras (colonialism, Communism, global capitalism), the different classes of the new in Dubai can hardly be attributed to epochs and decades defined by ideologies and styles: OMA-AMO, the research project on the Arabian coast led by Rem Koolhaas, has found in Dubai the prototype of the emerging, non-Western city. Such a city cannot look back on a long history and the architectural palimpsests that go along with such a history. Instead the city is in a permanent state of coming into being, one that does not contradict a linear perspective of time, but is the logical consequence of that concept: the result of a compulsive desire for a future in the superlative, or at least in the comparative, one that from the beginning equates what has gone before with the lesser or the smaller. Capitalist society has spent the lion's share of its time looking back and making plans. In a time of turbo-capitalism, in turn, individual being-as-doing turns entirely to being-as-proposing, not least so as to sustain

the illusion of constant progress. This is so, after all, because a project, in the literal sense, is never concluded, remaining forever in a stage of *has becoming*. But how can such a state of affairs be represented photographically? Surely not in the *moment décisif*, which would be able to express the essence of an event, but instead in active recognition of the fact that the vain attempt to arrest photographically the fluid of time is not the actual impetus for the practice of photography. The impetus is to be found in that incommensurability in space and time of the photographic image and its subject, driving us onward to ever new images of the *moment raté*.

3. Space Mettig uses the panorama format in his works because it more closely corresponds to the human field of vision than do the usual, more square pictures of large format cameras. The awkwardness of large format cameras can also get in the way of the spontaneous discovery of images. A Linhof Technorama retains high image quality, but also allows relatively spontaneous photography. In particular, moreover, it allows the photographer to get closer to the subject than would be possible with a large format camera. Photographs made in this way act neither like products of a participatory, social-anthropological observation, nor as images of the foreign in the sense of visual anthropology, but rather as images of being-foreign. And yet they remain views, in both the photographic and in the wider sense of the word: They not only show what is, but also express the attitude of the photographer. This is made very clear in the pictures from Shanghai and Kathmandu. We see there longing for the simple and human, and for the simple and natural, on the one hand. On the other, we see that what is destroying this bucolic idyll is precisely the progress that made the photographer's arrival and picture-taking possible. Mettig's new works thus display the basic contradiction of photographic practice, a practice which is at once the function and also the precondition of the technological innovations whose socio-economic consequences it documents.

Though the images are iconized through their large-scale presentation, they are always photographs of specific, found places, events, and people, who are placed in meta-referential sense contexts through their selection and hierarchy in photo wall formations, or (at most) four-part slide projections. These contexts raise the photographs to the level of generalizable statements, which they could not attain as separate and unconnected single pictures. The individual image in itself has only a truncated individual meaning, and is at the mercy of affective associations in the sense of Barthes' *punctum*. Only in combination with other images (or texts) can it indicate something beyond itself, beyond its material presence and the indexical reference to the physical co-presence of photographer and photographed, and thus go from being an element that indicates a difference in meaning (phoneme) to being an element that has a meaning (morpheme) in the photographic image-sentence.

The individual panoramas complement each other to form a panopticon, a total view of the phenomenon of the emerging non-Western city, without plunging into such picturesque clichés as overpopulation, inadequate hygiene in shanty towns, or the anonymity and coldness of central business districts and their mirrored glass façades. While the pictures from Shanghai and Dubai show people primarily as functions of urban architecture, landscape photographs and group portraits predominate in the pictures from Kathmandu and Delhi. In a number of almost Arcadian scenes, humans and animals lie together in harmony on the water. And yet in every picture a single detail, like a highway crossing over a river, undermines the picturesque cliché and directs

the viewer's attention to the socio-economic problems of these places: the juxtapositions and collisions, not to be overcome even by the best urban planners (best, at least, according to the model of the Western city), between agrarian, industrial, and postindustrial societies. These conflict zones are what Mettig studies in the megacities of the Middle and Far East, those sites of the "no longer/not yet," where the old is left to decay and the coming of the new is still only an idea. Despite the overwhelming presence of half-built shells and finished office and apartment buildings in the photographs from Shanghai and Dubai, the middle of the images are often empty, a sort of metaphor for the artificially created inner absence from which the capitalist ideology of growth derives its legitimation. Mettig positions himself unmistakably against the ideology of the superlative, the ideology that characterizes, for example, the frenetic construction work of Dubai. At the same time, he does not uncritically favor the old, the ugly and unhealthy chaos which he portrays just as emotionlessly as the negative outgrowths of genuine ambitions in Asian and Arab metropolises. In contrast to his early works in the 1970s, in which Socialist China was presented as an alternative to American-style capitalism, Mettig's new works present themselves as projection surfaces for contemplation. The goal of these views of urban landscapes and their inhabitants is to come to an image of what will or what could constitute human existence in the twenty-first century.

The total corpus of images from five different urban regions of the Middle and Far East is not so much an illustration of socio-economic structures and processes as it is an overall picture of the phenomena that made themselves available, "all at once," within the photographer's field of view. This overall picture is composed, in the literal sense of the word, and put together from individual pictures. Mettig did not keep constant his distance from the subject, the time of day, the shutter speed and the aperture, which would have given the different places, subjects, and events a common measure. Instead, he made his photographs spontaneously (if always with the same camera and format of film), and only afterwards ordered them according to units that give them meaning. His photographs show the face of global capitalism that transcends boundaries that are strictly regional and cultural, how it makes its mark on urban centers of accumulation and the people who live and work in them.

Coda The theme of the exhibit *Extension Turn* 2 at eastlinkgallery, Shanghai, in which Mettig took part in 2006 with his *Unspecified Landscapes (2003)*, was the scientific and artistic grasp of inherently dynamic processes (such as the uncontrolled horizontal and vertical growth of cities), the structural principles of which are no longer understood. Such processes find a particularly intelligible visual exponent in the phenomenon of cloud formation: Clouds can be photographed, of course, yet they resist a conceptuality indifferent to time. This has long posed major methodological problems in the scientific classification of particular cloud formations to models generated from them through photographic records.

Like Le Gray and Stieglitz before him, Mettig is fascinated by the natural phenomenon of clouds. In contrast to his predecessors, however, he does not photograph clouds from below, but from above, while flying over a Chinese mountain hardly distinguishable from the masses of clouds that surround it: Clouds and stone make up a landscape that he rightly calls "unspecific."

Yet when clouds are a central part of a landscape that is not precisely defined, and so cannot precisely be localized, this signifies a redefinition of photographic reference, one that does

not exhaust itself in the has-been-there of the photographic subject, since it also encompasses physical processes not reducible to a particular place or point in time, and so also not reducible to a particular concept.

And so this text concludes, so to speak, coming from the flip side, the referent that is not an object, but procedural instead, back to its point of departure, which touched on the three constituents of the photographic image, the subject, understood as the central ordering authority of geometric space, time, understood as the making-current of the past in human consciousness, and space, understood as the basis of the individual-subjective relation to the object in the natural image of vision and its photographic representation.

1 See Krämer, Sybille. 2003. Die Rationalisierung der Visualität und die Visualisierung der Ratio. Zentralperspektive und Kalkül als Kulturtechniken des ‚geistigen Auges'. In: Schramm, Helmar (ed.), *Bühnen des Wissens. Interferenzen zwischen Wissenschaft und Kunst*. Berlin: Dahlem University Press, pp. 50-67.

2 See Crary, Jonathan. 1990. *Techniques of the Observer: On Vision and Modernity in the Nineteenth Century*. Cambridge, MA: MIT Press.

3 See Kemp, Wolfgang. 1978 (2006). 2. Das Neue Sehen: Problemgeschichtliches zur fotografischen Perspektive In: Id., *Foto-Essays zur Geschichte und Theorie der Fotografie*. Munich: Schirmer/Mosel, pp. 51-101.

4 See Kemp, Wolfgang. 1978 (2006). 1. Quantität und Qualität: Formbestimmtheit und Format der Fotografie. In: Id., *Foto-Essays zur Geschichte und Theorie der Fotografie*. Munich: Schirmer/Mosel, pp. 10-50, esp. the quotation on p. 37

5 See Rancière, Jacques. 2005. Über das Undarstellbare. In: Id., *Politik der Bilder*. Berlin: diaphanes, pp. 127-159

6 The future perfect tense (*has becoming*) combines the (just occurred) conclusion of an action (*has become*) with its continuation in the present (*becoming*). See Chung, Chuihua Judy; Inaba, Jeffrey; Koolhaas, Rem; Leong, Sze Tsung (eds.). 2001. *Great Leap Forward. Harvard Design School Project on the City*. Cologne: Taschen, p. 706

7 See Lewis, Rhodri. 2006. *From Athens to Elsinore: The Early Modern Art of Memory, Reconsidered*. Berlin: Max-Planck-Institut für Wissenschaftsgeschichte (Preprint 319).

8 See Kemp, Wolfgang. 1978 (2006). 3. Bilder des Verfalls: Die Fotografie in der Tradition des Pittoresken'. In: Id., *Foto-Essays zur Geschichte und Theorie der Fotografie*. Munich: Schirmer/Mosel, pp. 102-143.

9 See Delahaye's photo book *L'autre* (Phaidon 1997), with covertly made photographs from 1995-1997 of passagers on the Paris Metro. Like Mettig, with his photographs from the New York subway from 2004/2005, Delahaye quite naturally refers back to Walker Evans' Subway Portraits from the 1930s, this drawing on an "occupied" theme, however, not impairing to any extent the independence of his pictorial ingenuities.

"Don't Be Left Behind" brings together breathtaking panorama photographs of Asian population centers and their inhabitants. Bhutan, Kathmandu Valley, Delhi, Shanghai and Dubai are the stations selected by Klaus Mettig for his research project on the present and future. The camera roams through the streets and markets, captures precise moments of life and confronts us with the existence of other people and other cultures, and the diversity of their identities. These photographic works seem to be unedited documents of daily life. Yet as already complex individual photographs join together into a composition in many parts, forming sequences and blocks, it swiftly becomes clear just how carefully thought out is each subject, framing, and final choice of dimensions. Klaus Mettig endows the succession of panoramas with breakbeat-like rhythm; he folds in on each other the subjects, following the process of literary montage, the cut-up. He uses the tempo of the progression of the photos to bring time into play. This includes the sought-after moment frozen in place, the time that exists between the subjects and exposures, between different regions and processes of change that globalization drives at different speeds and in different ways, and the real time of flipping through the book itself.

The project's title "Don't Be Left Behind" calls on us to catch up, to make haste. It surfaces in a photograph as an advertising slogan for luxurious living in Dubai, establishing a swiftness that can hardly be reconciled with the wealth of images. The viewer almost stumbles over the sheer opulence of the work. The question of how to evaluate what has been frozen in place is posed in each photograph as well as in the growing complexity of the whole. The discrepancy between the prescribed tempo of observation and Mettig's decision to place the aforementioned photograph at the end of the book is a testament less to the book's construction making a statement than to the dilemma of perceiving only very late the racing, galloping, pace of change. It hardly allows the question, "Who will stay behind?"

Klaus Mettig has documented a world whose order is undergoing radical, breakneck, non-linear change. Through the staggering assemblage of his photographs, the artist gives back to the term "globalization" the complexity it often loses in political discourse. He has developed a structure, both concise and unusual, to preserve and display this multifariousness. This conceptional method is reflected both in the photographic technique and in its presentation in the book.

From a pool of over 600 exposures, Klaus Mettig has selected 67 panoramic photographs for the book. He has grouped them according to the Asian countries in which they were taken. A closer look at the five sets of photographs makes clear that their author has placed Delhi at the center. Bhutan and Dubai, of which there are far fewer photographs, are the prelude and the coda. Slipped in between are the somewhat larger complexes of Kathmandu and Shanghai, each with the same number of images. The chapters all employ a similar dramaturgy, progressing from landscape panorama to dense human assemblages, then returning to the backdrop of the megalopolis. Only in Dubai does the camera remain in the distance, fixating on the deserted spaces between the clustered skyscrapers.

The photographs are united by a deep interest in the daily life of people in a world that seems, medially conditioned, as though it were familiar, but which we will always experience as foreign.

With their high resolution and precision, the photographs contain a fascinating abundance of details. The large-format panoramic camera captures all areas with equal exactitude, that is, at the same distance, such that a flat hierarchy arises in the relationship of the individual image elements and events to one another. These are partial views of landscapes, dwellings, both quotidian and ritual performances, attendant circumstances with powers of entrancement under which we may not wish to fall, for only too clearly will they reveal to us an unknown and devastating despair.

Architectural creations like colonnades, viaducts, bridges and pipelines are ubiquitous. They are the fixed structures around which arises endemic life, life that is chaotic, wild, makeshift. It is striking, by contrast, how small a role automobiles or vehicles of any kind play in these dense urban areas. Mettig develops a singular image of slowed mobility. He maintains deliberateness despite chaos, composure amidst tumult.

The extreme landscape format and the manner of composition of each image, most often arranged by a few vertical elements, such as columns and supports, turn the scene that has been preserved into a stage for events still in progress, or into an arena for an age-old history and its tradition. In one photograph, the monumental wheels of a ceremonial vehicle abut a building. In another, banners are raised to mark a ritual site. The many markets and plazas in which people peacefully go about their business call to mind carefully choreographed mass scenes, and the entry of large dramatic choruses.

Mettig has drafted the scenario for a world caught up in transformation, transformation comprised of changes hardly perceptible at first. The sense of restlessness grows as one pages through the book and beholds the stages of action. The sections of photographs from Shanghai contain images that make manifest a concept of progress that seems to introduce the future. A peculiar stillness emanates from the populated city squares of Shanghai. Likewise, the skeletal unfinished skyscrapers of Dubai seem old and inelegant in the light, as though, before even finished, they were already ruins of a new era. "Don't Be Left Behind," the slogan on a monumental billboard advertising a new city center, endows the urban development desired by investors and businesses for our globalized world with an exclamation mark. It is Mettig the visionary who incorporates into the images the formidable sterility of this inhuman dream of perfection and wealth.

The five regions and their inhabitants have little in common with one another. The connection comes about through the way in which the individual chapters run up against each other, through the interworking of the plates without interruption, and the refusal to accentuate a transition. For the exhibition projects related to this complex of works, Klaus Mettig developed a method of presentation similar in radicality to the conception of this volume, placing a mere one or two panoramas per city alongside the other cities. The examination of the life-worlds of other cultures is enacted as a confrontation. The connective element is an oppositionality only medially and associatively to be assembled.

Mettig is interested in the ceaseless flow of images and in the creativity of human life, which he can capture only amidst many subjects, reflected across multiple series of photographs. Every image has its significance, and derives from a particular interest. He can preserve what is disparate while bringing out what is held in common. He has no desire to record similarities. His photographic works are not a limited circumscription of cultures, endowing destitution with visual order, nor

merely a capturing of communities that pulse with life and function according to a plan beyond our comprehension. With sovereign command, he positions himself and his carefully selected material within the complex information density of our media age.

Klaus Mettig exhibited his first flood of images in a work he presented at documenta 7 in 1982. Over the course of three years, he took over 2568 photographs of a television displaying news programs, selecting them according to a specific content-based principle. He then placed the photographs one after another and developed a pattern both ceaselessly changing and, paradoxically, repeating, for a wall covering. The news images create a wall newspaper, 2.52 meters tall and 65 meters across – the German Autumn the NATO Double-Track Decision, and Afghanistan as a photo wall, divided into small sections, all but infinite in appearance. Mettig does not question whether these images convey news and give shape to current events, but he adopts them as a model, a shell in which we live. It is time become image, time in which human bodies interact in each other, in front of one another, whether conscious of the many events of their political and social reality or not.

Used to view the subject of Asian civilizations, this visualization of a complex socialization, the inflation that alone can make singularity possible, yet renders it without impact, comes across as both fitting and strangely foreign. Taking the camera as tool for his excursions, Mettig conveys to us once again that the medial expression of life and cultures through the photographic image will ultimately annul its lived reality and creativity.

Mettig has taken an unusual approach to fitting the panorama photographs into the book's dimensions: He has folded the photographs back. Each plate crosses the book's binding and fold three times. The pictures thus rest atop each other on the folds, where a new composition of images arises. The result is a book in which center and periphery are in constant alternation, generating a continuity in disparity. Mettig thus constructs formally the same theme that he addresses in the content of his images and the context they engender. He declares the edge and the middle to be equal in dignity. What is more, he has made a conscious choice of the Technorama camera, which captures the action occurring at the corner of the eye.

No sooner have we finished with one panorama that we will never fully comprehend, than we arrive at the next, which is of just as great importance. Sometimes the difference appears minimal, and we are inclined to perceive the two different parts as forming a single whole. The pictorial elements seem like linear memory. In their fragmentation, they underscore the complexity of visual occurrences, and with it the complexity of what we call reality.

Such a radicality of systematics, moreover, implies an obsession. This radicality traces the drive, the compulsion, always to seek new connections, to keep in view things that seem insignificant at first, and never to lose sight of context. It is the method of the serial killer, the man who must extinguish human life in new and ever more artificial ways, leaving behind many clues, to conquer his phobias – except the reverse is the case for Mettig. He seeks to preserve human life, to clarify it for himself, cutting up his photographs and dividing them into portions, relentlessly arranging and juxtaposing different cultures and traditions alongside each another. A given image will not be fully understood on a first thumbing through the book. Mettig's photographs reveal their secrets when examined twice, though no subjects are repeated or varied.

Today, the variance of urban landscape can no longer be captured in one, or in many, photographs providing a harmonizing overview. Synchronicity can hardly be preserved photographically, nor would one want to, when it would only direct the gaze onward to something new. We do not learn who is living or will someday live in the residential high-rises on which we train our sights. We can only imagine that it will not be the people whose faces we have encountered elsewhere in this collection of photographs.

Mettig uses his method of cutting and fragmentation to unmask the deceptive pretention of the panorama, that claim to showing everything which evokes a mythos of completion and totality. The artist chooses the form of the panorama for just this reason, and turns against each other the vital antagonists of wide-open space and fine detail. A balance is struck between distance and proximity, that which is internally conveyed and that which is externally present, landscape and portrait. Vertically oriented portraits resolve into view out of the horizontally framed landscape.

The photographs often seem to be hung from a horizontal line, and as though they, in addition to being presented with twin vertical folds, could also be folded lengthwise. The image construction is structured as two horizontal strips, each of equal formal significance. The lower half of the picture relates to proximity and detail, and makes pictorial space experiential, walkable, and tangible. The upper half of the picture represents a more general principle of breadth and openness. This is still true of the pictures from Dubai, despite the fact that the lower part seems barren and inhospitable, hardly inviting the viewer to jump in. This schema fails to function only in the various representations of garbage dumps. Upper and lower have come so close to one another that an equilibrium arises: The dynamics shut down; constriction and complex confusion spread out.

For 35 years, Klaus Mettig has worked with social portraits and the politics of urban economies in great cities. In this latest photo project, he creates a condensate of the misery that comes from the clash of political systems and has ascended to the level of a life-world, and he evokes comparable situations across boundaries. In the age of globalization, these juxtapositions grow increasingly ludicrous. Mettig's method of comparison and of the penetration of the photographic surface through principles of artificiality allow us to become aware of the variant structure of the ongoing shifting of contexts, shifts we witness in international politics and business as well. What does a critical view of the world still mean today? What recognitions can we win from photographs that, whether personal or medial, we now find suspect?

Klaus Mettig has given us much to discover in details and interconnections. At the same time, he uses his principle of the cut-up to press us to perceive the traces of change in the real.

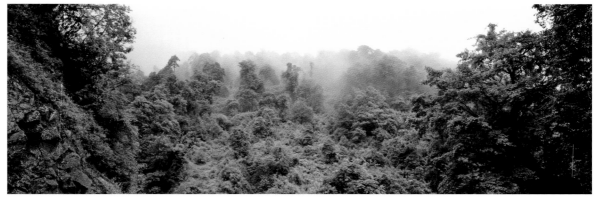

Bhutan 08/2005 #11/03

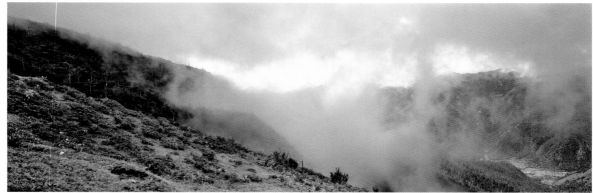

Bhutan 08/2005 #02/03

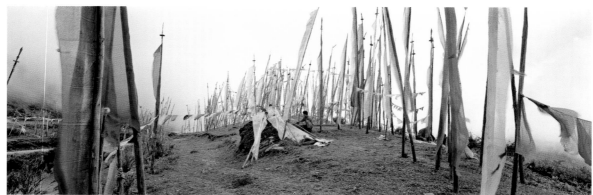

Bhutan 08/2005 #02/02

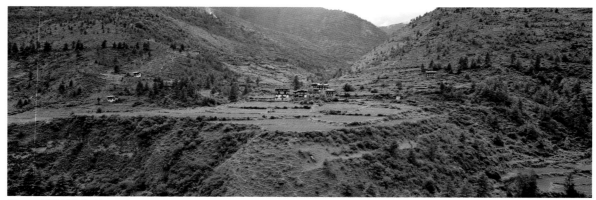

Bhutan 08/2005 #06/01

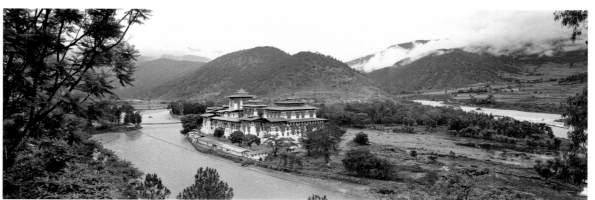

Bhutan 08/2005 #09/02

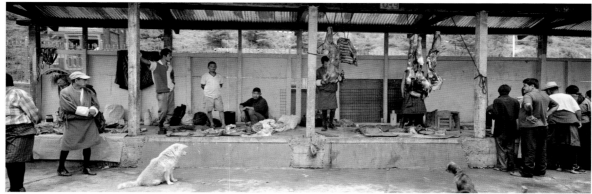

Bhutan 08/2005 #01/01

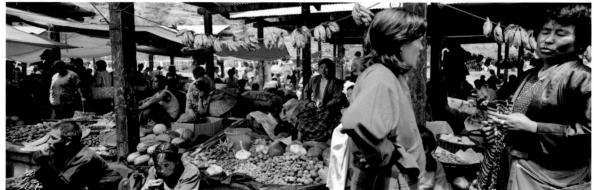

Bhutan 08/2005 #04/02

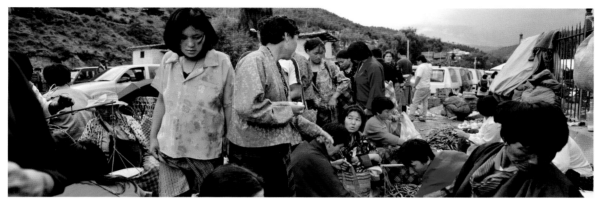

Bhutan 08/2005 #01/04

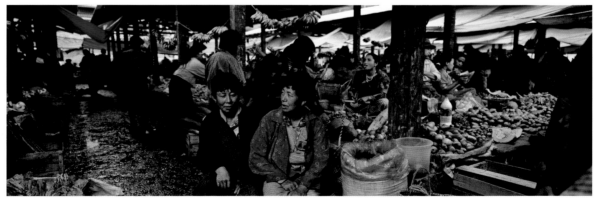

Bhutan 08/2005 #04/01

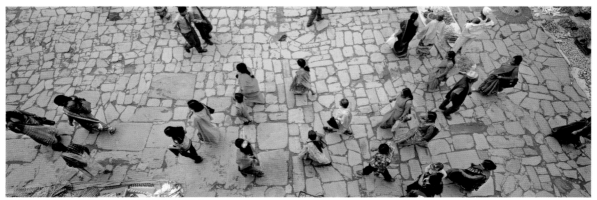

Kathmandu Valley/Bhaktapur 08/2005 #13/01

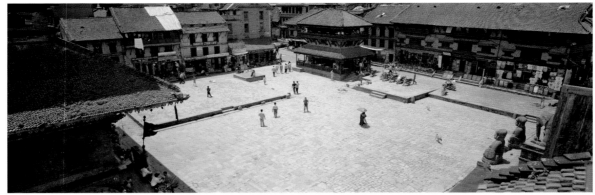

Kathmandu Valley/Bhaktapur 08/2005 #01/04

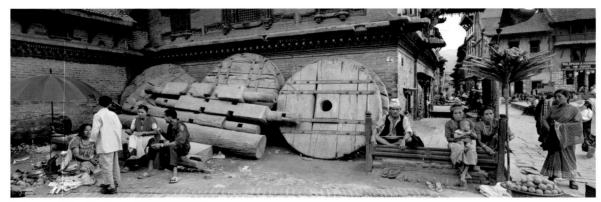

Kathmandu Valley/Bhaktapur 08/2005 #19/03

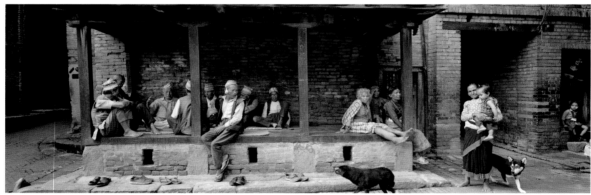

Kathmandu Valley/Bhaktapur 08/2005 #20/03

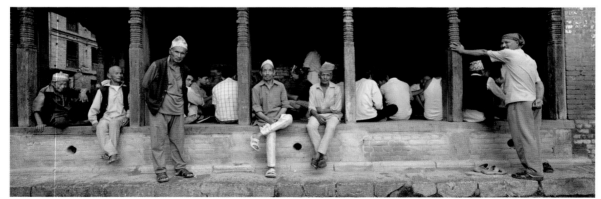

Kathmandu Valley/Bhaktapur 08/2005 #18/02

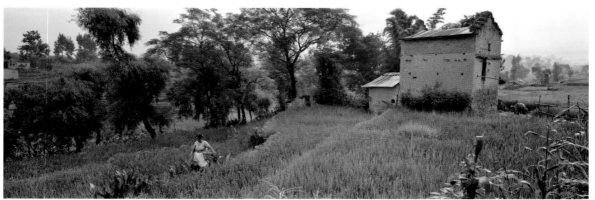

Kathmandu Valley/Bhaktapur 08/2005 #25/03

Kathmandu 08/2005 #16/03

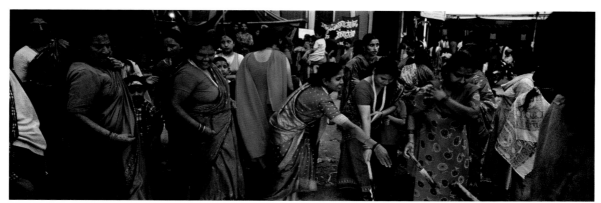

Kathmandu 08/2005 #38/02

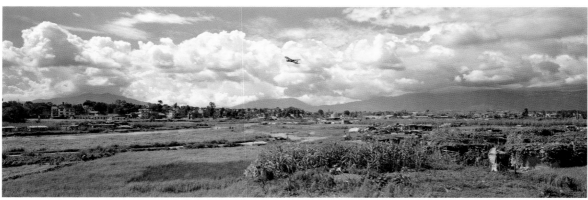

Kathmandu 08/2005 #12/04

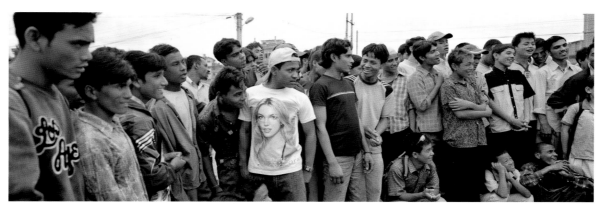

Kathmandu 08/2005 #17/01

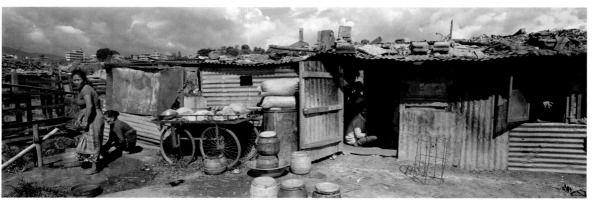

Kathmandu 08/2005 #17/03

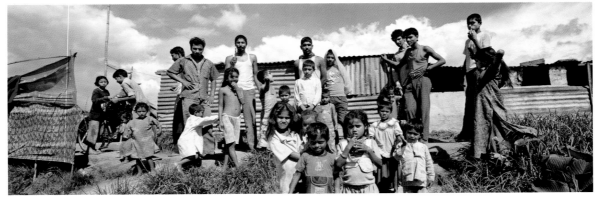

Kathmandu 08/2005 #27/04

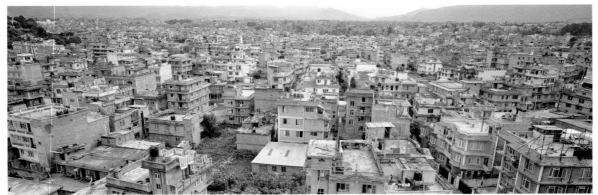

Kathmandu 08/2005 #11/01

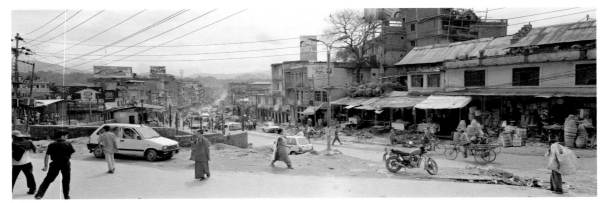

Kathmandu 08/2005 #29/03

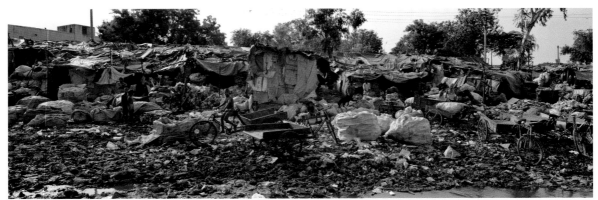

Delhi 08/2005 #25/04

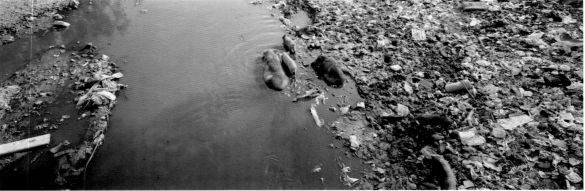

Delhi 08/2005 #07/04

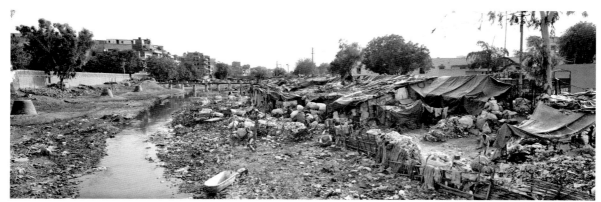

Delhi 08/2005 #54/02

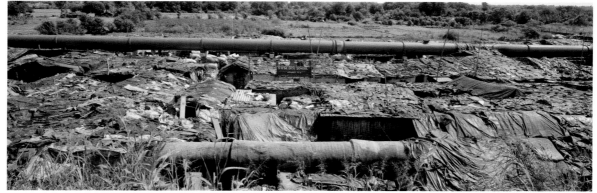

Delhi 08/2005 #19/03

Delhi 08/2005 #33/01

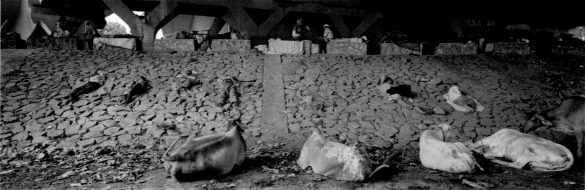

Delhi 08/2005 #30/04

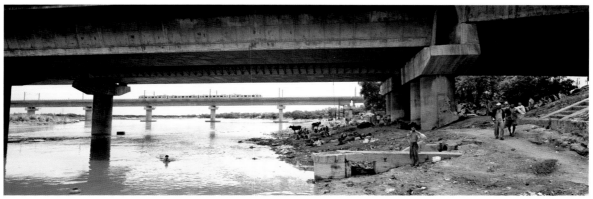

Delhi 08/2005 #09/02

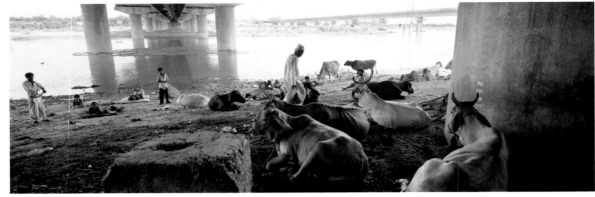

Delhi 08/2005 #39/02

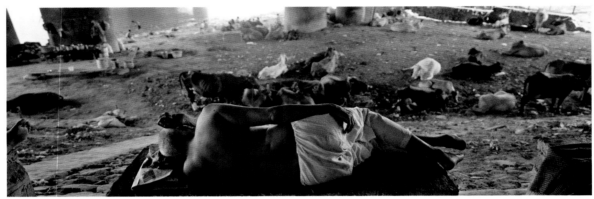

Delhi 08/2005 #28/04

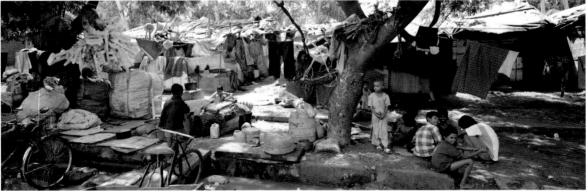

Delhi 08/2005 #24/01

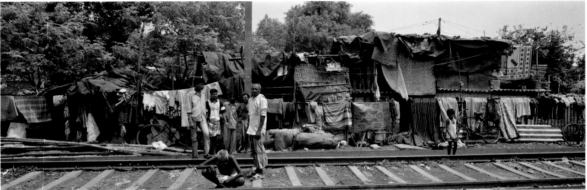

Delhi 08/2005 #71/04

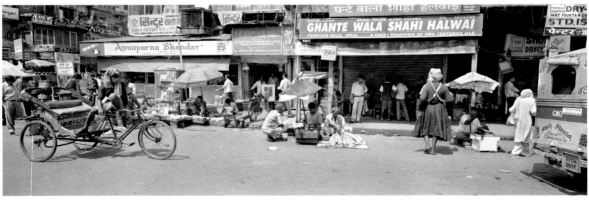

Delhi 08/2005 #64/04

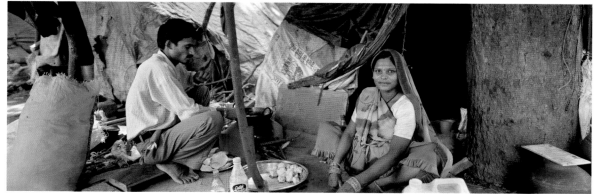

Delhi 08/2005 #15/04

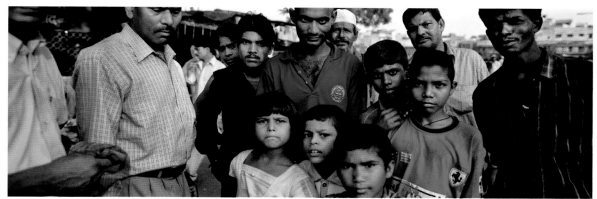

Delhi 08/2005 #27/01

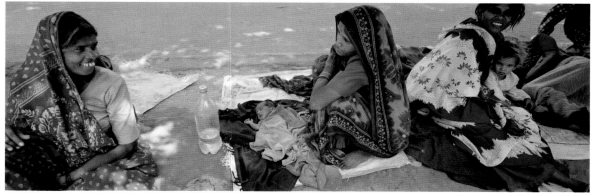

Delhi 08/2005 #34/04

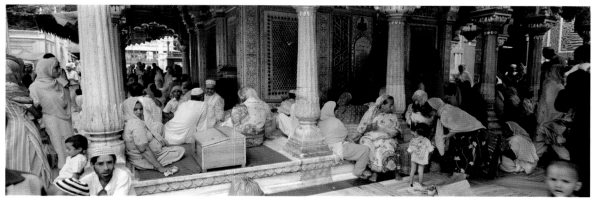

Delhi 08/2005 #26/04

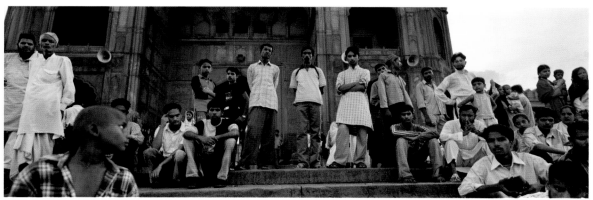

Delhi 08/2005 #27/03

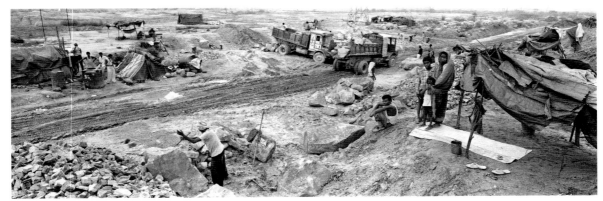

Delhi 08/2005 #65/04

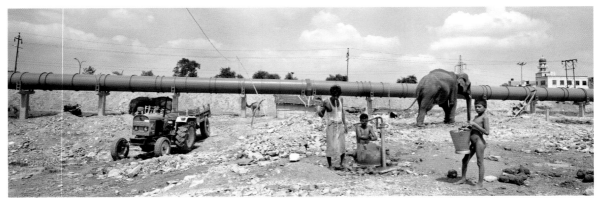

Delhi 08/2005 #14/01

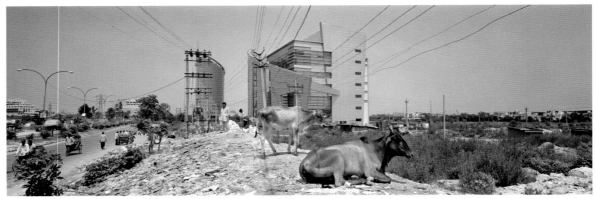

Delhi 08/2005 #31/04

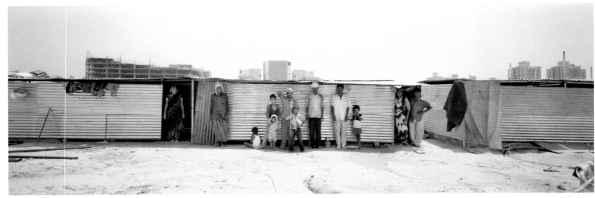

Delhi 08/2005 #13/02

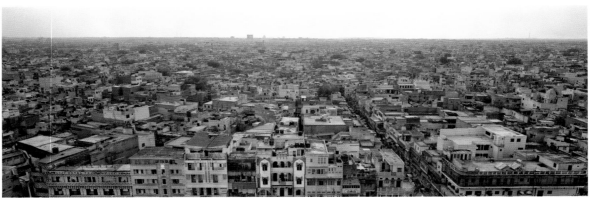

Delhi 08/2005 #23/01

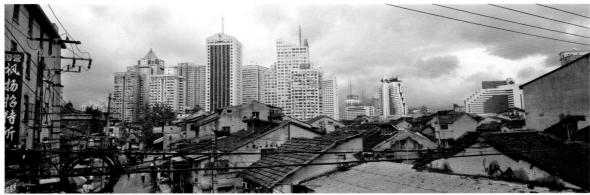

Shanghai 09/2006 #20/02

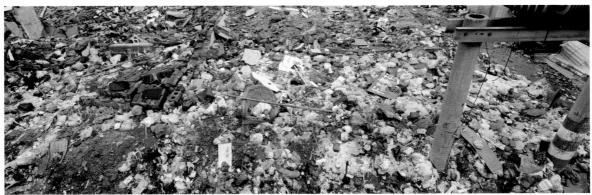

Shanghai 09/2006 #20/01

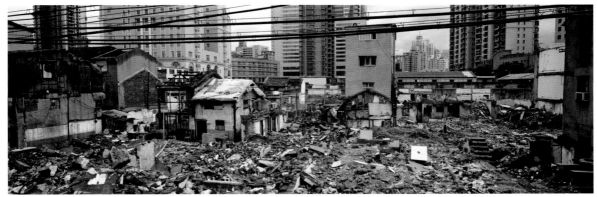

Shanghai 09/2006 #19/03

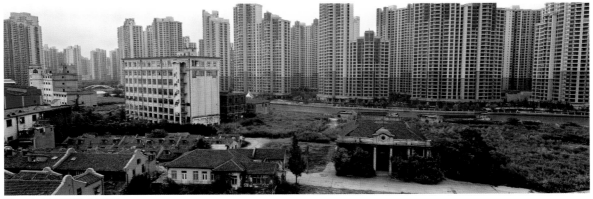

Shanghai 09/2006 #17/03

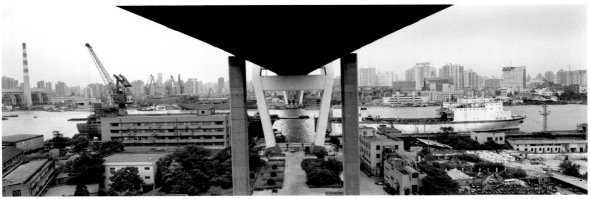

Shanghai 09/2006 #24/03

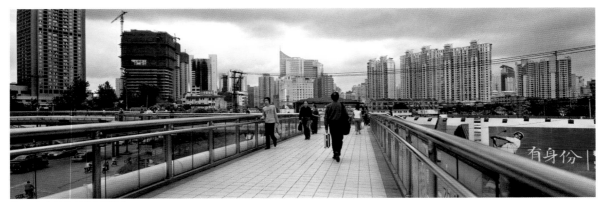

Shanghai 09/2006 #25/04

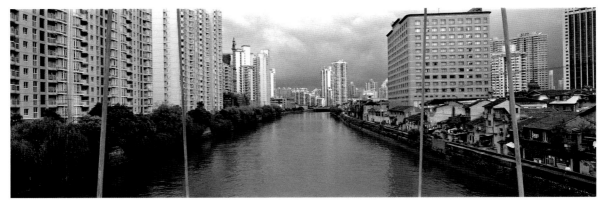

Shanghai 09/2006 #07/03

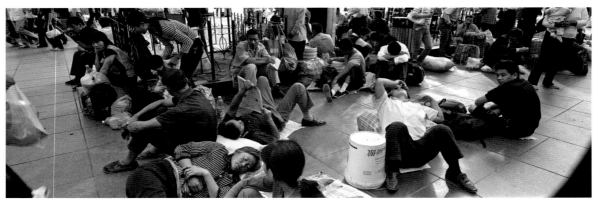

Shanghai 09/2006 #10/01

Shanghai 09/2006 #03/03

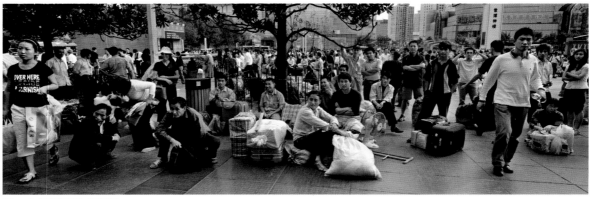

Shanghai 09/2006 #17/04

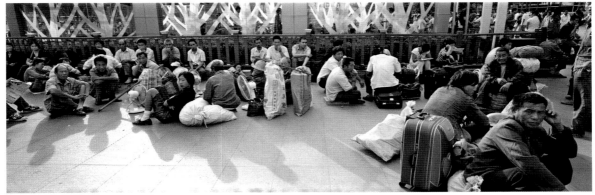

Shanghai 09/2006 #01/02

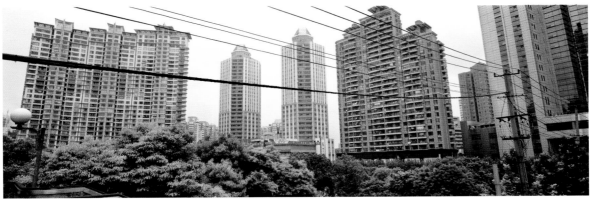

Shanghai 09/2006 #24/04

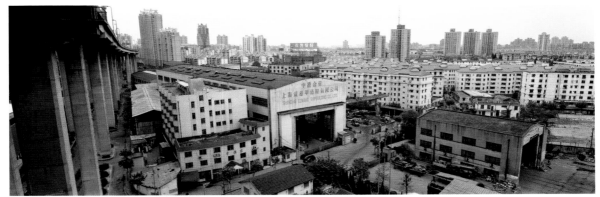

Shanghai 09/2006 #22/02

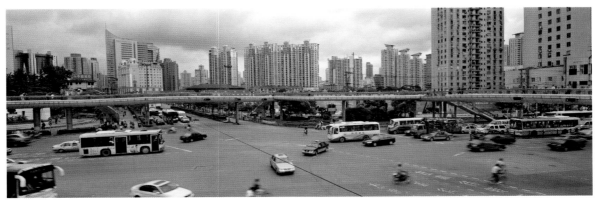

Shanghai 09/2006 #21/04

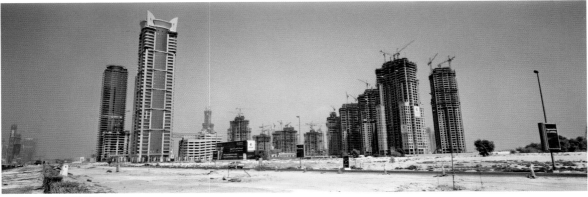

Dubai 09/2006 #01/01

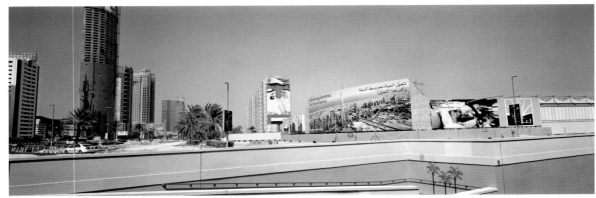

Dubai 09/2006 #02/03

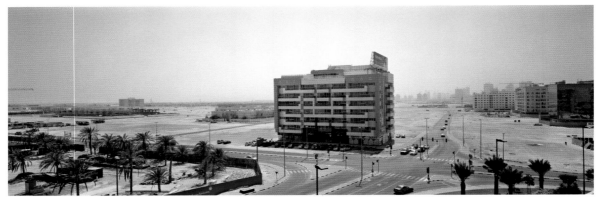

Dubai 09/2006 #03/02

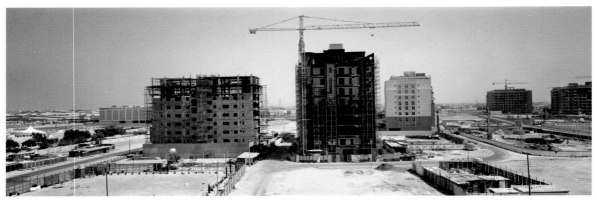

Dubai 09/2006 #03/01

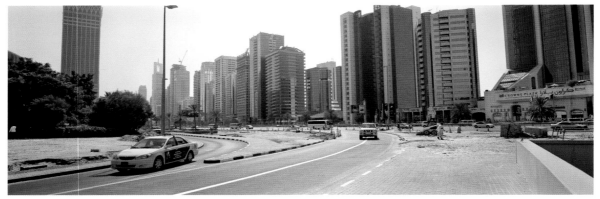

Dubai 09/2006 #02/04

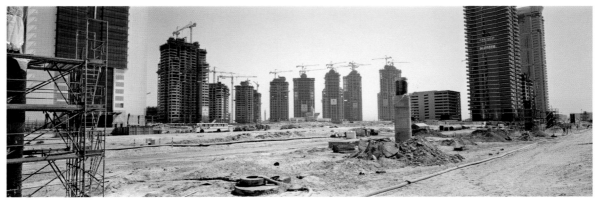

Dubai 09/2006 #01/03

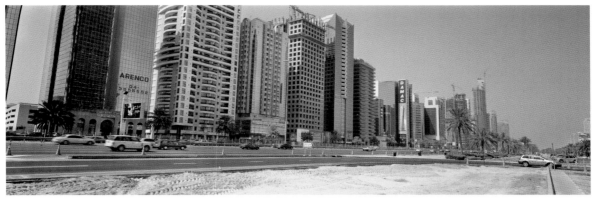

Dubai 09/2006 #02/01

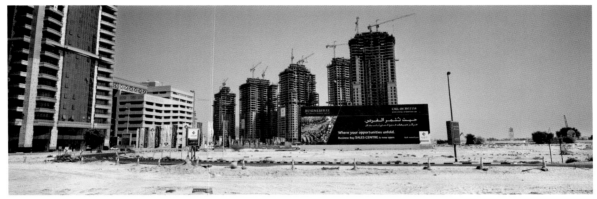

Dubai 09/2006 #01/02

Linhof Technorama 617 S III
Schneider Kreuznach Super Angulon 5.6/90XL
Fuji 800Z/100 Acros, Kodak TX/TMY/160VC/400VC, Ilford HP5 Plus

Homrich HVA St 25
Rodenstock Rodagon G 5.6/240

Kodak Ultra Endura
Acryl, Edelstahl, Holz
Acrylic, Stainless Steel, Wood

Masse / Size:
125 x 375 cm

BIOGRAFIE 1950 geboren in Brandenburg 1973 USA 1976-77 Whitney-Museum of American Art, New York: Independent Study Program 1978 VR China 1985 UdSSR 1986 USA / Sofia 1992 Korea / Hongkong / VR China 1997 Istanbul 2000 Moskau 2002 VR China 2003 VR China 2004 New York 2005 New York 2005 Bhutan / Kathmandu / Delhi 2006 VR China / Dubai 2007 New York 2008 VR China / Dubai / New York 2009 New York / Korea EINZELAUSSTELLUNGEN 1974 Galerie Ingrid von Oppenheim, Köln. 1975 Galerie Erhard Klein, Bonn. 1978 Stichting de Appel, Amsterdam. 1980 Städtische Kunsthalle, Düsseldorf. 1981 Galerija Studentskog Centra, Zagreb. 1982 *Stedelijk Van Abbe Museum, Eindhoven. 1983 Galerie Erhard Klein, Bonn. *Städtisches Kunstmuseum, Bonn. *Württembergischer Kunstverein, Stuttgart. 1988 *Castello di Rivoli, Museo d'Arte Contemporanea, Turin. *Kunstmuseum, Düsseldorf. 1990 Galerie Vorsetzen, Hamburg. 1992 Galerie Elke Droescher, Hamburg. 1995 Foto Forum, St. Gallen. 2004 Storms Galerie, München. 2005 *'Ultra Endura', Oldenburger Kunstverein und Edith-Russ-Haus für Medienkunst, Oldenburg. 2007 *'Don't be left behind', Kulturzentrum Sinsteden. 2008 *NGBK und Haus am Kleistpark, Berlin. 2010 *Museum Kunst Palast, Düsseldorf GRUPPENAUSSTELLUNGEN 1973 *'Between 7' Städtische Kunsthalle, Düsseldorf. *'Some 260 Miles from here' Gallery-House, London. 1974 'Düsseldorfer Scene' Galerie Toni Gerber, Zürich. 'Projektionen 1968-1974' Galerie Oppenheim, Kunstmarkt Basel. 1975 'Klaus Mettig Filme und Projektionen 1973-1975' Sonderveranstaltung Städtische Kunsthalle, Düsseldorf. 1976 *'Photography as Art' Galerija Grada, Zagreb; Modern Art Museum, Belgrad; Rastavni Salon Rotocz, Maribor. *'5th April Meeting' Student Cultural Center, Belgrad. 'Nachbarschaft' Städtische Kunsthalle, Düsseldorf. 1977 Performances / Lectures / Installationen Yorck-University, Toronto; Center for Art and Communication, Toronto; Concordia University, Montreal; 03 23 03, Montreal; University of Ottawa; College of Art and Design, Minneapolis; California Institute of the Arts, Valencia / Los Angeles; San Francisco Art Institute; University of California, Santa Barbara; University of California, Irvine; University of California, San Diego; Los Angeles Institute for Contemporary Arts; Hall Walls-Ashford Hollow Foundation, Buffalo. 1978 *'China - America' Stichting de Appel, Amsterdam. *'Performance Art Festival' Beursschouwburg, Brüssel. *'Extract II' Theater a/d Rijn, Arnheim. 1980 *'18.10.-15.11.1980' Galerie Max Hetzler, Stuttgart. 1981 *'Gegenbilder - Die Kunst der jungen deutschen Generation' Badischer Kunstverein, Karlsruhe. *'Sammlung Oppenheim - Highlights' Städtisches Kunstmuseum, Bonn. 1982 *'documenta 7' Neue Galerie und Museum Fridericianum, Kassel. *'Gegen das Kriegsrecht in Polen - für Solidarnosc' Kunstpalast Düsseldorf. 1982-83 *'Videokunst in Deutschland' Kölnischer Kunstverein, Köln; Kunsthalle Hamburg; Badischer Kunstverein, Karlsruhe; Westfälischer Kunstverein, Münster; Städtische Galerie im Lenbachhaus, München; Kunsthalle Nürnberg; Nationalgalerie, Berlin; Ständige Vertretung der Bundesrepublik Deutschland in Berlin. 1983-84 *'Ansatzpunkte kritischer Kunst heute' Bonner Kunstverein, Bonn; NGBK, Berlin. 1984 *'Medium Fotografie' Galerie Gugu Ernesto, Köln. *'Dada' Bonner Kunstverein, Bonn. *'Fotokunst aus NRW' Kunstverein Soest; Museum Bochum. *'Grossfotos' Kunstraum Bonn; Museum Bochum. *'Nehmen Sie Dada ernst - es lohnt sich' Kunstmuseum Düsseldorf. *'Treppen' Galerie Gugu Ernesto, Köln. 1985 *'Medium Fotografie' Oldenburger Kunstverein, Oldenburg; PPS-Galerie F.C. Gundlach, Hamburg. *'Rheingold' Palazzo della Società Promotrice delle Belle Arti, Turin. *'Cover. Doppelgänger' Aorta, Amsterdam. *'Treppen' Gesellschaft für aktuelle Kunst, Bremen. *'20 Jahre Edition Staeck: Genommene Kurven' Heidelberger Kunstverein, Heidelberg; Kunstmuseum Düsseldorf. *'Talking Back To The Media' Aorta, Amsterdam. *'Der Schein des Objektiven' Art Cologne, Köln. 1986 *'Augenhöhe - Van Abbe Museum 1936-1986' Van Abbe Museum, Eindhoven. *'Sie machen was sie wollen - Junge Rheinische Kunst' Galerie Schipka, Sofia. 1987 *'Hacen Lo Que Quieren - Arte Joven Renano' Museo de Arte Contemporánea de Sevilla. *'Karl Schmidt-Rottluff Stipendium' Ausstellungshallen Mathildenhöhe, Darmstadt. 'Vorsetzen' Galerie Vorsetzen, Hamburg. 1988 *'Ansichten' Westfälischer Kunstverein, Münster. *'Pyramiden' Internationales Congress-Centrum, Berlin; Galerie Jule Kewenig, Köln-Frechen. *'Meine Zeit Mein Raubtier' Kunstpalast Düsseldorf. 'Fotoarbeiten' Wolfgang Wittrock, Düsseldorf. 1989 *'2000 Jahre. Die Gegenwart der Vergangenheit' Bonner Kunstverein, Bonn. 1990 'Arbeiten auf Papier' Galerie Vorsetzen, Hamburg. *'Herzsprung' Haus am Waldsee, Berlin. 1991 *'Umwandlungen' Nationalmuseum für Zeitgenössische Kunst, Seoul, Korea. 1995 *'RAM. Realität - Anspruch - Medium' Badischer Kunstverein, Karlsruhe; Bundesministerium für Post und Telekommunikation, Bonn; Kunstfonds e.V., Bonn; Bonner Kunstverein, Bonn; Kunst- und Ausstellungshalle der Bundesrepublik Deutschland, Bonn; Neues Museum Weserburg, Bremen; Lindenau-Museum, Altenburg; Museum Wiesbaden; Nassauischer Kunstverein, Wiesbaden. 1997-99 *'Pro Lidice. 52 Künstler aus Deutschland' Goethe Institut, Prag; Schleswig Holsteiner Kunstverein, Kiel; (1998), Museum Fridricianum, Kassel; (1998-99), Museum Ostdeutsche Galerie, Regensburg (1999). 1999 'Erotik' Galerie Erhard Klein, Bad Münstereifel. 'Les Adieux' Galerie Jule Kewenig, Köln-Frechen. 2000 *'Hommage an Achim Duchow' Galerie Erhard Klein, Bad Münstereifel. *'2356 km. Kunst aus Düsseldorf in Moskau' Neue Manege, Moskau. *'Künstler für Fortuna Düsseldorf' Düsseldorf. '7534684 - ich bin wieder da, aber im Moment nicht hier !' Kunstverein Lippstadt. 2002 *'Heute bis jetzt. Zeitgenössische Fotografie in Düsseldorf' Museum Kunst Palast, Düsseldorf. 'Künstler helfen alten und neuen Meistern' Neue Nationalgalerie Berlin. *'Urban Creation' Fourth Shanghai Biennale, Shanghai Art Museum. 2003-04 'Tuscheelemente' Bundespresseamt Berlin; Bureau of Cultural Affairs Hsin-Chu, Taiwan. 2004 'Himmel über der Strasse. Topographie der Obdachlosigkeit' fiftyfifty zu Gast in der Storms Galerie, Düsseldorf. 'Die Chinesen. Fotografie und Videos aus China' Kunstmuseum Wolfsburg. 2005 *'Zur Vorstellung des Terrors: die RAF-Ausstellung' KW Institute for Contemporary Art, Berlin; Neue Galerie Graz. 'Founders Day. Jack Smith and the Work of Reinvention' Grimm/Rosenfeld, New York. 2006 'Extension Turn 2' Eastlink Galerie, Shanghai. 'Every Day ...another artist/work/show' Salzburger Kunstverein, Salzburg. 'Artists for Tichy - Tichy for Artists' The East Bohemian Gallery of Fine Arts, Pardubice und 2007 Museum Moderner Kunst Passau. 2008 *'Translocalmotion' Seventh Shanghai Biennale, Shanghai Art Museum. *'Objectivites. La photographie a Düsseldorf' Musee d 'Art Moderne de la Ville de Paris, Paris. 'The Forgotten Bar Project' Ritter Butzke / Berlin-Kreuzberg, Berlin. 2009 *'Wir Kleinbürger. Zeitgenossen und Zeit genossinnen' Hamburger Kunsthalle, Hamburg. 'Central Nervous System I' Galerie im Regierungsviertel, Art Cologne, Köln, 'Central Nervous System II' Galerie im Regierungsviertel, Haus des Kindes, Berlin. 'Narcotica' Galerie im Regierungsviertel, Art Basel, Basel. 'Elevator To The Gallows' X Initiative, New York. *'Organ Mix' Total Museum of Contemporary Art, Seoul. (*Katalog)

Dank / Acknowledgement:

Antje Vollmer

Gert-Matthias Wegner

Shiva

Marianne Bahri

Gudrun Maria Sräga

Liu Ying Mei

Regina Wyrwoll

Gerit Christiani

KLAUS METTIG / DON'T BE LEFT BEHIND

Konzept / Concept:

Orson Sieverding

Klaus Mettig

Digital Mastering / Lithos / Layout:

Orson Sieverding, Studio 111a

Typografie / Typography:

Orson Sieverding

Miroslav Trlica

Text:

Julian Heynen

Ingrid Hölzl

Frank Wagner

Übersetzung / Translation:

Ben Letzler

© 2010 für die Fotografien / for the images

Klaus Mettig, VG Bild-Kunst

© 2010 für die Texte / for the texts:

Julian Heynen

Ingrid Hölzl

Frank Wagner

© 2010 für diese Ausgabe / for this edition:

Klaus Mettig und Steidl Verlag, Göttingen

Gesamtherstellung und Druck / Production and printing:

Steidl, Göttingen

Steidl

Düstere Str. 4 / 37073 Göttingen, Germany

Tel. +49 551-49 60 60 / Fax +49 551-49 60 649

mail@steidl.de

www.steidl.de / www.steidlville.com

ISBN 978-3-86521-595-6

Printed in Germany